Camera Techniques

Editor

Clyde Reynolds

NEWNES BOOKS

This edition published by Newnes Books,
a Division of The Hamlyn Publishing Group Limited
84-88 The Centre, Feltham, Middlesex, England

ISBN 0 600 35711 2

Printed in Great Britain

Contents

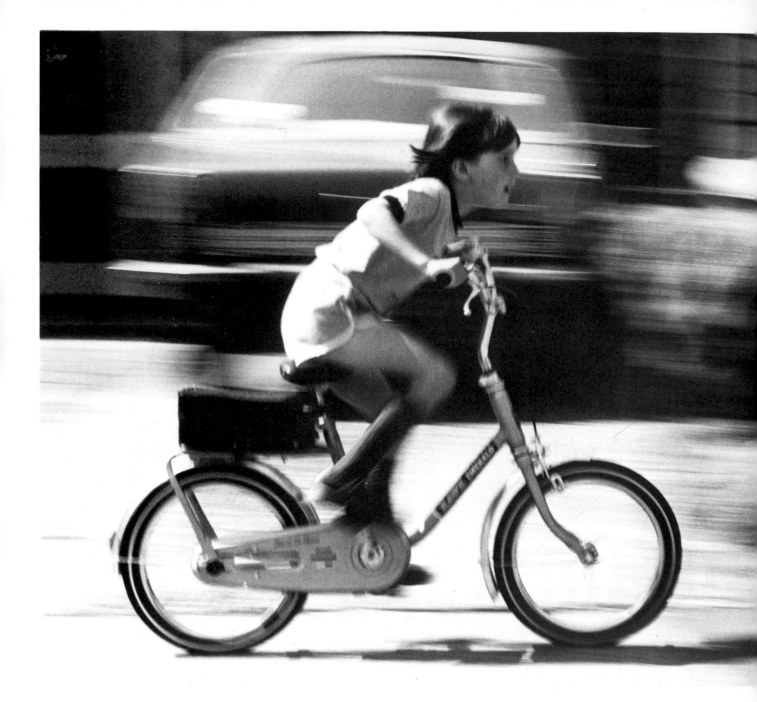

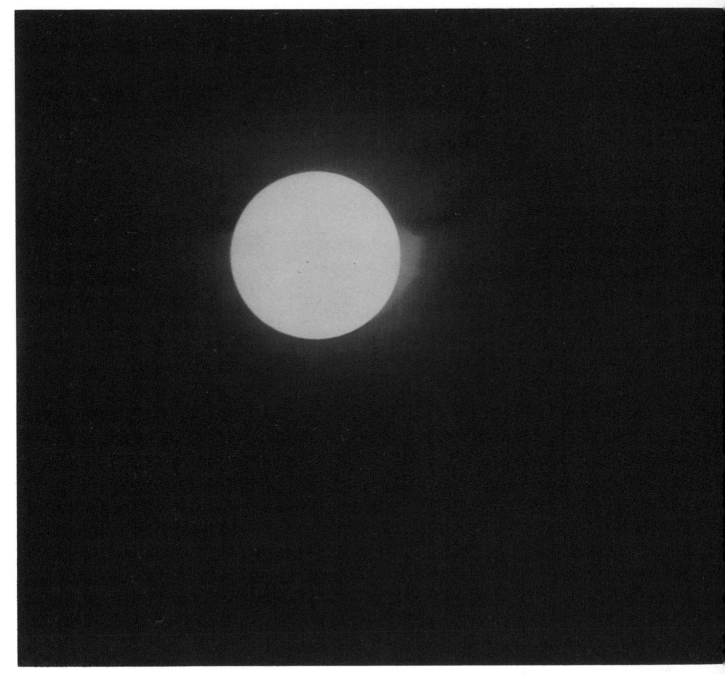

8

Ed Buziak

Preface

There are two facets to photography, technology and technique. The aspiring photographer needs to consider both: to understand just how his or her camera translates real life into pictures on film, so that its operation becomes second nature; then to begin to look at potential subjects, see how the light falls on them, and visualise the pictures he or she wants to create. *Camera Techniques* explains the technology, giving you the understanding to work your camera without worry, and shows you the way to develop an 'eye' for a good picture.

Camera Techniques is a compilation of information from several experts designed to help you take better pictures. It is based on books in Focal Press's Photographer's Library: *Indoor photography* by David Lynch, *Colour films* by George Wakefield, *Make the most of your pictures* by Roger Darker, *Black-and-white photography* by John Wasley, *Portrait photography* and *Special effects in the camera*, both by John Wade. The sections from each book come together to tell you all the things you need to know to be able to use your camera, lenses and accessories with confidence. They are bound together with the theme of making better photographs – choosing the most appropriate film, the best view, the right equipment, and selecting the camera settings you need to capture the essence of the scene in your photographs.

The text is illustrated throughout with explanatory diagrams, to make the more technical points really clear. To most readers, though, the photographs will prove of even more benefit. They are examples of a wide range of styles and ideas. Some, no doubt, you will dislike, or at least think pointless. Others, I hope, will attract, entertain or intrigue you. All should give you food for thought. If they inspire you to try out new ideas, they will have more than justified their inclusion in the book.

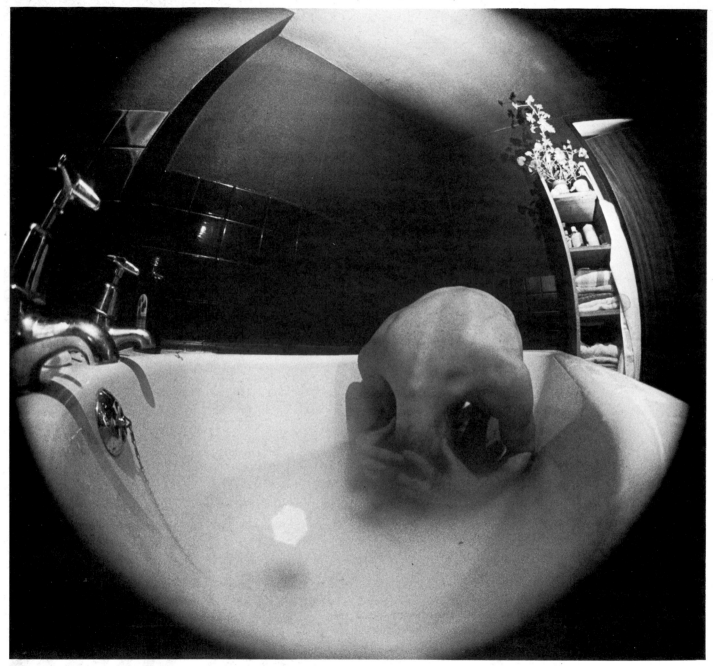

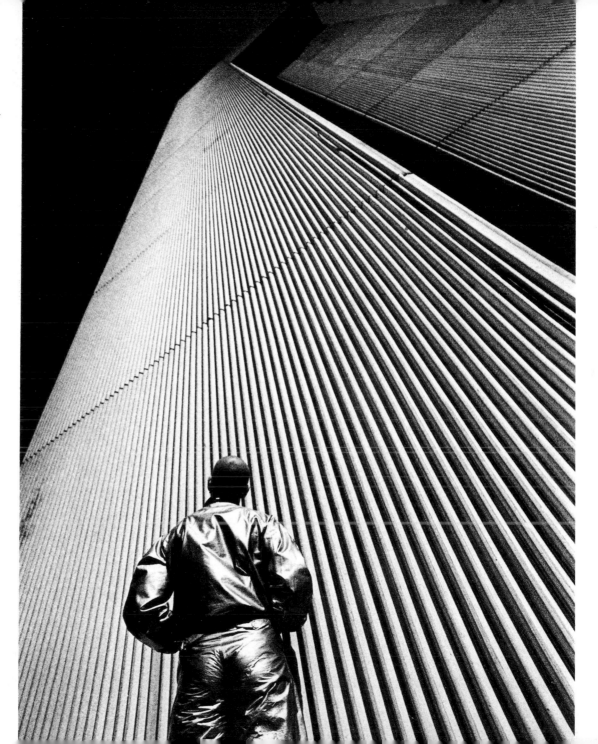

Left: an unusual way to take a self-portrait makes good use of the strange image from a full-frame fisheye. *Ed Buziak*.

Right: a red filter and a low viewpoint transform this quite ordinary scene into a picture with a difference. *Frank Peeters*.

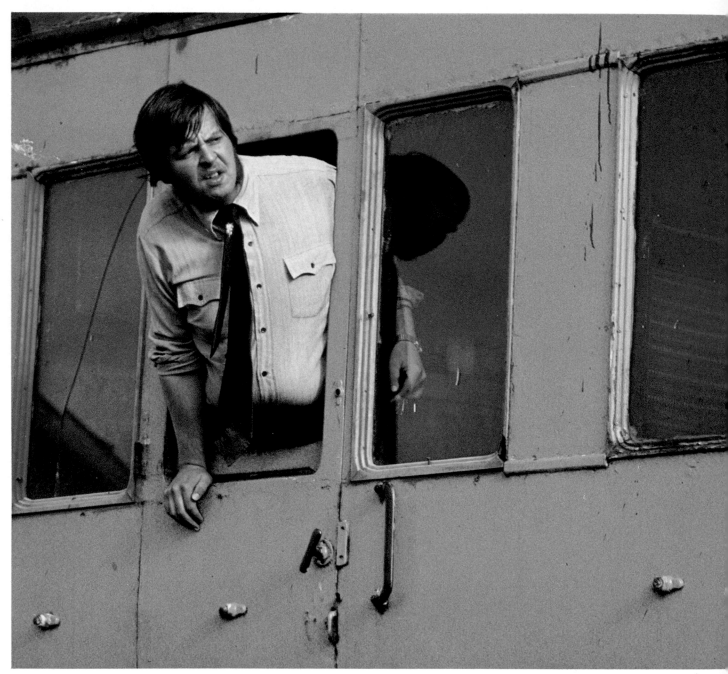

Photography

Over the last few decades, cameras have become accepted as part of all our lives in the developed world. We expect to be able to picture special occasions and recall them later with a set of little colour prints. At the same time, we are surrounded by papers and magazines that use photographs to show us the world, or create a dream world where everything is brighter, better, and more accessible than reality. At times there seems little in common between the holiday 'snaps' produced with a simple camera and the sophisticated hard work needed to succeed as a professional photographer. Yet they are all facets of the same subject – photography.

More and more people are replacing their simple cameras with much more complicated models, capable of producing results of really professional quality. They are set to join the ranks of photographic enthusiasts, who have the best of all worlds: the knowledge and equipment to match professionals, and the freedom to pursue their own artistic courses with no art directors leaning over their shoulders. However, there is no need to feel that you have to have the latest electronic marvel to start taking really good pictures. It is the eye behind the viewfinder that counts. As long as your camera works, it can picture your vision.

Seeing pictures

Alexei Brodowitch, the innovative art director of Harpers Bazaar for so long, is credited with nurturing some of America's best-known photographers. Looking at their work, especially that for the magazine, reveals one common streak: each image contains just the material needed to convey its message, nothing more. That is the way to achieve notable photographs. Every time, before pressing the shutter release, look at the image in the viewfinder. Decide whether it shows the subject the way you really want it to be seen. Then look at the

background and the surroundings. Do they detract from the idea you intend to convey? Or do they contribute to the picture? If they detract, try to select a better viewpoint or a different lens, or at least use the shutter speed and aperture controls to blur out the worst problems. Of course, if you are intending to make your own prints, or have them made to your specification, then you can alter the effect of background later. Even so, you will probably still achieve better results if the scene is right when you take the picture.

Just what you include depends on your ideas for the picture. For a holiday record shot, you want all the family to be recognised – so not too far away – and the beach or mountain location to be included as well. In addition, you may want to include a hotel or bar, your car, a funny hat, or any one of a whole range of other accessories. The resulting jumble may not be art, but if it shows what you want it to, then it is right. However, if it also shows twenty other people with equal prominence, all the litter from yesterday's carnival, and the wrong hotel, it is probably wrong.

So concentrate on including the elements you need and excluding the rest. That doesn't mean that you have to go close up to every person you want to portray. You can show a group of mountaineers as tiny dots on a snowy ridge with great effect; but wait for the moment that they are recognisably mountaineers, not just slight differences in the tone of the snow.

Even when your main subject nearly fills the frame, the background is important. Pictures of Aunt Agatha with roses growing out of her ear might add a little humour to your family album, but are best avoided as formal records at weddings or funerals. One of the major pitfalls of the single-lens reflex (page 23) is that you see the viewing image at full lens aperture. So when you focus on a nearby subject the background is very blurred. If the lens stops down to a small aperture to take the picture, the background sharpness can increase

dramatically, turning a diffuse blur into a clear distraction. To avoid that problem, either use the depth-of-field preview button to look at the (darkened) image on the screen, or take the camera from your eye for a second to examine the scene.

Once you start to translate an idea (even a quick holiday snap starts as an idea of showing someone where you have been) into a picture, remember the rule 'frame the subject, the whole subject, and nothing but the subject'.

Angles and viewpoints
The angle from which you look at a subject can greatly influence your pictures. Most cameras today have eye-level viewfinders, and encourage a normal eye-level viewpoint. That is fine for ordinary-looking pictures of normal subjects. However, one of the best ways to start taking eye-catching photographs is to start experimenting with viewing positions. For example, when picturing people at a dance, try some shots from floor level, looking up; or look down from a balcony, or even from a ladder. Viewpoint is particularly important when working with children. For natural-looking pictures, get down to their eye-level, not yours. If you stand up, especially close by, your pictures will show them with large heads and little feet. Also, anything the children are doing will appear less significant than it does to them.

With nearby subjects, comparatively small changes of camera position can make quite dramatic changes in size or relative position. You can, for example, hide unwanted background details behind your subject, or remove false connections between near and far parts of a scene. Distant landscapes, of course, are unaffected by such small changes in position. Thus you can ensure that your pictures are right by moving the camera, nearby subjects, or both, against the background.

When you have all the elements of your composition arranged as you wish, then you have

Right: a medium-speed 35 mm film and standard developer can produce extraordinarily sharp and vivid results when handled carefully. *Graham Whistler.*

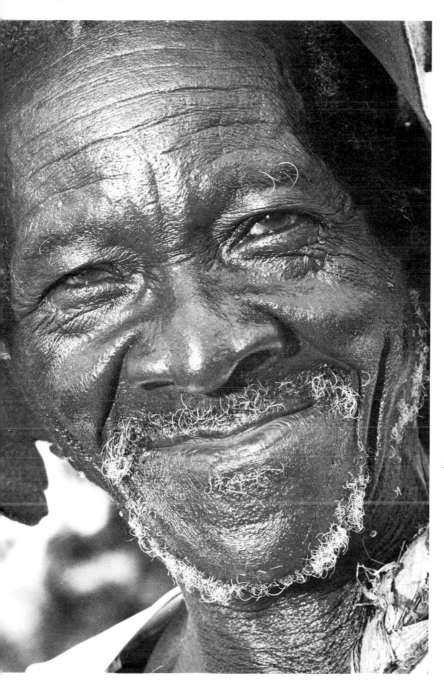

to decide just how much of the whole scene to include. That is where the ability to change lenses comes in. After you are satisfied with the picture, decide on the lens (or zoom lens setting) you need. When working with only one lens, or a restricted range of lenses, you may have to compromise between the ideal arrangement and the necessary camera position to include the right amount of the subject. With practice, it becomes automatic to arrange a subject to suit the field of view of your camera, or of a particular lens. So it is quite possible to take great pictures with a fixed-lens camera. The ability to select different fields of view just increases the range of options.

The two commonly discussed effects of different lenses – the 'exaggerated' perspective of wide-angle shots, and the flattening effect of telephotos – are both caused solely by viewpoint. Of course, the lenses encourage such viewpoints. A wide-angle lens reproduces each distant part of a scene so small as to be often insignificant. So it is natural to go close to the foreground with such a lens, producing the expected result. In the same way, it is natural to use a telephoto lens to magnify a small distant part of the subject, which produces the 'stacked up' effect so common with such lenses. Only with special lenses (see page 225) do the optics actually distort the subject.

Camera controls

There are three main controls on every camera: focus, shutter speed and lens aperture. On lots of cameras, one or more of them is preset by the manufacturer to work in standard conditions, and any of them can be automated and beyond the photographer's control. The focus control simply sets the lens so that the important parts of the subject are rendered sharply. The other two controls affect both the way light from the subject affects the film, and picture sharpness.

The shutter speed is the time for which light from the scene in front of the lens reaches the film. With a static subject the speed is of little consequence as

15

long as the exposure is correct. With a moving subject (or a potentially moving hand-held camera) the shutter speed has a profound effect on sharpness. The longer the time (the slower the speed), the greater will be the effective movement of the image, and thus the more blurred the picture. For normal purposes a speed of 1/60 to 1/250 second is fine, but speeds of 1/1000 second and shorter are needed to take sharp pictures of fast-moving subjects such as athletes or traffic. Of course, there are many times when you *want* to blur part of a picture. Then you have to select a longer shutter speed.

The lens aperture is (crudely) the size of the hole in the lens through which light reaches the film. With the shutter speed, it controls the exposure by balancing the proportion of light from the subject that reaches the film with the light-sensitivity of that film. At the same time it controls the depth of field, that is the distance either side of the focus distance over which the subject is still pictured tolerably sharp. The smaller the aperture, the greater the depth of field for any particular lens focused at any given distance.

Lens apertures are calibrated in *f*-stops, which are the actual diameter divided by the lens focal length. This gives a scale of numbers from *f*/1 to *f*/256: the larger the number, the smaller the aperture. Most normal lenses have maximum apertures between *f*/1.2 and *f*/8, and close down to between *f*/16 and *f*/32. The scale runs *f*/1, 1.4, 2, 2.8, 4, 5.6, 8, 11, 16, 22, etc. Each succeeding figure represents half the light-passing capacity, to go with the doubling shutter-speed scale of 1/1000, 1/500, 1/250, 1/125, 1/60, 1/30, 1/15, 1/8, 1/4, 1/2, and 1 second. These two scales combine to give the exposure needed by the film, as described on pages 105 and 169.

Films
There is one final element in the decisions about a picture. In fact it could be regarded as the primary element, for it is the basic essential: film. There is a lot to be said about films (see pages 73–103), but

16

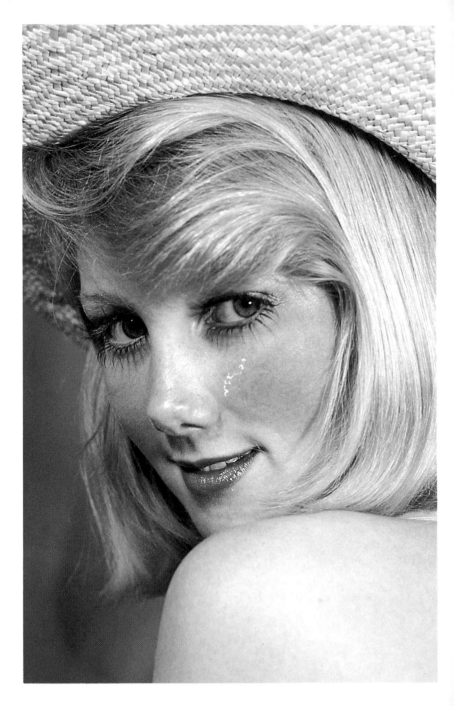

Above: panning the camera with a moving subject renders it sharp against a blurred background. A simple technique which produces competent if not spectacular shots. *Steve Barnes.*

Left: indoors, the lighting and surroundings can be arranged exactly to suit the subject. A really tight crop makes the background insignificant. *Paul King.*

for the moment let us just look at the basic decisions. Should the pictures be coloured or monochrome, prints or transparencies? It all depends on your intentions for them. For quick reference there is nothing to beat colour prints, but for serious viewing there is a lot to be said in favour of transparencies. They also have the advantage of being very much the preferred medium from which to reproduce colour in books and magazines. For decoration, on the other hand, black-and-white prints still find a lot of favour. There are two main reasons for this: it is relatively easy to make large prints, and the images are virtually permanent even when displayed in full sunlight.

Having chosen your medium, you have to shoot to suit it. Colour prints tend to be most impressive when portraying relatively simple subjects without too much saturated colour, largely because of the operation of automated colour printers; the colour darkroom worker is less restricted in subject. Small prints in particular call for simple images, and

portraits are probably the best subjects of all. Colour transparencies, on the other hand, can do real justice to blazing colours, and large projected images reveal the beauty of great detail. Black-and-white work calls for quite a different eye. While colour photography (print or slide) has difficulty in handling high contrasts, monochrome thrives on them. Dense blacks and brilliant whites lead to striking pictures. Cross- and back-lighting are the staple of the black-and-white worker, since few subjects are strong enough in themselves to stand direct front lighting without their colour.

Faced with one subject, a dozen experienced photographers would take a dozen quite different pictures, using different films, lenses, viewpoints, camera settings, and instants of exposure. Couple those variables with the infinite choice of subjects and lighting, and you can see why photography is fascinating far beyond its ability to record people and places for later recall. All it needs is a little understanding, and a lot of application.

The ideal camera

Despite the claims of the enthusiastic advertiser, there is no camera which is ideal for every type of photography. Narrow down the field in which you expect a camera to function, however, and you are more likely to find one which will do much of what you ask. Even by narrowing the field down solely to indoor photography, for example, you are still unlikely to find a camera which will do all that you might require. Just consider: one day you might be photographing the interior of a banqueting hall, a huge area with tall columns, pictures on the walls and a wealth of detail. Next day, you might be in a night club, or even a theatre, photographing one of the performers and trying desperately to make yourself invisible.

Now, in the first instance, to record the best picture possible, you need a stand camera (possibly a monorail) with a full range of movements. You also require a firm, solid tripod, and perhaps some auxiliary lighting. It will take you at least an hour to set up, take four pictures and then strip the equipment down again. Contrast that with the job in the night club, where you are anxious to remain as inconspicuous as possible. Here you will undoubtedly be working with one or maybe two 35 mm single-lens reflex cameras, and it might take you minutes to position yourself, take half-a-dozen pictures and then retreat rapidly.

These are just two facets of the many forms of photography which you might need to tackle, and the contrasts in other areas might be just as great. Imagine, for instance, making a delicate portrait of a child one day, and a photomicrograph the next. Or you might need to photograph a car in a studio in the morning, and then travel to a stadium in the afternoon to photograph an athletics meeting, perhaps, or even an indoor event.

The point to be made, then, is that there is no camera which is ideally suited to every job. There are several good, all-round cameras – the famous Hasselblad for instance which is the standby of many professional photographers and the sole working tool of many more; but even that little gem is not designed to do *every* job perfectly, and it is unfair to expect it to turn out perfect pictures in situations to which it is not suited. What *you* have to do is decide which type of work you are most likely to tackle and then suit the camera to the job. It isn't always easy to do that and, economically, it may not be feasible to have more than one camera.

To give you some idea of what is currently available, we will run through the types of camera you might consider. Look at their good and bad points, and try to decide what aspects of photography they might be suitable for. There are many ways of doing this but, to me at least, the most logical seems to consist of dividing them according to type. We will start small and gradually think bigger!

Disc and 110 cameras

In 1982 Kodak introduced the film disc, a relatively rigid disc of film which accepts 15 pictures round its circumference. With a frame size of 8 × 10.5 mm, the cameras can be fitted with fixed-focus lenses of relatively wide aperture, and still maintain sharp focus over an acceptable range of distance. Many of the cameras use this ability to provide automatic exposure control to suit a range of lighting conditions. The film's rating (ISO 200/24°) and the wide lens aperture allow high shutter speeds, thus avoiding the camera shake which is all too common with 110 size cameras.

The aim of the system is to provide simple snapshot ability over a wide range of conditions, with a film which has advantages to the photofinisher. Disc cameras can provide the serious photographer with a handy notebook, but cannot be expected to provide large prints. There is no colour reversal or monochrome film available for these cameras.

In the early 1970s, Kodak introduced what was then the smallest (13 × 17 mm) film format to a startled – and rather sceptical – photographic world. They also introduced a range of cameras – basically simple – which would accept this new format. It didn't take other camera manufacturers long to latch on to the fact that here was a winner in the non-enthusiast section of the amateur market, and so there was a wide range of cameras available, all similar and rather simple in concept, which could be tucked safely into a pocket or handbag ready for any opportunity. However, it wasn't simply a new type of camera that Kodak had introduced; it was a completely new range of films which offered finer grain, better resolution and improved contrast and colour. This meant that the results produced by the tiny cameras were far superior to what might otherwise have been expected. Further development has made the disc cameras possible.

At the same time as this was happening, camera manufacturers generally were concerned with producing cameras which were smaller and lighter than ever before. This move was helped along by the advances in microelectronics, which meant that mechanical parts of a camera could be replaced by

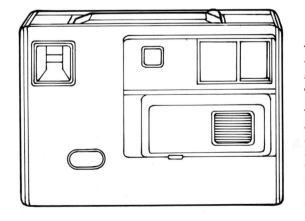

The disc camera is loaded with a cartridge containing a rigid polyester-based film disc yielding fifteen 8 × 10.5 mm colour negatives. The central portion of the disc carries information for automatic processing machines. Most disc cameras have motorised film advance, fully automatic exposure and electronic flash.

20

The average 110 camera is for the person who wants photography at its simplest. No problems with exposure or focusing and a sure picture every time.

Unfortunately, the very simplicity of this type of camera imposes the greatest restrictions on the creativity of the photographer.

Although the compact 35 mm camera is only slightly bigger than the 110 and disc types, its potential for high-quality work is considerably greater. To some extent, this is due to the larger area of the 35 mm frame, but is also a direct result of having focusing lenses and increased user control of exposure.

miniature electronic circuits; this advance also offered a bonus in greater reliability. Even so, there is little serious equipment available. Apart from Minolta, Pentax and a few others, no other manufacturer has produced a 110 camera which can be considered as anything other than a photographic notebook.

Disc and 110 cameras are fine for taking small snapshots out of doors on bright days, but what about indoors, or when the sun goes down? How do these cameras react to the challenge? Unfortunately, in the majority of cases, not terribly well. The limit of the lower-priced models is reached when you push on a flash accessory and retreat nine feet from your subject. As the price of the camera increases, you are likely to benefit from built-in electronic flash and a wider range of flash distances – particularly if you use one of the faster films. Unfortunately, it is the very fact that these cameras are designed with the snapshotter in mind that militates against their being more useful to the serious photographer. Many of them are perfectly capable of being used indoors *without* flash but, unfortunately, you have no way of knowing what aperture or shutter speed you might be working at. The non-automatic versions are marked with weather symbols (and, while out of doors a little white cloud can mean something, in a crowded discotheque it is not a great deal of help) and the fully-automatic models are precisely that – fully automatic. In other words, they react to the particular lighting conditions they can 'see' and give you no indication of the settings at which they are working.

At best, disc and 110 cameras can be considered unhelpful to the serious photographer. Their main attractions are lightness and pocketability. If what you require is something which can be carried with you wherever you go, easily and unobtrusively, then it is worthwhile having one of these little cameras. However, don't expect to be able to produce really big enlargements from the pictures you take, because it simply isn't possible.

35 mm viewfinder cameras

There is currently a wide range of viewfinder 35 mm cameras available. Some are very basic – little more than uprated versions of a simple 110 camera with weather symbols rather than shutter-speed or aperture settings. A few are extremely comprehensive with interchangeable lenses and automatic exposure control. The majority, however, fall between these two extremes and, up to a point, you get what you pay for.

Probably the most important advantage of any 35 mm camera over its smaller opposition is that the frame size is so much bigger. Because you produce a negative or transparency measuring 24 × 36 mm you have a head start in picture quality: the area of a 35 mm picture frame is four times that of the 110 frame and nearly ten times that of a disc negative. While on the subject of films, there is another distinct advantage in the variety available: it is a lot wider than that available in the smaller size. Not only are there films available in a greater variety of types and speeds, they are also available from a greater number of manufacturers.

Although 35 mm viewfinder cameras are quite sizeable when you compare them with smaller format models, they are still neat and pocketable (frequently being referred to as 'compacts' by those in the know). Obviously, models vary from manufacturer to manufacturer, but most are well thought out with controls which fall very readily to hand; a distinct advantage when you are working in a darkened room or theatre.

All viewfinder cameras have one disadvantage in common, though, and no matter how much you pay for your camera, you cannot get away from it. It is called parallax. You've probably heard of it. If you haven't, then I can only describe it as one of those irritating little problems that you forget about until you see your processed pictures. Then you look at them in disbelief and kick yourself. From a photographic point of view, parallax refers to the actual difference in viewpoint of the taking lens as

opposed to the viewing lens (or viewfinder). No matter how insignificant that difference may appear, believe me, the closer you get to your subject, the greater the effect the difference will have. To demonstrate this for yourself, place your camera on a table about 15 cm away from an object such as a matchbox (something that isn't going to walk away just at the crucial moment). Next, place a 15 cm rule perpendicularly to the camera lens (but make sure you don't touch the lens), and move the matchbox until its centre is perpendicular to the ruler. Look through the viewfinder to see just how far off centre your subject appears. If you still stare in disbelief, try taking some close-up pictures. Don't forget, though, that you will probably need close-up attachments unless your camera lens is capable of focusing a subject as close as 15 cm.

In theory, it is quite simple to compensate for parallax: just line up the picture, and then move the camera so that the centre of the lens is where the viewfinder was. That is easy with a fixed camera support, but less so with a hand-held camera and a moving subject. Luckily, parallax seldom causes any problems with subjects more than a metre or so from the camera. For serious close-up work, though, an uncorrected viewfinder is a major problem. The most sophisticated rangefinder cameras have their viewfinders coupled to the focus mechanism to eliminate parallax error throughout the normal lens travel. To go closer with ease calls either for additional viewing aids, or for a conversion prism to be fitted over the viewfinder. Close-up lens sets for some fixed-lens models come with parallax-correcting prisms attached. Also, some accessory viewfinders can be adjusted to account at least for vertical parallax. While these all help with moderate close-ups, none make these cameras ideal for really small subjects.

What other disadvantages do viewfinder cameras have? Really, only one rather minor one: the viewfinder image is often fairly small. However, it is also usually quite bright and one disadvantage is thus offset by another advantage. Some viewfinders

include more than you will actually get on your film. Such finders have a white 'ghost' frame suspended in the finder, and this shows exactly what you will include in the picture. Viewfinders like this are helpful with moving subjects because you can see the image 'swimming' into the picture.

Viewfinders can be a very personal thing, and it is well worth trying several cameras to see what suits you before you buy. This particularly applies if you wear spectacles, as some cameras are simply not designed with the spectacle-wearer in mind.

Focusing

Focusing is not necessary with a few basic 35 mm viewfinder cameras because they have a small aperture and are pre-focused to a distance of about 5 m. Everything from about 2 m onwards is rendered reasonably sharply. However, the small aperture does make them unsuitable for serious work. Where focusing *is* required, it is often simplified by the use of symbols, e.g. a head and shoulders symbol for subjects between 1 and 2 m from the camera, a group of figures for subjects between 2 and 5 m away and a mountain range for subjects from 5 m onwards. In the more advanced viewfinder cameras, subject distances are engraved on the lens mount and you have to set this fairly accurately if you want sharp pictures. To help you to do this, the camera may incorporate a coupled rangefinder.

Rangefinders work by producing a second image in the centre of the viewfinder (although a few 'break' the image horizontally). Operating the rangefinder causes the two images to coincide (or the broken image to become whole). When this happens, the lens is in focus.

Some rangefinder images are less clear than others. Focusing, however, is a particularly important operation and so it is worth taking the trouble to check that the camera you are considering buying has a rangefinder which suits you. Don't forget that when you are working indoors, light levels can be

quite low, and a rangefinder which seems a model of clarity when you are using it to focus on a sunny scene out of doors may be well nigh invisible when you attempt to use it indoors. Remember, too, that tungsten lamps give out light which is yellowish in colour. If, as is so often the case, the rangefinder image is also yellow, it may disappear when you try to use it indoors in this sort of lighting.

If you have a viewfinder camera which is not equipped with a rangefinder, or if you are tempted to buy such a model, don't be put off because of this. Rangefinders can be purchased as separate items and will, of course, work with any type of camera, because they are simply measuring devices. Remember, too, that in many indoor situations, a tape measure is often quicker to use and more accurate than a separate rangefinder!

Autofocus

The development of microelectronic components has allowed focusing to be automated on a wide range of 35 mm compact cameras, and on a number of other models. They use a variety of methods to sense the distance; measuring the apparent contrast is the most popular, with IR-emitting and sonar-emitting systems also used. Whatever the mechanism, the effect is the same: when you release the shutter, the lens moves to focus sharply on whatever is centred in the viewfinder at the time. Usually the sensitive area is marked by a line or patch in the finder.

To make sensible use of an autofocus camera, you need one that offers either manual override or a focus hold. With the hold, you align the important part of the scene with the focusing area, and press in the 'hold' control. Then recompose however you wish, certain that the right part of your subject will be sharp.

SLR cameras

Undoubtedly the most popular type of camera among enthusiasts these days is the 35 mm single-lens reflex. For many types of photography it

is also very widely favoured by professionals. There are some good reasons for this. It is compact (the latest SLRs are almost as tiny as the 35 mm viewfinder cameras of a few years ago). It is versatile: an almost infinite variety of accessories is available for most SLR cameras, both from the camera manufacturer and from specialist accessory manufacturers. Most important of all, though, the SLR camera is accurate from a viewfinding point of view. It lets you see *precisely* the image you are going to record on film. (In fact most cameras record a little more on the film to allow you some margin for error.) What you see when you look through the viewfinder is what you are going to reproduce in your picture – and that can be a benefit second to none when you are working close to your subject. Just think: no parallax problems to worry about! Another benefit offered by the SLR is that it lets you see the amount of depth of field (the area in front of, and behind, the point focused on which is rendered tolerably sharply) in your picture. This alters as you open and close the lens aperture – the wider the aperture, the less depth of field. When you view the subject through the viewfinder of the SLR you can actually see this and decide exactly how much, or how little, you need.

Although single-lens reflex cameras come in numerous shapes and sizes, the one that usually springs to mind is the familiar 35 mm eye-level type with its pentaprism housing above the lens. It was the development of the pentaprism which was responsible for the sudden upsurge in popularity of this type of camera in the mid-60s. Of course, as with everything else, there was a long delay between the arrival of the first pentaprism camera (in 1948) and general acceptance of the type. Before this, there were few 35 mm single-lens reflex cameras around, and those that were had to be used at waist level, the image passing through the lens and being reflected by a mirror onto a ground-glass screen on the top of the camera.

There were several problems inherent in this system. Most important was the fact that the

For most serious amateurs and many professionals, the single-lens reflex is not the *only* choice of camera. Whether it's in the 35 mm format with eye-level viewing (top diagram) or in the 6 × 6 cm format with waist-level viewing (below), the single-lens reflex camera has one benefit which outweighs any other; the image you see through the viewfinder is the one which will appear on your film. No matter what lens you use, what aperture you work at, what filter or effect screen you use – you know, simply by looking through the viewfinder, what the result will be.

image, although right way up, was laterally reversed; images of objects on the right-hand side of the subject appeared on the left-hand side of the viewfinder. Admittedly, this was not an insurmountable problem, but it was inconvenient. Another problem was simply the shape of the camera. 35 mm film gives a choice of picture formats and, while it is reasonably easy to look *down* into a viewfinder when it is being used for one format, it is not so easy to look *sideways* into it and still hold it steady when it is being used for the other.

When the pentaprism was introduced, things changed rapidly. A pentaprism is simply a block of glass with five working faces. After an image passes through the first face, it is reflected internally from three of the others to pass out of the fifth at right angles to its previous direction of travel. Speaking simply, this means that you can use at eye level an SLR camera which is fitted with a pentaprism, just as you would a viewfinder camera. It also means that the image no longer appears laterally reversed; it is right way up and facing the right way. Not all SLR cameras follow this design principle though, and probably the most famous SLR, the Hasselblad, does not necessarily make use of a pentaprism. The Hasselblad produces 12 pictures, each 6 cm square, on 120 film, and it is designed to be used either on a tripod or at waist level. However, it and most other 120-size SLRs have pentaprisms available, and several look just like scaled-up 35 mm models.

Probably the most important benefit of any SLR, no matter what its shape or size, is that it lets you see through the viewfinder, the image which will actually appear on the film. This means that you can change lenses, add lenses, add extension tubes, filters – anything at all – and see what effect these things have on the image. It is particularly helpful for indoor work, since you can choose exceptionally wide apertures and be sure that the important areas of the picture are as sharp as you need them to be. No viewfinder camera, no matter how sophisticated it may be, can offer this advantage.

Some single-lens reflex cameras are comparatively inexpensive, whereas others demand that their would-be purchaser be something of a millionaire. What you have to remember is that, no matter how simple the camera appears, it is still a relatively complex piece of equipment. When you look through the viewfinder, you see an image reflected by a mirror onto a ground glass screen which is exactly the same distance from the lens as the film at the focal plane (it has to be, otherwise you would not be able to focus correctly). Then, when you release the shutter, the mirror has to swing out of the way, the shutter itself operate and the mirror swing down again to show you an image in the viewfinder once more.

Usually the more expensive the camera, the more you can do with it (or the more it will do for you). Most SLRs offer fully-automatic diaphragms. That is, although you set the aperture on the aperture ring, the diaphragm does not actually close down until the shutter is released, and thus you see a clear bright image right up to the moment you take the picture. Most, too, offer through-the-lens metering (TTL) whereby the brightness of the image falling on the viewing screen (or even on the film area) is measured by one or more photocells. The required exposure is then indicated either by a readout within the viewfinder or by a needle centering on an index mark. Some cameras offer completely automatic exposure control: you don't have to set shutter or aperture, but simply point and shoot. With others, you pre-set either shutter or aperture and the one not pre-set alters to give the correct exposure.

Although focusing with any SLR could be carried out using the image on the ground-glass screen, most cameras incorporate some form of rangefinder. Usually this is a microprism, a split-image device or a combination of the two, located in a small section of the centre area of the

viewfinder. The microprism, while showing an image which is in focus sharply and clearly, causes an out-of-focus area to break up and appear to shimmer. The split-image prism cuts the image in half and displaces one half relative to the other. As the image is brought into focus, the two halves join together to form a single image.

From the point of view of indoor work, the single-lens reflex camera has a lot to recommend it. It is quick and easy to use. It gives a big, bright clear image in the viewfinder. It is easy to focus and most cameras make exposure calculation simple. However, it has got to be slightly bigger and heavier than its viewfinder counterpart, and shutter operation is usually fairly noisy (although this is not always the case). If you intend to use flash fairly frequently, you may find that with 35 mm SLR (or any camera which has a focal-plane shutter) your choice of shutter speeds may be somewhat restricted. Some cameras will allow synchronization at speeds up to 1/150 second, but with others you may need to use speeds as slow as 1/20 second (see the section on synchronising camera and flash, page 143).

Twin-lens reflex cameras
The twin-lens reflex camera works rather like two cameras, one sitting on top of the other. The lower one actually takes the picture while the top one acts as a large viewfinder, allowing an image to pass through the lens and be reflected by a mirror onto a ground-glass screen in the top of the camera. The taking lens and the viewing lens at the front of the camera are both focused as a unit by a single knob which moves the whole front panel of the camera backwards and forwards to focus the images. The lenses are identical in focal length and similar in aperture, although obviously the viewing lens does not need to be built to such high optical standards as its companion.

Twin-lens reflex cameras are big and rather cumbersome when compared with a 35 mm SLR, but this is partly because they take a much larger

size of film, producing 12 pictures, 6 cm square, on 120-size film. They are normally used at waist level, the photographer looking down into the ground-glass screen. For fairly static subjects this causes few problems, but it does mean that the camera is not very manoeuverable. To make matters worse, the viewfinder image is laterally reversed, and this can make moving subjects difficult to follow. However, with practice the correct technique can soon be mastered.

Although to some extent superseded by the SLR, the twin-lens reflex camera is still favoured by many photographers. Although relatively large and heavy, it is capable of high-quality (but not very rapid) work.

A picture that could have been taken with virtually any camera. This is an interesting combination of lines, angles, blacks and whites in which the seated figure repeats the arrowhead of the tent doorway. *Geoff Marion.*

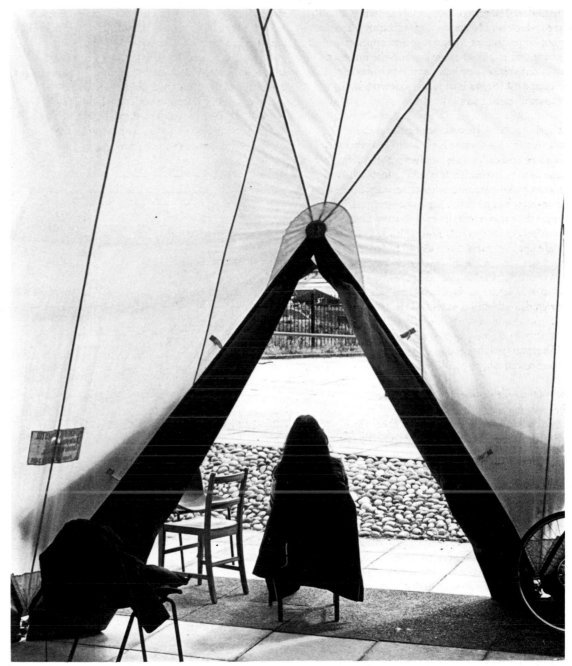

Because the viewing lens on the TLR is situated above the taking lens, close-up pictures can present parallax problems. On some models this is to some extent compensated for by a mask connected to the focusing system. As the lens panel is racked out for close-range focusing, the mask comes into operation to blank off that part of the image (in the viewfinder) which would be lost to the taking lens. There is one twin-lens reflex camera which offers interchangeable lenses. This involves not only replacement of the complete lens panel (because the lenses work in pairs) but also replacement of the between-lens shutter, which means that equipping yourself with a set of lenses can be potentially a somewhat costly operation.

Because it takes a large-sized picture and because, if it is handled correctly, it is capable of producing very high quality photographs, the twin-lens reflex is popular with many photographers. It is not particularly quick to operate, though, and for this reason is best suited to still or slow-moving subjects. For indoor work, it is probably ideal for portraiture (bearing in mind the potential parallax problem) or for general record work, where high quality is more important than speed of operation.

Stand cameras
Stand cameras, if used correctly, probably produce the ultimate in photographic quality. Generally speaking, they use a large size of film to produce a negative or transparency which needs relatively little enlargement. Because they are big, heavy and cumbersome, they have to be used on a tripod. (However, there are some models which are designed to be held in the hand; they are usually called 'press' or 'technical' cameras, even though nowadays they are rarely if ever used by press men.) The stand camera, even though cumbersome, is incredibly adaptable, and is used extensively by professional photographers for studio, industrial or architectural photography. Basically, it is something of a do-it-yourself camera which the photographer designs and builds to tackle the job in hand. In its most common form it consists of two

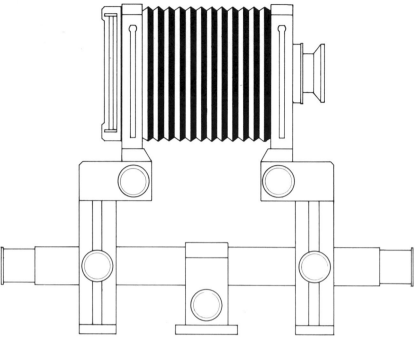

panels, one to hold the film, the other to hold the lens, which are joined by a light-tight set of bellows, the whole thing being mounted on a bar or monorail. The wonderful thing is that everything is interchangeable and movable – the lens and film panels rise and fall, swing and tilt, move backwards, forwards and sideways, and yet everything locks individually in place.

But how do you use such an obvious monster? Surprisingly, quite easily, after years of practice! In all honesty, though, the stand camera is really for use by the skilled professional who can (a) justify the cost of running such a large format camera, and (b) use it to its full potential. It does, literally, have to be built onto the tripod when it is needed, and the photographer selects the lens and the film which are most suitable for the job he is working on. To view the subject he opens the camera lens and, working under a dark cloth, composes and focuses the image on the ground-glass screen at the rear of

For architectural shots, static, studio work and any situation where the quality of the final result takes precedence over all else, the large-format stand camera reigns supreme. Big, cumbersome and slow-to-use, it becomes, in the hands of the expert, an incredibly versatile and adaptable tool, particularly in the monorail form shown here.

You don't *have* to use a technical camera to produce good architectural interiors, you just have to be rather careful. This picture was taken with a Rolleiflex which, while not the ideal camera for this sort of work, does have a grid pattern engraved on the focusing screen which helps the photographer to maintain squareness. *Geoff Marion*.

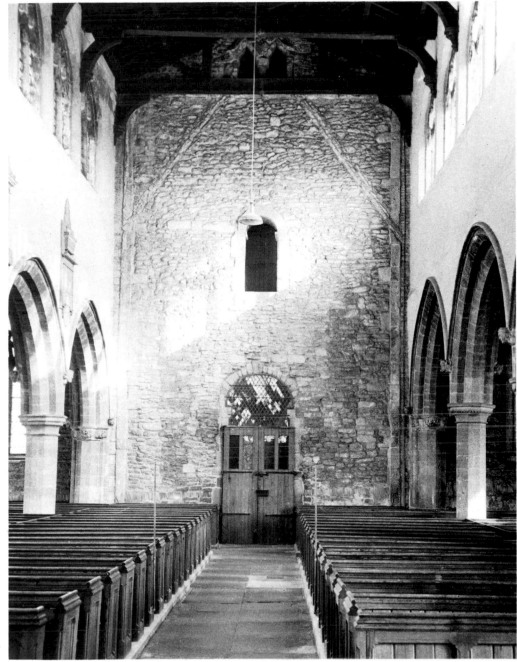

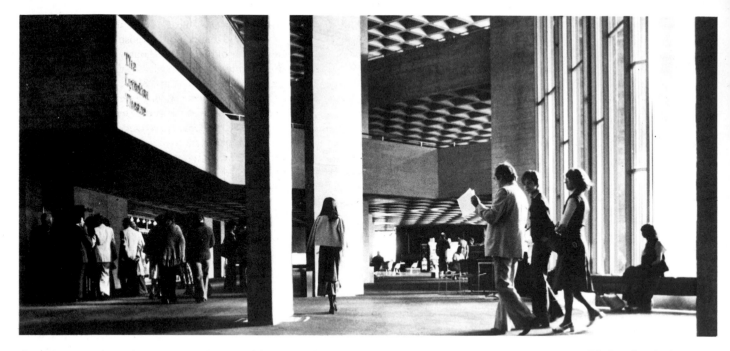

the camera. He then, if necessary, makes use of the camera movements to correct or alter the geometry of the image. The best-known movement is 'rising front' and this is used to 'correct' converging verticals. As you know, if you point a camera upwards to include the top of a tall building, the image of the building will appear to become progressively narrower towards the top. However, if the film and the lens both remain vertical but the lens is raised slightly, the top of the building will be included in the picture and the sides of the building will remain parallel.

Stand cameras are marvellous to work with. They produce wonderfully detailed pictures of superb quality when they are used correctly. But unless you plan to take only architectural or studio shots on a professional basis, they are simply too slow and too expensive to be worth considering.

Instant picture cameras
Instant picture cameras have been around for quite

a long time (probably a lot longer than you think), but they have still not reached a stage of development which allows them to be considered for serious work. The main problem is that most are instant *print* cameras. You take a picture and within minutes you are able to look at a finished print with a full tonal range and sparkling colours. The trouble is, that is where it all stops because, apart from one black-and-white material which gives you a negative, unless you go through a copying stage, you are left with a picture measuring about 7 × 10 cm.

In point of fact, the cameras themselves are produced very much with the snapshotter in mind, and there has been only one serious attempt to design a camera for the more advanced amateur. The Polaroid SX-70 is a single-lens reflex camera of very novel (not to say ingenious) design. In order to allow it to produce a print of a reasonable size and yet still remain compact enough to be pocketable, it has been designed to fold up when not in use. A

The benefits of using a stand camera are obvious when you look at this picture taken in the National Theatre in London. Although the camera level is extremely low, a strong impression of height is conveyed and all the uprights are absolutely vertical. *National Theatre, London.*

clever system of mirrors ensures that a high-quality image is passed to the eye when looking through the viewfinder, and to the material when making the exposure.

For indoor photography of a more serious nature, none of the instant picture cameras offer the versatility that you need. Although all types have automatic exposure control, none allow you to select the shutter speed or aperture of your choice. This doesn't help when you are trying to control depth of field or stop action. All, too, offer the facility of flash pictures, but again this is of a very rudimentary nature, using a single flash source located on the top of the camera. While perfectly satisfactory for indoor snapshots, it certainly won't help you to illuminate a large room evenly or a group portrait satisfactorily.

However, you should not write off instant pictures instantly. Polaroid offer special backs to fit the Hasselblad and certain stand cameras and, while these do not produce pictures of finished quality, they do provide the opportunity of seeing a proof in full colour. This enables the photographer to check his lighting set-up, his pictorial arrangement and his focusing and exposure. Obviously, neither the backs nor the materials are particularly cheap, but when you are on a difficult assignment, with perhaps one opportunity to provide a perfect result, they offer very welcome insurance. You can also produce finished prints on 10 × 8 Polaroid material.

Conclusions

Do you still need to make your mind up about the ideal camera for your own work, or has all become clear? Now that we have seen what the cameras are capable of and what they are best suited for, the deciding factor is the type of work you intend to do. Obviously, where you need to move quickly or work in a confined space, a small camera is essential. However, it should also be one which gives you a large, clear viewfinder image so that you can compose and focus the image as quickly

and easily as possible. Controls should fall readily to hand and focusing and exposure setting should be capable of being carried out with the camera in the viewing position. Logically, the choice here would seem to be a 35 mm SLR camera which offers all these benefits. However, a 120 SLR with pentaprism is also worth considering if really high quality enlargements are required, but of course this is heavier and also more expensive to operate. Also in the running, and generally favoured by the all-round photographer, is the waist-level SLR, but this can be a lot slower to operate and certainly needs a separate exposure meter.

For more generalized indoor work, such as portraiture or record shots, where speed and manoeuvrability are not of prime importance, choose between the 35 mm SLR, the 120 SLR and the twin-lens reflex. If economy is a deciding factor, you must opt for 35 mm. If, on the other hand, your budget will run to it, and quality demands it, you should choose the 120 size. Remember that if close-up work is to play a large part in your work, it is preferable to choose a single-lens reflex or a stand camera. Try to decide, too, whether the majority of your pictures will be hand-held shots or taken with camera on tripod. If the former, comfort will be a prime consideration and you want a camera which sits easily in your hands and is not heavy or uncomfortable. Again, choose one which has its controls conveniently situated with no cumbersome knobs or awkwardly-placed levers to operate.

Finally, if architectural or commercial studio photography is likely to provide the bulk of your work, then you really have no option. You need a stand camera, and you need to be able to operate it efficiently to ensure that you gain full benefit from it. Stand cameras are expensive and materials in the sizes used by them are expensive. A wasted shot can cost a lot of money. This is where you need to consider carefully what accessories are necessary. And this is where an instant picture back may prove to be indispensable.

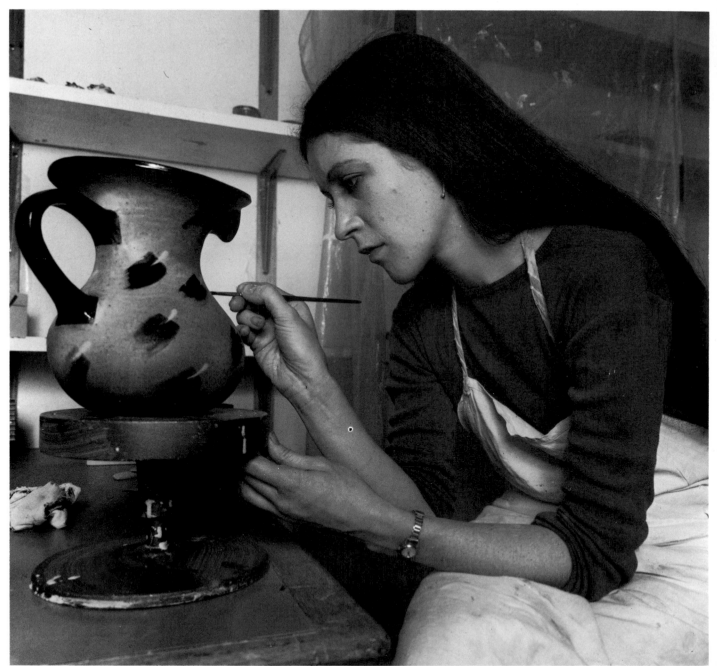

Additional equipment

Renata Fontenla

If you are getting started in photography, it makes sense to work as much as possible within the limitations of the equipment you already possess. There is no point in buying lots of additional equipment until you are quite sure it is absolutely necessary. If you stick outdoors on bright days, a simple camera is fine; there are lots of subjects which can be successfully tackled with nothing more. However, there are plenty more which demand extra equipment if one is even to consider taking them seriously. Some extra equipment can be fairly simple and relatively inexpensive – a cable release, for instance, is unlikely to cause anybody any financial headaches and yet it has to be one of the most important items in the photographer's armoury. At the other end of the scale, although additional lenses (e.g. wide-angle or telephoto) can be extremely useful, they are rarely vital when one is starting out and, given their cost, it is better to acquire them gradually as one's range of equipment is built up.

Exposure meters

One of the most important items that I can think of, the exposure meter, may come as part of your camera. If so, that's fine. If not, then I suggest you seriously consider buying a good one, as whether it comes built in to the camera or as a separate hand-held unit, a meter can be the best friend you have. Long gone are the days when a photographer's pride insisted that he estimate the exposure and be correct to within a couple of stops. Colour films, particularly slow transparency materials, demand very accurate exposure and, if you want to produce high quality results (even in black and white) then exposure should be accurate to within a half stop! Exposure meters, however, are only as good as their owners, and a very expensive meter is just as capable of recommending the wrong exposure as the old-fashioned

photographer mentioned above. If you have a meter therefore, learn how to use it correctly and look after it; not only will it repay you with a saving in material, it may also be responsible for salvaging your pride too.

What we sometimes forget is that exposure meters can't see as we can; they can only measure the amount of light falling on them. Point an exposure meter at a subject and all it indicates is that a certain amount of light is being reflected its way. To make matters slightly more difficult (for us but not for it), it has been programmed to assume that what is in front of it is an average subject. Because it *can't* see, and because they can only *measure* quantities of light, an exposure meter *has* to be designed with the average subject in mind and the average subject, if you were to mix up all its tones, would turn out to be a mid-grey. What the meter does, then, is to measure the amount of light being reflected from the subject and then suggest an exposure to you which would cause that subject to be recorded as a mid-tone. Point a meter at a black object and it will give you the correct exposure for a mid-tone which is not very well lit, i.e. an exposure which will record that object as a mid-tone; in other words, gross overexposure will result. Similarly, point a meter at a white object and it will indicate gross underexposure, to record the white object as a mid-tone.

The point to bear in mind, therefore, is that an exposure meter which measures reflected light is fine when the subject is an average one with no excessive areas of light or dark. As soon as dark or light tones constitute large or significant areas of the subject, however, then you have to start thinking a little. When this occurs, the best thing to do is look at the subject, pick out something which in your estimation constitutes a mid-tone and take a reading from that. In this respect, portraiture is fairly easy. Usually the most important part of a portrait is the person's face and if you can arrange for that to be exposed correctly, everything else (assuming it is correctly lit) will follow. If the sitter

34

were a dark-haired man in a charcoal grey suit against a brown background, it would be madness to take a general reading from the camera position, since the meter would indicate massive overexposure. Take the reading from the sitter's face, however, and no problem at all should arise.

Large rooms can cause problems, as can close-ups of shiny metal or other unusual objects. The answer here is to make use of a substitute subject. Instead of taking a reading from the object you are photographing, take the reading from the palm of your hand or, better still, from a grey card which reflects 18 per cent of the light falling on it. If you decide to use the grey card technique, make some test exposures first. Take your reading from the card and then make a series of exposures at ½-stop intervals, ranging from two stops under to two stops over the exposure recommended by the meter. Examining the negatives will tell you whether the indicated exposure was correct or not. If it was, you're home and dry and you should have few exposure problems in store. If it was not, then simply remember by how much you will need to modify your grey card reading to arrive at the correct exposure in future. Always remember, when you make an exposure reading from something other than the subject itself, that the light falling on the substitute must be the same as that falling on the subject. It is all too easy to let your own shadow affect the reading.

Through-the-lens meters

Because TTL meters are required to work in a very confined space (cameras seem to grow smaller every week!) they need to be extremely compact. The light-sensitive cells which they use, therefore, also have to be as small as possible, and the most frequently-used types are cadmium-sulphide, silicon blue and Ga As P (gallium arsenide phosphorus). Probably the most important thing to remember about such light-meters is that they are all operated by batteries. If you forget to switch off the current, the battery is drained and you are left with no exposure meter! That is a disadvantage but

Modern single-lens reflex cameras can feature very sophisticated metering systems. All work on the same principle, however, in that part of the light passing through the lens is directed to the sensitive cell which, in turn, activates a needle (in simpler cameras) or produces a digital exposure readout.

not a terribly serious one; you simply have to train yourself not to be forgetful.

On the other side of the coin, however, are two important advantages – particularly for indoor work. First, these cells are extremely sensitive to low levels of illumination – some will even operate outdoors on a brightly-lit night (although in this sort of situation they can be very slow to react, taking perhaps even minutes). That can pay dividends when you are working in a poorly-lit

gymnasium, for instance, or maybe at an ice-stadium with fast-changing lighting. Second, they read the light which is actually passing through the lens. This means that you can monitor changing conditions right up to the moment of exposure.

Probably the best type of meter is the one which uses the Ga As P cell. This offers very good spectral sensitivity (important in non-daylight conditions) and it reacts extremely quickly in low-light situations. Next comes the silicon blue cell, which also has very good spectral sensitivity (owing to a blue filter placed in front of the cell) and, in poor light, reacts almost as quickly as the Ga As P cell. Most commonly found, though, is the CdS (cadmium-sulphide) meter. Extremely accurate and easy to use in the majority of situations, the CdS cell does have two drawbacks. First, it has a memory. If it is exposed to a really bright light it will tend to remember this and read low for some time afterwards. Second, it is oversensitive to red light. This means that, although it works well in daylight, in artificial light (specifically tungsten) which is rich in red, it tends to overestimate. The only way around this is to set a film speed approximately two-thirds slower than quoted when working in tungsten illumination – say ASA 64 instead of ASA 100. However, this is very much a situation where only trying and testing will provide the answer.

In situations where you have to act quickly, or perhaps remain as inconspicuous as possible, TTL meters are in a class of their own. They are convenient, quick and give you control right up to the moment of exposure. However, you do have to be aware of what they are telling you when they give you a reading. TTL meters fall roughly into three categories: those which take a general reading over the whole area; those which do much the same but are particularly sensitive to the central area of the picture (or, perhaps, the lower third of the picture area) – these are termed 'centre-weighted' meters; finally, there are the 'spot' meters which

OVER
1000
500
250
125
60
30
15
8
4
2
1
2s
4s
8s
UNDER

sensitive cell

measure from a spot in the centre of the picture area covering anything from 2–10°. Make sure that you know how *your* particular meter reacts and you will be able to interpret very accurately the information it gives you.

Meters which cover the whole field are fine, provided there are no particularly light or dark areas in the field of view. If there are, the information given will be biased towards either under- or overexposure. Should there be such areas in the picture field, then unless you are exposing particularly for them, you will either have to lift or lower the meter so that it does not see them, or go in much closer so that they are excluded from field of view. An alternative course of action is to aim the meter at a mid-tone, such as a grey card or the palm of your hand. Provided the object you aim at is lit in the same way as the subject, the reading you get will produce the required result.

Probably better than these are the 'centre-weighted' meters. With centre-weighting, provided you have major part of the subject in the centre of the viewfinder (or in that portion which is most weighted), you needn't worry about odd areas of brightness or darkness (provided they are not excessive) around the edges of the picture. Nevertheless, situations will still occur in which you will need to move in close to the subject, or use a grey card if you want an accurate reading. A strongly rim-lit portrait is such a case in point; another is the interior of a church, in which a stained-glass window is prominent.

A word of warning! If you have a TTL meter which is weighted towards the bottom of the frame, that is fine; used carefully it will give you very good results. Always remember, though, it is really designed for horizontal use. When you turn the camera on its side for vertical pictures, remember what your meter is seeing, and act accordingly. You may need to take a reading with the camera horizontal, *then* turn it vertically to take the picture.

36

To achieve maximum impact with a simple subject calls for accurate exposure, maintaining detail and life in the shadows and highlights, and the longest possible range of tones between clear white and deep black. The bright reflection in the centre could well overinfluence a reflected-light meter, so take an incident-light reading, or meter from a suitable substitute subject. *B. Dawson.*

The third type of meter, the 'spot' meter, enables you to take readings from a very small part of the subject without going too close to it. Use an important part of the subject which approximates to a mid-tone to make your readings; in a picture which includes figures, for instance, use a face. Spot meters were designed originally to enable the photographer to take both highlight and shadow readings. He could then calculate whether or not the tone range of the subject fell within the

capabilities of the material he was using or whether he would need to soften the illumination by using fill-in flash or a reflector. If you have the time to spend, and if you cannot tell by experience, this is a good system. In the majority of cases, 4 stops should be the maximum allowable difference between important bright areas and important dark areas which need to be recorded showing detail. This, however, does not include small, specular reflections or tiny areas of deep shadow which one would expect to record as brilliant white or maximum black.

Separate exposure meters

Because so many single-lens reflex cameras nowadays have an exposure meter built in, the separate, hand-held meter tends to be disregarded or considered somewhat old-fashioned. This is by no means the case and, if your particular photographic interest concentrates on unusual lighting conditions, then this is the instrument for you. It can certainly be used to do everything that the TTL meter will do, and sometimes with a great deal more success.

The Sinarsix is an exposure meter which enables spot readings to be taken at the film plane of a Sinar stand camera. It is incorporated in a cassette which slots into the camera back in just the same way as a film holder and includes a meter (1) and a probe (3) which can be moved to any point on the image plane (2) to make a reading. It is fitted with a dark slide, which is pushed home while the reading is being made to prevent errors due to extraneous light.

Many hand-held meters make use of a selenium cell and, because this does not work from a battery, it is rarely likely to become suddenly 'inoperative'. Some, however, use a CdS cell and here again you have to remember the on-off switch. The hand-held meter works in much the same way as the general-reading TTL variety and it has a similar, or slightly greater, angle of acceptance to that of a standard lens. Use it from the camera position to take a general reflected light reading of the subject or, better still, go in close and take readings of specific, important areas of the subject, to ensure that the illumination balances correctly and that unimportant areas of the picture are not unduly influencing the reading.

The hand-held meter offers one very important advantage over the built-in variety: it can be used to make incident-light readings. As its name suggests, an incident-light reading is one which measures the

light incident (or falling) on the subject rather than the light which the subject is reflecting. Really, an incident-light meter disregards completely the tones of the subject and, by measuring only the light falling on the subject, tells you what exposure to give to ensure that the subject is recorded as a mid-tone. The lights and darks of the subject itself play no part in the assessment of exposure.

To make an incident-light reading, you have to fit a special baffle over the receptor of the meter. This is then pointed at the camera from the subject position so that the light falling on the subject also falls on the meter baffle. You then note the position of the needle on the meter and calculate exposure in the normal way. Where it is not possible to get close to the subject, you can arrive at the correct exposure in exactly the same way *provided* you are pointing the meter at the camera from the direction of the subject, and *provided* the illumination falling on the meter is exactly the same as that falling on the subject. If this is not possible, simply remove the baffle and revert to the more usual reflected-light reading.

Spot meters and photometers

Before we leave the subject of exposure meters, it is worth mentioning two types which are rather different from the majority of hand-held or separate exposure meters. The first is the spot meter: this is merely a larger and more cumbersome self-contained version of the spot-meter found in SLR cameras. It is expensive, slow to use and doesn't really offer a lot in the way of benefits. The second is the photometer: this too is bulky, slow, expensive and really, in the majority of circumstances for the average photographer, very difficult to justify. It looks something like a small tubular periscope, with an eyepiece through which the subject is viewed. In the eyepiece appears a small, egg-shaped spot, the brightness of which can be made to vary by rotating the lower part of the tube. When the spot matches the subject in brightness, the exposure can be read off the outside of the meter housing.

A typical exposure meter of the selenium cell variety is shown here. Such a meter is extremely versatile, very simple to use and features an exposure setting dial (1), a light-reading scale (2) and even a button lock (3), which holds the meter needle in position once the reading has been made.

Photometers allow you to make readings from quite small, key areas of the subject, even from some distance. They also have a wide range of sensitivity, which suits them to somewhat extreme conditions. Generally speaking, however, there are few situations which would demand a photometer rather than a more conventional type of meter. Certainly, unless such situations were the norm rather than the exception, it would make more sense to use a conventional meter plus a little bit of guesswork rather than invest in one of these.

Colour temperature meters

Depending on the exactitude of the work you are doing or the variety of the light sources you are likely to meet, it may be worthwhile (or even necessary) for you to buy a colour temperature meter. Although colour temperature can be defined

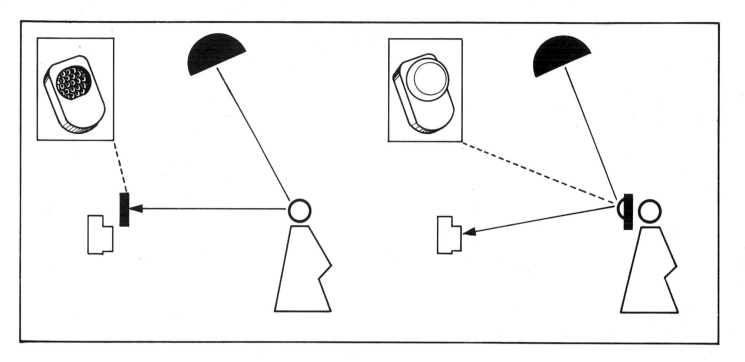

A meter of the selenium-cell variety is usually capable of two modes of operation. Left: the most commonly-used method, where a reading is taken which measures the light *reflected* by the subject. Provided the reading is taken from an important part of the subject (such as a skin tone), results can be fairly accurate. For indoor work, however, better exposures can often be obtained by taking an incident-light reading from the subject position (right). Using this method, a diffuser is placed over the meter window and the light *falling* on the subject is measured.

as the temperature to which a black body must be heated to enable it to radiate light of a particular colour, in practice it is simply a value which enables you to work out the filtration needed to convert one form of illumination into another. For instance, to convert daylight into the equivalent of tungsten you would need to use an 85B (or strong amber) filter.

A colour temperature meter will give you this information by measuring the relative amounts of red, green and blue light present in the illumination. However, colour temperature meters are not perfect (some measure only the red and blue light present, assuming the intensity of green to be midway between that of the red and the blue). Most have a spectral sensitivity which only approximates to that of a typical colour film, and their accuracy, particularly with regard to fluorescent lamps or other illuminants which may be made up of line spectra, may be slightly suspect. Nevertheless, most

of them will enable results to be produced which, without being absolutely perfect, are quite acceptable for most purposes.

Tripods etc.
The 'etc.' is there because a tripod is not necessarily the only means of preventing camera movement. And that, really, is what this section is all about – making sure that your camera is as still as can be at the moment of exposure. Even indoors, there are many occasions when you will be able to hand-hold your camera quite safely without fear of camera shake. However, if you are seriously interested in indoor work, it won't be too long before you come up against a situation where the shutter speed required is longer than you can chance, hand-held, and where the nearest support for your camera is too low/too high/at the wrong angle/too far away (delete as applicable).

The length of time for which you can hand-hold

your camera and still produce sharp pictures will depend on a variety of things: the type of camera you have (whether or not operating the shutter causes the whole camera to vibrate); the steadiness of your own hand (some people can hold their hands out without a perceptible tremor, some cannot); the position you have to adopt to take the picture (if you have to stand on tip-toe on one leg, then the dice are rather loaded against you); and finally, the shutter speed you have to use (the faster the shutter speed, the more chance you have of holding the camera still). Probably even more important is that once having made your choice of viewpoint, you can place your camera on a support in that position and know that it is fixed. You can make alterations to the lighting or the arrangement of the subject knowing that you don't have to worry about trying to find that exact viewpoint again.

The type of camera support you choose will ultimately depend on the type of photography you prefer. Once again, the accessories that the portrait photographer would choose are rather different from those required by the man who specialises in informal party pictures and who is going to try to hand-hold no matter how tricky the circumstances might be. For occasional use and for circumstances where bulky equipment would be more a hindrance than a help, camera clamps, mini-tripods, pistol grips and monopods are all worthy of consideration.

Probably the best and most useful all-rounder is the monopod. It can be used in almost any situation, taking up virtually no more space than the photographer; it is adjustable for height and it does offer reasonable, if short-term, stability. Certainly, exposures of up to a second should present little difficulty with this type of camera support. A close second for convenience of use is the pistol-grip type of camera support, although this is probably more useful where long-focal-length lenses are being used. These frequently have a tripod bush of their own into which the grip can be screwed.

Handy items which, if you have the cash to spare, can prove to be little miracle-workers, are camera clamps. These are usually engineered so that they are capable of fulfilling a variety of functions. They can act as a mini-tripod which will stand on a table or other flat surface. They can be clamped to a shelf bracket, chair leg or similar support, and frequently you will find types which can be screwed into a wooden surface; but you may not find this a very popular feature indoors. Mini-tripods, as a self-contained item, are fine if you can find the right place to stand them. I invariably find that the available flat surfaces are in the wrong place and at the wrong height.

With tripods proper, there can be few ifs and buts. The primary considerations are strength and rigidity, with lightness, portability and cost playing relatively minor rôles in the decision-making process. The obvious argument here will be that cost *does* play a significant part in one's choice but, like a cheap tripod, such an argument does not stand up. Even a cheap tripod costs a fair bit of money and, if it is not rigid and stable, it is totally useless and you have wasted your money. So, at the outset, buy the best that you can afford and, if you cannot afford a good one, wait and save until you can. Lightness and portability should be sacrificed, if need be, in favour of strength and rigidity.

Look, then, for a tripod which is obviously well-made. Examine the hinges and ensure that there is no sideways movement in them. Check that they work smoothly without being loose and floppy. Look carefully at the legs, and particularly at the method of extending and locking them. Extension legs have a habit of subsiding in cheap tripods, given a little bit of wear. Another point which requires critical examination is the tripod head. You need some means of tilting and revolving the camera without moving the whole tripod. A simple ball-and-socket head can be fine providing it locks firmly in position and providing your camera isn't too big and too heavy for it. Lastly, look at the feet. Are they capable of holding the whole thing,

tripod and camera, firmly in position on a variety of surfaces? If they're not, they could literally let the whole thing down.

Cable release

No matter what sort of camera you have – even if it has the most silky-smooth shutter release ever constructed – it is a complete and utter waste of time putting it on a tripod if you do not also use a cable release. As far as camera movement is concerned, probably the most critical part of any exposure is the instant the shutter release is squeezed. For this reason, use a cable release to absorb the movement of your finger and choose one which is long enough and flexible enough to do the job properly. Anything shorter than about 25 cm can be considered a waste of money. Even if you normally hand-hold your camera, it is worthwhile using a cable release with it. The pictures you take may rarely suffer from camera shake, but a cable release will certainly cut down the proportion of those that do.

Lens hood

It may seem almost insulting to presume to give advice on such a thing as a lens hood, but nevertheless I am going to risk my neck. Lens hoods, indoors, are just as vital as lens hoods outdoors. Perhaps even more so. The problems arise particularly with wide angle lenses, which are difficult to shield properly, and with long focus lenses where a lamp can be well outside the field of view and yet still be shining directly onto the front surface of the lens.

Always use the deepest lens hood you can find which does not impinge onto the field of view. If you have an SLR camera, you can check this quite simply by looking through the viewfinder. With other types of camera you will have to open the lens and place a sheet of tissue or a ground-glass screen at the film plane to ascertain whether the hood is suitable. Be prepared to have to buy, or make, a hood for each focal length of lens you have. What works for a 45 mm lens is not even worth considering on a 150 mm lens – it simply isn't deep enough.

The ideal lens hood, which will work whatever the focal length of the lens you have, is the bellows type. This simply fits over the lens and can be extended to the required length depending on the lens you have in use. This type of lens hood is used with stand cameras where the viewing screen shows whether the hood is entering the picture area or not. The most widely used version for a hand-held camera is that supplied by Hasselblad, but such hoods can be used with any SLR.

Filters

If you are the sort of photographer who turns his hand to anything then it may well be worth your while carrying a variety of filters and close-up lenses. As far as colour filters are concerned, provided you are careful with your acquisitions there is no reason why gelatin filters should not suffice for the less frequently used colours. If you find you have a frequent call on one or two particular colours or a particular conversion filter, then buy glass filters – and look after them carefully. Scratch a filter and the effect is the same as if you had scratched the camera lens.

For work involving highly reflective or shiny surfaces, you might find a polarising filter useful. This will cut down, or even eradicate completely, reflections from shiny, non-metallic surfaces. However, some increase in exposure will be necessary, depending on how the filter is used. Special-effect filters, such as diffraction screens and star filters, are rarely required. They should, in any case, be used sparingly to enhance the atmosphere already present in a picture. Never imagine that they will make a mundane shot any better than it would otherwise have been.

Close-up lenses and tele-converters can be handy for odd occasions, but never make the mistake of assuming that they are an inexpensive alternative to the correct tool. If you need to go in close to your

subject, and reproduce it sharply you will achieve the best results with a lens which is designed to work at close distances, and with extension tubes or a bellows system that enable you to rack the lens out far enough. Equally, if you need a longer telephoto lens, the best solution is to buy one. Low-priced close-up lenses and tele-converters do their job at the expense of definition. You pays your money and you takes your choice, so to speak.

Lenses

If you are serious about the work you do, it is unlikely that you will be satisfied for very long with the standard lens fitted to the camera. In many ways it is a pity that so many manufacturers insist on fitting such an item. Where the facility exists for interchangeable lenses, surely it is more sensible to allow the photographer to purchase the camera body of his choice and then select the focal length of lens which is most suitable for the work he does. Indoors, you will probably find that you need only a limited range of focal lengths, and these will probably suffice for most of the jobs that you are likely to tackle. Lenses naturally fall into three groupings; wide-angle, standard and long-focus. Let's look at each group individually, starting with the standard lens.

Standard lens

A standard lens is the one fitted to the camera by the manufacturer. No matter what size or format your camera is, it will have a standard lens which follows an informally accepted ruling, namely, the focal length of that lens will be roughly equal to the diagonal of the negative produced. For most 35 mm cameras, that means the standard lens will be about 50 mm, although in practice it can vary between 40–55 mm. For general picture-taking, a standard lens of this focal length is perfectly adequate. Most subjects are situated in such a way that if you want to get more into the picture area you can move back or, if you want to fill the frame with a smaller section, you can move closer. However, we are not concerned here with general picture-taking. Besides, there always comes a time when you

simply cannot move back any farther; and moving closer will produce its own particular problems. It is at these times that you need the help of either the wide-angle or the long-focus lens.

Wide-angle lenses

Any lens which has a shorter focal length than the standard lens can be considered a wide-angle lens. This is because the shorter the focal length of a lens, the greater the angle of view it will take in. An important benefit of wide-angle lenses (and the

People often work in relatively low light. This, coupled with the need to stand back yet pick out the worker from his surroundings, can call for a moderately long focal length with wide aperture, such as an 85 mm *f*/2 lens. *Raymond Lea.*

shorter the focal length the greater the benefit) is that they offer increased depth of field. For any given focusing distance at any given aperture, depth of field increases as lens focal length decreases.

Using a wide-angle lens from the same viewpoint as a standard lens will allow you to include a much greater area of the subject, and for this reason it is likely to be the man who specialises in photographing interiors who will find such a lens most useful. The important consideration, therefore, is likely to be the angle of view that such a lens will take in. For a 35 mm camera, perhaps the most useful wide-angle lens is one which has a focal length of about 28 mm. This covers an angle of view of 76° (a standard lens gives you around 50°) and can probably be considered the 'standard' wide-angle lens. For a 6 × 6 camera the equivalent lens would be about 60 mm. However, wider-angle lenses are readily available and obviously the one you buy will depend very much on your own particular requirements.

Wide-angle lenses are often accused of distorting the image. Although this is in fact true of lenses which take in an angle of 90° or more, in the majority of cases it is an unfair accusation. It stems from the fact that we tend to look at pictures from a particular viewpoint. If you have a picture measuring 20 × 25 cm for example, you will probably hold it about 40 cm away from your eyes because that is a comfortable distance from which to view a picture of that size. For a picture taken with a standard lens the perspective will appear right because the field of view covered by such a lens approximates to that of our own eyes, and that viewing distance is proportional to the focal length of the taking lens (you can calculate this by multiplying the focal length of the camera lens by the degree of enlargement). However, if you make a similar-sized enlargement from a picture taken with a 28 mm lens, you would still naturally view it from about 40 cm; but in this case perspective will appear to be heightened (or distorted) simply because that viewing distance is wrong. You

should, but almost certainly won't, view such a print from a distance of about 22 cm for it to appear to be correct.

If you specialize in towns or architecture, where it is frequently necessary to point the camera upwards, or where you need to get objects both near the camera and in the background sharp while still using a fairly wide aperture, it is worth noting that certain manufacturers offer wide-angle lenses with similar facilities to those found on a stand camera – in other words, rising and tilting front. For most casual work such lenses would probably not warrant the cost, but certainly in such specialised circumstances they offer a marvellous solution to a very irritating problem. They even provide a way of cutting costs significantly. If you normally use a large format camera and can bring yourself to consider 35 mm photography, these lenses offer you some of the versatility of a stand camera coupled with massive savings in weight and cost and, of course, much greater portability.

Long-focus lenses
As you might expect, the long-focus lens is the complete opposite of the wide-angle lens. The longer the focal length becomes, then the narrower the angle of view included, the greater the image magnification and the less depth of field you have to play with. For 35 mm cameras, a long-focus lens is any lens which has a focal length of around 85 mm upward. And upwards can take you to some real monsters of 1000 mm and more.

There are two reasons for choosing a longer focal length. The first is simply to picture a distant subject larger in the frame, without the need to go nearer; the second is to be able to stand further back, thus achieving the 'perspective' you want, without including too much of the surroundings in the frame. In general, most photographers are quite content with a range of lenses that goes up to around four times the standard focal length, i.e. up to 200 mm for a 35 mm camera, or 350 mm for a 6 × 5 model. Lenses of even longer focal length are

big and unwieldy, and they cover such a narrow angle that any slight camera movement makes the image swing about. So such lenses call for a rigid camera support to give of their best. On the other hand, lenses of around double the normal focal length are often chosen for portrait photography.

Although long-focus lenses are generally used to enable the photographer to get a larger image of his subject without physically moving closer, they do have another purpose. Because they tend to produce slightly flatter perspective, the shorter varieties are ideal for portraiture. A lens which is about 50–100 per cent longer than the standard lens will enable you to fill the frame adequately without retreating too far away from the sitter, and will produce a picture which records noses, chins and hands in a much more flattering manner (in other words, they won't appear too big in relation to the rest of the subject).

Left: theatre pictures can be taken quite successfully from a seat in the audience, as is proved here. This one was taken with a Nikon, fitted with a 200 mm lens. If you plan to do much of this type of work, a 75–250 mm zoom lens could be a worthwhile investment. *Geoff Marion.*

Right: zoom lenses offer so much by their very versatility that you have to forgive their shortcomings. This picture was taken with a zoom lens in its macro mode and it demonstrates an annoying defect of the lens – barrel distortion, which occurs at one end of its zooming scale (you get pincushion distortion at the other). Most zoom lenses are something of a compromise, offering convenience rather than perfection and you simply have to make up your own mind about which you need.

Variable focal-length lenses

Although earlier I mentioned that camera lenses could be split into three groups, there is really a fourth category we ought to consider, that of the variable focal length or 'zoom' lens. Zoom lenses allow you to alter their focal length (and thus the angle of view and image size) within limits, to suit the situation. They can, therefore, offer more flexibility and sometimes replace a small range of fixed focal-length lenses. Zoom lenses work by allowing you to alter the relative positions of the groups of elements which go to make up the lens. Usually there are four of these groups, of which the first, or front, group is used for focusing; the second is movable to allow the focal length of the lens to be altered; the third also moves in conjunction with the second group to ensure that focusing remains unaffected by zooming; the fourth, or rear, group does not move at all. Although this may give the impression that such a lens is complicated to use, the reverse is the case. Instead of having only one movement to carry out (to focus the lens), you have another: the zooming movement which usually consists of sliding the barrel of the lens backwards or forwards.

Obviously, you really need to see what is happening when you zoom the lens and this means that such lenses are somewhat impractical for non-SLR or view cameras. In fact, for still photography they are only widely available for the 35 mm SLR camera field. Until a short while ago zoom lenses were somewhat renowned for the poorness of the image quality they were capable of delivering. In the past few years, however, lens design has improved significantly and, although a good zoom will still not match the quality produced by a good fixed focal length lens, it certainly does not lag too far behind.

Before we become too euphoric about these lenses, though, there are, as always, a few debit points to be considered. First, maximum apertures are usually fairly modest. Where a fairly ordinary 50 mm lens is quite likely to boast an aperture of

f/1.8, its zoom replacement in the 35–80 mm category may be two stops slower. The next minus concerns size and weight. Any zoom lens is going to be bigger and heavier than its fixed-focal-length counterpart. Finally, minimum focusing distances can be quite distant: 1 metre or more. The saving feature here, though, is that many zoom lenses have a macro facility which allows you to get really close to your subject – within a few centimetres. Usually a reproduction ratio of up to 1:2 is possible with these lenses, i.e. the picture is about half actual size. Again, quality is not quite as high as would be attainable with a lens of fixed focal length, but for the majority of situations it is certainly more than adequate.

When choosing a lens, it does pay you to buy the best you can afford. Within limits, the more you pay, the better the quality of the lens is likely to be. Similarly, if two lenses of the same focal length retail at the same price but the maximum aperture of one is larger than the maximum aperture of the other, then almost certainly the one with the smaller aperture will be a better lens. However, *all* lenses vary in the quality of the image they produce, and even supposedly identical lenses from the same manufacturer may offer slightly differing results. Most popular photographic magazines run tests on lenses and these can prove very helpful. Remember, though, that what is left unsaid is often more important than what is said, and no magazine editor wishes to offend his advertisers!

If you are in the market for a lens and you want the best quality you can get, look through the advertising pages of the photographic magazines. There are some retailers who actually test the lenses that they sell and they will guarantee you a certain degree of quality according to the rating that they give the lens. Obviously, such dealers cannot offer rock-bottom prices if they perform such a service, but there again you make a choice. You either get a top-quality lens or you get discount. Take a chance on the latter, of course, and you may get both. There again, you may not.

46

28 mm lens at *f*/4

80 mm lens at *f*/4

The focal length of the lens and the aperture you choose affect perspective and depth of field.

28 mm lens at f/8

28 mm lens at f/16

80 mm lens at f/8

80 mm lens at f/16

Chris Howes

Translating the image

As a teacher of advanced photography I have learnt one thing: it is a subject that cannot be taught. Encouraged yes, taught no. Photochemistry can be explained in textbooks, but the creative part of photography is seeing a subject and translating it in a personal manner, taking full advantage of the technical possibilities. The most the tutor can do is encourage the student to think photography for himself, in his own way, and to clarify and interpret his own intentions.

Every photograph can be analysed to see whether it achieved these intentions, and how it might have been improved. If the achievement isn't all it ought to have been, what went wrong and what should have been done? Many people will give their opinions, but most of this well-intentioned advice will be different because nobody can see through another's eyes. For example, the judges of club competitions often produce weighty criticisms based upon nothing more than personal opinion, and condemn a lot of highly promising work as a result. For those members of camera clubs and societies who suffer this sort of thing, take heart. If the 'judge' cannot appreciate your work, the fault is probably as much his as it is yours. Your photographs are your own creation, nobody else's. Other people may not understand them but that is because they do not see them as you do. Photographs can be justly criticised for poor technique and lack of apparent purpose, but to use a purely subjective method of assessment cannot be accepted by any logically thinking photographer. Unfortunately, many a promising one has lost heart because of this type of false assessment. My sincere message to my own students for many years has been: accept only criticism that is logical to you. Criticism that cannot be sensibly explained and stand up under scrutiny is invalid. And my advice to people who discuss the work of others and upon

Notice the point of radiation about one-eighth of the way down on the right-hand side. Above it to the left is a lot of jetsam that has nothing to do with the radiation pattern and could be omitted. In doing this it would be nice to get the radiation centre near to the corner. The brightness in this area hasn't been made prominent enough during printing. If it were locally treated with one of the recommended reducers to improve the catchlights without affecting the blacks, the appearance would be greatly improved. Also, the negative could have been reversed during printing so that the picture is read from left to right instead of from right to left.

whose pictorial judgement they have to rely is: analyse, do not criticise. Always explain in detail the reasons for your comments. There is nothing wrong in holding personal opinions, but nothing right in using them to judge other people's work.

Having realised the answers can only come from the photographer himself if a sensible outcome is required, a means of locating the malfunction has to be found. With colour or monochrome prints, of course, there is a middle stage that can be inspected: the negative or, in the case of reversal prints, the transparency. With slides, however, there is no handy middle stage available for evaluation. If a slide is not completely satisfactory, use it as the intermediate by making a corrected duplicate of it. Thus in the creation of any photograph it is possible to find an intermediate stage at which an assessment can be made, and all the necessary corrections carried out, in order to produce the desired result.

Assessing and proofing the negative
Assuming that there is (as there ought to be) a purpose behind every exposure, each negative will have the seeds of a successful picture sown somewhere within it. So every negative needs to be carefully considered in relation to the subject and to other negatives. As several exposures of a subject's differing aspects are likely to have been made, these comparisons are an important step in the matter of interpretation. Perhaps one of the best things to do is to feed the roll of film through a projector and study each negative individually in a highly enlarged state upon a screen.Failing this, if the enlarger head can be swung round, an image projected upon white paper on the floor is almost equally useful. Such methods enable every negative detail to be carefully studied, and it is worth deliberately defacing any negative that will not stand up to analytical scrutiny. A bad negative will never produce a good print, and only good prints enhance a photographer's reputation. Bad prints will ruin it, so be thoroughly ruthless from the start. It is routine with most photographers to make

contact prints from all their negatives; if it isn't possible to use projection assessment, scrutinise the contact prints closely through a magnifying glass, although the prints will seldom carry all the detail of the negatives from which they were taken.

Once you are satisfied that the negative adequately reflects your purpose and is also of suitable quality, make a proof print from it. The proof need not be very large, and the cheapest paper should be used, because its role is to give a preview of what the finished picture might look like and how it should be controlled and cropped. Unless a very important print has to be made, this will probably be too lengthy and expensive a routine to apply to colour, in which case an assessment should be attempted from the contact prints. Made on cheap paper, perhaps government surplus or outdated stock, the proof print will never show the rich quality of the final one and should never be shown to others. It is nothing more than a trial to confirm the negative assessment, and unless it directly matches the quality of the final print it should never be used for anything else. The entire purpose of these pre-print proceedings is to decide whether the purpose of the finished picture will be obvious by its content. That purpose will only be fully appreciated in its final form if it is obvious at the intermediate stage. If it isn't, it will become even more vague after printing. If it is, the printing can be controlled to emphasise and isolate it.

Making the final print
One of the most inhibiting things in printing is the masking frame, because it instantly imposes boundaries on the print that are not dictated by the picture content, thus tempting the photographer to make the picture fit the frame instead of the frame fitting the picture. It also leaves a white border around the print and reduces the picture area. The main reason for using a frame is its ability to hold the paper flat, but nowadays, with the increasing use of resin-coated papers, this is nothing like as important as it once was. It is much better to use a board covered with yellow adhesive film marked

Negative assessment checklist

Is there anything on the negative (e.g. lettering) that must appear the right way round?	If not, consider whether it might look better reversed.
Is the area of principal subject matter clear?	Decide whether it would be better cropped vertically or horizontally. Try framing.
What are the main supporting and opposing interests?	Decide where exactly the cropping should occur to include the one and exclude the other. Try framing.
If the opposing interests cannot be cropped out, can they be toned down?	Try shading them with the hand and study the shadow balance.
Are the important highlights high enough?	If not, dampen the negative emulsion and locally swab that area with thin negative dye, applying it little and often. Retouching dye thinned four to one is useful.
Are the secondary interests strong enough to play a good supporting role?	Again consider the use of very thin negative dye.
What areas need to be deepened on printing?	Note areas to be 'burnt-in'.
What areas need to be lightened on printing?	Note areas to be 'held back'.
Provided the principal subject matter is clearly defined, is there too much contrast in the negative?	If it is monochrome, consider whether it would respond to water-bathing during printing. If so, note. If not, consider reharmonising or reducing.
Is there too little contrast?	First consider whether controlled water-bathing is possible; if not, intensify.
Is the negative scratched?	If so, coat it with clear, thin, cellulose varnish and dry in a dust-free atmosphere, or sandwich between two sheets of glass after coating both sides with glycerine while printing.
Are there any areas of the negative so inferior as to be beyond reasonable control?	Deface it or punch a hole through it.

with parallel lines at right angles to each other, and a pair of thick black L-shaped cards with arms a little longer than the height and width of the paper being used. (The yellow surface is non-actinic with monochrome papers, yet is bright enough to focus upon easily. Any yellow light thrown back from its surface will not degrade the image.) Place one of the L-shaped cards in edge contact with two sides of the printing paper, then slide the other card along a third side so that its other arm moves across the surface of the paper. By this means, together with adjustment of the enlarger head, the maximum print size can be obtained while maintaining the most effective height-to-width ratio for the picture.

If fibre papers are used, it is quite a useful dodge to run a small length of double-sided sticky tape across the corners of the board; the print can be pressed to these and held flat. The bands of tape will accommodate several prints before requiring

replacement. Another good idea is to make the
board slightly larger than the enlarger easel and use
it as a movable baseboard; one side of it should be
yellow and the other white. It can be moved in any
direction in order to make image arrangement that
much easier.

One great advantage of printing colour
transparencies on to reversal paper is the ability to
see what the colours of the picture are going to look
like before making the print. The transparency is
projected on the easel in the usual fashion for
printing. The only additional thing to do is to
decide on the depth of tint: remember that with
reversal materials, unlike the others, increase of
exposure reduces depth of tint and vice versa.
Commencing with a slide (presumably trade
processed), the routine of negative evaluation and
proofing is avoided; this offsets, to some extent, the
greater cost of reversal material. The rest depends

Nicely composed, this print is almost in the top echelon apart from the fact that modelling is lost in the forehead and the cheek. This is simply because the negative and paper did not exactly match in contrast, and the exposure was not selected for the highlights. Simply 'stewing' the print in the developer would probably have put this right.

on skill in printing and filtration, matters that can be handled easily by normal test-strip technique.

Most home colour processing involves the use of a print drum, which introduces difficulties in making test strips. If too many are made, the chemicals will soon be exhausted and the processing time will probably be doubled. Because of this and the high cost of chemicals, photographers are tempted to estimate exposure time and filtration, with the inevitable risk of quality loss. By far the best way of dealing with this problem is to mask off the end of each print (before assessing its arrangement) to use for testing the next negative or transparency. Each print is therefore accompanied by the test strip for the following one, which can be readily trimmed off. Suitable masks for such an arrangement can be made out thick card or hardboard.

Colour slide control
Nowadays, most slides are processed at a laboratory so there is very little that can be done to modify them apart from masking, tinting and copying. A slide can be 'cropped' by cutting a mask out of thin black paper and fitting it between the frame and the emulsion side of the film. Another way is to use black adhesive tape, although this becomes rather sticky as time advances and shrinks as well. For this reason it should be used only as a temporary expedient. Obviously, a masked slide will project a much smaller image than the unmasked ones, so unless a zoom lens is fitted to the projector it may be preferable to copy it on to another slide. In most cases, though, the contrast must not be allowed to increase during copying, so a small amount of light should be thrown on to the front surface of the slide while the main illumination is provided at the back. By copying only part of the original picture area, the image can be made larger within the frame than before, thus enabling irrelevant details to be omitted. Another advantage is that faulty colour balance can be restored by using a filter complementary to the cast. Whereas sandwiching a piece of filter material to the slide itself increases the density and tints the

highlights, filtering during copying allows the density to be reduced and restores colour balance at the same time. The other modification that can be carried out directly on the slide is to dye the unwanted areas of highlight. For anybody who has never attempted it before, the remedy sounds worse than the disease, but after one of two attempts have been made to prove how easy and effective it is, it soon becomes part of the experienced photographer's routine.

Preparing a slide for colour printing or copying As most colour-reversal processing is standardised, the only density and colour saturation control is that of exposure. The more of it given, the weaker the colours. On the other hand, reduction of exposure can so saturate colour that, while appreciably increasing density, it can create pseudo-moonlight effects during the brightest of sunny days. Nothing can be done to restore highlight detail lost by overexposure, but if some exists it might be improved by sandwiching the transparency with a filter of slightly less density than the missing colour, but of the same hue. Given these conditions, a reasonable print or copy slide can be made of it. Slight underexposure is beneficial for slides deliberately made for copying, provided the image isn't so dense that it completely blocks the printing light. The stronger colours make copying less subject to variation, while longer exposures during enlarging or copying make up for the lack of exposure in the original.

One final word about this. Any colour filter used during enlarging or copying will affect all the colours in the scene, lightening those similar to it and darkening those that are complementary. A light-hued filter can therefore change the entire appearance of the original and should be used with discretion and an interpretive and creative eye. Graduated colour filters normally used for outdoor colour effects are useful under these conditions. In fact, colour filtration can be applied equally well to the transparency as to the original scene, the only difference being in balancing the source lighting.

Competing interests dilute the effect in proportion to their strength. Cover the chap on the left and note the effect!

Right: framing is important. Imagine the lifebuoy and cross filling two-thirds of the frame and consider the effect. Cover the top quarter of the picture and then the left-hand quarter of the remaining area, and you get an idea of the result of extra care in framing.

Interpretation

As a postal letter conveys information, so does a photographic picture, its effectiveness depending entirely upon the skill employed in its production. A badly composed letter leaves the reader wondering exactly what the writer had in mind, and a badly arranged photograph has almost exactly the same effect. Any ability to communicate with others is not a gift from heaven, but something that comes from increasing use and understanding of language. In the same manner that mastery of a tongue can be acquired, so can mastery of pictorial communication. The photographic equivalent of letter writing lies in an ability that is sometimes called 'photographic seeing', which is the manner in which the photographer visualises the picture in order to make its purpose clear to the viewer. Hence the title of this chapter: in the graphic arts, the word 'interpretation' is used to describe the process of translating pictorial impulses and purposes into permanent visual form.

While it is possible that a fair amount of good photographic work lies around unheralded and unsung, the mass of work produced falls short of the best, not only technically but in subject interpretation. It is perhaps no wonder that people get the wrong idea when they read in press advertisements such things as 'the camera that makes an artist out of you', or 'you are an experienced photographer when you handle a (camera name)'. But no matter what camera is used or what technique is undertaken, without a subject, a purpose and a little knowledge of interpretation it is all a complete waste of time.

Unfortunately, many people simply frame the subject without very much thought, but how much more effective the picture finally appears when the photographer carefully studies the entire viewfinder image. Some camera manufacturers treat the

viewfinder as a convenient place to display an array of lights and scales and meters. Use these for what they are worth, but then try and forget them, with their obvious interference and distraction; they have nothing to do with the scene in front of the camera. Use the viewfinder for its fundamental purpose, seeing the subject as the camera sees it, remembering that the viewfinder image is something personal to the photographer. What goes on around belongs to everybody else, but what is seen in the viewfinder is the photographer's alone. See it, adjust to it, live it. When the principal subject is right and everything else takes its subsidiary place, then, and only then, make the exposure. It is surprising how few photographers treat the subject so meticulously, but not so surprising that they produce very little memorable work as a result.

Identifying interests, their relationships and priorities
Something captures the attention. It could be a sparkle in an eye, a living flower in a dead landscape, a red splash of light upon blue-shadowed hills, the heightening of activity prior to an event. No matter what it is, it provides the true purpose for taking the photograph. The picture is filled with components of secondary interest, some of which support the purpose while others oppose it. A mental discipline arises that becomes second nature: the ability to 'see' photographically. It can be described as follows. Be clear about the purpose, and recognise the **principal interest**. Arrange the angle, depth of field, shutter speed and lighting to make it prominent in the picture. Examine the **supporting secondary interests** to enhance the effect of the principal interest. Identify the **opposing secondary interests**, and either subdue or eliminate them by careful selection of depth of field, camera position and angle, arrangements of shadow etc. Remember, opposing interests dilute the effect of the picture in proportion to their strength.

Consider a hypothetical example: a diver jumping off a high board still vibrating after a leap, with bright sunshine pouring into the top corner of the picture. Being quite the brightest part of the scene, the highlight should be eliminated because it is strongly competitive. Catching the eye so very strongly with its light, it reduces the impact of the diver and board. One interest must not compete with the other, so the most important component must be made dominant. In this example, of course, the diver is obviously the most important. You could silhouette him against the light, choosing a shutter speed of around $\frac{1}{125}$ to catch him at that moment, before the final descent, when the board is still moving. Thus the sharply rendered diver becomes the principal interest, aided by the now supporting brightness. The board, softened slightly by movement, becomes secondary, although of a strongly supporting nature. If the viewfinder were used just to frame the diver, it is doubtful whether any of this would have been considered. The relative strengths of the secondary interests would then have been enough to have weakened the picture. It is so important that the principal interest should be visually separated from the remainder of the tones and colours comprising the final arrangement.

Ensuring understanding of purpose
There must be no hesitancy in the viewer's mind about the original purpose for which a shot was taken, otherwise the photographer has failed abysmally in his attempt to communicate. Thus the principal subject has to be clearly defined within the picture space, making use of many simple devices, either separately or together. They help in the clarification of purpose and can be conveniently listed as follows.

1 Careful choice of filter for the effect you have in mind. Filtration can very often be exploited to the enormous advantage of the picture. In monochrome, for instance, an orange filter is always a good one to have around because it separates brickwork from natural substances, lightens fair skins and removes glare from skies by darkening all but the clouds; these are distortions

of reality that can quite happily be accepted and used for emphasis.

2 Exposure. If the subject is of particularly light or dark tone, much the same effects can be obtained by careful choice of exposure. Remembering that the only part of the picture that absolutely demands correct exposure is the principal interest, this is not too difficult. Take the meter right up to the subject and measure the reflected light from it, exclusive of all else. But then an adjustment is necessary if correct subject tones are to be assured. Here is a rule of thumb (it is nothing more) that works well. When exclusively measuring the principal subject, if the subject is light toned, open up one stop more than the meter indicates. If it is darker than average, close down one stop. If the subject is average in tone, of course, the reading needs no further adjustment. (Useful tonal guidelines are that Northern European skin is light in tone, Asian skin is average, and African skin is dark.) If the principal interest is too far away, or sited in too awkward a position for an exclusive reading to be taken from it, take the reading of something nearby of similar tone.

3 Careful placing of subject matter within the viewfinder image. Try to select an angle where the principal interest stands out against background tones, or at the point where secondary interests appear to meet. These simple devices direct the attention towards the most important area.

4 Selection of depth of field. When anything is thrown out of focus, it is invariably lightened in tone. Thus a large aperture will not only give rise to enhanced subject separation by showing the sharp detail of the principal interest against the softness of the background, but also produce a helpful tonal contrast as well.

5 Use of psychological contrast. This is always worth trying because most people are affected by it. Thus the necessary contrast the principal subject interest requires may be obtained by setting hard against soft, small against large, light against dark and so on.

Points 1 to 5, concerning filters, exposure, placing, depth of field and psychological contrast, all apply equally well to colour. However, colour is another dimension that brings its own peculiarities.

6 Constancy of screen brightness when projecting slides. If the ultimate purpose is to produce a slide show from a number of transparencies, constancy of brightness is of major importance. The white of the screen should be seen through the highlights of each successive slide. This effect can be obtained by either of two exposure methods. To use the incident-light exposure method, place an opal screen over the meter cell and take a measurement from the subject position with the cell pointing towards the camera. To use the highlight method, place a white card in front of the principal interest and increase the reading from the meter by a factor of six (i.e. by 2½ stops); if the subject itself is photographic white, such as brightly lit white buildings or sunlit snow, measure directly off the brightest part and increase exposure by a factor of eight (i.e. by 3 stops.)

7 Use of colour contrast. This is largely a matter of subject arrangement to set the principal interest against a background of contrasting hue. The rendering of the sky and reflections from shiny non-metallic surfaces such as glass and water can be varied to some degree by the use of a polarising filter. This is easy enough to use with a reflex camera, because the changes it introduces can be seen directly in the viewfinder simply by rotating it within its special holder.

8 Use of red. The eye seems to have an affinity for red and nearly always seeks it out. If there is any bright red in a colour picture, the attention will invariably settle upon it. For this reason, it is always a good ploy to try and associate the principal interest with something red in colour. If its own colour is red, so much the better!

The eye scans up and down this vertical arrangement, settling at the top with the kittens. This tends to feel a little top-heavy, and can easily be remedied if some of the base area is taken away. The eye then scans the subject horizontally, from the light-toned kitten on the left to the one peeping over the top on the right. So fit this part in a smaller horizonal format: nothing is lost except unnecessary detail, and the eye starts and finishes on the kittens without diversion. Also the eyelines are placed on a diagonal, which makes it more lively still.

Eyescan and format

In reading a book, Western eyes scan the pages from left to right. It is no wonder, then, that a picture is read from left to right as well. But what occurs when one views something that towers into the sky? A moment's thought will show that the eye 'reads' it in an upward direction. It would be foolish to ignore this matter of conditioned eyescan together with the psychological reactions that go with it, because when any interfering interest interrupts the flow it becomes an important obstacle. For instance, a large heavily toned tree on the left-hand side of a landscape seems to obstruct the eye in its left-to-right scanning of the picture. Having overcome this obstacle, the eye sweeps rapidly off the right-hand edge. This must dilute the effect appreciably unless something exists in the picture to halt the eye's rapid traverse from one side to the other. Reverse the picture so that this same tree is at the extreme right-hand side, then notice how easily the eye slips into the left extremity because the obstacle has been removed. However, as it scans the picture, it reaches the optical stop of the tree on the right-hand side. Thus it dwells upon the contents of the picture area without running off, and interest in the picture is maintained.

Eyescan is effective in yet another way. If the picture format is horizontal, the eye wants to scan across it, whereas if it is vertical the eye is encouraged to scan up and down it. The effect is emphasised by differences in the height-to-width ratio. The greater the height in relation to the width, the stronger is the desire to read the picture vertically, whereas when the width is very much greater than the height, side-to-side scanning is much more emphatic. It really is surprising how many people hold the camera horizontally for whatever shots come their way. If an obviously vertical shot is arranged within a horizontal format, or vice versa, it usually looks as uncomfortable as any other misfit. With a square-format camera, try to visualise the subject within a vertical or horizontal format on the viewfinder screen and to overcome the natural desire to fit it within the square boundaries. Unless, for editorial reasons, a square shape is necessary, it is advisable to use it only for symmetrical subjects.

When pictures are taken specially for presentation in a slide-sound show, optical continuity requires the pictures to be of similar and uniform shape and format. If the picture kept on jumping from horizontal to vertical without any warning, it would become very irritating. The problem can be largely overcome by using a square screen on which the horizontal and vertical shots are projected in groups, with preferably not less than ten in each , using a slow fade at the end of one group and the start of another. Although this is a specialised field, it is becoming increasingly popular, and most serious workers in it avoid vertical-format shots altogether. The techniques are therefore those of cine, where vertical-eyescan shots are avoided if at all possible. If they are not avoidable, the tangential line can be used to create some measure of horizontal interest. It is better to place the vertical interest more to the right of the picture than the left so that the eye, in reading the picture from left to right, scans the screen before coming to rest on the principal interest.

Silhouettes, strong skies and 'small against large' should lead to good pictures. This one has them all, but does not look particularly strong. The sky might be strengthened by several methods, including transplant. The ground line is parallel with the bottom edge, and its implied placidity is in contrast with the plodding figures. As no component can be definitely related to either vertical or horizontal, the ground might be shown at an angle to emphasise hard uphill struggle.

Shapes and arrangement

Two and a half thousand years ago, Pythagoras is said to have held a piece of string in front of his students and asked them where a knot should be tied to be at its most aesthetically satisfying position. They decided that such a position could be found 0.38 of the way along its length. A couple of centuries later, Euclid declared that this proportion, defined by Pythagoras as being 'a harmonious proportion in tune with the universe', was indeed 'a ratio where the smaller part is to the larger as the larger is to the whole'. This interested Leonardo of Pisa, a noted Renaissance mathematician who attempted to prove that all satisfying proportions in art are based upon mathematical formulae and progressions. This meant he had to translate linear terms into spatial ones, an exercise he embarked upon with great gusto. So much so, in fact, that his more renowned namesake, Leonardo da Vinci, listened attentively and incorporated his principal spatial ratio into some of his paintings. Having now become two-dimensional, it was defined as 'a rectangle whose length is the same proportion to its breadth as half its perimeter is to its longer length'. Latter-day photographic sages have simplified the 'golden mean' or 'golden section' from 0.38 to 0.33 and called it by such names as 'the most powerful point' or 'sub-division of thirds'. To judge by one dictionary definition of the golden mean as being 'neither too little nor too much', this is probably near enough, although appreciably different from the original.

An expressive shot, but could it be improved? The child wants to be up and away, so perhaps the static position is not the best one, and the chopped-off legs do not provide the same strength of base as the bottom of the dress might have done. A little cropping would change all that and make the picture even more appealing.

While not disagreeing with the theory of harmonic ratios applied to pieces of string and plain rectangles, I don't think it necessarily applies when other elements are added. The content we put into the space is itself subject to further harmonic ratios, and indeed Leonardo of Pisa tried to prove this. But a picture that needs a pocket calculator as well as a camera can hardly be a product of the 'seeing eye', and mathematical qualifications do not ensure that their possessor is a good photographer.

24 pictorial propositions

If picture-making is a creative pursuit, there can be no rules. Imagination needs no keeper, but conform to rules and you are one of the flock. There are, however, a number of guiding precepts that have been of help to artists through the ages and are always worth consideration by the photographer. Here are some of them. They are put forward as propositions for consideration, nothing more. Although based upon logical reasoning they have nothing to do with preconceived ratios, golden harmonies or the like. Such ratios may support some of them, but if so, it is coincidental.

Proposition 1 A straight line is the shortest distance between two points. When the line is viewed as a whole, the eye first seeks out the two points and then finally rests at the point of balance, the position of the fulcrum of a see-saw. When the straight line is vertical, the eye-scan normally starts at the bottom and runs to the top before resting on the mid-position.

Proposition 2 When a straight line is bent at an angle, or is crossed by another, the attention rests on the point of change or the crossing point.

Proposition 3 A rectangle is a straight line bent at right angles in four places. These positions attract the attention and form arrowheads that point outwards. When all four arrowheads are viewed at once the attention is held at the point of equal 'pull', i.e. the middle. This is known as the 'static position' because it is the point of optical rest.

62

Proposition 4 If a uniform shape is placed in the static position it will seem to be at rest.

Proposition 5 If a non-uniform shape is placed in the static position its only sense of movement will be that implied by its own shape.

Proposition 6 If any shape is placed near a corner it will seem to be attracted by that corner, its attraction being determined (a) by its nearness to the corner and (b) by movement implied by its own shape.

Proposition 7 Because of the attraction of corners, positions near them are known as 'active'. Owing to the influence of the centre, implied movement is from corner to centre and vice versa.

Proposition 8 Superimposed upon the sense of activity generated by the joint influence of active and static positions are those of gravity and one's ability to read. Unless stronger influences prevail, movement in space has a downward implication, while the eye scans a picture from left to right because Western people are taught to read that way. For this reason, the term 'reading a picture' means viewing it from left to right.

Proposition 9 Shape affects the direction of eyescan. The eye scans a horizontal shape along its length, usually from left to right. It scans the length of a vertical shape up and down, usually from bottom to top. Faced with a square, the eye is left in a state of indecision because it is as broad as it is long. The further a shape departs from the square, the greater the effect on eyescan.

Proposition 10 Shape can apply to picture format or to the arrangement of the subject within it. The effect is emphasised if one echoes the other, but a clash of interests arises if they oppose.

Proposition 11 As the format has a recognisable shape, so too should the subject matter. Without it the impression is that of an ill-fitting suit.

Pages 63 and 65 show in graphic form the pictorial propositions described in the text.

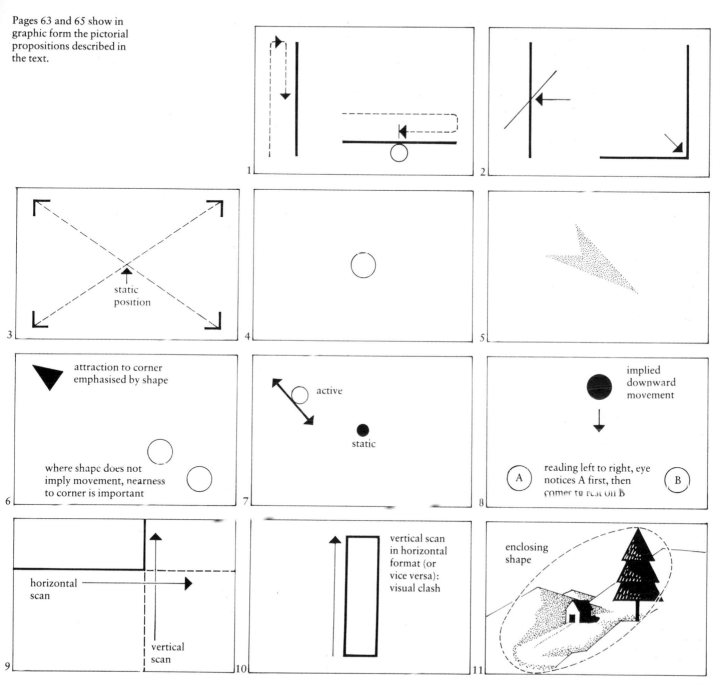

1

2

3 static position

4

5

6 attraction to corner emphasised by shape

where shape does not imply movement, nearness to corner is important

7 active

static

8 implied downward movement

A reading left to right, eye notices A first, then comes to rest on B B

9 horizontal scan

vertical scan

10 vertical scan in horizontal format (or vice versa): visual clash

11 enclosing shape

Proposition 12 Tone implies weight: the heavier the tone, the heavier the weight. Heavy tone at the top of the format produces a lowering feeling, but at the bottom, having apparently settled, it implies stability.

Proposition 13 The eye seeks out brightness, and moves from heavy tone to light, where it will finally settle.

Proposition 14 The eye is attracted to a crossing or convergence of lines, and generally follows lines towards such a point.

Proposition 15 A line that is subconsciously suggested by components of pictorial interest, such as an arrow speeding towards a distant target or the direction of a person's gaze, is known as an 'implied line' and is often stronger in effect than a visible one. Implied lines often appear in pictures without the photographer realising it until afterwards, when he finds that, although perhaps unwanted, they are the most prominent.

Proposition 16 Uncrossed lines running parallel to the sides of the picture reduce the effective picture area by forming a kind of barrier.

Proposition 17 A vertical line implies height, balance and inspiration. A horizontal one suggests width, rest, solidity (if resting on base) or floating (if in space). If the line is leaning it gives the impression of falling, and therefore movement. The implied movement is in the direction of the angle, being at its minimum the nearer it is to the horizontal or vertical, with its maximum at 45°.

Proposition 18 A 'centre of interest' is produced in an abstract fashion wherever constructional lines cross or meet, or wherever there is contrast of tone or colour.

Proposition 19 A 'division of interest' can dilute the effect of a picture in proportion to the strength, position and number of centres of interest.

Proposition 20 'Unity' exists in a picture where the intended centre of interest is strong enough to overcome the effect of all others, or where it is unopposed. All good pictures are supposed to have unity.

Proposition 21 'Variety' is a term used for supporting secondary interests that make a picture more interesting. Pictures used for their own intrinsic worth are usually considered to be improved by the inclusion of variety.

Proposition 22 'Radiation' is where the supporting interests lead the eye towards the principal one. Considered to be a highly desirable asset.

Proposition 23 'Rest' is a quality possessed by a picture with a satisfying content, free from opposing or competing interests.

Proposition 24 'Infinity' is a term that describes the 'mystery' in a good picture, the little bit of the story that need only be implied and for that reason is left untold. It has been described as the quality that causes the viewer to see *through* a picture instead of just needing to look at its surface. It is usually obtained in a photograph by careful use of depth of field or by burning-in/holding-back one of the more prominent secondary interests. A picture produced for its own intrinsic worth, to hang on the wall, for instance, is generally considered to be improved by the presence of infinity.

An inevitable question from anyone who sees this list of 24 propositions for the first time is: 'Am I supposed to remember that lot?' The answer is no. The sole purpose of the propositions is to help with picture analysis and the understanding of visual communication. It is not a case of committing them to memory, but of appreciating the sense behind them. There is a saying that 'a good picture is a good picture is a good picture', meaning that it isn't anything else. Anybody who appreciates pictures, even in the most unsophisticated fashion, will appreciate a good one because it contains nothing

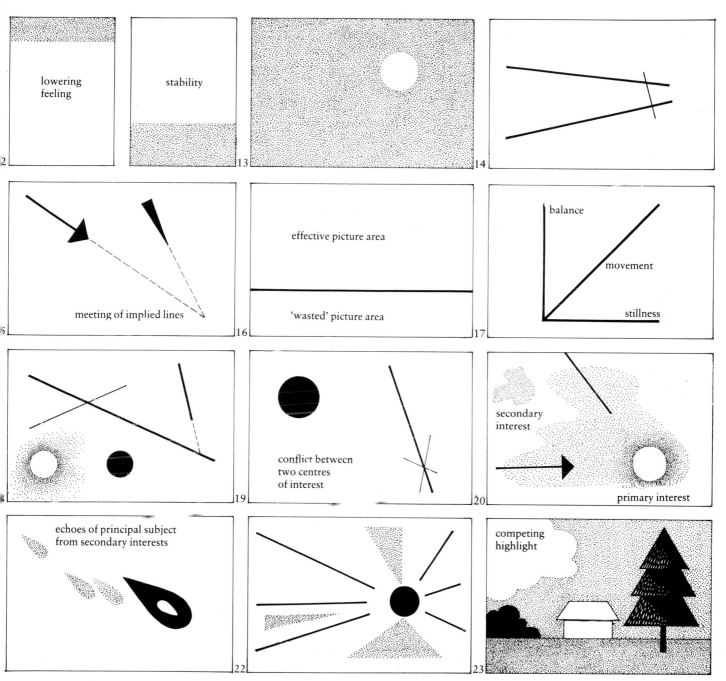

lowering feeling

stability

meeting of implied lines

effective picture area

'wasted' picture area

balance

movement

stillness

secondary interest

primary interest

conflict between two centres of interest

echoes of principal subject from secondary interests

competing highlight

that disturbs its own potency. If, however, there is something about a picture that seems slightly awkward, maybe a little weak, people may react by saying, 'It's a good picture, but there's something about it that . . .' They feel it could be better but they can't see how, apart from hazarding a guess.

If you can be decisive about the work of others, you can certainly produce better work of your own; that is the secret of success, to appreciate how the story can be better told and how its message can be better understood. Nothing else matters. There is no mystery about it. A picture is as much a means of communication as the written or spoken word, a piece of music, or a sculpture. It has its grammar: the set of propositions.

Making better pictures is a retrospective process. Look at pictures, analyse them, see how they could be improved and apply the lessons in the future. At the same time, if you see anything that detracts, eliminate it from your way of working. Ultimate success should always be planned, but in the full knowledge that it will never be reached, because there is *always* room for improvement. Perfection is sought by humans but never attained.

Imaginative use of line and tone

Pictorial constructional 'lines' have already been discussed and will be referred to again later. The true picture-making photographer should learn the advantages of their use as well as any artist. A line is anything that directs the eye from one part of a picture to another, preferably towards the principal subject interest. Lines can be a series of repetitive objects, rows of trees, the horizon, or 'implied' as already discussed. What hasn't been explained so far is their character. Hogarth, for example, claimed that the most beautiful line in nature was that formed by a woman's back, the so-called 'Line of Beauty', rather like an elongated 'S'. Pictures based upon such a line certainly look pleasant, but to try and compose a subject around predetermined lines is not usually possible for any photographer. What is important is to be able to recognise line

Diagonal arrangement in a photograph gives a greater impression of vitality, but has to be used with discretion. A slight angle can look like careless arrangement, whereas 45° may be too much. This shot of a hydrofoil with a horizontal horizon was dull. Tilted, it becomes more attractive because of the implied sense of movement; the shot could well have been taken on another boat caught in the wash and it therefore seems authentic. In the case of the portrait, if tilted at an angle (as shown by the white lines) the sitter instantly appears more vivacious.

where it exists, and to make the most of it. A few examples are worth discussing.

The leaning line (see Proposition 17) A pencil standing on its end can represent a vertical line. Move the top slightly and it falls over, in an arc from 90° to 0°. An angle of, say, 85° is at the start of the movement, which does not seem very rapid at that point. At 45°, the movement seems to be at its most powerful because after this its opportunity of continuing becomes less the more it nears 0°, when it comes to a dead stop. It follows that a diagonal line is an active one; in a picture, a line appears to be at its most potent when it runs diagonally from one corner to another. From an interpretive point of view, this is most important. If the principal subject interest is arranged along a horizontal line it appears to be at rest. If in alignment with a vertical

one, it is in balance and often gives the impression of reaching upwards. If neither one nor the other, but somewhere between the two, the subject appears more active the nearer the line approaches a diagonal. Great advantage can be taken of this because movement can be implied where none was present, provided nothing exists in the picture that can be related to a known horizontal or vertical. For instance, if a church spire is shown leaning at an angle of about 45° and the ground can be seen, it looks as if an earthquake is happening. Remove the ground from the picture and the feeling is simply one of recessional perspective coupled with a feeling of vitality. This is worth remembering. If a diagonal line does not imply movement, it will suggest vitality instead.

Obviously, the angle of the line shouldn't be so little as to suggest carelessness in aligning the camera, but should be an obvious decision of the photographer. Consider a portrait as an example. Many photographers arrange the head vertically, which gives it a staid and rather formal appearance. Display it at an angle within the frame and it looks more alive at once. So an experienced portraitist will usually hold the camera at an angle so as to get the biggest image on the film while maintaining an angular setting.

The coupling (transverse) line Every experienced photographer avoids the sort of scene that divides interest equally between one part and another, because it reduces concentration and leaves the viewer wondering what he or she is expected to look at. Yet in some scenes a division of interest is almost certain unless something is done to avoid it, for example beach and sky, sea and horizon, and many similar types of subject. The answer is to provide some sort of link between the two interests, provided that one will be dominant. This can be done by introducing a transverse line, usually at or near right angles with the main compositional lines of the two interests. For instance, suppose the divided interest is between landscape and sky, with a more or less flat horizon. Move around with the

camera until you find some vertical feature that will link the two. The obvious thing that comes to mind in a country scene is a tree. For use as a link line it should be rooted in the foreground with its branches spread into the sky. The two separate interests of sky and ground are then joined together by the tree to form a united scene. This is a most important use of line, and can make a weak scene remarkably strong.

This picture could be described as both a riverscape and a skyscape; in other words, it shows divided interest and makes an ideal setting for a transverse-line subject. The speckled bar breaks across the dark belt in the middle and links the two halves. It could be a crane, the mast of a boat, a tree on the near bank, anything prompting a vertical eyescan to go with the vertical format.

Getting the wrong effects from line Because line is such a powerful picture-making ingredient, care should be taken not to use it wrongly. For instance, if lines cross, one's attention is automatically drawn to that point, which is awkward if the principal subject interest is somewhere else. Instantly, a division of interest is introduced and the picture weakened accordingly. Incorrect use of line can also occur where one line abuts another, because the two appear to be linked. Cases that abound are where the tops of foreground objects terminate at the horizon line and appear to be holding it up. If this occurs, try to convert the vertical into a transverse link line passing right through the horizon and coupling the foreground with the sky.

Radiation (see Proposition 22) The term 'radiation' refers to the convergence of lines, for example creases in material or in skin, fences and telegraph wires on landscapes, the horizon on a seascape, and implied lines like the flight of an arrow or the direction of sight. Such lines are used with advantage to pick out the principal subject interest, since whatever lies at the meeting or focus of lines will tend to dominate. In the ideal case, the principal subject interest has obvious pictorial lines leading to it. Once again, this is not put forward as something that *should* be done, but if borne in mind good effect can be made of it.

Tonal contrast (see Proposition 13) Tonal contrast is as important as line convergence in enabling the viewer to pick out the principal subject interest. Small light areas against large dark ones are instantly noticed, the reverse being equally true. Arrange the point of maximum tonal contrast on or near the principal subject interest and there will be no confusion in the mind of the viewer as to where he should look.

Division of interest (see Proposition 19) Few things dilute the effect of a picture more than prompting the viewer to look at two or more parts of it at the same time. As discussed earlier, division of interest can be generated by more than one consideration (competing subjects, conflicting tonal balance, barriers formed by lines parallel with the frame edges, and the like). Perhaps the most powerful and unfortunate of all is when radiation conflicts with tonal contrast. This happens without one realising it, because it is not always easy to see during the framing of the subject in the viewfinder, but it is immediately obvious if present in the finished picture. Perhaps the most frequent case is when an interesting subject in the foreground has to compete with a strong white blob of white sky in the top corner that instantly compels attention. But if both the focus of radiation and the area of maximum contrast can be arranged on or around the principal subject interest, how strongly the message goes over!

Balance
Whenever artists discuss their work, one hears the word 'balance' continually cropping up. Yet, as a pictorial term, it is something the layman seems to know very little about. This strange yet important ingredient of good pictures is far too vague for translation into simple propositions, but too fundamental to be ignored. In cases where pictorial components of equal interest in all but dominance exist, it goes to the very heart of successful picture-making. Depending on their interest status, they have to be either balanced about the principal subject or made subordinate to it. At all events, the arrangement has to be in sympathy with the picture's intended purpose.

This all seems terribly complicated and pretentious, but it isn't really. Consider a see-saw. It is in equilibrium when its weight is distributed evenly on each side of the fulcrum (figure 1). Add a weight to one side of the see-saw, and that side hits the ground (figure 2). In other words the weight, and the line leading towards it, draw the attention to one corner of the picture while the rest of the picture space remains a wasted area. Balance can be restored by placing weight on the other side of the see-saw (figure 3). This can be a similar weight at an equal distance from the fulcrum, a heavier

weight nearer to it, or a much less dense object (but of similar weight) spread over its own side of the plank. Moving the fulcrum also affects balance, of course; the weights have to be redistributed to compensate.

Try and relate the see-saw to the rectangle of the picture format and the fulcrum to the principal subject interest. Remember that tone equals weight; light tones and tints lighten it, and dark tones and tints increase it. The arrangement in figure 4 looks 'comfortable' but not very exciting. The effect could be considered static, restful, and quiet. Disturb the balance by changing the distribution of weight but leaving the fulcrum in the same position and the opposite effect is created (figure 5). The whole arrangement looks uncomfortable to an extent that could easily be described as 'unbalanced'. Move the fulcrum to one side, i.e. move the vertical line to either right or left, and, by distribution of tones, restore 'balance' (figure 6). The effect immediately looks 'comfortable' despite movement of the fulcrum. The effect is much more lively and interesting than when the fulcrum is centrally placed. Disturb the balance by changing the distribution of weight but leaving the fulcrum unchanged, and once again a restless, uncomfortable feeling is introduced.

Notice that no mention has been made of whether a picture should be in or out of balance. This is something entirely for the photographer to decide. A comfortable subject needs a comfortable setting, i.e. a 'balanced' one, encouraging the viewer's reactions to be in tune with the subject. Suppose, however, the subject is an 'uncomfortable' one in terms of its message, and is deliberately intended to be so. Wouldn't it be folly to give it a comforting layout in direct contradiction to the subject? Such a design would surely produce psychological confusion in the viewer.

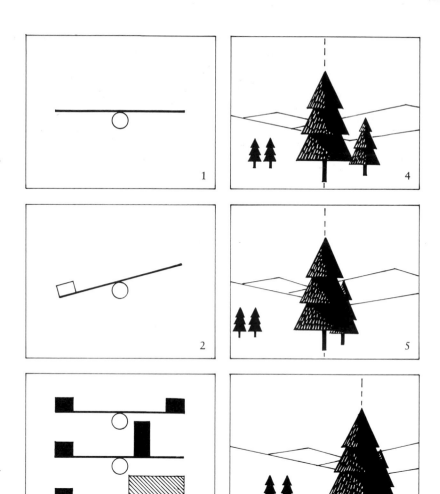

Summary
It is so easy for photographic writers and some photographers to deride the principles of picture construction as being 'old hat'. It is equally easy for manufacturers to claim that their marvellous new automated product makes its owner a good photographer, or for others to make out that quality is guaranteed if you follow a few simple rules. To get good quality out, we have to do our best to put good quality in, and it is nothing to do with either a careless or a dogmatic approach. That is why nothing in this book is intended to be other than a basis for logical consideration.

70

The title, *Summer skyscape*, tells us that the principal subject is intended to be the sky, with the foreground details providing a base to which it can relate. However, the tree is so prominent that it could be the principal subject. The sky seems to have been a bit unnaturally overexposed on the right-hand side during printing, and the clouds are so near the horizon that this could well be a combination print. If it is, the sky should be faded as it reaches the horizon. The base, being parallel, does not really balance the tree but provides a stage upon which something might occur. Indeed, one gets the feeling that this will become very much better once the action starts.

There is no need to commit any of it deliberately to memory, because that would only lead to indecision at the time of taking the photograph.

The way to go about it is to look at your own work, as well as that of others, and spend some time analysing it in the light of what is discussed in this book, making good use of those maxims or propositions you can accept and rejecting those you cannot. To accept them all without further thought would certainly produce good-looking work, but not those outstanding shots that evolve from the application of one's own views, beliefs and outlook. Always look at any finished picture with a searching eye, and the way to take photographs will develop unconsciously. A good driver is one who reacts to the happening of the moment, correctly and instantaneously, without having to think about what the driving instructor told him many years ago. Similarly, the good photographer, having become knowledgeable in the elements of picture-making, will unconsciously avoid those little errors that previously took the edge off the finished results.

Flat out A beautifully caught motor-cycling shot showing excellent camera technique. To be effective, the rider's features must be clearly shown, even though other parts of the subject may be soft. The panning is excellent. Two things dilute the effect: the horizontal position of the rider placed in the static position, which reduces the effect of speed, and the white line parallel with the base. Framed as shown, the rider is on a diagonal, and so is the white line. This deliberately destabilises the arrangement and simulates speed. Thus the impression and the action are now made sympathetic. Propositions 3, 5, 7, 9, 10, 13, 15, 16, 17.

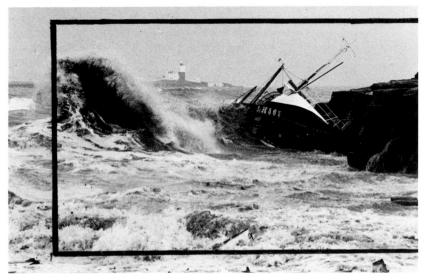

Power This study of a wreck in high seas gives the appearance of the wave rolling away from the ship, when it would have looked so much more effective coming towards it. Simply trimming away the space on the left-hand side of the wave makes it seem to roll from the edge of the frame towards the wreck. To restore the feeling of movement towards the right the elongated horizontal shape needs to be restored, and the recommended trim does this. It is an exciting shot, very well seen but presumably metered through the lens or used with an automatic camera, because the principal subject (the boat) is underexposed, thus losing all the shadow interest in areas of almost unrelieved black. The camera position, with the lighthouse placed where it is, is very good. Propositions 1, 2, 9, 13, 18, 21.

Norbert Krüger

How colour films work

Colour films for camera use can be bought in sheet, roll, cassette and disc form. Sheet films are used in view cameras and the like. Roll films, in which the film is rolled up in backing paper, are used in medium-format cameras. Cartridge films (sizes 110 and 126) are roll films too, in that they have a paper back. 35 mm films are packed in cassettes. These, and unbacked 70 mm films, which can be used in some 6 × 6 cm cameras, are also available in bulk lengths. Disc films have been introduced by Kodak for their innovatory disc cameras. All these films have a clear base, usually made of cellulose acetate or polyester; the light-sensitive emulsions are coated on one side, and a light-absorbing anti-halation backing is normally coated on the other.

All the colour films used in cameras have the same basic construction. They are coated with three emulsion layers which are quite thin, so that the total thickness of all the emulsions is little greater than that of the single layer coated on monochrome films. In the case of some camera colour materials, especially those of high speed, this basic 'tripack' construction is modified, and some layers may be double- or even triple-coated. However, this does not affect the fundamental principles of their operation. Multi-coating of emulsions may be used to extend exposure range and hence increase exposure latitude. It was an expedient widely used at one time to increase the exposure latitude of monochrome films. If two emulsions are used, a slow one next to the film base and a fast one on top, latitude in the direction of overexposure is increased. If a subject highlight exposes the front layer right through in the absence of another emulsion behind it, highlight detail is burned out. But if there is another slower emulsion behind the fast one, it takes over and records the highlight gradation satisfactorily. This can be taken even further: in Ektachrome 400 film, for example, the

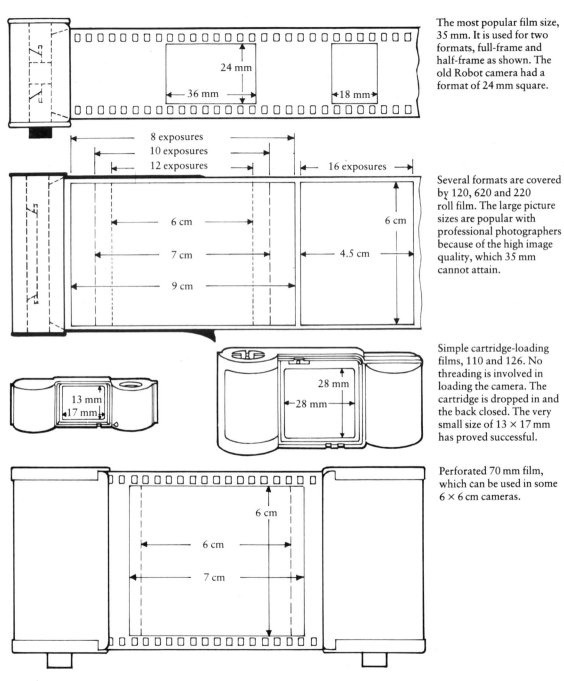

The most popular film size, 35 mm. It is used for two formats, full-frame and half-frame as shown. The old Robot camera had a format of 24 mm square.

Several formats are covered by 120, 620 and 220 roll film. The large picture sizes are popular with professional photographers because of the high image quality, which 35 mm cannot attain.

Simple cartridge-loading films, 110 and 126. No threading is involved in loading the camera. The cartridge is dropped in and the back closed. The very small size of 13 × 17 mm has proved successful.

Perforated 70 mm film, which can be used in some 6 × 6 cm cameras.

green- and red-sensitive layers are triple-coated with fast, medium and slow emulsions.

Three-layer films are known as 'integral tripack' materials, and the three emulsions are sensitive to different regions of the spectrum. The outermost emulsion (i.e. the one nearest the lens in the camera) is a relatively simple one that is sensitive to blue light. It does not respond to green or red light, and so records only the blue light reflected from the subject. Below this is a yellow filter produced from finely-divided colloidal silver. This allows only green and red light to pass through to the other layers. When the film has been exposed, this yellow filter layer will have served its purpose and needs to be removed, otherwise it would impart a strong yellow colour to transparencies or negatives. It disappears, in fact, during the final stages of processing, which remove all the silver from the emulsion ('fixing' the image). The middle layer of emulsion is sensitive to both blue and green light, and is thus 'orthochromatic'. Since no blue light passes through the yellow filter layer, this layer records only the green light from the subject. Behind the green-sensitive emulsion layer and next to the film base is a layer that is sensitive to red light (and of course to blue, but no blue light reaches it). It is sometimes stated that the red-sensitive emulsion layer of a tripack film is panchromatic, but this is not generally true. It is sensitive to blue and to red light but not to green. However, a recent development is to coat a red filter layer on top of the rear emulsion so that a truly panchromatic emulsion can be used for the red-recording layer. This offers a wider choice of sensitising dyes that can be exploited usefully in the manufacture of fast films. When an integral tripack colour film is exposed in the camera, the three emulsions record the blue, green and red light reflected by the subject. This is the first stage in the making of a colour photograph by any of the modern processes; it has a parallel in the mechanism of colour perception in the human eye, in which there are three types of cones, responding to the blue, green and red components of colours seen.

Development
When a silver emulsion is exposed in a camera a latent image is formed that has to be revealed by development. This is carried out in a solution containing one or more organic reducing agents that convert silver halides to metallic silver. Exposed crystals are reduced rapidly, but unexposed crystals only very slowly; so an essential property of a reducing agent that acts as a photographic developer is a big difference in the speed at which it reduces exposed and unexposed silver halides. The latent image consists of silver halides that have received enough exposure to light for silver atoms to have been released which collect at specks of silver sulphide on the crystals and at mechanical defects in the crystals. These silver atoms act as development centres at which the reducing process starts. Every exposed crystal is developed completely to silver unless the development is stopped prematurely.

Chemical reduction involves the transfer of electrons from the reducing agent to the substance being reduced; there is always a concurrent process of oxidation. In development the halides are reduced to metallic silver and the developing agent is oxidised. The developing agent loses electrons and the silver bromide gains electrons. This is a formal definition of reduction and oxidation, but

Kodak disc cameras have a film format even smaller than 110. However, it is reckoned the the system design produces better picture quality.

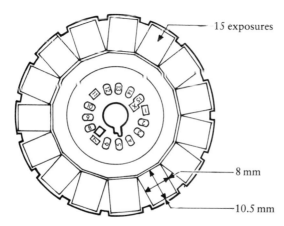

15 exposures

8 mm

10.5 mm

75

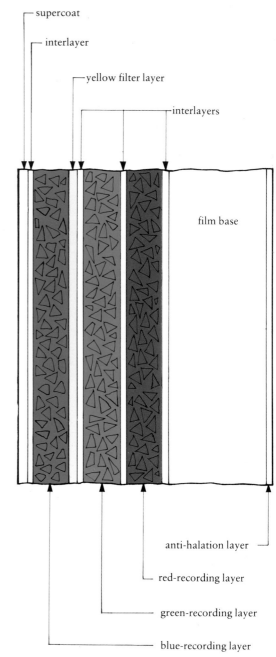

supercoat

interlayer

yellow filter layer

interlayers

film base

anti-halation layer

red-recording layer

green-recording layer

blue-recording layer

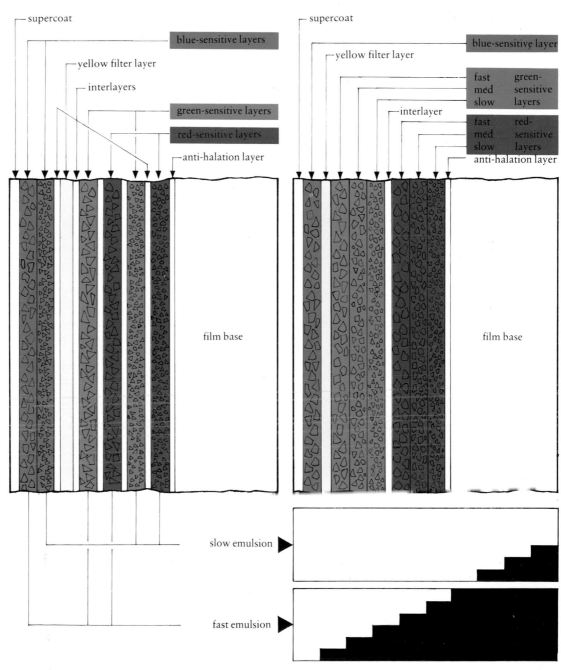

Left: section of a simple integral tripack colour film, showing the emulsion layers and the various other incidental layers.

Right: integral tripack film in which all three emulsion layers are double-coated, a fast layer in front and a slow one behind. The fast and slow layers for green and red recording are separated, as can be seen.

Far right: an even more complicated tripack film in which the green- and red-sensitive layers are triple-coated. The blue-sensitive emulsion is a single layer.

supercoat

blue-sensitive layers

yellow filter layer

interlayers

green-sensitive layers

red-sensitive layers

anti-halation layer

film base

supercoat

yellow filter layer

blue-sensitive layer

fast green-
med sensitive
slow layers

interlayer

fast red-
med sensitive
slow layers

anti-halation layer

film base

slow emulsion ▶

fast emulsion ▶

there are familiar examples of these two reactions. When an iron nail rusts it combines with oxygen in the air, i.e. it undergoes oxidation. In fact oxidation does not always involve oxygen: if metallic sodium combined directly with chlorine gas to form sodium chloride (common salt), this would be a process of oxidation although no oxygen is involved. In these examples the oxygen and the chlorine gain electrons and are said to have been reduced.

In colour or 'chromogenic' development a special developing agent is used, typically a diaminobenzene derivative, the oxidation products of which combine with colour couplers to produce dyes. The dye is produced as the silver is deposited in proportion to its amount. Different colour couplers produce different coloured dyes with the same developing agent. In colour photography the dyes are yellow, magenta and cyan. In most colour films the necessary couplers are incorporated in the emulsion layers. Such films are called 'substantive'. In non-substantive reversal films, notably Kodachrome, the couplers are in the colour developers, and a separate colour developer containing the appropriate coupler is required for each emulsion layer. For this reason, Kodachrome films cannot be processed by the user but have to be sent either to the manufacturer or to an authorised processing station capable of operating the rather complicated processing procedure.

When the colour couplers are incorporated in the film emulsions, means have to be found for preventing them wandering from one emulsion layer to another or out of the emulsion into the processing solutions. As colour couplers have to be soluble it is not an easy matter to achieve this. Agfa attacked this problem initially by making the colour couplers of large molecular size. This does not make them insoluble, but it does prevent their moving around in the relatively small spaces in the sponge-like network of the gelatin. In Kodak Ektachrome materials the couplers are dispersed in the emulsion in tiny oily globules; these do not move around in the gelatin, and the couplers used

cannot diffuse out of the globules because they are insoluble in water. Processes of this type call for a colour developer that contains benzyl alcohol in addition to the usual reagents. This acts as a go-between for the colour developer reaction products and the colour couplers in their oily globules.

Colour negative films

All colour negative films incorporate couplers in their emulsions. The blue-sensitive top layer incorporates a yellow dye former, the green-sensitive middle layer a magenta dye former, and the red-sensitive bottom layer a cyan dye former. They are developed in a colour developer that produces negative silver images along with dye images; the now unwanted silver image is bleached, fixed and washed out. Large-scale processers often have separate bleach and fix baths. However, most small-scale systems now use a combined bleach-fix, or 'blix', to simplify and speed up processing. Once processed, the negative has three dye images, each negative in tone, and complementary in colour to the light that exposed that layer. In the blue-sensitive layer, for example, the more blue light that was reflected from the subject, the more yellow dye is now present in that layer. When the negative is printed, that yellow dye layer controls the blue light reaching the printing paper. The printing paper has a similar integral tripack emulsion, and once again the blue-sensitive layer produces yellow dye. The effect is to produce a print image with no yellow dye in parts corresponding to parts of the subject that reflected blue light strongly, and a deep yellow dye in areas that reflected no blue light at all. (This corresponds exactly with monochrome processing and printing. In a monochrome print the parts of the subject that reflected a lot of light are represented by a lack of silver, and the parts that reflected no light are represented by strong silver density.) Clearly, where white light reached the film there will be no dye in any of the three print layers, so the print will show white. On the other hand, where no light reached the film, dye will be formed in all three layers; this

means that the print will absorb red, green and blue light, i.e. all light, and so will appear black.

The dyes that can be formed chromogenically are not perfect. For example, while magenta dyes absorb green strongly and transmit most of the red, they absorb far too much blue light. In the same way, cyan dyes tend to absorb too much green and blue. To minimise the problem caused by the inaccuracies in absorption qualities of the dyes in colour negatives, the couplers from which the dyes are to be made are themselves coloured (see page 100). These colours remain in the areas where the couplers are not converted to coloured dye, giving the negatives an overall orange or brick-red colour.

Colour reversal films

When a colour reversal film has been exposed, the first stage of processing involves a more or less straightforward black-and-white development during which uncoloured negative images in silver are produced in the three layers. Although the processing of different makes and types of reversal films differs in detail, the next essential step is to fog all the silver bromide that was not reduced to silver during the first development. Fogging can be carried out by exposing the film back and front to white light, or it can be done chemically by means of a suitable reagent, either separately or in the colour developer. During colour development, the fogged silver bromide in all three layers is reduced to metallic silver, and simultaneously the by-products of development combine with the couplers in the layers to produce the yellow, magenta and cyan images. As the images correspond to the unused silver halides remaining after the first negative development, they are positive. At this stage, there are negative and positive images in metallic silver and positive images in the three dyestuffs; the film is opaque, and only hints of an image are visible. The metallic silver has served its purpose and now has to be removed from the film. This is done in two stages: first, a bleach bath oxidises the silver back to silver bromide; then, after a wash, a fixing bath converts

the silver bromide to soluble compounds, which are removed from the film by washing in running water. The finished colour pictures thus contain no silver at all and consist only of dyes in the three gelatin layers.

The image hue is, in each case, complementary to the colour that the layer records. As the outermost emulsion layer records only the blue light coming from the subject it must be processed to a positive image in yellow, because yellow controls only the blue light and is fully transparent to both green and red. Similarly, the middle layer that records green must be processed to a positive magenta image, as magenta controls only green light and is transparent to blue and red. The positive cyan image in the layer next to the base controls the red light that the layer records in the camera.

Kodachrome

As in all reversal film processing, the first development of Kodachrome is in a black-and-white developer, which produces silver negative images in all three layers. The next step is to expose the back of the film to red light: this renders developable the silver halide in the layer next to the base. Its sensitivity to red light is not destroyed by the first developer. (Of course, neither of the other layers is red sensitive.) The film is then treated in a colour developer containing a cyan coupler, which produces a positive image in silver and cyan dye. The front of the film is now exposed to blue light, which makes the silver halides in the outermost emulsion developable; the yellow filter layer behind the front emulsion prevents the middle layer being exposed to the blue light. A second colour developer containing a yellow coupler produces positive images in silver and yellow dye. This leaves just the middle emulsion layer to be colour developed, and a fogging developer embodying a magenta coupler is used to produce silver and magenta dye. At this stage the film contains silver negative images, silver positive images and positive images in yellow, magenta and cyan dyes. The silver has now served its purpose

Colour negative film being exposed to a colour chart having colours black, red, green, blue and white (reading from top to bottom).

The film after colour development. The black dots represent both silver and dye.

The finished colour negative, containing dye images only.

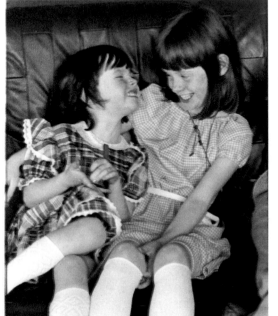

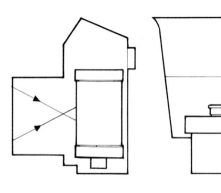

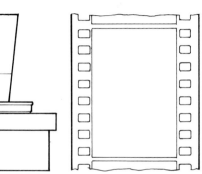

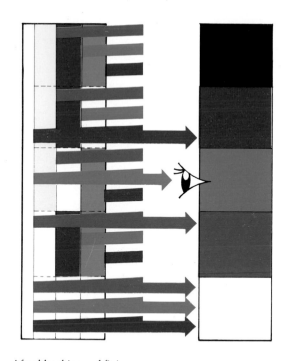

The colour negative in the enlarger, its transmissions of blue, green and red being controlled by the image dyes.

The image projected on to the enlarger baseboard where the colour printing paper is exposed.

On development the colour paper shows positive images in silver and in yellow, magenta and cyan dyes. The order of the layers is the reverse of that in a camera film

After bleaching and fixing, the print bears an image which is a replica of the original colour chart.

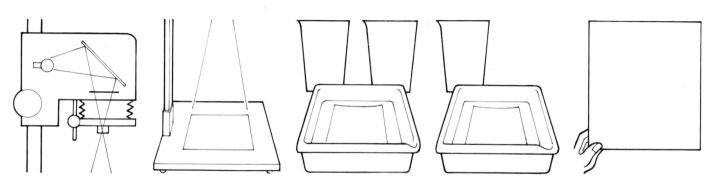

and is bleached to oxidise it to silver bromide, which is removed by fixation. A final wash to remove all soluble compounds completes the processing sequence. The foregoing outline omits incidental solutions such as stop-bath or hardener.

Professional films

Most manufacturers offer a choice of ordinary films and 'professional' ones. Some offer different emulsions, others apparently the same. So what is the difference? The main one is a question of aging. Every film alters with age. The emulsions ripen, changing slowly in sensitivity and contrast. Each layer of a colour film alters differently, so the colour balance alters as well. Sometimes, too, characteristic curves (page 83) can 'cross' or 'uncross' with time, making the film unusable or not depending on its state of ripening. The film sold in corner shops can be kept for months on the shelf, or (horror!) in a sunny window. Clearly the manufacturer has to take this into account when supplying it, so ordinary films are formulated to ripen some time after delivery, and to age as slowly as possible. Professional films, on the other hand, are stored by knowledgeable dealers. They remain in cold store until sold. Professional photographers, too, keep their film cool. So 'professional' films are fully ripened by the manufacturer, and start deteriorating as soon as they warm up. They are designed with no compromise to shelf life to give the best possible results immediately, and may go off-colour much faster than their ordinary equivalents.

As well as a shorter unexposed life, 'professional' films often have very poor latent-image keeping properties. The amateur snapshooter is often characterised as taking films 'with a Christmas tree at both ends'. Clearly he needs a film with excellent latent-image keeping qualities. This goes with good pre-exposure keeping qualities. So choose the film that suits the conditions. Kept carefully (in a refrigerator or freezer), exposed within a day or so, and processed immediately it is used, 'professional' film gives the best possible results. On the other hand, on an expedition or a foreign assignment, it is preferable to use ordinary 'amateur' materials, which allow much greater freedom of operation. 'Professional' films may offer slightly different colour balance and contrast. They may produce slightly lower contrast images, and in particular are better suited to picturing people than the equivalent 'amateur' materials. However, given the available contrast and colour in the subject, professional films produce transparencies or negatives with as great a tone range and colour saturation.

Keeping colour films

Colour films need to be kept cool and dry. Warmth, and especially damp, can seriously affect sensitivity and colour balance in quite a short time. Professional films must be kept cool, before and after exposure. For long-term storage, put them in a freezer at below 0° C. For a few weeks, an ordinary domestic refrigerator below 10° C is acceptable. 'Amateur' films also keep better in cold storage. The best way to use any type of film to obtain consistent results is to buy in relatively large quantities all with the same batch number. Take a series of test shots on one roll of film to ascertain exactly the best ISO rating, and to find whether any colour correction filters would improve the rendering on reversal film. Then maintain the remainder of the film in cold storage, taking it out only as needed. Removed from cold storage, film must be allowed time to warm up, otherwise moisture may condense on its surface, with deleterious effects. Take the material from the freezer or refrigerator in time to allow it to reach room temperature *before* opening its airtight packing (see the table).

Recommended warm-up times for films

	14° C rise	56°C rise
roll film	½ hour	1 hour
35 mm and cartridge film	1 hour	1½ hours
25-sheet box of cut film	2 hours	3 hours
bulk film	3 hours	5 hours

Characteristic curve of basic reversal film.

Characteristic curve of basic negative film.

Characteristic curve of masked colour film exposed to light for which it is balanced (tungsten).

Characteristic curve of colour negative film balanced for tungsten but exposed to daylight. The blue-sensitive layer has given too dense an image and the red-sensitive layer an image which is too thin

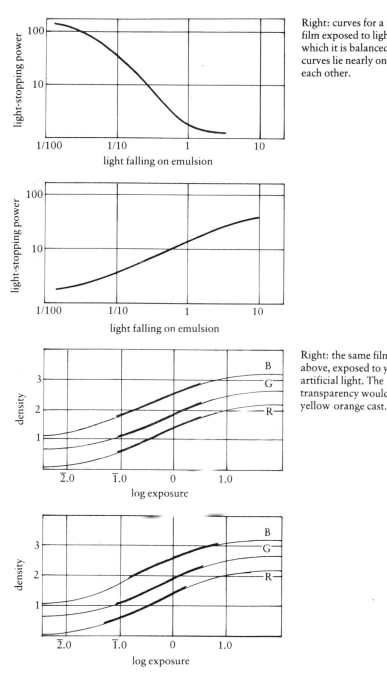

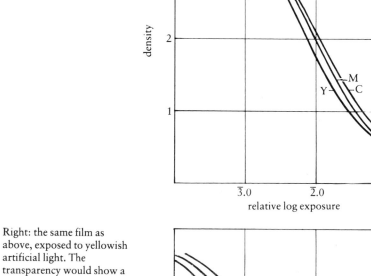

Right: curves for a reversal film exposed to light for which it is balanced. The curves lie nearly on top of each other.

Right: the same film as above, exposed to yellowish artificial light. The transparency would show a yellow-orange cast.

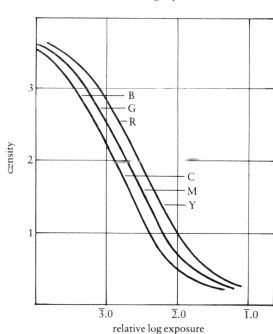

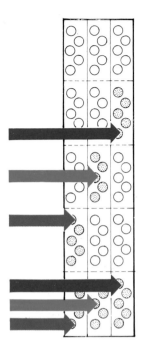 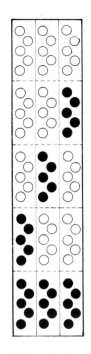

A colour reversal film exposed to a colour chart with black, red, green, blue and white areas as on pages 80–81.

After the first development, silver negative images are present in the three layers.

The film is now fogged and colour developed to form the final dye images along with silver images.

After bleaching and fixing, the transparency has only the three dye images forming the finished picture.

Projected on the screen, the transparency shows the colours of the original colour chart.

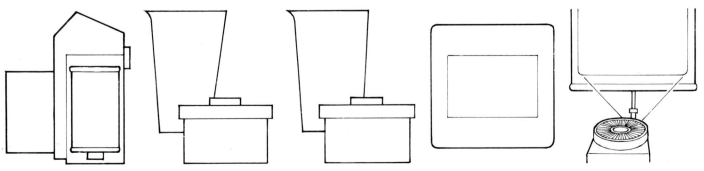

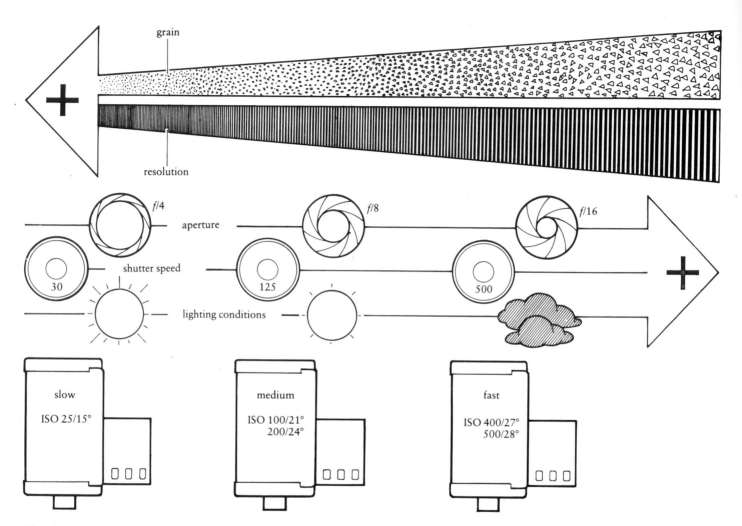

grain

resolution

aperture

$f/4$ $f/8$ $f/16$

shutter speed

30 125 500

lighting conditions

slow

ISO 25/15°

medium

ISO 100/21°
200/24°

fast

ISO 400/27°
500/28°

The advantages and
disadvantages of slow and
fast colour films. As film
speed increases, exposures
become smaller, grain
increases and resolution
diminishes. But a fast film
may enable pictures to be
taken that would otherwise
be lost.

Colour reversal films such as Ektachrome can be push processed to increase their effective speed. This is achieved by increasing the time in the first developer. Up to two stops speed increase may be obtained in this way, but at the expense of some image quality.

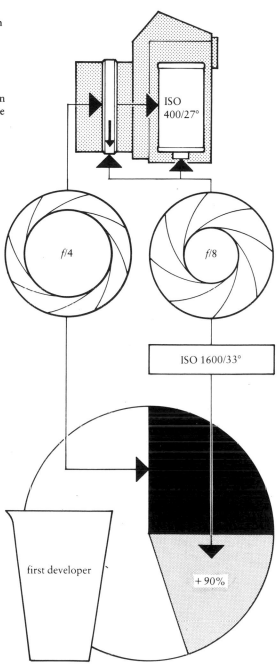

ISO 400/27°

f/4

f/8

ISO 1600/33°

first developer

+ 90%

Colour reversal films

As their name implies, colour reversal films are reversal processed to produce transparencies. Most of the commonly available ones are intended to produce slides for projection, so they produce images of the highest possible contrast coincidental with good colour fidelity and colour saturation. Transparencies are also used as originals for photomechanical reproduction, and for direct display. In both these cases excessive contrast can be a problem. For this reason some materials, labelled professional, offer a slightly lower contrast image. Professional colour films are furnished with more information than are their amateur counterparts. The instruction leaflet gives the actual tested film speed rather than the designed film speed. Thus, for example, an ISO 64/19° film may carry supplementary instructions suggesting that this batch is better exposed at perhaps ISO 50/18° or 80/20°. The instructions may also suggest a pale filter that it is advisable to use to obtain a perfectly neutral colour balance. Apart from these professional films, there are a number of special-purpose reversal films available. While these are clearly the first choice for specific jobs, they can also be used to provide a rather different quality in quite normal situations.

The slowest normal reversal film now available is Kodachrome 25, which is chosen by many enthusiasts for its high definition and freedom from graininess. For still photographers this film is available only in 35 mm; it is chosen by many professional photographers in situations where they want to use 35 mm cameras. While renowned for its picture quality, Kodachrome 25 is, of course, a very slow film (ISO 25/15°). The basic exposure out of doors on a sunny day is 1/125 second at f/8. Thus even on a fine day it can introduce problems using lenses of 200 mm focal length and longer. Even with standard and wide-angle lenses, the

necessarily large apertures demanded on less than fine days mean that the photographer has to accept very small depth of field. This is one reason why Kodachrome 64, which offers almost the same definition and contrast, while being at ISO 64/19° over twice as sensitive, is gaining in popularity over the slower version. However, Kodachrome 25 will long have its faithful adherents and rightly so.

As Kodachromes are non-substantive films, they can be processed only by the manufacturer or in a very sophisticated laboratory. In Europe, indeed over most of the world, Kodachrome is sold at a price that includes processing. Each pack comes with a process mailer for returning it to a Kodak processing laboratory. These yellow envelopes have no special value. The film can, in fact, be returned without the envelope as the cassette itself indicates that the film has been sold process-paid. In some countries, notably those of North America, the film is normally sold without processing rights. In that case the processing is paid for separately through any photographic dealer. The simplest procedure is to buy a process-mailer and use this to mail the film to the laboratory. The price paid for such mailers is the cost of processing, and the mailers themselves are evidence that the bill has been paid.

Film speed and resolving power

An important consideration in choosing a film is its speed. The fastest reversal films available are about sixteen times as sensitive as the slowest. A fast film has more grain and lower resolution than a slow one. On the other hand, the very fast colour films now available make colour photography feasible under light conditions that formerly allowed only monochrome photography. There are reversal films rated at ISO 400/27° or 500/28°, which puts them in the same speed category as such black-and-white films as Tri-X and HP5. With such colour films it is quite possible to take pictures by the fireside using normal room lighting, and the photographer need be no longer a slave to his flash unit, which unless employed with skill gives flat lighting effects and destroys the atmosphere of the fireside. Reversal

films of medium speed such as ISO 100/21° to 200/24° are a useful compromise between the slowest and the fastest. The medium-speed films are a little sharper and less grainy than the fastest; both these characteristics are important if it is proposed to make prints from selected transparencies.

The photographer who looks for the very best technical quality in his colour pictures may well wonder whether the very fast colour films now available reach the highest standards. There need be no misgivings on this score, and among colour-slide films it is difficult to distinguish between the fast and slow under normal conditions. Nevertheless, where conditions permit, a slower film is the best choice as it always has the edge on quality, however slight. But remember that unsharpness arising from inadequate depth of field or blurring caused by camera shake can nullify a slow film's inherently superior image quality.

It is necessary to distinguish between certain image qualities that combine to determine the excellence or otherwise of the overall definition. The first is 'resolution', or the rendering of fine details, and it is determined by many factors. A fine-grain emulsion usually has better resolving power than one of coarse grain, which in turn means that a slow film resolves detail better than a fast one. Resolving power also tends to increase as the contrast of the emulsion increases, and this again favours the slow film. Good rendering of fine details was for a long time regarded as being all-important in the assessment of image quality, but it is now realised that it is important to reproduce large details sharply. Thus sharpness, contour definition or 'acutance' is now regarded as being more important than resolution. Acutance is a quantitative expression of contour definition, and increases with the opacity of the emulsion. Acutance for white light can be greatly increased (at the expense of speed) by adding a yellow dye to an emulsion. Graininess not only reduces resolving power but also diminishes apparent sharpness, so here again the advantage is with the slower films.

Colour temperature expressed in kelvins is a measure of the visual colour of a light source. The higher the colour temperature the bluer the light. The approximate colour temperatures of some common sources are indicated. See also page 138.

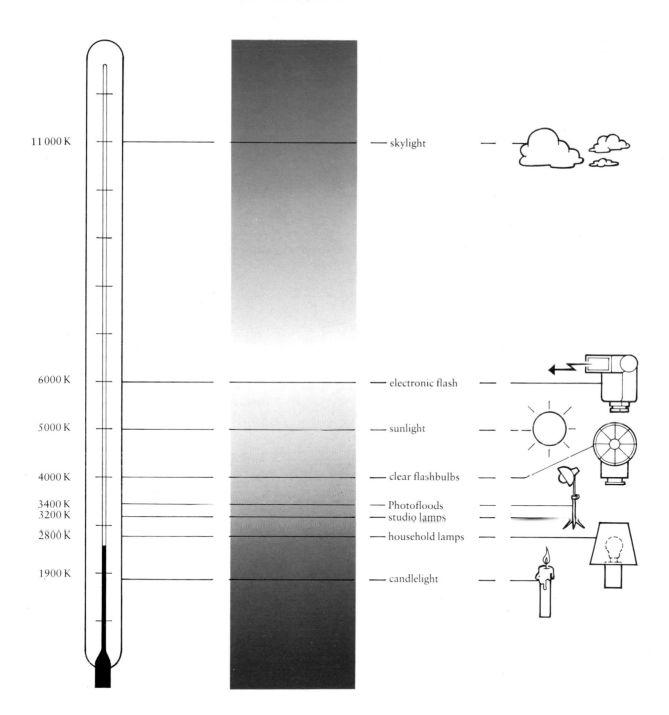

11 000 K — skylight

6000 K — electronic flash

5000 K — sunlight

4000 K — clear flashbulbs

3400 K — Photofloods
3200 K — studio lamps
2800 K — household lamps

1900 K — candlelight

Unfortunately, the exact interrelationships between sharpness, resolving power, graininess and tone reproduction that lead to good or bad definition have still to be determined. In fact there is a tendency to confusion in the terminology relating to image quality. The word 'definition' is often employed as a synonym for sharpness or acutance. To describe an image as having good definition really means that it shows good rendering of fine details. Definition is thus more a function of resolving power than of acutance or sharpness. In general, when an image is described as having good definition, both resolution and acutance are being taken into account. Good acutance, on the other hand, refers only to edge sharpness without reference to resolution.

Push processing

When extreme high speed is needed for dealing with very adverse lighting conditions, an ISO 400/27° reversal film can be processed to give it a much higher speed. A two-stop increase to ISO 1600/33° is practicable, and the loss of colour quality and increase in graininess are by no means objectionable. Such increase in speed is achieved by increasing the time in the first developer; an increase of 75 per cent gives a two-stop speed increase. Some processing laboratories offer a service for processing certain reversal films in this manner, usually at a higher price. It is important to state the speed rating at which a film has been exposed, so that it will be given an appropriate time in the first developer. In some countries the film manufacturers offer extra-speed process mailers, which ensure that the film is correctly treated. All the remaining processing steps remain unaltered; it is only the time in the first developer that affects the speed of the material.

It is possible to expose a reversal film at lower speeds than the official rating, and in such cases it is necessary to reduce the time in the first developer. This is not generally a useful procedure, although it may be done accidentally. By reducing the first development from six to four minutes the effective

speed of the film is halved, but there is a loss of contrast and the colour balance is affected adversely. The accompanying table gives the modified times in the first developer of the E6 process necessary for speed settings higher and lower than the official ISO rating for Ektachrome films. It should be noted that the speed modifications and altered first development times can be applied to all Ektachrome films, but that the best quality results from normal speed ratings and standard processing.

modified speed rating	time in first developer
×4	11½ minutes
×2	8 minutes
×1 normal	6 minutes
×½	4 minutes

Colour balance

When the eyes are stimulated by any illumination containing fairly equal amounts of all wavelengths from 400 to 700 nm, the resulting colour sensation is devoid of hue and the light is described as 'white'. However, the sensation is only relative. The three colour receptors in the retina of the eye have remarkable powers of adaptation. Walk into a room lit only by tungsten lamps from a garden lit by daylight and the immediate impression is that the light is yellowish, but after only a few seconds of exposure to the tungsten lighting its yellowish appearance is less noticeable, and within a minute or so the artificial light appears to be white. The three retinal sensors adjust their sensitivities so that any illumination containing substantial amounts of all wavelengths appears white. This power of adaptation can be seen in a darkroom with the white lights turned on, and with a small hole in the blackout allowing a pencil of sunlight to enter to form a disc of light on the wall. The out-of-focus image of the sun's disc looks decidedly blue because the eyes are adapted to the colour of the artificial lighting and the blue cones are more sensitive than usual. Yet the sun's light is often described as being

'golden', which indeed it is when compared with the blue sky. The ability of the eyes to adapt themselves can also be demonstrated by projecting a colour slide with a marked colour cast on a screen in a darkened room. It will appear to have neutral balance because there are no reference colours in the vicinity. If the same slide is projected in daylight on an 'Ektalite' screen its colour cast will be very evident because of coloured objects in the field of view. So a much higher standard of colour balance is required in colour prints than in slides, simply because the former are viewed in normal lighting where the colours of objects can be compared with the colours in the print.

Unlike the eye, the three emulsion layers of a colour film have no powers of adaptation and have to be balanced to suit the illumination by which it will be exposed. We thus have 'daylight' and 'tungsten' films, to suit average sunlight/skylight conditions and photographic tungsten lamps respectively. In making a film for daylight use the sensitivities of the three emulsions are adjusted so that the blue-sensitive layer is slower than the red-sensitive layer, as daylight is relatively rich in blue and deficient in red. (Electronic flash and blue flash bulbs are designed to produce a similar spectral distribution, providing correct colour balance on daylight films). A tungsten-balanced film on the other hand has a blue-sensitive layer that is relatively faster than the red-sensitive layer, tungsten lighting being rich in red and deficient in blue. Tungsten-light films are usually balanced for 3200 K illumination, as provided by photographic studio lamps (see page 139). A few are balanced for 3400 K lighting, as produced by Photofloods. If a reversal film balanced for daylight is exposed to tungsten lighting without an appropriate colour filter on the camera lens, the resulting transparencies will be characterised by a yellow-orange colour cast. Conversely, a tungsten-balanced film exposed in daylight with no filter will produce transparencies with a strong bluish cast. A yellowish cast results even if

Colour films are balanced for a particular colour of subject illumination, daylight or tungsten. If a film is to be exposed by light for which it is not balanced, a conversion filter must be used on the camera lens: bluish for exposing daylight film in tungsten illumination and amber for exposing tungsten film in daylight.

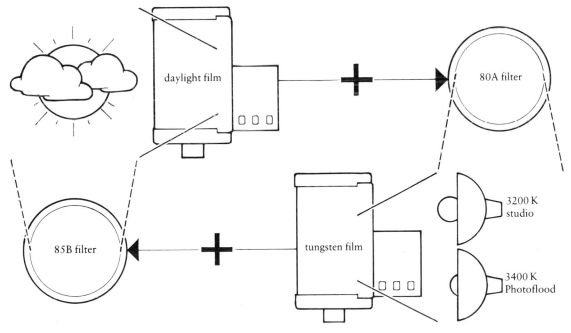

tungsten-balanced film is exposed in ordinary domestic lighting. As high-speed colour reversal films become popular, it may be that a type balanced for domestic lighting will be introduced. Relatively few enthusiasts use studio lamps; most prefer to rely on flash sources for their indoor photography when the available light is unsuitable.

Contrast range

The word 'contrast' has several meanings in photography, but basically it refers to the brightness range in a subject or picture. The relationship between subject and image contrast can be expressed as a ratio, on the assumption that subject and film brightness can be measured adequately. These two parameters, expressed as density (D) and the logarithm of the exposure (log E), can be plotted on a graph to produce the 'characteristic curve' of the light-sensitive material. (Colour films, of course, have three separate curves for the three emulsion layers, but the principle is the same). Density is expressed logarithmically, too; i.e. a density of 2 has 100 times the light-stopping power of film base.

The original measure of 'contrastiness' of a film or paper was gamma (γ), the slope of the straight-line portion of the characteristic curve: so $\gamma = D/\log E$. The higher the value of gamma, the higher the image contrast produced from any particular subject. In theory, a material with a gamma of 1 should reproduce the subject tones exactly. However, with the losses produced by non-image-forming light in camera and projector optics, most projection films have a measured gamma higher than unity. (Negative materials have a much lower gamma, usually about 0.6–0.7, which gives them greater latitude; the contrast is returned to normal in printing).

In practice, the image quality and latitude depend on more than the straight-line part of the film curve. The shape of the toe and shoulder is also important in determining the film's ability to record shadow and highlight detail, so they contribute to the overall effective contrast. Most manufacturers therefore quote a 'contrast index' rather than gamma for their materials. This can be thought of as the material's true gamma modified to represent the most useful single-figure measurement of visual contrast.

Colour reversal films intended for camera use, as distinct from those for making duplicates from existing transparencies, are processed to a high contrast. If a high-quality transparency is inspected in a viewer it will be seen that it shows a very wide range of tones; the highlights are almost clean film and the darkest shadows are extremely black to the extent that probably little or no detail can be seen in them. The image contrast of a good transparency is, in fact, usually greater than that of the subject itself. It is partly their very high contrast that gives transparencies such an impact. The very large density range a transparency can exhibit compares very favourably with the range of a paper print. The latter can never be more than about 2.0 (100 to 1), whereas the density of a transparency may extend from 0.2 to 3.2 or higher, a range of 3.0 (1000 to 1). It may be wondered why a reversal colour film is designed to give pictures that are much larger than life with regard to contrast. The reason lies mainly in the difficulty of maintaining good colour saturation in a colour photograph. This is an inherent difficulty, but it can be partly overcome by keeping contrast high. All other factors being the same, a transparency processed to a high contrast will show better saturation than one processed to a lower contrast.

Another reason for good contrast in a reversal film is to counteract the effects of non-image-forming light both in the camera and in projection. In the camera, flare reduces the contrast of the image formed by the lens as it adds equally to all the illuminances of the image. A scene contrast of 100 to 1 is likely to be reduced by non-image-forming light to perhaps 40 to 1. In projection, lens flare is probably less than in the average camera, but the ambient light falling on the screen from various

92

Daylight reversal film exposed by available tungsten light without a conversion filter. The overall orange-red cast is the result.

Daylight film exposed by mixed lighting from the blue sky outside and the tungsten lamps inside. The bluishness of the daylight and the warmth of the tungsten light are very evident.

	film	low-contrast resolution	high-contrast resolution
Low and high contrast resolutions of some Kodak reversal and negative films	Ektachrome 64	50	125
	Ektachrome 200	50	125
	Ektachrome 400	40	80
The figures in the table are lines per millimetre	Kodacolor II	50	100
	Kodacolor 400	40	63

sources reduces the apparent contrast of the projected pictures. This is to the extent that the apparent luminance range of the screen pictures is only a little bigger than that of a paper print. Nevertheless the reproduction quality of a projected slide is potentially better than that of a print.

Bearing in mind the high contrast or large density range of a typical reversal transparency, it may come as something of a surprise to learn that a colour reversal film has only a relatively small exposure range. This means that these films can reproduce faithfully only subjects of fairly low contrast, such as outdoor scenes lit by the sun behind the camera. The limit for scene contrast is about 50 to 1 for most reversal films. Subjects more contrasty than this are reproduced with some compression of highlight and shadow tones; the middle tones may be reproduced satisfactorily but with contrast higher than they had in actuality.

So although reversal film can exhibit very high contrast in its pictures, it cannot reproduce properly subjects of large brightness (luminance) range. It must not be thought, however, that acceptable colour transparencies cannot be made of subjects having higher than average contrast. In general, as long as the middle tones are reproduced satisfactorily, the eye will tolerate very considerable flattening at the highlight and shadow ends of the scale. If a typical transparency is viewed critically it will be seen that the contrast of the middle tones has been increased and that of the highlights and shadows has been reduced.

Apart from questions of colour and tone reproduction, an essential quality in a reversal film is good sharpness and resolution. Projection of a 35 mm transparency to make a picture perhaps 1½ metres (5 feet) wide involves a magnification of about ×40 and demands excellent definition in the slide. Currently available reversal films are very satisfactory in this respect, but sharpness and resolving power inevitably tend to deteriorate as emulsion speed increases. The table above gives the low- and high-contrast resolutions of three Kodak reversal films, with figures for two negative (Kodacolor) films for comparison.

Reciprocity-law failure
The law of reciprocity states that the effect of exposure to light on an emulsion depends only on the total amount of energy that falls on it, and that a long exposure to a weak light will have the same effect as a correspondingly short time of exposure to a powerful light. The only condition that has to be satisfied is that $T \times I = k$, where T is time of exposure, I is intensity of the light and k is a constant. The law applies over a wide range of times and intensities, but it begins to fall down at very short times and at very long times.

All silver bromide emulsions suffer from reciprocity failure when they are given exposure times longer than those for which they are designed. This takes two forms. First, the effective speed of the emulsion is reduced by long exposure times, and the longer they are the greater the reduction in speed. Typically, a monochrome film exposed under low-light conditions such that an exposure meter

indicates a time of 100 seconds will actually require an exposure time of 1200 seconds, so great is the loss of speed. Second, at long exposure times the contrast to which an emulsion develops in a given time is markedly increased.

The three emulsions of a colour film have different reciprocity-failure characteristics. This means that at long exposure times the relative speeds of the three layers alter, and in the case of reversal film undesirable colour casts occur. Also, because the contrasts of the three layers may change, second-order colour casts may appear. These would be seen in a scale of grey tones that might appear neutral in the middle tones but be tinged with colour in the lightest and darkest tones. Changes in the relative speeds of the three layers can be compensated for by using appropriate colour-compensating filters on the camera lens. Nothing, however, can be done about the crossed curves that result with some films at very long exposure times. The accompanying table gives recommendations regarding exposure increases and filtration for reciprocity failure with some colour reversal films. Where the table states 'NR' (not recommended) for certain films at very long times the reason is that, in such cases, a very serious result of overlong exposures is a 'see-saw' colour cast.

Typical reciprocity-failure corrections needed for reversal films

| | | exposure time: seconds | | | | | |
		1/1000	1/100	1/10	1	10	100
Ektachrome 64	professional	+½ stop NF	none	none	+½ stop NF	+1½ stops NF	NR
Ektachrome 50	professional	no increase CC10C	no increase CC10C	none	none	+½ stop NF	+1½ stops CC10C
Ektachrome 200		+½ stop NF	none	none	+½ stop CC10R	NR	NR
Ektachrome 160	professional	none	none	none	+½ stop CC10R	+1 stop CC10R	NR
Ektachrome 400		none	none	none	+½ stop NF	+1½ stops CC10C	+2½ stops CC10C
Kodachrome 25		none	none	none	+1 stop CC10M	+1½ stops CC10M	+2½ stops CC10M
Kodachrome 64		none	none	none	+1 stop CC10R	NR	NR
Agfachrome 64/100	professional	none	none	none	no increase CC05M	+⅔ stop CC10M	NR
Agfachrome 50L		none	none	none	no increase	+⅓ stop	+½ stop
Agfachrome CT18		none	none	none	long exposures produce yellow-green cast		
Agfachrome CT21		none	none	none	long exposures produce yellow-green cast		
Fujichrome 100	daylight	none	none	none	none	+1 stop CC05C	+1⅓ stops CC10C

Len Stirrup

Colour negative films

Colour transparencies, when projected with excellent equipment, provide stunning contrast and colour saturation. They are also ideal starting points for photomechanical reproduction. However, colour prints are much more convenient for display or for quick reference. Even most large display transparencies are simply colour prints made on film rather than on paper. Modern reversal colour print materials can produce brilliant prints from transparencies, but it is easier to make high-quality prints from camera-exposed negatives. So colour negative film is the most widely used material, and much the best choice when multiple prints or even transparencies are wanted. Early colour negative films introduced in the 1940s were available in two types like reversal films, one for exposing in daylight and the other for use with tungsten lighting. This situation changed, and negative films for amateurs are now 'universal'. They can be exposed to a wide variety of light sources, any mismatch in colour balance being corrected at the printing stage. Professional negative films, on the other hand, are made in the two types, daylight and tungsten, for the reason that it is easier to make a really good print from a negative film balanced for a specific light source than from a universal film. Movie films are normally balanced for tungsten light, and exposed through a suitable filter in daylight.

A negative film has the same basic construction as a reversal film. The blue-sensitive layer is outermost, and beneath it is the usual colloidal-silver yellow filter layer to absorb blue light. Behind the yellow filter layer is the green-sensitive emulsion and next to the film base is the red-sensitive emulsion. This basic construction is elaborated, each layer being multi-coated to improve the overall properties of the material. Quite unlike reversal colour film, negative film is developed to a fairly low contrast

97

and colour printing papers have exposure ranges to suit. A low-contrast negative material generally has a big exposure range, and colour negative films are no exception. A big exposure range is part of the secret of the universal negative film: it enables the material to be exposed in lighting ranging from sunny daylight to household tungsten lamps, and any lack of balance in the resulting negatives is correctable at the printing stage.

Exposure times and film speeds

Colour negative films are made for specific exposure times. Deviating far from such times can result in unprintable negatives. Most universal films are intended for comparatively short exposures, as are most daylight-balanced films. Films intended for short exposures are normally designated type S, e.g. Kodak Vericolor III S; they may not produce good negatives at exposures longer than 1/10 second. Conversely, long-exposure films, called type L, are intended to be used with exposure times of up to ten seconds or so. Even so, type L films may not be recommended for exposures much longer than that. Most still negative films balanced for tungsten illumination are intended for the long exposures that are common in tungsten-lit studio work.

The restrictions with regard to the duration of exposures come about because of 'reciprocity failure' (see page 94). An integral tripack film has three emulsion layers of quite widely-differing properties, and their reciprocity characteristics differ also. For the best performance (such as is called for in critical professional work) it is desirable to restrict a colour negative film to a particular range of exposure times to avoid even the slightest reciprocity failure. Failure of the law involves, in effect, changes in the relative speeds of the three layers, and more importantly changes in the contrasts to which the three layers will be developed at the specified development time. This does not mean that if a type S film is given an exposure time just slightly longer than 1/10 second the colour rendering will be unacceptable. There

may be no detectable fault, but the risk is there and it increases as exposure times depart from the range recommended by the maker of the film.

The table opposite shows the increases in exposure times and filtration required by various negative films when circumstances force the photographer to give very short or very long exposure times. The table states 'NR' (not recommended) for certain films at very long times; in such cases, a very serious result of overlong exposures is a 'see-saw' colour cast. The result in the print may be (for example) a cyan cast in the highlights and a reddish cast in the shadows. This is the result of the different reciprocity characteristics of the three film layers; in the example quoted the cyan layer has processed to a lower contrast than the other two. There is no way of getting a good-quality print from a colour negative with a see-saw colour cast. The only way of avoiding such a cast is to use a larger lens aperture or more light, shortening the exposure time to bring it to within the range recommended by the manufacturer.

The speeds of colour negative films vary from about ISO 64/19° to 1000/33°; but a professional type L film may vary in speed from ISO 25/15° to 80/20° depending on the duration of the exposure that is given. The film becomes effectively slower as the exposure time increases, because of low-intensity reciprocity failure. Very fast colour negative films rated at ISO 1000/33° are comparatively new arrivals, although their coming had been forecast for many years. They put colour photography on the same footing exposurewise as monochrome: even with relatively simple cameras, with lenses of modest aperture by today's standards, it is practical to take pictures under very low-light conditions. The manufacturers of fast colour negative films have been able to modify the spectral sensitivities of the blue- and red-sensitive layers so that the material is not as sensitive to changes in the colour of subject illumination as were some earlier films. This means that they can be exposed under very widely differing colours of

Typical reciprocity-failure corrections needed for negative films

| | exposure time: seconds | | | | | |
	1/1000	1/100	1/10	1	10	100
Kodacolor II	none	none	+½ stop CC10C	+½ stop CC15C	+1½ stop CC30C	+2½ stop CC30C
Kodacolor 400	none	none	none	+½ stop NF	+1 stop NF	+2 stops NF
Agfacolor CNS	none	none	none	+⅓ stop	+1 stop	+2 stops
Agfacolor CNS 400	none	none	none	+1 stop NF	+2 stops NF	+3 stops NF
Agfacolor 80S	none	none	none	none	+1 stop NF	NR
Vericolor II type S	none	none	none	NR	NR	NR
Vericolor II type L*NR	NR		+⅓ stop	+1 stop NF	NR NF	
*different speed ratings according to exposure times:				ISO 80/20°	ISO 64/19°	ISO 40/17°

subject lighting without the occurrence of objectionable colour casts in prints.

Negative colours

The coloured images in a negative are yellow, magenta and cyan, as in a transparency film. Again, the blue-sensitive layer carries a yellow image, the green-sensitive layer a magenta image, and the red-sensitive layer a cyan image. These colours are convenient but they are not essential. All that is required of a colour negative is that each of the three images shall be capable of being recorded uniquely by one layer of the printing paper. As it is, all colour negatives may be described as 'complementary colour negatives' as their image colours are complementary to the colours in the subject and to the spectral sensitivities of the emulsion layers that carry them. It is worth noting that the spectral sensitivity curves of the blue- and red-sensitive layers of a colour paper do not peak in the middle of the blue and red regions of the spectrum, but are spaced more widely. This leaves gaps into which the overlapping transmission regions of the dyes used in the negative fall, and these are not reproduced by the positive material.

This applies also to print and slide films; typical peak sensitivities are 400 nm for the blue-sensitive layer and 680 nm for the red-sensitive layer.

As a colour negative is developed to a rather low contrast the colours seen in it are not very saturated, but careful inspection will reveal that red lips are reproduced as cyan, green grass and trees as magenta, yellow flowers as blue, and so on. The image colours are further hidden by the fact that all currently available colour negative films incorporate integral coloured masks that impart an overall yellow-orange hue to the processed film. A 'mask' in this context is a coloured positive image in perfect register with the negative images, and its purpose is to correct for the shortcomings of the colourant in the emulsion layer to which it is applied. To take a specific example, the magenta dye forming the image in the middle layer of the film should absorb only green light and should be perfectly transparent at all densities to both blue and red light. In practice, even the best magenta dye has some density to blue light, and the denser the magenta the larger the proportion of blue light that is absorbed. Thus the magenta image is, to a certain

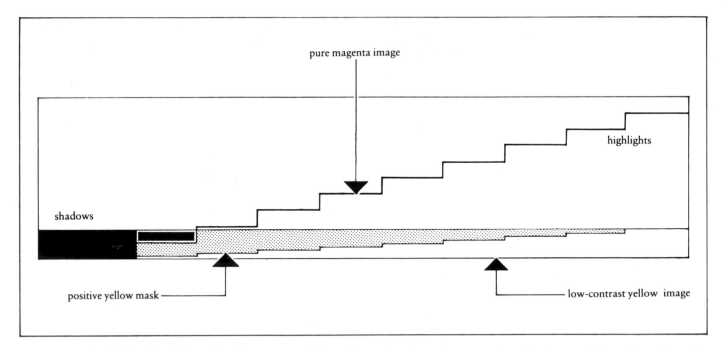

pure magenta image

highlights

shadows

positive yellow mask — — low-contrast yellow image

extent, usurping the function of the yellow dye, a fact that gives rise to lack of fidelity in the final colour reproduction. A magenta image may be regarded as having two components: an image consisting of a perfect magenta dyestuff absorbing only green light, plus a low-contrast yellow image absorbing blue light. If this low-contrast yellow image can be cancelled out by means of a yellow positive image of the same contrast in register with it, the result is a theoretically perfect magenta image overlaid with a pale yellow filter. The latter has no effect other than to reduce the total amount of blue light transmitted to the printing paper, and this can be put right very easily by modifying the colour of the printing light.

Kodak devised an elegant method of incorporating the necessary coloured masks. Discussing the magenta image again, the coupler in this layer of the film is itself coloured yellow, its blue absorption being the same as the unwanted blue absorption of the magenta dye formed in the colour developer.

100

Where silver and magenta dye are produced in the colour developer the coupler is used up and its yellow colour disappears. Where the coupler is not used up, it remains in the film and its yellow colour means that it absorbs blue light. The end result is, in effect, a perfect magenta image (negative), a low-contrast yellow image (negative) and a low-contrast yellow image of unused coupler (positive). The low-contrast negative and positive yellow images cancel each other out and act solely as a uniform pale yellow filter.

The best cyan colourants are even worse than the magenta, in that they absorb some blue light and some green light to which they should be perfectly transparent at all densities. A positive mask of low contrast absorbing both blue and green light is thus needed in the cyan layer of a negative film. This is pink in colour, and combined with the yellow mask in the magenta layer it gives the once familiar yellow-orange colour of a masked colour negative. Kodak produce the pink mask by means of a

The working of integral coloured masks in colour negative film. The diagram shows the yellow positive mask generated in the magenta layer of a typical film. The blue absorption of the yellow mask is equal to the unwanted blue absorption of the magenta dye at various densities.

coloured colour coupler. The colour is pink, although the colour produced in the colour developer is cyan. Manufacturers other than Kodak form similar integral masks in the negative films during the processing of the material, though not necessarily by the use of coloured couplers.

Type II colour films, introduced by Kodak with Kodacolor II in 1972, have a much less orange mask than earlier films. This is because the system of masking with coloured couplers provides only part of the solution in these films. The rest of the masking effect is produced by inter-image effects. The dye couplers in each layer when forming dye also form a restraining compound such as benzotriazole or bromide. This, to some extent, inhibits colour formation in the adjacent layers. With a complicated multi-layer emulsion, the inhibitory effect can be directed to a degree toward one or other of the adjoining dye-forming layers. For example, the inhibiting effect of magenta development can be directed towards the yellow dye-forming layer; thus wherever there is considerable magenta density, and consequently unwanted yellow density because of the inaccuracies in absorption of the magenta dye, yellow dye formation is inhibited. In the same way, restrainers from the cyan-forming layer can be used to restrict magenta dye formation, and to some extent yellow dye formation. Couplers that perform in this way are known as 'development inhibiter releasing' (DIR) couplers. A combination of DIR couplers and a paler integral masking system (which may be produced by coloured couplers or by dye formation during processing) results in the more accurate colour reproduction from modern negatives, while keeping them pale enough to allow very short print-exposure times, especially on automatic printers. DIR couplers are also used in reversal films, where clearly a coloured mask is totally impracticable.

Colour balance
If a colour negative film is exposed to light for which it is balanced it has a large exposure range;

that is, it is capable of recording accurately subjects having high contrast, and with scenes of average or low contrast it offers considerable latitude in exposure. It is sometimes stated that a typical colour negative film has exposure latitude to the extent of one stop underexposure and up to three stops overexposure. However, exposure latitude in practice depends very much on scene contrast. It must be assumed therefore that such a statement is based on average outdoor scenes with the sun behind the camera.

A colour negative film for amateur use is likely to have a bigger exposure range than professional films balanced for either daylight or tungsten illumination. The precise balance of amateur negative films is never stated, but they clearly work well in daylight. The balance may well be for a light source somewhere between the colour of average sunlight and skylight and that of tungsten lighting. If such a film is exposed to light for which it is not quite balanced, the big exposure range of the material makes it possible to restore lost balance during printing. However, the biggest exposure latitude exists when the subject illumination is that for which the film is balanced. The further the colour of the lighting is away from this the smaller the exposure latitude and the greater the risk of tinted shadows in prints, especially with minimally exposed negatives.

Experience has shown that it is a sound policy to overexpose colour negative film to the extent of about half a stop, where possible, in order to be sure of adequate detail and neutral colour in shadow areas of prints. The exposure latitude is nearly all in the direction of overexposure; if minor errors combine to lead to even slight underexposure, print quality suffers. Apart from any errors in colour rendering, underexposure produces low-contrast negatives and there are no means of putting this right at the printing stage. Nevertheless, when lighting conditions are such that minimal exposures are essential, it is worth risking slightly inferior colour quality for the sake

of obtaining pictures. It is worth noting that the exposure guide packed with one make of ISO 400/27° colour negative film suggests a basic exposure in bright or hazy sun of 1/250 second at *f*/16. The same manufacturer suggests 1/500 second at /16 under the same conditions for ISO 400/27° monochrome film.

What happens when a colour negative film is exposed to light for which it is not balanced? Suppose that a daylight balanced film is exposed to household tungsten lighting, which is rich in red and weak in blue compared with daylight. The resulting negatives will have cyan images that are denser than they should be and yellow images that are thinner than they should be, assuming that the exposure level was correct for the green-sensitive layer producing the magenta image. To attempt to put this fault right the colour printer has to add yellow filtering to his exposing light beam, and also a little magenta filtering to bring all the images in the negative to the same effective density. (This is a slightly simplified picture of what has to be done, but it is adequate for this discussion.) The chances are that the yellow images of such negatives will not be just thin; their shadows may be underexposed and devoid of detail. This cannot be put right by any amount of filtration during printing, and a phenomenon arises that has been described as 'the filter printing through the shadows'. In effect the yellow image becomes *too dense* in the shadows through the addition of yellow filtration, and the result in the print is that the shadow areas become tinted. They assume a bluish hue because of insufficient yellow dye in the shadows of the print. The situation becomes more complicated if the magenta image is also slightly underexposed.

The problem may be regarded as another type of see-saw colour cast. It can be distinguished from such faults caused by reciprocity failure because it occurs only in the deepest shadows. The simple solution is to treat colour negative films in the same way as colour transparency films. Whatever their actual aim points, universal colour negative films

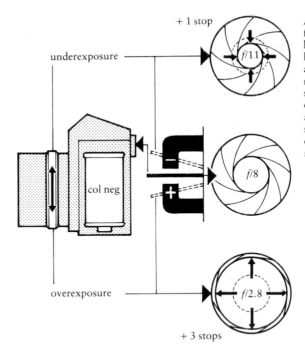

An amateur colour negative film such as Kodacolor II has considerable exposure latitude, amounting to about one stop towards underexposure and three stops in the direction of overexposure. This is for average outdoor scenes. As subject contrast increases, exposure latitude becomes smaller.

give good-quality prints when exposed to daylight or electronic flash. Automatic colour printers are always set up to print from daylight-exposed negatives. At the same time, they produce excellent prints from tungsten-light negatives exposed to the correct colour of lighting. Use a blue filter such as a Wratten 80B with 'universal' colour films exposed to tungsten lighting. This produces negatives that are easy to print with more or less the same filtration as those exposed in daylight. The only problem with this course of action is that the blue filter absorbs a considerable amount of light, requiring a two-stop exposure increase. Coupled with the normally low level of tungsten illumination, this can lead to the need for very long exposures. However, most universal colour negative films will produce good-quality negatives with exposures of up to one second or so. With longer exposures, reciprocity-law failure may necessitate even longer exposures. For example, at

In exposing a daylight colour negative film by tungsten lighting, a bluish 80B filter should be used on the lens. If the light is poor this may lead to very long exposures that give rise to severe reciprocity failure. It may be better to use a paler filter such as the 80C, which has a factor of only ×2 as against the ×3 for the 80B.

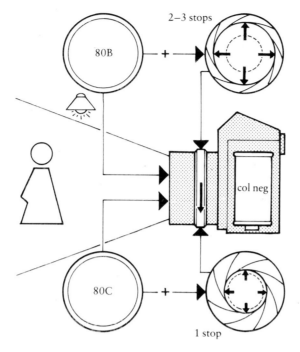

2–3 stops

80B

col neg

80C

1 stop

100 seconds most films need between two and three stops more exposure than their film speed would suggest. Thus an ISO 400/27° film with an 80B filter given an exposure time of 100 seconds has an effective film speed of between ISO 12/12° and 25/15°. If combined with a colour mismatch this will make printing impossible. Under some circumstances, the best compromise is to use a paler blue filter such as a Wratten 80C, which needs a one-stop exposure increase, and to leave the remainder of the colour correction to the printer.

Processing and printing
All colour negative materials contain the necessary colour couplers in their emulsion layers, which means that they can be processed by the user as well as by photofinishers. The processing routine is much simpler than that for a reversal film. It involves colour development, bleaching of the developed metallic silver to convert it back to silver

bromide, fixing to remove all the silver bromide, and washing. Most colour negative films use Kodak's process C41, which was first introduced with Kodacolor II. Kodak's own Flexicolor chemicals are basically formulated for large-scale processing. They are also available in small kits, but a number of the alternative kits are easier to use on a small scale. A typical alternative kit consists of two bottles of concentrated solutions, a colour developer and a bleach-fix. Each is diluted with water as required, and can be mixed in the exact quantity needed. The remaining concentrates keep better than working-strength solutions. The whole of the five-stage process takes 12 or 13 minutes, including pre-heating the tank and washing the film. So, apart from temperature control, it is just as easy as processing a monochrome film.

Some colour negative films can be push-processed to increase their speed. This involves increasing the time in the colour developer, but if it is carried too far 'see-saw' colour casts (described earlier) may be introduced because of differences in contrast between the three images arising from the longer development time. These casts cannot be corrected at the printing stage and if they are more than very slight they can be most objectionable.

With a colour negative that has integral colour-correcting masks, the density to blue light is always greater than the density to green light, which in turn is more than the density to red light. These differences are due to the presence of the masks; unmasked negatives used to have more or less the same densities to blue, green and red. Colour printing papers are designed for use with masked negatives, and the speeds of the three emulsion layers are adjusted to suit the spectral composition of the light from a masked negative. The speed adjustment is modified so that there tends to be too much blue and green light reaching the paper for neutral balance. The usual filter pack therefore contains yellow and magenta filters. Try to avoid the use of cyan colour filters, in order to keep printing exposure times conveniently short.

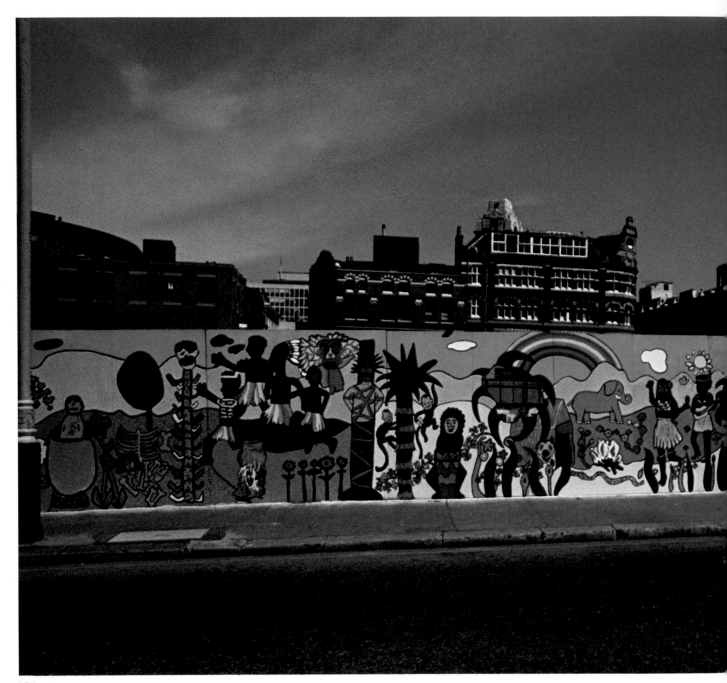

Sidney Ray

Exposing colour film

Both types of colour film, negative and reversal, call for accurate exposure to give their best results. Ideally exposures should be right to within a third of a stop. This calls for a little care in using an exposure meter, whether this is integral with a camera or a separate instrument. However, there is always at least a little latitude in the exposure given to a film, and this is bigger with negative film than with reversal. The former has a very large exposure range: slightly less or considerably more than optimum exposure will still yield satisfactory results. This should not encourage careless use of a meter but should be regarded more as an insurance in the event of equipment and other errors.

Under- and overexposure are easy to recognise in a colour transparency. Insufficient exposure produces a very dense picture with deep colours, and with shadow areas that are virtually opaque and without detail. Slight underexposure may still give an acceptable transparency that merely demands an extra-powerful light source for viewing or projection. What appear to be very dense shadows with little or no gradation may reveal a great deal of detail if the viewing source is adequately powerful. Transparencies that are likely to be reproduced on the printed page should ideally be underexposed slightly, a third of a stop less than the meter indication. The richer colours that result, and the well-marked highlight gradation, make for much more satisfactory reproduction than can be obtained from a correctly exposed transparency.

A feature of a slightly underexposed transparency is that its highlight gradation has higher contrast than in a correctly exposed transparency, because the lightest subject tones fall on a steeper part of the film curve. Shadows will be dense but are likely to show excellent detail if a powerful viewing light is used. In reproduction the highlight gradation can

be retained with only slight losses and the shadow detail can be reproduced satisfactorily, although it may be difficult to see under normal viewing conditions. On the other hand an overexposed transparency is lacking in density, and its colours are weak and desaturated. Highlight gradation is weak and may be missing altogether.

There is nothing that can be done to correct an overexposed transparency. Methods of intensification that can be applied to silver images are not applicable to dye images. But there *are* methods for reducing the excessive density of an underexposed transparency. They involve the bleaching of the dye images, which can be dealt with separately to correct errors of colour balance. As there are risks attached to the use of any processes of chemical after-treatment it is advisable to make the best possible duplicate transparency before working on a perhaps irreplaceable original. The process of duplication itself offers scope for changing both density and colour balance, so the making of a good duplicate may well do away with the need for reducing the density of the original. There is always a gain in contrast when making a duplicate transparency, although the tendency is less with current duplicating films than with older ones. A duplicating film should process to a gamma of approximately 1.0 (page 45), but not all such films meet this requirement and some give considerable gain in contrast unless steps are taken to prevent it.

Determining the exposure

Reversal film is very critical as regards exposure. To begin with it has a small exposure range, generally no more than 100 to 1 and often less. Secondly, a dense transparency or a pale one is unsatisfactory when viewed or projected. There is a little room for personal preference as regards density; some people prefer the rich colours of a somewhat dense image while others like the pastel colours produced by rather generous exposure. The owner of a powerful projector may find slightly dense transparencies preferable to somewhat light

ones, especially when projecting small pictures in the home. Transparencies for reproduction by the printer or for duplicating should be on the dense side rather than too light.

Exposure meters are calibrated in accordance with international standards, and so are automatic cameras. Both should be correct to within plus or minus one-third of a stop. There may be camera errors of various kinds to take into account; shutter speeds may be incorrect, apertures may not be correctly calibrated, and (despite the efficiency of modern coating methods for securing optimum light transmission of lenses) a zoom lens lets through less light than a simple three- or four-element standard lens. Such small errors may all be in the same direction and add up to produce the wrong density. Furthermore, the actual speed of a colour film may differ from its stated speed by perhaps one-third of a stop. For these reasons it may be found that colour transparencies are consistently denser or thinner than is considered ideal. In such cases the general exposure level can be adjusted up or down by any desired amount by changing the film speed setting on camera or meter. If it is found that an ISO 100/21° film is producing slightly dense slides, the speed can be reduced to 80/20°; this will increase all exposures by one-third of a stop. Conversely, if transparencies using the normal speed rating are too pale, use a higher figure. For example, a number of photographers rate Kodachrome 25 at ISO 40/17° or even occasionally 50/18°, even though they use the manufacturer's ratings for other transparency films including Ektachromes. It is seldom necessary to use a speed setting considerably different from that recommended by the film manufacturer unless there is a camera or meter fault. If a particular camera or meter consistently needs the film-speed calibration to be one stop or more away from the manufacturer's recommendation, it is best returned to a photographic dealer or distributor for its settings to be corrected. Clearly, though, if all your equipment calls for the same alteration in exposure setting, then the different setting is a matter of

A simple pictorial exposure guide for an ISO 64/19° colour film out of doors. The aperture/shutter-speed combinations given are for average scenes with the sun coming from behind the camera.

personal choice and not something that calls for recalibrating the equipment.

Today, most photographers depend on their meters to calculate the correct exposure. However, it is well worth remembering the basic rule of thumb. If the shutter speed is numerically equivalent to the ISO film speed, the lens should be set at f/16 in bright sun, or f/8 on a cloudy-bright day. Thus an ISO 125/22° film needs 1/125 second at f/16 for a normal scene on a bright, sunny day. If your photographic equipment indicates an exposure far away from this, clearly something is amiss. The most widespread reason nowadays for incorrect exposures is incorrect calibration of the film-speed dial or inadvertent mis-setting of the exposure-compensation dial. Knowledge of what the exposure should be provides a continual check on the settings, and on potential malfunctions of the equipment.

A simple pictorial exposure guide for an ISO 64/19° colour film out of doors. The aperture/shutter-speed combinations given are for average scenes with the sun coming from behind the camera.

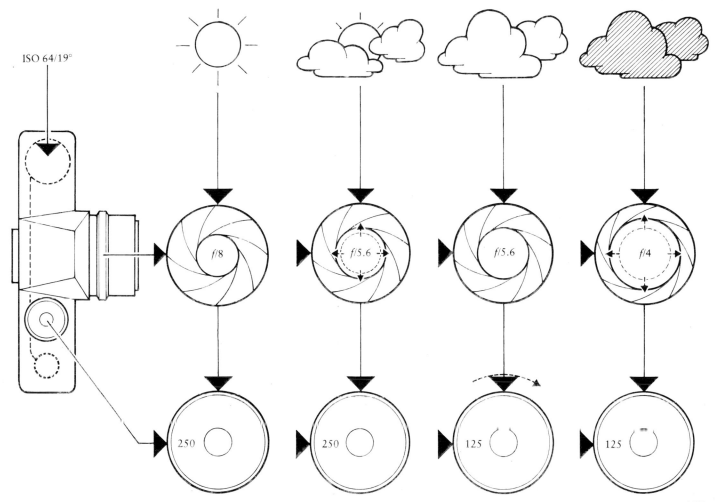

ISO 64/19°

Film varies slightly from batch to batch. This is acknowledged in the supplementary instructions for some professional films, but is just as likely to be the case with ordinary films. Also, the way a film has been stored can affect its sensitivity. To reduce the potential differences caused by batch-to-batch variations, it is well worth buying transparency film in fairly large quantities. Make sure that all the film has the same batch number. Whether it is professional film bought from a wholesaler or amateur film bought from a normal photographic dealer, store it in sealed containers in a refrigerator or a freezer. That should maintain its speed and colour balance exactly as it was when the film was purchased. If the first film exposed and processed gives transparencies that are too dark or too light, expose subsequent films in the same batch with a suitably lower or higher speed setting.

The simplest way of arriving at correct exposures for reversal colour film is to follow the simple guide enclosed with every roll or cassette of film. Such a guide packed with a particular film rated at ISO 64/19° covers four categories of weather conditions: bright or hazy sun, weak hazy sun, cloudy bright and cloudy dull. The basic exposures recommended under these different weather conditions refer to average scenes, and in bright or slightly hazy sun an exposure of 1/250 second at $f/8$ is recommended. Keeping the shutter speed at 1/250 second, the lens should be opened up to $f/5.6$ for weak hazy sun. In cloudy-bright weather 1/125 second at $f/5.6$ is suitable, and for cloudy-dull conditions 1/125 second at $f/4$ is recommended. It will be seen that from the full sun condition to cloudy dull there is a one-stop increase in exposure for each change in the weather for the worse. This applies universally and is worth remembering as there may be a time when an exposure meter develops a fault.

The simple exposure guide includes recommendations for modifying exposures to take care of departures from the average subject. For example, nearby side-lit subjects in bright sunlight call for half a stop more exposure than more distant or front-lit subjects. Nearby back-lit subjects require a one-stop exposure increase compared with the average scene. 'Nearby' in this context means distances from the lens of three metres or less. The exposure guide is often despised, but it is likely to give more reliable results than an indifferent meter or a good meter used carelessly.

More and more cameras today are fitted with built-in meters. These measure the average luminance of the subject at which they are directed. Such a built-in meter may form part of a system of automatic exposure control in which the photographer has merely to point the camera at his chosen subject and to press the shutter release button. The light measurement carried out by the meter is converted into an appropriate shutter speed and f-number in accordance with the amount of light reflected by the subject on to the photocell of the metering system. A great deal is often made of the fact that the average luminance of a subject is not really the proper basis on which to calculate camera exposures. While it is certainly true that average luminance is not ideal as an exposure criterion, it has the advantage that it can be measured easily and accurately without unduly complex equipment and, above all, reversal film exposed with the aid of a reflected-light meter yields a very high proportion of correctly exposed transparencies.

Before looking at the various methods of measuring light it is worth considering what are the aims in estimating the exposure to give to a reversal film. The exposure, as determined by the time duration and the lens aperture, should match the light reflected by the subject to the film speed so that all the subject tones and hues will be reproduced as unique densities in the three film layers. If the resulting transparency is then illuminated to a suitable level, all the tones in it will have the same luminances as the equivalent subject tones and their colours will be the same, within the limits of the film. A mid-tone in the subject will be reproduced

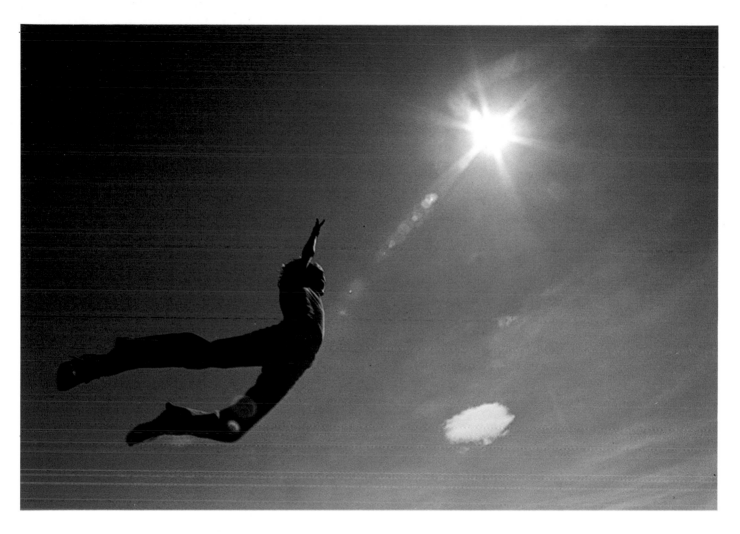

When shooting into the sun or against a very light sky, a reflected-light meter will indicate too small an exposure. In difficult cases it is advisable to expose several frames, bracketing the indicated exposure. *Brian Angus.*

as a mid-density in the transparency; highlights will be low densities not far removed from clear film, and dark shadows will be high densities approaching the maximum the film can yield. If too much exposure is given, the lightest tones will all be uniformly clear film, i.e. will be 'burned-out'. Too little exposure will produce shadows of uniformly high density and showing no gradation. Highlights will be much denser than clear film, although they will show excellent gradation.

The major problem is the exposure range of the film. A typical reversal film has an exposure range of about 50 to 1, or 1.7 on a logarithmic scale. As most subjects have luminance ranges much in excess of 50 to 1, there is really no such thing as a correct exposure, except for very low-contrast subjects on a dull day. It can be argued that a reversal film should be exposed on the basis of the brightest diffuse highlight in the subject, as good highlight reproduction is of paramount

importance. However, when the subject has a large luminance range, exposing for the highlights means clogged shadows, and the mid-tones may be dark. So a compromise is often essential. When the highlights are but a small part of the scene, the most satisfactory exposure can be one that reproduces the mid-tones correctly and sacrifices the highlights and shadows about equally. Sometimes either the highlights or the shadows may be all-important pictorially, in which case the photographer may prefer to bias his exposures accordingly. To do this unerringly demands some experience. Whenever there is any possible doubt, the answer is to take a series of pictures at different exposure levels. This procedure, called 'bracketing', is quite simple. Take one picture at the recommended meter reading, then take pictures with one stop more and one stop less exposure. In extreme cases it may be better to take five different shots, bracketing from two stops overexposure to two stops underexposure. This is a

In photographing a very contrasty subject with a film having a small exposure range (and all reversal films have small exposure ranges), a truthful colour picture is an impossibility. The best compromise is generally to expose for the middle tones of the scene.

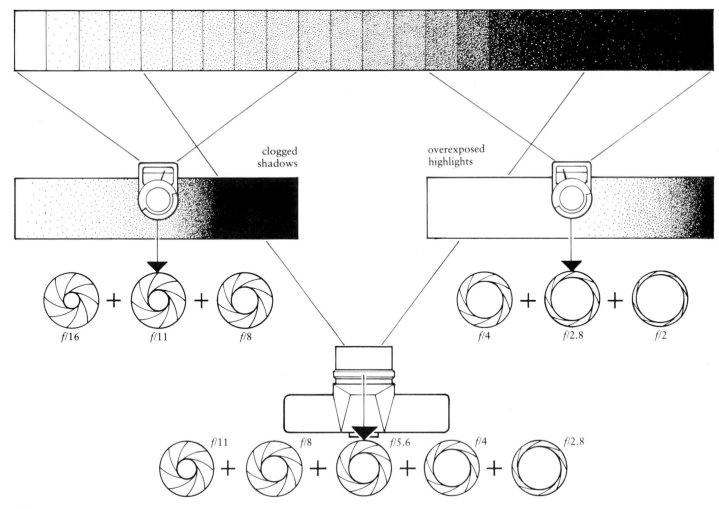

clogged shadows

overexposed highlights

f/16 + f/11 + f/8

f/4 + f/2.8 + f/2

f/11 + f/8 + f/5.6 + f/4 + f/2.8

practice followed by even the most experienced professional photographers, and is one of the main reasons why they can be sure of producing a really good transparency under virtually any conditions.

Reflected-light meters
Any reflected-light meter, whether hand-held or built into the camera, measures the light reflected from the subject. So clearly its reading depends not only on the light level but also on the average reflectance of the subject. An average subject reflects about 18 per cent of the light that falls on it, and reflected-light meters are calibrated to take this into account. If you meter from a grey surface that reflects 18 per cent of the light, and follow the meter reading, the resulting transparency will be a mid-grey. In the same way, a meter reading from a piece of white card followed directly will reproduce that white card also as mid-grey; the same thing happens with a black card. Unusual subject tones

By measuring the luminance of an 18 per cent reflectance grey card, a reflected-light meter will usually indicate a satisfactory exposure.

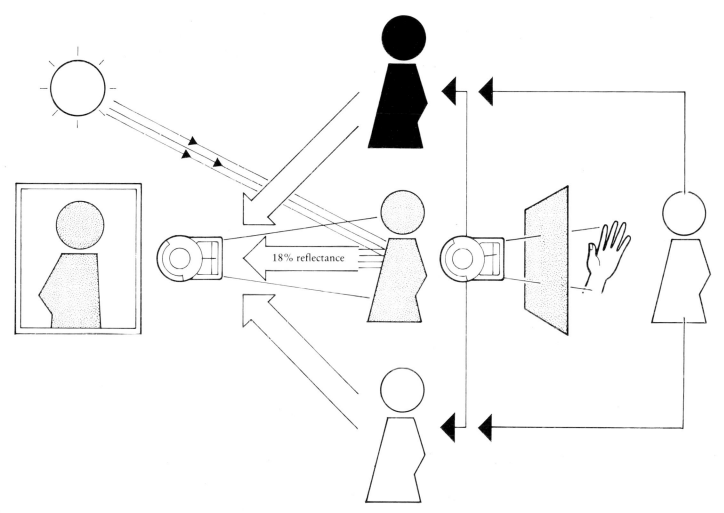

18% reflectance

also bias the exposure reading like this. Luckily, most subjects reflect on average about 18 per cent of the light that falls on them, so a reflected-light reading produces a transparency close to the tones of the original subject in over 90 per cent of cases.

The most accurate way to match the tones of a transparency to the subject is to measure the light that falls on the subject rather than the light reflected from it. As reflected-light meters are calibrated to assume an average subject reflectance of 18 per cent, they can provide a measure of the illumination by measuring from a subject of known 18 per cent reflectance. Photographic suppliers sell cards coloured grey that reflect exactly 18 per cent of the light that falls on them. When the subject is unusually light or unusually dark, a grey-card reading is a good starting point. Of course there are occasions when you want a dark subject to be pictured lighter, or a light subject to be pictured darker, in which case the grey-card reading needs to be modified to suit your preference. In the absence

of a grey card it is sometimes necessary to meter from another substitute. Most photographers use the palm of their hand. This reflects a little more than 18 per cent, but is close enough for most purposes. Whenever using any substitute metering target, be quite sure that it is lit in exactly the same way as your subject. When this is not possible, and much of the subject is unusually light or dark, take the reflected-light exposure measurement from a mid-toned part of that subject.

Spot meters
In many cases it is possible to go up to a subject and take a close-up meter reading, using this as the basis for exposures from the normal shooting position. When the subject is inaccessible, and it is necessary to take a close-up reading, the answer is to use a spot meter. Some single-lens reflex cameras have a built-in spot-metering facility. All of them offer some selective reading capability with telephoto lenses. However, a true spot meter is a more precise instrument. It has a very small angle of acceptance,

A spot meter with an angle of acceptance of 1° or less enables any small subject tone to be measured from the position of the camera. Exposures can be based on a highlight, shadow or middle tone at will, and such an instrument has a precision that is not matched by any other.

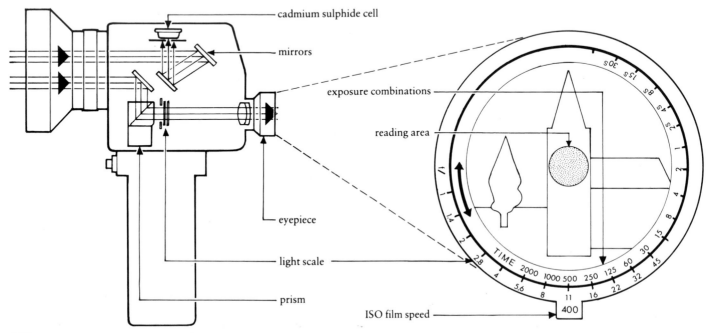

cadmium sulphide cell

mirrors

exposure combinations

reading area

eyepiece

light scale

prism

ISO film speed

ideally one degree or even half a degree. With such a meter it is possible to measure the luminance of a small subject area, or separate areas, in order to decide on the luminance range. One of the more widely used spot meters was the SE1 exposure photometer. It was a visual instrument with an angle of less than half a degree. Today there are a number of photographic spot meters available based either on CdS cells or, more commonly, on silicon photodiodes. Individual meters use slightly different display systems. Some have needles, some LEDs or LCDS. Some provide a direct exposure readout, others read out in exposure values and provide a calculator dial to give the camera settings. In principle, though, they are all similar. They allow accurate determination of the luminance of small areas of a distant subject.

The simplest way to use the spot meter is as a long-distance reflected-light meter. Point the meter at a mid-tone in the subject, and use that reading as direct determinant of camera settings. Suitable

A subject like this, with a large area of black background, tends to mislead a reflected-light meter used in the normal manner. A reading from a grey card or a reading from a mid-tone with a spot meter would be more satisfactory. *Jim Standen.*

mid-tones include green grass, brick or stonework, and reasonably dark skin. Where it is not possible to measure from a mid-tone, measure from a suitable area of lighter or darker tone and modify the exposure setting accordingly. For example, a white card or piece of very white cloth reflects about 90 per cent of the light that falls on it. So multiply the exposure time of a white card reading by five to mimic a grey-card reading. A spot meter can also be used to great advantage to measure contrast range, as discussed later.

Built-in exposure meters
As far as the actual exposure is concerned, it makes no difference whether a reflected-light meter is held in the hand or built into the camera. However, it is much more convenient to have the meter built into the camera and coupled with the exposure controls. Also, the almost universal adoption of through-the-lens metering in single-lens reflexes allows the meter's angle of acceptance to be matched to the angle of incidence of the lens in use. With a hand-held meter, or an uncoupled built-in meter, the light measurement is displayed or transferred on to a calculator dial. This dial calibrated with film speed then indicates the exposure combinations potentially available to give the correct exposure. These settings are transferred to the camera, selecting the optimum compromise between shutter speed and lens aperture for the subject in question. However, most built-in meters are coupled to the camera controls. Fully coupled versions have a display in the viewfinder or on top of the camera. The camera has, of course, to be programmed with the speed of the film. Most accept film speeds on the ISO scale. Once set for the correct film speed, the camera is focused on the subject and the meter readout aligned or nulled using the aperture and shutter-speed controls on the camera.

Some cameras have LED displays in which the correct-exposure LED, sometimes coloured green, has to be illuminated by altering the controls. These cameras usually have other LEDs indicating

113

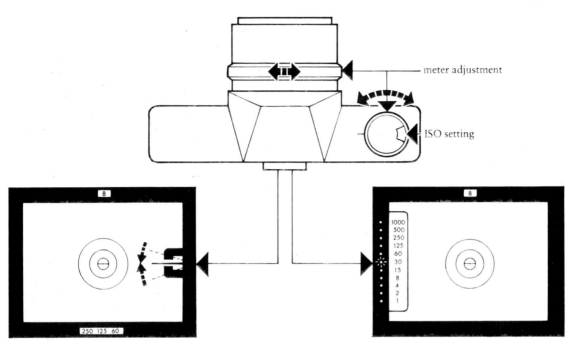

meter adjustment

ISO setting

8

250 125 60

8

1000
500
250
125
60
30
15
8
4
2
1

Left: two kinds of
viewfinder display given by
a single-lens reflex with
manual exposure control. It
is important that the display
shall not occupy too much
of the viewfinder area, as
this can confuse you when
you are trying to compose
the picture.

Right: there are two types
of camera automation apart
from the programmed
shutter system. Either the
photographer chooses an
appropriate shutter speed
and the camera automation
sets the lens aperture or the
aperture is set manually to
suit the depth of field
required and the camera
selects the right shutter
speed. Both systems have
their uses, and some
cameras offer both systems
at the touch of a switch.

whether the settings would lead to under- or
overexposure. Some models with a needle display
work similarly. Adjusting the shutter-speed and
aperture controls allows the needle to be moved to
a correct exposure point. The effect in all cases is
the same. The camera controls are set to match
exactly the reading of light reflected from the
subject. The best way to use such a manual
exposure camera is to treat it as a camera and
separate meter. At the beginning of a session, take
one or more meter readings from suitable parts of
the subject, decide on the best exposure and set the
camera controls accordingly. Then, if possible,
switch off the meter. Once the camera is set for the
optimum exposure, it will not need adjusting again
unless conditions change. When working outdoors,
for example, if a cloud obscures the sun, clearly the
meter reading will no longer apply.

Automatic exposure controls
It is often not possible to turn off a coupled meter.
So during a session the display continually changes,

if only slightly, with changing camera position. It is
difficult for the photographer not to keep altering
the lens aperture to produce what appears to be the
optimum exposure. This distracts quite
considerably from the real business of taking
photographs. The answer is to use a camera with
the meter actually controlling the exposure. Instead
of displaying any discrepancy between the
exposure-control settings and the light reading, the
camera adjusts one or both of the controls to match
its light reading. The more sophisticated automatic
cameras give the photographer control over the
actual shutter speed and aperture settings. With a
'shutter-speed priority' camera the photographer
sets the shutter-speed dial, and the meter on the
camera adjusts the lens aperture to suit the
exposure to the film speed. Most cameras also
display the aperture setting. Then if the aperture is
unsuitable the photographer can alter the shutter
speed so that the camera automatically selects a
more suitable aperture. The other type of
controlled automation is called 'aperture priority'.

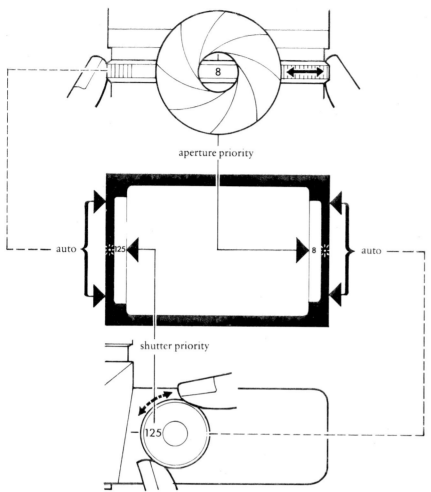

aperture priority

auto

auto

shutter priority

In an aperture priority camera the photographer selects the lens aperture and the camera adjusts the shutter speed to suit that aperture. Once again most, but by no means all, aperture priority cameras display the shutter speed they set. Thus the photographer can control the shutter speed by selecting a suitable aperture. The choice between shutter-speed priority and aperture priority operation is a personal one. However, a number of cameras now enable the photographer to select the priority mode at the flick of a switch.

Most simple automatic cameras, and a few sophisticated ones, select the combination of shutter speed and aperture to give the correct exposure without regard to the pictorial needs of the subject. Such cameras are fine for snapshots, especially with comparatively fast film on bright days. Then they give a combination of relatively short shutter speed and relatively small aperture ensuring pictures that are sharp overall. Once they are to be used for action photography or in low-light conditions, however, programmed shutters become much less useful. Thus a camera that gives no exposure information or control to the photographer cannot be regarded as the best choice for the photographic enthusiast.

Override controls
As already noted there are many occasions when the best transparency, or even the best negative, is not produced by following a reflected-light meter reading absolutely. For example, when the subject is unusually light or standing against a light background it is necessary to give more exposure than the meter suggests. Conversely, with dark subjects or subjects spotlit against a dark background, the optimum exposure is less than suggested by the meter. So, irrespective of how the camera determines the actual exposure combination, for serious work the photographer needs to be able to modify the exposure level given by an automatic camera. The simplest control is a back-light button. This increases the exposure by one-and-a-half or two stops when it is pressed in. As its name implies, its main function is to compensate for back-lighting. More sophisticated controls have a dial that allows the photographer to increase the exposure by one or two stops, or to decrease it by one or two stops. These controls can be used in two ways. The photographer can simply use his experience to adjust the exposure-override control when he knows that the reflected-light reading used directly will not be the best possible choice. Alternatively, the exposure-override control can be used to match the exposure readout from the picture-taking position to a previously obtained

reading close by the subject or from a suitable substitute. In this case, if the camera controls allow it, it is probably better to set the predetermined exposure manually, and not to use the automatic control at all.

Exposure-compensation controls on most cameras simply modify the film-speed setting input to the meter. Thus setting the control to +1 (or ×2, which is the same thing) is exactly equivalent to halving the film-speed setting. On 35 mm cameras without exposure-override controls, the same effect can be achieved by altering the film-speed setting. Double the ASA figure to reduce the exposure by one stop, quadruple it to decrease it by two stops. Halve or quarter it to increase the exposure. Unfortunately, this facility is not available on cartridge-loading cameras because the film cartridge automatically calibrates the camera for the manufacturer's rating for that film. When an override control is used, or the film-speed setting changed, this naturally influences the exposure until the control is returned to its normal position. So it is very important after using a compensated exposure to return the controls to zero, or to reset the normal speed for the film in use. Failing to do this results in incorrectly exposed transparencies for pictures taken in normal conditions. On some cameras, a major advantage of using the exposure-override control rather than altering the film-speed setting is that the viewfinder display indicates when the compensation control is set away from its normal position.

A very important exposure aid is found on some cameras. It is an 'exposure hold' control. If the shutter button is half depressed, or some other control moved, the camera retains its exposure reading until a picture is taken or the control is released. Exposure hold is used to remember a close-up or selective meter reading. Meter from the most appropriate mid-tone, and operate the exposure hold control. Return to the chosen viewpoint, and the camera will operate at the metered exposure. The controls differ from model to model. Some, indeed, hold the exposure but

116

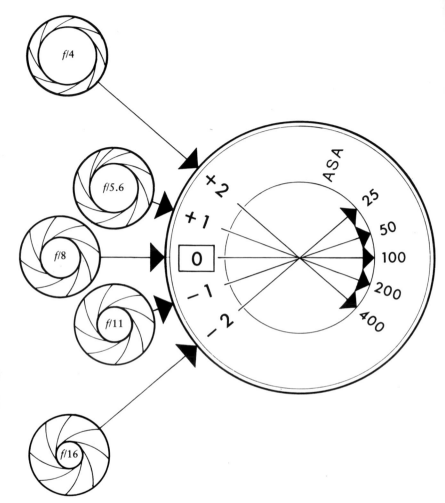

continue to read out the meter-calculated exposure as position or light changes.

Viewfinder displays and manual exposure
While there are great advantages in using a camera that automatically selects the correct exposure, it is important to know both the shutter speed and the lens aperture in use. In many older match-needle cameras, the viewfinder display indicates only whether or not the controls are set for the metered

The exposure given by an automatic camera may have to be modified manually to suit unusual subjects. This is easily done in any case by altering the film-speed setting to a higher or lower value, but some cameras are fitted with an override control (left) which does the same thing. It is important to cancel any exposure compensation for subsequent exposures.

Right: a viewfinder display that shows both the shutter speed and the aperture in use.

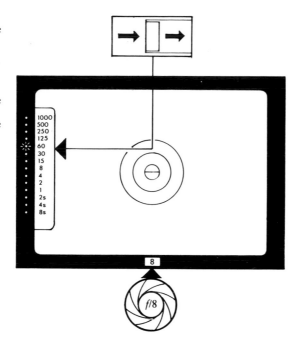

exposure. The more sophisticated automatic exposure cameras, including most single-lens reflexes, have a viewfinder display of the factor controlled by the exposure meter, i.e. the lens aperture in shutter-speed priority cameras, or the shutter speed in aperture priority cameras. Some models also show the manually selected factor so that it is unnecessary to take your eye from the viewfinder at any stage.

Knowing the combination of shutter speed and lens aperture is important in determining exactly how pictures come out. With automatic exposure control one or other of these must vary whenever the light reflected from the subject changes. In many cases these changes do not necessitate a change in exposure. For example, when photographing a person standing against a light background, the meter reading may change with alterations in the composition. The exposure, though, is unlikely to need to change at all. It is for conditions like this that manual exposure control is

so useful. When the shutter speed and aperture are displayed in the viewfinder, it is particularly easy to transfer from automatic exposure control to manual exposure control.

Reflected-light metering influences
Apart from its overall tone, another factor that influences the validity of the exposures indicated by a reflected-light meter is the distribution of tones within the subject. A scene containing large areas of highlights will tend to be underexposed by reliance on such a meter; one with large areas of shadow will tend to be overexposed. Large highlight areas or actual light sources within the angle of acceptance of a meter are particularly troublesome, and in extreme cases can lead to gross underexposure. In general, high-contrast scenes tend to be underexposed, and low-contrast ones overexposed, when following a reflected-light meter reading. It is now firmly established that for many subjects having higher contrast than can be accommodated by the exposure range of reversal film, exposures should be based on the subject mid-tones and not on a shadow or a highlight. This, as a rule, gives the best compromise renderings of high-contrast scenes. Indeed, the ISO Standard covering the speed of reversal film bases speed on the exposure required to produce a middle density.

Because a reflected-light meter pegs the average luminance of a subject at a point roughly in the middle of the useful part of the characteristic curve of the film, and because it takes more account of bright highlights than of deep shadows, it gives much better results with reversal film than might be expected. It is easy to demonstrate that the reflected-light meter indicates exposures for reversal film that compromise very satisfactorily between highlights and shadows. This is the best that any meter can do, as the exposure range of reversal material is far too small to accommodate the whole of the scale of even average sunlit scenes. However, unbalanced tone distribution of the subject is another matter when it comes to the validity of exposures indicated by a reflected-light

meter for reversal film. As in the exposure of black-and-white negative film, unduly large areas of highlights give rise to underexposure and large dark areas cause the reflected-light meter to indicate exposures that are too long. The experienced photographer is able to correct indicated exposures, taking into account departures from average tone distribution.

The basis of exposure estimation by an automatic camera is just the same as that of any reflected-light meter, namely the average luminance of the subject. The same observation applies to the increasingly popular 35 mm pentaprism single-lens reflex camera equipped with through-the-lens (TTL) metering systems. These systems are reflected-light meters; most of them measure average scene luminance, although there are modifications in that some cameras are 'centre-weighted' so that the middle of the subject has more influence on the indicated exposure than the edges. A typical example of centre-weighting is one in which 67 per cent of the total metering sensitivity is concentrated into a central circular area 12 mm in diameter. In an arrangement like this it is assumed that the important part of every subject from the point of view of exposure is in the centre of the picture, but this is untrue as often as it is true. Centre-weighting works very well in the case of a nearby subject against a light foreground and background, as it tends to base exposure on the subject rather than on its surroundings. It does not always work so well if the subject is light against dark surroundings; the result is likely to be underexposure of foreground and background. One or two cameras have meters weighted toward the bottom of the picture area. This is fine for horizontal-format shots. However, it can lead to underexposure when the camera is held on its side. With a meter weighted like this, it pays to cross-check between horizontal and vertical compositions.

On balance, a fully integrating metering system is the most generally useful and the easiest to use. The

more heavily the centre is weighted the more closely it approaches spot metering and the greater the care required in its use. In fact, as long as the calibration level of a metering system is in accordance with the relevant international standards it does not matter very much whether a particular system is a fully integrating one or has centre-weighting. Take two SLR cameras, one claimed to give centre-weighting and the other not, and point them both at subject after subject; in most cases the same exposure indications will result, provided that there is no calibration error in either camera. The centre-weighting may give more correctly exposed pictures with subjects having very bright skies or very light foregrounds.

The advantage of a TTL metering system is that only the light from the part of the subject that is to be included in the picture is taken into account by the meter. The effective angle of acceptance of the metering system changes with the angle of view of the lens, being small for long-focus lenses and large

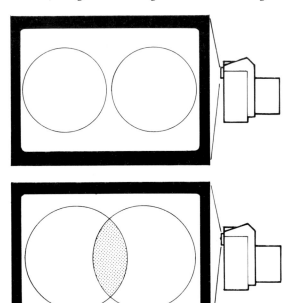

The built-in meter of a camera may integrate the whole of the picture area or it may be centre-weighted by arranging the light sensors so that the middle of the image is favoured. This arrangement is based on the assumption that the most important part of every picture is in the middle of the field, which is by no means true.

An exposure meter may measure either the light reflected by a subject or the light falling on it. For incident-light readings the photocell window has to be covered with a domed diffusing light receptor; the meter is held at the subject or an equivalent position with the receptor pointed at the camera lens.

for wide-angle lenses, which is as it should be. The best TTL systems indicate an appropriate exposure no matter what focal length of lens is in use. In a typical system the photographer is able to manipulate his lens apertures and shutter speeds to bring a meter needle to a reference point, needle and reference point being visible in the viewfinder. The reference mark may be provided with indicators showing degrees of under- and overexposure, to enable small corrections to be made for unusual subject characteristics.

Incident-light meters

Reflected-light readings are beset by two problems. Firstly, as discussed, they are influenced by the tone of the subject. Secondly, and rather more difficult to overcome, the meter can be influenced by the subject contrast. This is basically because the meter is more influenced by highlights than by shadows. As a result, following a reflected-light reading tends to result in underexposure with high-contrast scenes, and overexposure with low-contrast ones. As indicated earlier, one solution to this problem is to measure the light falling on the subject. The first exposure-measuring devices did just that. They were simply rolls of light-sensitive paper. To determine the light level, a new section of the paper was uncurled from its light-tight housing and held in the light. The time it took to darken to a reference standard was measured; the shorter the time, the brighter the lighting. From the darkening time, the exposure for whatever film was in the camera could be calculated. With the development of photoelectric instruments before World War II, P. C. Smethurst designed an incident-light meter for photography. This differed from a reflected-light meter only in that the photocell was covered with a flat opal-glass diffuser. The meter was used from the subject position to measure the strength of the main light source, e.g. the sun in outdoor photography in fine weather. The effect was similar to taking a reflected-light reading from a clean white card, but rather more convenient. Thus the meter effectively measured the luminance of the brightest diffuse highlight in the scene.

A highlight meter is not influenced either by the scene contrast or by the luminance distribution, and it gives very consistent results, but it has severe disadvantages when applied to the exposure of colour reversal material. The problem comes when the subject is lit from the side. In that case the shadows form an important part of the picture, and following the highlight reading leads them to be underexposed. One solution was to take two readings, one with the meter pointed towards the main light source, the other with it directed to the

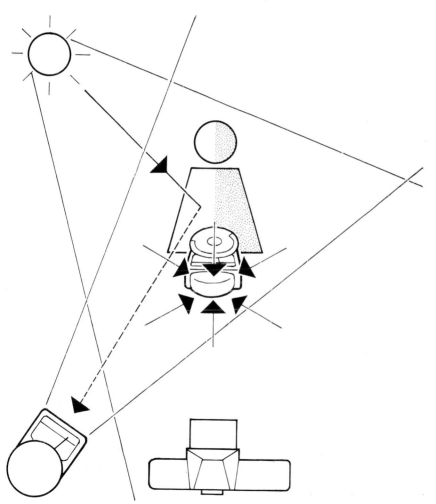

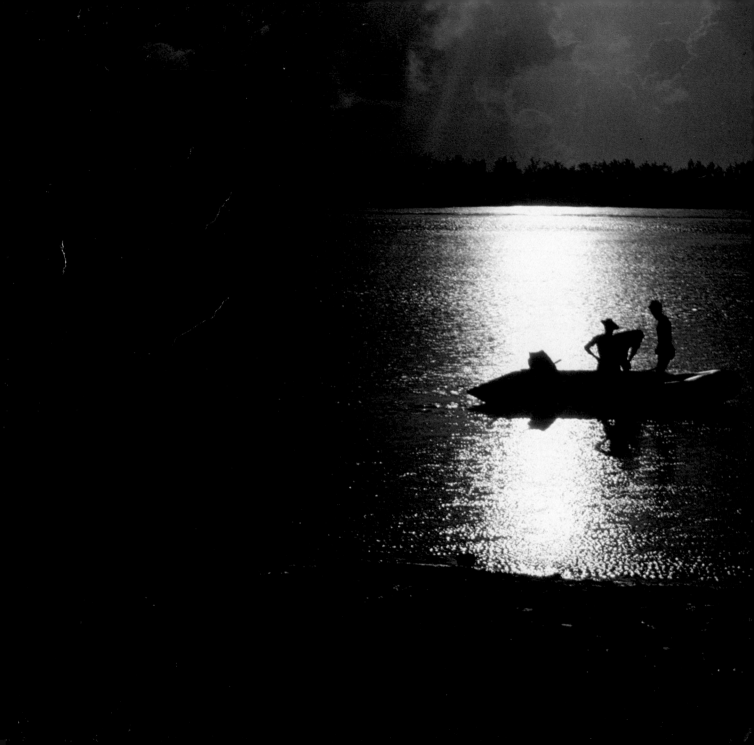

camera. The exposure was set mid-way between the two readings. This duplex method, as it was christened, proved very satisfactory with many scenes, as it tends to place the subject mid-tones in the centre of the useful part of the characteristic curve of the films. Modern general-purpose incident-light meters have, instead of a flat opal disc, a hemispherical receptor. This is designed so that they produce the optimum compromise reading when directed toward the camera position from the subject. The Invercone that was fitted to Weston meters is an extremely successful receptor for incident light.

There is no doubt that the incident-light meter gives the most consistent and reliable exposure indication for reversal film. The only adjustments necessary are small ones for subjects that can be classed as all light or all dark. A high-key subject should be given half a stop less exposure than is indicated by the incident-light meter. For example, an open beach scene with light-coloured sand and a pale-blue sky is likely to come out with rather low density and weak gradation if an incident-light reading is followed. While this may well be an accurate picture, it is preferable to give a little less exposure, so producing a more attractive transparency. An all-dark scene is rather rare, but an interior of an oak-panelled room with dark furniture and furnishings, and no window in the field of view, is an example. It should be given up to half a stop *more* exposure than indicated by an incident-light meter, to preserve gradation and colour in the very important dark tones. Such corrections should never be overdone, and in cases of doubt it is preferable to follow the meter indication as it stands. It is important to distinguish between the reflected-light meter and the incident-light meter when dealing with all-light and all-dark scenes. The reflected-light meter will indicate an exposure that is too small for an all-light scene, whereas with the incident-light meter the indicated exposure will tend to be too large, though to a lesser extent. The reverse is the case with an all-dark subject; the reflected-light

meter will overexpose it and the incident-light meter will underexpose it. These apparent anomalies are easily understood when it is considered how the two types of meter operate.

Colour negative films
Negative films demand rather different treatment from the point of view of exposure compared with reversal material. An important difference between the two types of integral tripack materials lies in the magnitudes of their exposure ranges. Whereas the exposure range of a reversal film is small, typically about 50 to 1 (logarithmically 1.7), that of a negative film is likely to be at least 1000 to 1 (logarithmically 3.0). Manufacturers may state that a particular colour negative film has exposure latitude amounting to one stop in the direction of underexposure and perhaps two stops in the direction of overexposure . Such figures are necessarily approximate and are based on the assumption that subjects are of average contrast.

Take for example a negative film such as Vericolor III type S, which is balanced for exposure in sunny daylight conditions. This has a log exposure range of approximately 3.0, judging from the characteristic curves published for the material. It is an easy matter to calculate that, with a subject having a luminance range of 100 to 1, the latitude in exposure is 10 to 1. This is roughly three stops. The photographer does not have to be very precise in using his exposure meter in view of the fairly large tolerance. Provided that this film is exposed in sunny daylight, all levels of camera exposure from slightly under to substantially over will yield negatives capable of producing prints of neutral balance from darkest shadows to brightest highlight. An underexposed negative will print with inadequate shadow gradation, and highlights may be flattened in a print from a negative exposed too generously, but there will be no serious errors in colour rendition. A very different situation arises if a film such as Vericolor III type S is exposed in light having a spectral distribution greatly different from that of daylight. The speeds of the three emulsion

Pages 120–121: a very difficult subject from the point of view of exposure. In practice, a general reading with a reflected-light meter would give a good result, as the brilliant highlight area is balanced by the large area of dark background. *Clyde Reynolds*

layers will no longer be the same; if the subject lighting is from tungsten lamps the red-sensitive layer will be faster than the other two and the blue-sensitive layer will be slower. The effective exposure range of the film will be reduced very substantially, and if the camera exposure is too little or too much it will be impossible to produce colour prints that are neutral throughout their tone scales. As will be seen later, the only way of restoring the equality of the speeds of the three emulsion layers is to use a suitable conversion filter on the camera lens. With tungsten lighting the filter required will have to absorb some red light and a little less green light, and ideally it should transmit all the blue light without loss. The hue of such a filter will be bluish.

Where a film has a big exposure range it means that it is capable of recording subjects of high contrast correctly. For example, a film with a log exposure range of 3.0 could accommodate a camera image illumination ratio of 1000 to 1. There would be only one correct exposure, which means that there is no exposure latitude at all. Given a reliable method of estimating the camera exposures needed, there would seem to be no objection to photographing the most contrasty scenes, as a colour negative film can record them successfully. Unfortunately, while negative material can deal with high-contrast scenes, a colour printing paper can show a luminance range of only about 100 to 1. Apart from this, a colour paper has an exposure range suited to negatives of average scenes; it could not yield a good print from the contrasty negative of a very wide-range subject. An acceptable result may be obtained provided that, in enlarging, considerable dodging is resorted to. Certainly, a print made by a photofinisher on an automatic rollhead printer would be unacceptable. But there is a limit to the extent of local exposure control that can be used, as changes in exposure time can give rise to changes in colour balance; holding back a shadow area that in a straight enlargement is much too dark and devoid of gradation may cause it to develop an unwanted colour cast. The very skilled printer uses greater ingenuity in dodging, and learns how to shade with colour-printing filters to maintain good colour balance in dodged areas.

To sum up: reversal film can show images of high contrast, but cannot record correctly subjects of high contrast; with negative film, while a contrasty subject can be made to produce an excellent negative, the printing paper cannot reproduce the full range of tones shown by the negative. It should not be thought, however, that these limitations make good colour photography difficult or even impossible when scene contrast is high. The eye is very tolerant of reproduction errors where these occur mainly at the ends of the tone scale.

Flare
In all the discussions concerning the exposure ranges of films and the luminance ranges of subjects, it has been assumed that the camera image illumination range of a subject is always the same as its luminance range. That is, the contrast of the image falling on the film is the same as that of the subject. In fact, this is not true; there is always some non-image-forming light or 'flare' in a camera. This has the effect of reducing the contrast of the image formed by the lens; in particular it flattens shadow gradation. It also reduces the saturation of the colours of the subject. In extreme cases the picture may have an unwanted colour cast if there is a large area of brilliant hue in the scene.

Modern multi-coated lenses have reduced flare to the point where it is seldom a problem. A perfectly clean lens with a properly-designed lens hood keeps flare to a minimum. However, the interior walls of the camera also introduce scattered light. They should be as non-reflecting as modern technology can make them, because light reflected from imperfectly blackened surfaces has the same effect as lens flare, although it may be more localised. The loss of image contrast due to flare occurs in both camera and slide projector, and this loss is one of the reasons why reversal films for camera use are processed to gammas greatly in excess of unity.

123

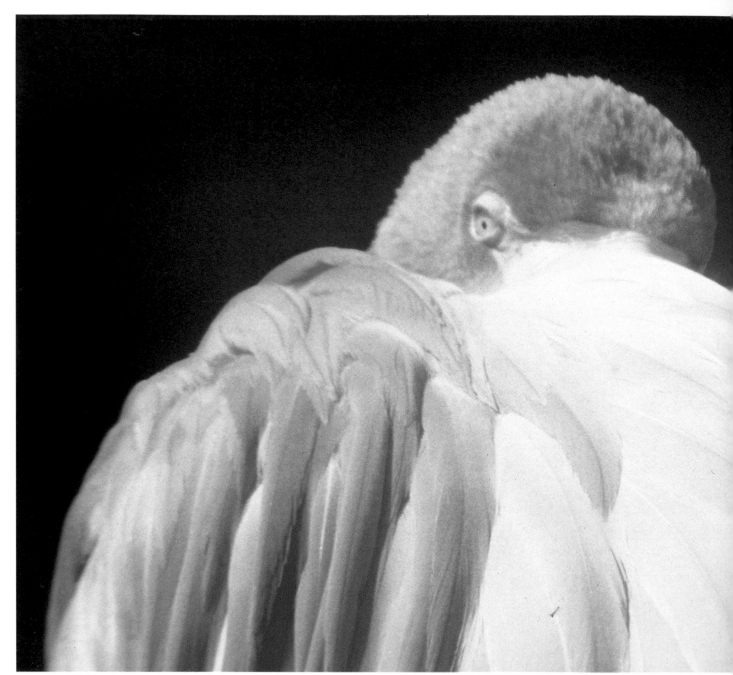

Lighting for colour

There is a major difference between the lighting requirements of black-and-white and colour photographic materials. In particular, reversal films need special treatment if they are to give the high-quality results they are capable of producing. The colour of the subject illumination should normally be that for which the reversal film is balanced, so it is worth balancing the lighting colour carefully. While the relatively crude colour conversion filters (85 and 80) are fine for colour negative materials, and for casual snapshots with reversal films, they are not sufficiently accurate for critical work. For these, choose from the range of amber (red) or blue light-balancing filters, such as Wratten 81 or 82 series or decamired (R and B) filters.

Lighting contrast
Assuming that the spectral composition of the subject illumination is suited to the colour film being used, or that a suitable conversion or light-balancing filter is being used, there remains the important matter of lighting contrast. Any subject has an inherent contrast. This is the ratio between the extreme reflectivities of the materials of which the subject is made up. If we consider a girl dressed in a white blouse and a black woollen fabric skirt, the white blouse might reflect as much as 85 per cent of the light falling on it and the black fabric of the skirt is unlikely to reflect less than 2 per cent of the light falling on it. If the girl is lit evenly by light coming equally from all directions, her contrast as a subject will be 85 to 2, or roughly 40 to 1. As there is no ordinary substance that is whiter than a white garment such as a blouse and nothing much blacker than black suiting, the inherent contrast of any scene never exceeds about 40 to 1. However, this inherent contrast is augmented by lighting contrast. If the girl in white blouse and black skirt stands in the sun so that parts of the blouse are facing the sun squarely and

Chris Howes

125

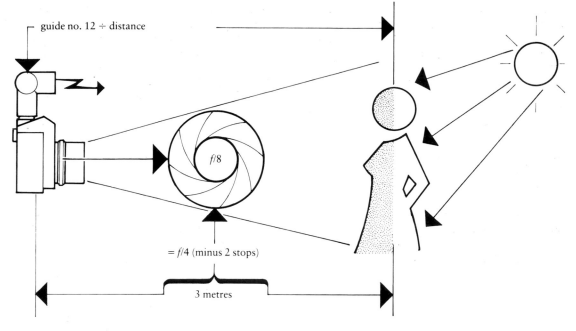

guide no. 12 ÷ distance

f/8

= *f*/4 (minus 2 stops)

3 metres

When shooting into the sun, the subject contrast may be higher than the exposure range of the film can deal with. A small flash on the camera will reduce the contrast to a manageable level. The normal flash guide number should be doubled to preserve a suitable balance between flash and daylight.

the shaded side of her skirt is receiving light only from the sky, there could be perhaps five times as much light falling on the lightest parts of the blouse as on the shadow side of the skirt. The inherent contrast of 40 to 1 now becomes an overall subject contrast of 40 × 5 or 200 to 1. It is this overall scene contrast that the reversal colour film has to record.

There can be much higher lighting contrasts than

the 5 to 1 mentioned in the previous paragraph. In any scene, the highest luminance is likely to be that of a white surface facing the main light source (the sun, out of doors), but the darkest tone may be a nearly black material lit only by light from the subject surroundings. The dark-brown bark of a large tree in full foliage is an example; it may have a much lower luminance than a black material in full sunlight, not because it does not reflect very well but because it is receiving such a small amount of

light. This means that overall subject tonal range out of doors can be very much higher than the 200 to 1 mentioned earlier. Subjects that are back-lit by the sun out of doors can have very big overall tonal ranges, and such subjects are often the most attractive ones for a colour picture.

If it is assumed that the average colour reversal film can record correctly a subject luminance range of no more than about 50 to 1, it is apparent that most outdoor subjects on a sunny day will be beyond the range of the film. That is why hazy sunlight is particularly effective for colour photography. The direct sunlight is reduced in intensity by the slight mist, but the light from the sky is increased by the haze; so both the lighting contrast and the overall tonal range are reduced. In this way subject contrast is kept within bounds but without the flat lighting of a cloudy day.

One way of reducing subject contrast out of doors when, say, taking pictures of people, is to work in the open shade of a building so that the only light on the subject is from the sky. As the subject lighting is coming from blue sky or blue sky with clouds, the resulting transparencies are likely to be somewhat cold in rendering, with a noticeable bluish cast. By using the pale pink 1A skylight filter for pictures in open shade this excessive blueness can be reduced, but the diffuse lighting causes loss of saturation.

A method of reducing the overall tonal range of backlit subjects out of doors that can be applied under certain circumstances is the use of fill-in flash. Suppose that a subject lit by the sun from behind is at a distance of 3 metres from the camera, and hence from the flash if it is mounted on the camera. If the normal guide number of the flash is 12 (metres), the lens aperture that would be used for ordinary flash photography would be 12 ÷ 3 or $f/4$. Generally speaking, a flash exposure of one-quarter of that applicable to a flash photograph is adequate for fill-in flash, so the lens would be stopped down from $f/4$ to $f/8$, two stops.

The shutter speed now has to be adjusted for the daylight exposure to suit the lens aperture of $f/8$ imposed on the photographer by the requirements of the fill-in flash. It is always better to have too little flash than too much. A flash that is too near or too powerful kills the drama of back-lighting by the sun, and tends to become the main light source.

A problem arises with fill-in flash in sunlight when using a camera with a focal-plane shutter. Assuming that electronic flash is being used (and there is little choice now that most flashbulbs have been discontinued), the fastest shutter speed that can be used with most small shutters is 1/60 second, this being the fastest that gives open blind. In bright sunshine this relatively slow shutter speed will call for a smaller aperture than the average lens is provided with, unless the colour film is a slow one. Assuming that the lighting conditions and film call for a daylight exposure of 1/60 second at $f/16$, the difficulty is in obtaining adequate fill-in from a small flash unit. Even with the flash 3 metres from the subject a guide number of 48 is needed, which is bigger than that of a small unit. The answer is a nearer flash distance or a more powerful flash unit.

An expedient often used by film makers for reducing subject contrast with nearby and close subjects is to use sheets of hardboard covered with crumpled aluminium foil as reflectors to throw some light on to the shaded side of the subject. White reflectors are often easier to use than shiny ones, but they do not reflect as much light, and often need to be larger. This is practicable in taking pictures of nearby subjects, such as people or animals. The precise effect of such added fill-in light can be seen before the shutter is released. Often a nearby sunlit wall acts as a suitable reflector. Take care, though, that it is reasonably neutral in colour. A coloured reflector will throw coloured light into the shadows, which can look odd in a transparency or print. When a nearby coloured object unavoidably colours the subject, include the object in the picture to ensure that the reason for the colour cast is obvious.

127

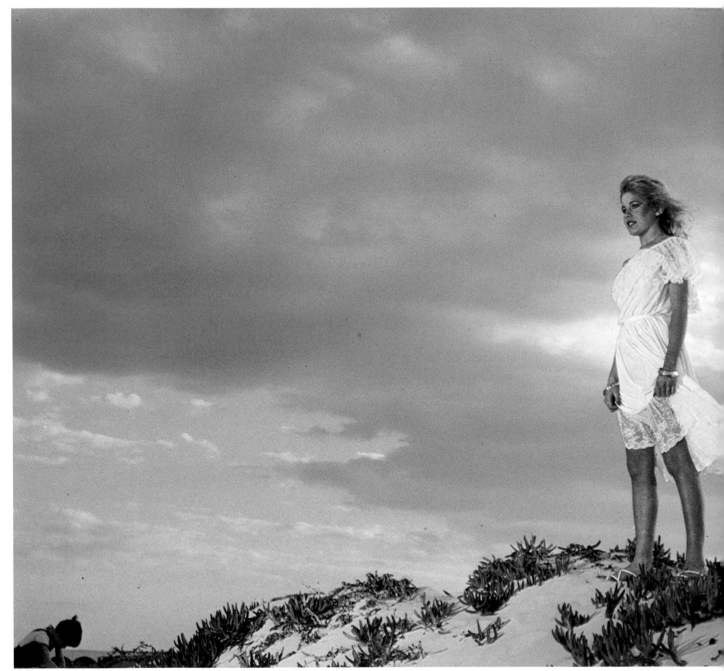

Left: an excellent example of the use of fill-in flash. The balance between the daylight and the fill-in is just right, and the effect of natural lighting has not been lost. *Clyde Reynolds*.

Right: flash on the camera may be the only feasible way of lighting an indoor subject like this. The lighting effect is rarely pleasant, and the small shadow on a background labels the picture as flash at once. *Raymond Lea*.

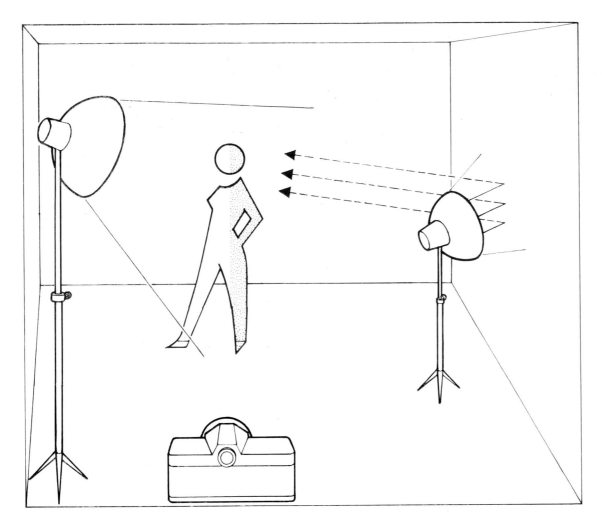

When working indoors
with tungsten lighting, a
main light from a flood is
normally placed somewhat
to one side of the subject
and fairly high; fill-in is
provided by a small source
nearly on the lens axis or
light from a large flood
directed at a light-coloured
wall.

Top left: bounce flash from the ceiling, with no direct light from the flash unit. With colour film it is essential that the ceiling and other reflecting surfaces shall be neutral in colour, preferably white. Top right: a two-beam flash unit, the main beam bounced from the ceiling and the secondary beam used as direct fill-in.

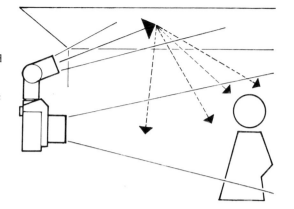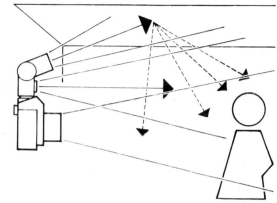

Centre: by using a white or silvered umbrella as a reflector for flash, very soft lighting can be obtained. Plenty of fill-in is normally provided by the spilled light from the large reflector being reflected by subject surroundings.

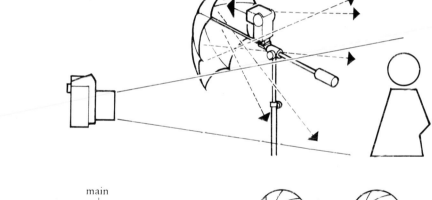

Bottom left: one flash unit direct as a main light and a smaller unit from the camera position as fill-in. The intensity of the fill-in can be reduced to a suitable level by covering the flash with one or more thicknesses of white handkerchief. Bottom right: with two units, the one on the camera for fill-in being a computer flash, the relative intensities from main light and fill-in can be adjusted to give a satisfactory lighting contrast (here, 2 to 1).

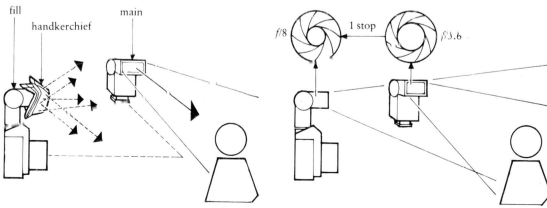

fill

handkerchief

main

f/8　　1 stop　　f/5.6

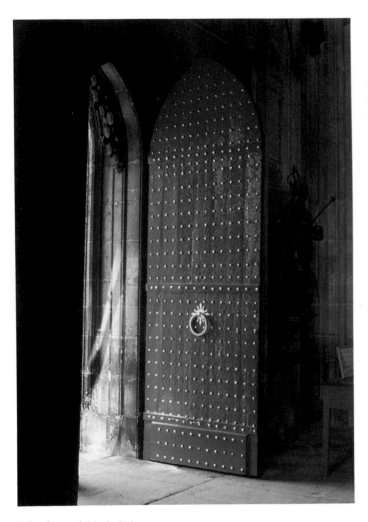

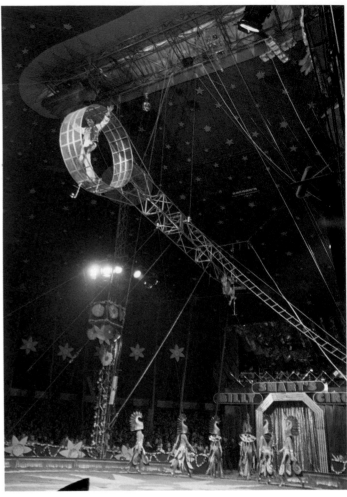

Taken by available daylight on daylight reversal film. The exposure was adjusted to suit the door, and as a result the shadows show minimum detail. *John Brancher*.

An available-light shot by artificial light. The rendering is rather warm because even tungsten film is not quite balanced for ordinary tungsten lamps. *Ed Buziak*.

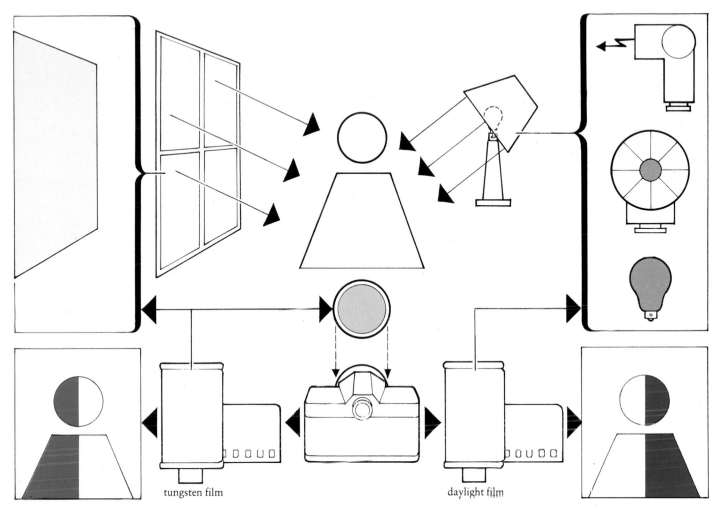

tungsten film

daylight film

When tungsten-balanced film is used in mixed lighting, the daylit parts of the subject will have a blue cast. To avoid this, filter the daylight with a sheet of orange or yellow film.

When daylight-balanced film is used in mixed lighting, the parts of the subject lit by tungsten lighting will have an orange cast. To avoid this, use electronic flash, blue flashbulbs or blue-filtered tungsten light rather than ordinary domestic lighting.

133

Indoor lighting

Working indoors by artificial light from flash or tungsten lamps, the photographer can control lighting contrasts. He can raise the level of the fill-in light to bring the overall tonal range of his subjects to within the exposure range of the film, or nearly so. It is generally considered that a lighting contrast of no more than 2 to 1 is suitable for colour reversal film when good reproduction from shadows to highlights is required. If the main light is twice as powerful as the fill-in and if, as is likely, the fill-in illuminates the highlights as well as the shadows, then the lighting ratio is 3 to 1 and not 2 to 1 as might be thought. However, a lighting contrast of 3 to 1 is acceptable if the subject is not one with a high inherent contrast, with areas of black in the shadows. The enthusiast or freelance working in a fairly small room with light-toned walls is unlikely to have much trouble with regard to lighting contrast, as there will be a reasonable amount of fill-in light from the walls. Plentiful fill-in can often be provided by directing an extra light source at a nearby wall, provided that the latter is neutral in tone and fairly light. A white bedsheet suitably suspended and well-lit with a flood will give nicely diffused fill-in that casts no shadows.

When using continuously burning light sources, as distinct from flash, a good idea of the overall tonal range of the subject can be gained by looking critically at it. An old trick used by professionals is to half-close the eyes while doing this, the effect thus seen being very much like the reproduction obtained on a photographic material. No such appraisal is possible when using a single flash unit. In the absence of modelling lights, the most manageable subject contrast is obtained either by using bounce flash (which can give rather flat lighting that is not always appropriate) or by using a single flash on the camera provided that the subject has enough variety of both tone and colour to stand the frontal lighting. The electronic flash unit that enables the light to be split into two beams, one direct and the other for bouncing from

walls or ceiling, enables overall tonal range to be controlled precisely.

In situations where reflecting surfaces are far from white, making bounce flash impracticable, a 'brolly' flash is a useful form of lighting. The flash is directed into the white or silver umbrella interior and the light is reflected in a broad beam giving soft illumination, although not quite as diffused as bounced flash. Brolly flash has the advantage that once a guide number has been determined for it by experiment it will apply for all future use, whereas there is no real consistency with bounce flash.

If two flash sources of similar power can be used together, set one up on an extension lead to serve as the main or modelling light to give 45° lighting; the second flash can be fired from the camera position with two thicknesses of white handkerchief draped over it to cut down the light if it is the same power as the main light. One simple way to work is to use an automatically controlled flash on the camera as a fill light. Select the camera lens aperture so that the fill-flash alone would underexpose the picture by one or two stops. For example, if the flash gives full exposure at $f/5.6$ (with the film in use), select $f/8$ or $f/11$. Arrange the main light to give full exposure from its required angle at the chosen aperture. The fill-light level will then remain constant irrespective of camera position. The best way of synchronising the main (off-camera) unit is with an electronic slave, thus avoiding the need for multiple connectors and cables. A few trial exposures with such a lighting arrangement will provide data for contrast control in the future.

Available light

Modern very fast colour films, both reversal and negative, enable satisfactory pictures to be taken indoors by available light. Problems can arise in the home, where the room lighting may come mainly from above. Although the eyes do not detect it, the lighting on and near the floor is at a much lower level than the lighting on table tops and other furniture. If there are lights mounted on a ceiling

3 metres from the floor and if a table is 1 metre high, the light on the table top will be 2¼ times as much as on the floor because of the operation of the inverse square law (which states that the intensity of illumination decreases in inverse proportion to the square of the distance from the light source). This fact will be very evident in a colour picture on reversal film, which exaggerates contrasts: if the film is correctly exposed for the table top, the floor will be very dark. Some table lamps arranged to throw extra light on to the floor can be helpful in such circumstances. The fashion for lighting interiors with little display spotlights is a great help to the photographer. These can often be arranged to light a reasonably large area evenly enough for colour reversal materials.

Lighting of mixed colour

As the colour of the light affects the colour of the resulting picture, a subject lit by light of more than one colour will come out more or less multicoloured. This is the case whether the picture is taken on reversal film or on negative film. Imagine an interior lit by daylight coming through the windows and by tungsten lights inside. Daylight-balanced reversal film will reproduce the daylit areas as a neutral colour, but the areas lit by tungsten lighting will come out with a yellow-orange cast. Conversely, on film balanced for tungsten lighting, the daylit parts will seem excessively blue. The results from negative film will probably look rather like those on daylight-balanced reversal film; however, if at the printing stage compensation is made for the tungsten lighting, the effect will again be to reproduce the daylit parts very blue. Clearly neither of these effects is ideal. One advantage, though, of modern high-speed colour materials is that they minimise the effect of differently coloured lighting, and thus make pictures taken in mixed lighting potentially more acceptable.

The answer with a daylit room requiring extra light is to provide that light from a daylight-coloured source. There are three possibilities: electronic flash, blue flashbulbs, and blue-filtered tungsten lighting. Of these solutions flash is probably the most convenient. When the tungsten lighting is the more important, perhaps being so placed as to add character to the picture, the exposure must be made on tungsten-balanced film, with a suitable pale-blue filter if the lighting is more orange than 3200 K photographic lamps. At the same time, to avoid a blue effect, the daylight coming through the windows must itself be coloured. The windows will have to be covered with orange or yellow acetate filters to adjust the colour of the daylight to that of the artificial illumination. Sheets of suitable material are available from photographic suppliers. It may also be possible to use theatrical acetate lighting material, or gel as it is commonly called.

In cases where there is no possibility of avoiding mixed light sources, it is worth taking a chance and making exposures if the subjects are promising. Even if the results are not truthful, the blueness of the daylight areas and the yellowness produced by tungsten lighting may not be wholly objectionable. In low-level available-light photography, even with a fast reversal film the use of a bluish conversion filter may be ruled out because of the big loss of effective speed. If pictures of some kind are better than no pictures at all, the unfiltered film should be exposed and the strong orange-red cast accepted. It is often not as objectionable as might be thought. A better solution, though, is to shoot on colour negative material and make the colour correction at the printing stage.

Throughout this section the emphasis has been on reversal films because of their direct colour reproduction. Although colour negative films have adequate exposure ranges colour prints on paper can exhibit only restricted luminance ranges. For this reason it is worth treating negative films in much the same way as reversal materials as far as subject lighting ratios are concerned; the same rules regarding mixed lighting apply, although there may be some scope for dealing with local colour casts at the enlarging stage.

Artificial light sources

As colour films of all types have steadily increased in speed, the possibilities of photography by artificial light have improved to the extent that, at the present time, colour photography matches black-and-white as regards film speeds. However, different light sources have different spectral distributions and artificial sources in particular differ greatly one from the other.

Colour temperature
It is convenient to be able to express the colour of a light source numerically. The scale normally used for illuminance is that of colour temperature. The units are known as 'kelvins', a kelvin being a step on the absolute temperature scale ($°C + 273$). The colour temperature scale runs from about 1500 K representing reddish light, up to about 12 000–18 000 K representing bluish light. Light from a tungsten-filament lamp may be 3200 K. That is, if a 'full radiator' is heated to this temperature, the light it emits will be a visual match for the source under consideration. What is more, if the light source approximates to a full radiator, the spectral distribution of its illumination will be very close to that of the full radiator at 3200 K. A full radiator or 'black body' is a hypothetical material that absorbs completely all incident radiation, and as a source it has maximum theoretical emissivity. A tungsten filament is not a full radiator, but is classed as a grey body; the actual temperature of a filament is slightly lower than that of the equivalent full radiator. Colour temperatures can be stated for various types of tungsten filament lamps and other artificial sources (see the table on page 138). They can be stated also for various forms of daylight and for artificial sources such as fluorescent tubes, but the values are not very reliable and for such sources 'correlated' colour temperatures are often quoted. If we say that the correlated colour temperature of average noon sunlight and skylight is 5500 K, it

Marc De Ganck

137

Colour temperatures of some common light sources	colour temperature	mired value
typical north skylight	7500–12000 K	133–83
typical cloudy daylight	6500 K	154
xenon electronic flash	6000 K	167
mean noon sunlight	5400 K	185
typical sunlight plus skylight	5500 K	182
blue flashbulbs	5500 K	182
photolamps (photofloods)	3400 K	294
tungsten halogen studio lamps	3300 K	303
studio tungsten lamps (Photopearl)	3200 K	313
general service lamps	2600–3000 K	380–330
candle flame	1400 K	714

means that a full radiator at this temperature would give the best match for sunlight and skylight, the match being a purely visual one.

Tungsten lighting
Ordinary household electric lamps, or 'general lighting service' lamps, naturally attract the photographer's attention because he uses them in the home and the home is the natural place for photographing the family. Pictures by available light are inevitably more spontaneous than those taken with flash or special high-intensity filament lamps. A living room with light-coloured walls and ceiling and lit with 200 to 300 watts of household lighting is illuminated well enough for informal pictures of pets, friends and family to be taken. But the household lamp has two shortcomings as far as colour photography is concerned. It is not very efficient at converting electrical energy into light and the colour of the illumination it emits is yellowish. The yellowish colour of the light from a household lamp is very evident if it can be compared directly with daylight, which is very much bluer. Expose a daylight reversal film by means of household lamps and the resulting transparencies will have a marked orange-red cast. A similar cast but not so strong will result if the same daylight film is exposed by photoflood illumination.

The relationship between the electrical energy consumed by a lamp and the light it emits is known as its 'luminous efficacy'. This is the preferred term for what was, for a long time, known as the 'luminous efficiency'. It is expressed as the number of lumens of light emitted per watt of electrical energy consumed. A 100-watt household lamp emits about 1200 lumens giving it a luminous efficacy of 12 lumens per watt. On the other hand, a 275-watt Photoflood lamp emits 8000 lumens giving it an efficacy of 29 lumens per watt. This high light output is obtained at the expense of the life of the lamp, however, which is only about three hours.

Because the luminous efficacy of household lamps is rather low there are special lamps for photography having much brighter luminous efficacies. Higher light outputs for a given current consumption are obtained by operating the filament at a higher temperature than is usual. This produces more and bluer light for a given current consumption, but the tungsten is heated to a temperature not far short of its melting point; metal is evaporated from its surface and in a relatively short space of time the lamp fails. The short life of only a few hours is not as uneconomical as it might seem, as such lamps need be switched on only for the brief periods required to make exposures.

Two types of overrun filament lamps are available to the photographer. One, intended primarily for professional use, radiates light at a colour temperature of 3200 K. This type of lamp has gone under various names such as 'Nitraphot', 'Photopearl' and others, but is now referred to as a 'tungsten lamp (3200 K)'. The other type of lamp is the Photoflood, made in two sizes, 275 and 500 watts. The colour temperature is higher, at 3400 K, than that of the tungsten lamp (3200 K). The Photoflood lamp is increasingly referred to as the 'photolamp (3400 K)'. To describe lamps as tungsten or photolamps without a colour temperature stated in parenthesis after the word is meaningless to the photographer. All filament lamps are tungsten lamps, with few specialised exceptions, and all kinds of lamps used by the photographer can be called photolamps.

Lighting units utilising tungsten-halogen lamps operating at 3200 K are available in various forms. Such lamps are suitable for tungsten-balanced colour films and are obtainable up to 1000 watts and bigger. They are more expensive than conventional tungsten lamps and should be used only with a safety-glass screen in front as protection against explosion. The latter is a rare event, but it can occur if a lamp is handled roughly. For the higher powers, fan cooling is necessary.

Light fittings

A major advantage of tungsten lighting is that the light is visible all the time. With a continuous light source, you can see exactly how the subject is going to be pictured. But the light from a bare bulb spreads in all directions. With a dense opal bulb the light is reasonably even, but with pearl or clear-glass envelopes the light is very uneven. For photographic purposes the light needs to be controlled so that it reaches the subject in exactly the right places, and at the right brightness. The fittings available for tungsten bulbs range from large, totally diffuse sources, to accurately focused parallel-beam spotlights. For most purposes one or two reasonably narrow-angle lights and one

wide-angle diffuse light are quite sufficient. Perhaps the easiest narrow-angle lights to use are silvered reflector spots. Such spotlights are widely used in displays and for household illumination. For photographic use, Photoflood versions are available; the light from these is very similar to that produced by narrow pudding-basin-like aluminium reflectors. Producing a softer, more diffuse light can be done in two ways. A large reflector spreads the light unevenly over a wide area. The white umbrellas widely used for flash photography are a good example of this. Alternatively, a light may be softened by being shone through white gauze or muslin. This, of course, also reduces the brightness of the light.

The conventional way to light a subject is with a single, comparatively bright, keylight, and one or more subsidiary units to lighten the shadows. The keylight may be soft or harsh, as the picture requires. Conventionally it is placed above the subject and to one side, more or less duplicating the effect of the sun on a summer afternoon. The position of this light determines the way the shadows fall on the subject, thus producing the modelling so essential for an attractive photograph. With all but the softest keylight, however, the luminance range between the shadows and the highlights is too big. Photographed with a single light, people appear to have black shadows under their chins and on one side of their faces. To reduce this contrast, the light must be thrown into the shadows. One simple and very effective way is to place a reflector, which can be a sheet of white material, on the side away from the keylight. Just outside the picture this reflector can lighten the shadows adequately. Alternatively, a separate diffuse light unit may be used, in which case it should shine from as near the camera as possible. The fill-in light should never cast shadows of its own: pictures with two shadows look odd. For sophisticated studio work one or more hard-edged spotlights are very useful. They can be used from behind the subject to provide rim lighting separating the subject from its background, or to

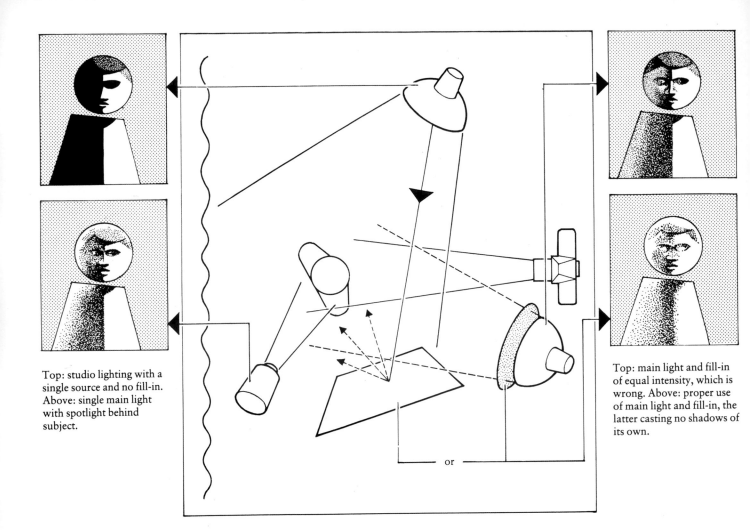

Top: studio lighting with a single source and no fill-in. Above: single main light with spotlight behind subject.

or

Top: main light and fill-in of equal intensity, which is wrong. Above: proper use of main light and fill-in, the latter casting no shadows of its own.

highlight small parts of the scene. The great advantage of using continuous lighting is that you can see precisely how the adjustment of each lamp affects the picture.

Fluorescent lighting
Fluorescent lighting is coming more and more into use, and is entering the home. This is on account of the very high luminous efficacies that can be achieved. It is not unusual for light output to be in

the region of 60 lumens per watt. From the point of view of the colour photographer the fluorescent tube is something of an enigma as far as the colour of the light it emits is concerned. The primary radiator is a mercury vapour source that is very rich in invisible ultra-violet, which causes the phosphors coated on the inside of the tube to fluoresce. The fluorescence is approximately white, but its precise colour depends on the mixture of phosphors used. Fluorescent tubes are described in such terms as

Right: a typical studio shot, with soft shadowless lighting on the features and a spotlight behind the model producing an outline of fringe highlights. *Michael Barrington Martin.*

140

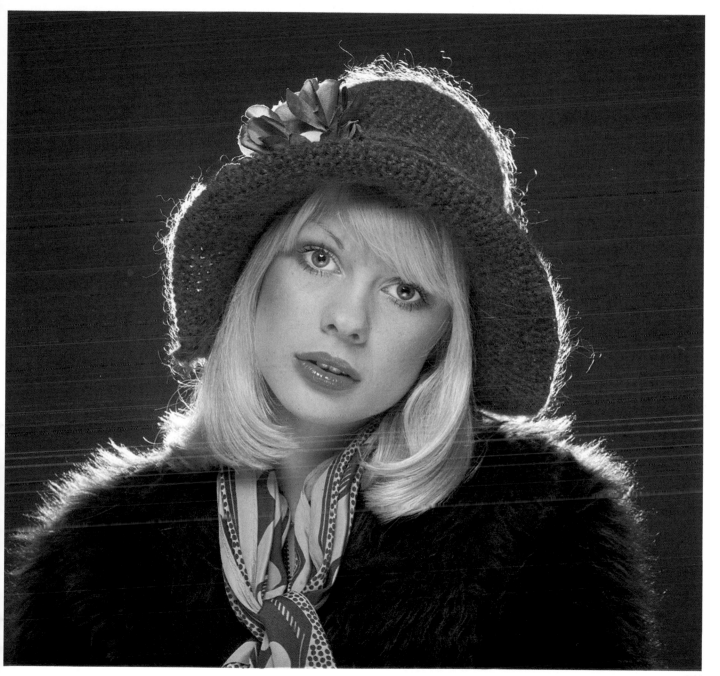

type of lamp	Filters and exposure increases for fluorescent lamps				
	daylight film		tungsten film		
	filter	exposure increase	filter	exposure increase	
daylight	40M + 30Y	1 stop	85B + 30M + 10Y	1⅔ stops	
white	20C + 30M	1 stop	40M + 40Y	1 stop	
warm white	40C + 40M	1⅓ stops	30M + 20Y	1 stop	
warm white deluxe	60C + 30M	1⅔ stops	10Y	⅓ stop	
cool white	30M	⅔ stop	50M + 60Y	1⅓ stops	
cool white deluxe	30C + 20M	1 stop	10M + 30Y	⅔ stop	

'daylight', 'warm white', 'warm white de luxe' and so forth. These names are little guide to the spectral distribution of the light radiation, which is a mixture of mercury vapour radiation and radiation from the phosphors. The mercury vapour radiation has a strong line in the green region of the spectrum, which can give rise to a greenish cast in transparencies. For a daylight fluorescent tube a green-absorbing filter such as a Kodak CC20M filter can be used with daylight reversal film; but such tubes vary a great deal, so preliminary tests are advisable before committing a considerable amount of film.

For using colour film with the most popular of fluorescent tubes, cool white, there are filters available: FLD for daylight film and FLT or FLB for tungsten-balanced film. Both of these filters call for an exposure increase of one stop. For other types of fluorescent tubes, Kodak offer the recommendations in the table above. The filter combinations in the table are made up from Kodak Wratten colour compensating (CC) filters available in gelatine film.

Flash
Flash sources make the photographer independent of a mains electricity supply. What is more, a flashgun or flash unit is more portable than lighting stands and reflectors. Flash bulbs and flashcubes have blue envelopes so that the light emitted by them has a colour temperature of 5500 K, which is the value for which daylight films are balanced. The

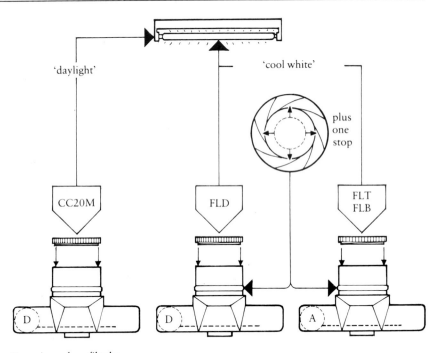

Exposing colour film by fluorescent lighting calls for special filtration because of the discontinuous spectra produced by such sources. The FLD filter is for daylight film, the FLT and FLB filters are for tungsten film.

old colourless flashbulbs have disappeared from the market. The light from an electronic flash unit has a colour temperature rather higher than 5500 K, but some units have a built-in filter or yellow-tinted reflector or tube to lower the colour temperature of the light to about 5500 K.

A flashgun, flashcube or electronic unit can usually be mounted on the camera so that, wherever the camera is moved, the sole light source goes with it. In black-and-white photography the flat frontal lighting given by flash mounted on the camera labels pictures 'flash' immediately, and the whole effect of any other lighting is destroyed. Flash on the camera is not quite as disastrous for colour photography, as there is colour gradation as well as tonal gradation to keep that deadly flatness at bay, but it still presents problems. First, it throws hard shadows on anything near behind the subject, and also produces thin, hard shadows below chins, beside noses and so on. Second, the light diminishes rapidly with distance, so isolating the subject in a sea of underexposed background. As a corollary to this, the flash over-lights anything nearer the camera than the main subject. That can produce harsh, white patches in colour pictures. Third, when a flash source, either bulb or electronic, is mounted on the camera close to the lens axis the unpleasant effect known as 'red eye' can occur in photographs of people or animals. The pupils of the eye are reproduced as brilliant red by a colour film instead of black. The reason for this is that the light from the flash passes through the cornea and lens of the eyes and is reflected back by the many blood vessels in the retina, and it emerges again from the eyes as narrow beams that enter the camera lens and are recorded by the film. The effect can be avoided completely by having the flash several inches away from the lens or by avoiding situations where models, human or animal, are looking directly at the camera lens.

So flash on the camera should be a last resort, as much more attractive lighting is possible by taking the flash somewhat away from the camera on an extension lead. This is difficult to do when working single-handed, but it is usually possible to mount the flash on a lightweight stand made for the purpose. Such a stand can be used to hold also a white or silver umbrella, which serves as a large reflector to give softer lighting than that produced by a small source in a small reflector.

The simplest lighting possible using a single source off the camera is that known as 45° lighting. The source is placed fairly well to one side of the subject and fairly high up. The direction of the light is 45° to the lens axis horizontally and about the same vertically. When working in a room with light-coloured decor there is likely to be sufficient light bounced off the walls and ceiling to provide adequate fill-in illumination to prevent the shadows being too dark and empty. If the room has dark walls and ceiling it may be possible to suspend a white bedsheet at the side of the subject away from the flash to provide the desirable fill-in. The ambitious may wish to use two flash sources, one as a main light and the other to provide fill-in.

Because of the unattractiveness of the results obtained with flash on the camera, and because of the preparations required for successful multiple flash exposures, a technique known as 'bounce' flash has become popular. This consists of directing the flash at the ceiling or the ceiling and walls so that only reflected light reaches the subject. The resulting lighting is very soft and diffused, and it has the effect of keeping subject luminance range to a low enough value for it to be recorded successfully by colour reversal film. For bounce flash to be practicable when exposing colour film it is essential that the reflecting surface used, ceiling or walls, shall be completely free from colour. Any colour will cause unwanted casts in the pictures.

Multiple flash
While a single flash unit with a reflector can provide excellent lighting, there are times when a more complex set-up is called for. Photographic studios depend heavily on a set of powerful flash

143

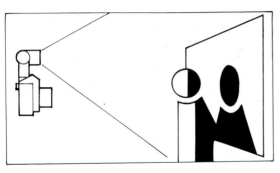

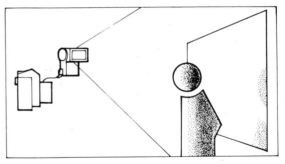

Far left: the simplest way of using flash by mounting the unit on the camera. The lighting is flat with narrow shadows behind the subject. Left: flash removed from the camera on an extension lead, and fill-in provided by light walls.

Far left: flash off the camera using a sheet reflector for fill-in or a small unit with slave attached. Left: single flash bounced off ceiling and walls.

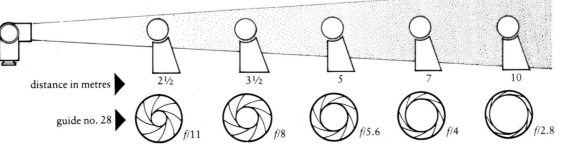

distance in metres ▶ 2½ 3½ 5 7 10

guide no. 28 ▶ f/11 f/8 f/5.6 f/4 f/2.8

The use of guide numbers. The flash distance is divided into the guide number to give the appropriate f-number. Doubling the intensity of a flash increases the guide number by a factor of 1.4.

heads, often controlled from separate floor-mounted power units. These are all connected together so that they can be fired simultaneously, either by a separate open-flash button or by the camera's shutter contact. On a smaller scale, it is possible to buy a set of mains-powered electronic flash heads. Some of these units plug into normal household light-bulb sockets. Others have power leads and require a conventional supply line. The most convenient sets of equipment all pack away into a suitcase, making them easily portable.

144

Alternatively it is quite possible to use a number of small portable flash units together. A few are designed to be interconnected for multiple flash, but most have no output socket for extra flashes. The most direct way of arranging for them all to fire at once is to use multiple leads with Y-connectors, so that when the camera shutter closes, all the units fire. This has two disadvantages. First, some flash units cannot be joined together without affecting one another, and even if the units all fire, it is possible that their

combined triggering currents will overload the camera's shutter contacts. Second, such an arrangement leaves a trail of wires around the room, which is unsightly and can be dangerous. A much better solution is to use electronic slave units to fire each of the flashes. These tiny units, usually embedded in a block of clear acetate, can detect the light from even the shortest electronic flash but are unaffected by continuously burning sources. When activated, a slave unit closes a switch, causing a flash unit plugged into it to fire virtually simultaneously with any other flash in the room. Thus it is quite simple to use one or more flash guns mounted away from the camera to give exactly the right lighting. A small flash unit mounted on the camera can provide both the trigger for the other flashes and fill-in light for the picture.

Fill-in flash
Outdoors on a sunlit day, the lighting contrast is far too high to take attractive portraits. The effect is the same as using a single flash, or tungsten light, off the camera. To reduce the lighting contrast to a reasonable figure, light must be added to the shadows. This can be done with a plain white or silver reflector. Alternatively, flash may be used. The aim must be to provide enough light from the flash to provide detail in the shadow areas, without effectively overpowering the sunlight. An overfilled flash picture looks very odd and unnatural indeed. The exposure must be calculated from the guide number, as described in the next section, and then altered so that the flash would, as a sole light source, underexpose the picture by between one and two stops.

Guide numbers
In flash photography exposure obviously cannot be determined using an ordinary exposure meter. To overcome this difficulty a system of guide numbers is used to calculate the lens aperture required for correct exposure at a given flash-to-subject distance. A basic guide number can be quoted for a particular flashbulb or flash unit for a given speed of film, and it can be assumed at this stage that the shutter speed is slow enough for the whole of the flash to be utilised. Assume that the guide number for a small flashbulb and a film with a speed of ISO 125/22° is 28. The distance (in metres) between the flash and the subject and the f-number at which the lens aperture is set are adjusted so that the product of the two is 28. Thus the exposure should be made with the lens set at $f/11$ and the flash-to-subject distance 2½ metres, or $f/4$ with the flash at 7 metres, and so forth. (Guide numbers can equally well be intended for measurements in feet. Clearly it is vital to know of a published guide number whether metres or feet are the appropriate units.)

Guide numbers are generally based on photography in a room of medium size with fairly light-toned walls and the flash on the camera. Any significant departure from these conditions means modifying the guide number. Working in a small room with light walls (as for example when photographing children in the bath) makes it necessary to increase the guide number. On the other hand in a large room with dark walls, or out of doors where there are no nearby reflecting surfaces, it is essential to decrease the guide number. Bear in mind that the exposure is inversely proportional to the square of the guide number, and doubling the guide number decreases the exposure by two stops. To change the level of a flash exposure by *one* stop, the guide number has to be multiplied or divided by the square root of 2 (1.4).

When using bounced flash there is some difficulty in arriving at the correct exposure. Assuming white walls and ceiling from which the flash is bounced, it has been suggested that the normal guide number applies but that the flash distance must be measured from flash to subject via the reflecting surface. This is far too vague for colour work, and bounced flash generally calls for some preliminary tests before committing a lot of film.

The use of flash as a fill-in to lighten unduly dark shadows, either indoors or out, presents exposure problems. Taking an indoor situation first, the

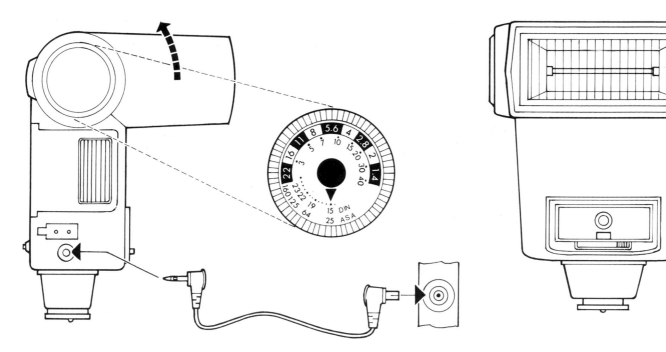

exposure for the daylight should be estimated in the usual way. This exposure must be based on the unshaded part of the subject. As the shutter speed may already have been decided from flash synchronisation considerations (see page 148) this sets the lens aperture (f-number). Then the flash distance is calculated from the f-number. An exposure now made on the basis of these simple calculations will yield a result in which the daylight and flash contribute equally to the lighting, and the picture is likely to look false. It is usually far better to make the flash contribution rather less by calculating from the guide number for an aperture one or two stops larger than used. Out of doors, fill-in flash may be applied in the same way, but bear in mind that published guide numbers do not apply out of doors because of the absence of reflecting walls. It is usual to double the published guide number under such conditions where the flash is the only source after dark; for synchro-sunlight shots the indoor guide number can be used without modification, or else halved.

146

Some caution is needed, however, since the flash is usually required to give only a hint of detail in the darkest shadows, and anything more is liable to look unnatural.

Automatic flash exposure control

The simplest small flash guns, and any complicated set-up, including synchro-sunlight, require exposure calculations to be made from the guide numbers; but these calculations are unnecessary with most modern electronic flash units used on the camera. Such units are called, quite incorrectly, 'computer flash units'. Each is equipped with a sensor that picks up light reflected from the subject. When enough light has reached the sensor the flash is switched off. (In some units, this shortening of the flash time is accompanied by saving the unused charge, ready for the next flash.) The advantage of such an arrangement is that when the guide number has been set up on the flash unit, the photographer can change his flash-to-subject distance at will. As long as he remains within the flash unit's operating

An automatic or 'computer' flash unit is fitted with a light sensor pointing at the subject. When the light from the latter reaches the amount for correct exposure the flash is quenched. This device enables the flash-to-subject distance to be altered within a certain range without incorrect exposure resulting and without the photographer having to make any adjustments to lens aperture.

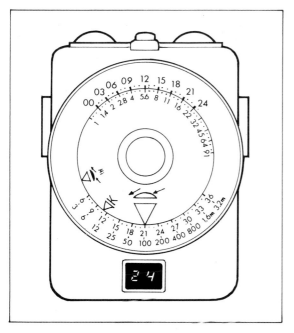

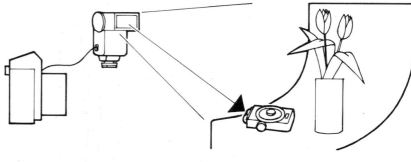

For determining the correct lens aperture in flash photography a flashmeter can be used. It is usually recommended that the domed light receiver of the meter be directed from the position of the subject to midway between the camera lens and the main flash source.

range, the exposure will be maintained at the correct level.

Automatic flash exposure control, like any other reflected-light exposure metering system, depends on a normally-reflecting subject. The exposure is particularly affected by highly-reflecting surfaces. Photograph a person standing against a mirror or window, and the result may be hopelessly underexposed. The flash, directed straight back to the sensor by the shiny glass surface, switches off the flash almost before it has begun.

To achieve correct exposure the camera lens must be set to an aperture to suit the film speed. The simplest automatic flash units allow the use of just one aperture for each film speed; a calculator dial on the side of the unit indicates the aperture and normally the maximum operating distance for each speed rating. Intermediate units allow the selection of two or three different lens apertures for each film speed. The most sophisticated units allow virtually

any aperture with film of virtually any speed. In this type the sensitivity of the light-detecting circuit must be variable to match the combination of film speed and lens aperture in use. Also, the smaller the lens aperture used the shorter the distance range of automatic exposure available.

As the sensor affects the light from one flash gun, clearly that unit must be providing the main light if the sensor is to control the exposure. The sensor should be near the camera, so in most cases automatic exposure cannot be used with flash off the camera, or with bounced flash. However, a number of units have removable sensors or, if mounted on the camera, sensors that can point toward the subject irrespective of the direction in which the flash-head is angled. One excellent use for 'computer' flash is in providing fill-in light, either in flash set-ups or with sunlight. By setting the flash to provide full exposure for a lens aperture one or two stops larger than that actually in use, it is simple to provide a low level of fill-in light.

Flash meters

Although an ordinary exposure meter cannot be used to measure the light from flash sources, there are flash meters designed for use with sources that radiate for only an instant. To use a flash meter involves expending flashes, so it is obviously viable only with electronic flash units, where the cost per flash is small. In use, a flash meter is placed in a representative part of the subject with its white plastic light receptor facing the camera lens. With some meters the recommendation is to point the meter halfway between the camera and the main light source. This is analogous to the duplex method of using an incident-light meter with continuous light sources (page 122). The speed of the film in use is set up on the meter and the flash or flashes are fired. The meter needle flies across the scale and comes to rest pointing at the *f*-number to which the camera lens should be set. The needle remains in that position until the meter is reset.

When the flash is used at close range, the exposures can be very short, as little as 1/50 000 second. This allows spectacular stop-motion effects, but can affect colour film. High-intensity (short-duration) reciprocity-law failure alters both colour and density, sometimes introducing quite unacceptable see-saw casts. To avoid this, when the short duration is unnecessary, reduce the flash output with a neutral-density filter. The filter goes over the tube, not over the sensor. The total exposure remains the same, but the flash duration is increased by the exposure factor of the filter.

Flash synchronisation

An aspect of camera exposures that arises when using flash of any kind is that of synchronising the flash with the shutter so that the bulk of the flash occurs while the shutter is open. When a shutter is set at a relatively slow speed there is no great difficulty in achieving perfect synchronisation. If it can be arranged that the flash is fired as the shutter reaches the fully open position, then any shutter (diaphragm or focal-plane) set at no faster than 1/30 second will capture the whole of a flash either

from an expendable bulb or from an electronic unit. Where a shutter has adjustable synchronisation, 'X' and 'FP' or 'X' and 'M', the 'X' setting ensures that the flash circuit is closed at the instant the shutter is fully open.

To use fast shutter speeds with a diaphragm shutter and expendable bulbs, it is essential that the shutter has an 'M' setting. On 'M' synchronisation there is a delay of about 12 milliseconds between the closing of the flash contacts and the release of the

The camera shutter must be synchronised so that it is fully open when the flash fires. Many cameras are provided with 'M' sync for use with flashbulbs and 'X' sync for electronic flash.

148

shutter blades. This is to accommodate the delay of about 20 milliseconds between the completing of the flash circuit and the peak of the flash from an 'M' type expendable flashbulb. At the 'M' setting, synchronisation is achieved at speeds up to the fastest provided.

Synchronisation of electronic flash with a diaphragm shutter merely demands that the flash circuit closes immediately the blades reach their fully open position. As there is negligible delay between the closing of the flash contacts and the occurrence of the flash, and as the duration of the flash from a small electronic unit rarely exceeds about 1/500 second, the whole of the flash is utilised at all shutter speeds. This is 'X' synchronisation (the 'X' stands for 'xenon', the inert gas that is used for filling electronic flash tubes). When using a camera that offers both 'X' and 'M' synchronisation, it is vitally important to check that it is set at 'X' for electronic flash. If it is inadvertently put to 'M' the result will be no pictures at all. The reverse mistake may not be so disastrous; expendable bulbs can be used at the 'X' setting provided that shutter speeds are 1/30 second or slower.

In synchronising electronic flash with a focal-plane shutter, the 'X' setting must be used and shutter speeds no shorter than the fastest that gives 'open blind' are essential. With a focal-plane shutter the first blind moves across the film, followed by the second blind; the gap between the two forms the 'slit' of the shutter. The faster the shutter speed the narrower the slit, and only at slow speeds does the leading blind uncover the film completely before the second blind starts to move. The makers of a camera state in their instruction booklet the fastest shutter speed at which electronic flash can be used; it varies from camera to camera, from 1/30 to 1/125 second. At speeds faster than those giving open blind, electronic flash gives images just the width of the shutter slit. I have a nice set of half pictures of a little tiger cub that came to dinner one evening: I had used the shutter at 1/125 second

instead of 1/60! Fortunately, in many of the shots the tiger's head was on the exposed bit of film.

Electronic flash units
The cost of a small electronic flash unit has been steadily falling until it is now possible to buy a unit of adequate power for picture-making in the home at around the price of 36 colour prints. Such a small unit is likely to be powered by two small dry cells. If these are replaced with rechargeable nickel-cadmium cells the cost per flash becomes very low indeed, much lower than that of expendable bulbs. The amount of light from a small electronic unit is rather less than that from a small expendable bulb, so a metre guide number of 14 is not unusual for ISO 100/21° film or 28 for ISO 400/27° film.

The light from a xenon flash tube is similar in colour to average noon sunlight plus skylight, but (unless there is built-in colour correction in the form of a tinted reflector) some find that colour transparencies on daylight film exposed with electronic flash are a little cold in rendering, having a slightly bluish cast. Where this is found to be the case a Wratten 81 or 81A filter, strapped over the flash-tube window of the flash unit with transparent tape, will lower the colour temperature of the light sufficiently to make colour rendering less cold. Either of these filters is likely to reduce the guide number slightly, and correction can be made by multiplying the normal guide number by 0.9, so that a metre guide number of 14 becomes 12½.

Some of the more advanced portable electronic flash units offer some valuable facilities. For example, with the unit in the accessory shoe of the camera it may be possible to aim the light at the ceiling for bounce-flash work. In at least one case the unit can be made to produce a double beam, one to project at the ceiling, and a weaker beam for direct lighting of the subject. As a rule, the more expensive the unit the more powerful the flashes it emits, and it may have facilities for running it from batteries, a.c. mains and rechargeable storage cells.

Black-and-white photography

In this age of colour, why black-and-white photography? It is a fair question, one which could be answered by a variety of stock answers, such as 'it gives a better impression of mood', or 'it reduces the scene to the basic elements, for a stronger composition', and so on. These arguments do not hold water. They are used to support the use of colour as often as black and white. What your photography does for you depends entirely on which medium you work in. So we are back to the original question, and no wiser.

The swing away from black-and-white began in the world of the snapshot. It is not difficult to see the reason. Compare snapshots in black and white with those in colour; the latter win every time. If mere pointing-and-shooting is your scene, it is easier to get pleasing colour than pleasing monochrome. After all, colour does look more natural than monochrome, and the colours do go a long way towards sorting out the jumbled mess that is the average snapshot. However, when the camera fan begins to advance his technique, things begin to change. (By the way, it should be understood that 'he' also implies 'she' throughout; the author is no chauvinist.) His first step is to make efforts to *think* about his pictures. As he concentrates on the scene, so underlying shapes, forms, lines, linear and subjective relationships of objects become in many ways more important than the subject matter itself. Thus, he takes these basic elements and creates his image by marshalling them into a special relationship with each other and with the subject. Gradually, as his eye gets keener, the chaos that once characterised his efforts is replaced by pictorial order.

Thinking in black and white
At this point a transformation takes place; monochrome and colour part company. They

Michael Dobson (left), *Raymond Lea* (above)

151

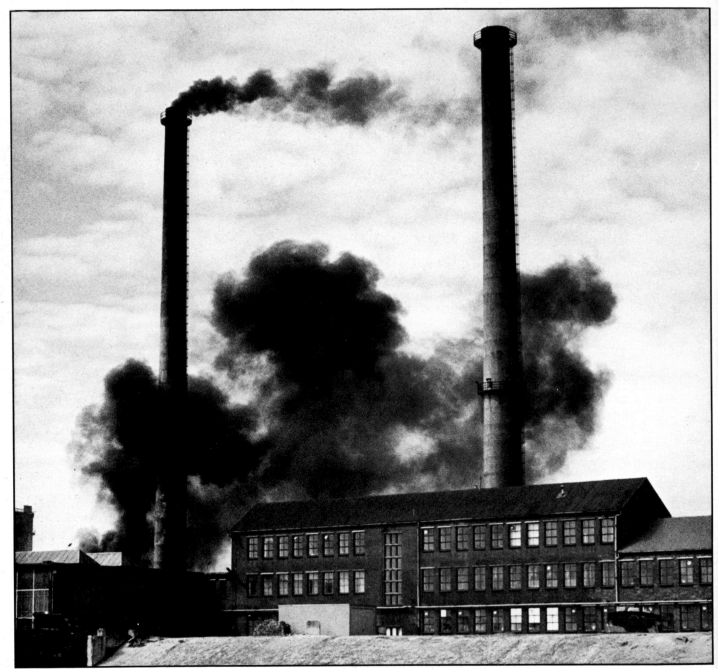

Ben Storm

become two entities, jostling with one another for supremacy. When a thinking photographer uses one in preference to the other, he has to apply his mind to the one in use. When shooting in colour, he must arrange the hues as a part of the composition and create using this extra natural dimension. On monochrome film he has to reduce the scene visually to shades of grey and produce pleasing pictures in a somewhat unnatural medium.

Herein lies the challenge. The mind has to shift gear from natural vision to a special monochrome vision in order to see in greys only. This is no easy task. A photographer rarely achieves this by simply looking at the scene, particularly in the early stages. He must use painstaking, almost mechanical methods to visualise the image in shades of grey so that he can predict the way the image will appear on the print. After this, he must arrange those greys in such a way that they react with one another to produce the maximum effect. It is not easy, no matter what the confirmed colour worker may say. Enough of the comparisons. Suffice it to say that monochrome photography is not the poor relation of colour, nor a second-class citizen. It has a field all of its own; it is an entirely separate medium. It has its own idiosyncrasies, its own problems, its own challenges, and its own ways of meeting them. Do not get confused because you can use either type of film in the same camera. This is all they have in common. Beyond, the division is profound.

That monochrome is less expensive than colour is to its credit, particularly in these days of rising costs. But it is important to learn to use black and white for its own sake, not as a substitute for colour when you cannot afford it. Aim at making the most of monochrome, even deliberately using it for certain subjects and for special effects. Use it *positively* and you will be well on the road to achieving exciting, stimulating results.

The goal of black and white
The aim of any photographic process is to deliver a first-class reproduction. In monochrome

photography, we shall refer to this end product as a Fine Print. The Fine Print is in a class of its own. It stands out; it sparkles; it is of such quality as to convert the colour enthusiast to black-and-white photography. Sadly, many photographers have never seen a Fine Print, and their ideas have been conditioned by prints which are less than excellent.

To begin with, a Fine Print has to be seen in the original. Copies or reproductions cannot do it justice or convey its impact. Therefore, if only to obtain an image of the standard to aim at (and certainly for inspiration) any time you have the opportunity to examine the original work of experts, take it! In the meantime, the aim of this book is to point you in that direction and encourage you along the rocky way towards achieving a Fine Print. The elements can be suggested quite simply, and if you follow them meticulously you will quickly produce your own first Fine Print. All you need is absolute control over exposure, development and printing.

'But wait', you protest, 'isn't that the basis of *all* picture-taking?' Certainly it is, but not in the way intended here. The idea is to start with your pre-visualised Fine Print *before* you press the shutter release. Then compose and assess the exposure that reflects your mental image. This, of course, requires a sound grounding in both exposure theory and practice. By understanding how light works and how it affects subject, meter and film, you are better placed to deal with luminance and colour, contrast and a host of other variables in terms of shades of grey. More important, you can use it to help you to see the image in monochrome, in advance. If it does not suit the mood you wish to convey, you can use this grounding to manipulate the greys to reflect the subjective values you foresee.

Processing is the bridging step. It responds to the exposure to produce precisely the negative you require. The correct methods and chemicals are determined by the exposure, and tempered by the

154

requirements of the paper on which your interpretation of the image will ultimately be printed.

In all of these stages, the only way to mould the image to your preconceived vision is to utilise your grounding in theory and practice. Working 'blind' by trial and error is to court disaster. The art of good black-and-white photography is to know exactly what to do, and what will happen at each stage. You must know not only how to take a picture, but also the precise effect any variation in procedure will have on the image. This knowledge is gained by experiencing the effect on your film, developer and printing paper of a wide variety of conditions. It is effected by appreciating that each successive stage should be handled, controlled and, if necessary, manipulated, to produce the required effect for the next step. Nothing can be treated alone. Appreciating this, what then is our goal? What is this Fine Print?

The Fine Print

A Fine Print must be *seen*. Words alone cannot give you the real picture. However, let us try to provide some of the basic points to look for; the rest is up to technique and a feel for the medium. A Fine Print is an image which does more than merely replicate the original scene. A simple record is not enough. In any case we are rarely able to transpose a scene onto paper literally, for both compositional and tonal reasons. Nevertheless, the Fine Print should have the full range of greys demanded by your pre-visualised image. Where detail is required in the important shadows and highlights it should be present, and the general tonal effect should be brilliant and with a special depth. In short, the print should be the best possible expression of the image you held in your mind's eye when you were at the scene. Moreover, every subsequent step you make after that point: exposure evaluation, processing, etc. should be directed towards the achievement of that image, each stage making the closest approach to your pre-visualised ideal of which the camera is capable.

This, fundamentally, is our aim. In the short space of these few chapters, a little measure of the application necessary to obtain good black-and-white pictures will emerge. It is a challenge to be met, and its proper use is a skill to be acquired. I hope that some of my own enthusiasm for the medium will filter through the necessary lengthy explanations, at least sufficiently for you to make a serious attempt.

The reasons for the need to develp the skills should be obvious. Confidence comes as a result of knowledge based on deeply ingrained groundwork. The philosophy is simple. Become fully familiar with the technicalities and make them a part of your habitual action, and then your conscious concentration will be freed for applying to the subject. This, of course, holds good whether you are shooting in colour or black and white. But, since the latter has inbuilt problems when it comes to depicting reality, technique becomes even more important. Once technique has become second nature, you have only to concentrate on composition, and on producing an aesthetically pleasing picture. Thus your confidence receives a boost. You *know* in advance that you will get a Fine Print. Together, you and your precision techniques will be able to create black-and-white pictures that really do you justice.

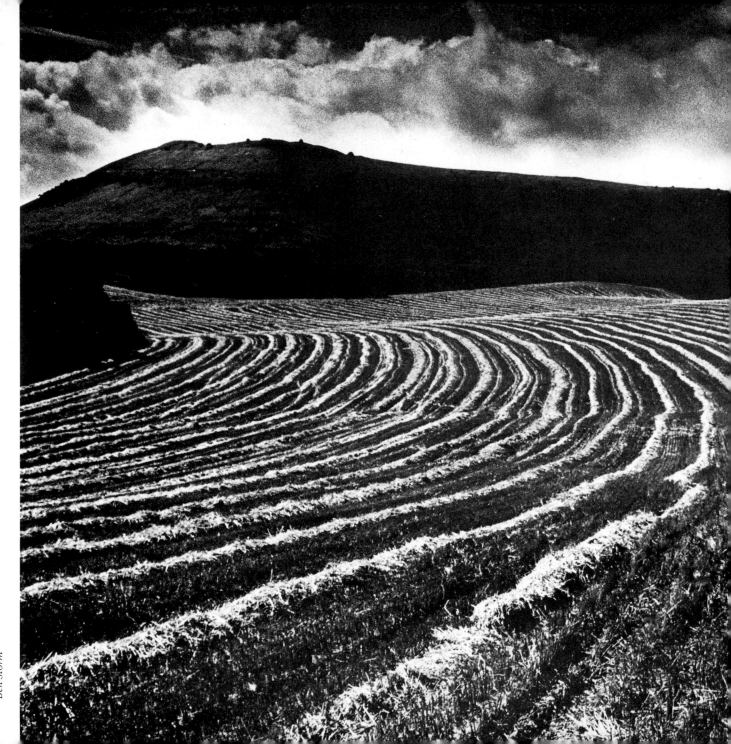

Light and the subject

Light is the life-blood of all photography, but one of the issues which sets monochrome apart from colour is that it is dependent largely on light and shade to produce its own individual effect. Colour can manage with hardly any shadows, relying on the relationship of colours. The problem is that we take light for granted. It is there, and we use it as a means of taking pictures. As long as there is sufficient light to affect the emulsion, and as long as the level is determined correctly, we can be assured of getting a correctly exposed photograph. However, the use of light goes a little deeper than this. The quality and direction of light make the picture, and the real answer to effective light-painting lies in understanding (a) its effects, (b) what it does to the subject, (c) how the film responds to it, and (d) how you can use it to capture the precise image you have in mind.

The content of light

The best starting point is to learn to appreciate the properties of light. White light is composed of a range of wavelengths, each of which, when seen separately, appears as a particular hue. With increasing wavelength the spectrum runs from violet, through blue, blue-green, green, yellow and orange, to red. Where light falls on objects it may be partially absorbed and partially reflected. Objects which absorb (say) most of the reds and blues reflect mainly green, and so appear to us to be green. That is how we see colours; it is also the way a film responds to them.

So-called white light is difficult to define. Its content varies according to the type of source. For example, household lamps have a high red content, whereas the sun, in combination with skylight, has a high blue content. When the sun is rising or setting, the extra atmosphere layers through which it must pass tend to lower the blue content of the

sunlight. These changes in content (or *colour temperature*) do not greatly affect monochrome film, though one type of emulsion may have greater sensitivity to the red end of the spectrum than another, and therefore be more sensitive to tungsten lighting.

The quality of light

Quality of light is important to black-and-white work in the relationships between light and shade. A harsh, strongly directional light casts hard shadows with very sharp edges; in a photograph these come out deep black, with no detail. A diffuse light softens these edges.

There are two factors which influence the light. One is the light source itself. Strongly directional light comes, for example, from a spotlight, or unrelieved desert sun. This means that the photographer often needs a supplementary light source (or a reflector) to lighten the shadows without changing their character. More details are given later. Light is softened by dispersing the light with diffusers, e.g. translucent material in front of the spot, or light cloud covering the sun. In both cases, directional light is then scattered in different directions, some of it into the shadows. The second factor is distance. This, of course, does not apply to sunlight, as our distance from the sun does not vary appreciably. With artificial light sources such as studio lighting, flash etc., the quality of the light changes as the subject is moved farther from the source. This also happens when the source is light from a window.

In these two areas we have the basic tools for personal expression; diffuse lighting can suggest gentleness and softness, while directional lighting can create moods of anger, danger, discomfort and starkness. Of course, there is a whole range between these extremes. There is, too, shadowless lighting. Each picture calls for just the right quality and tonal balance. Once you have chosen your light source, then, you must decide on the direction of the light.

158

This carved wooden panel was dramatically sidelit by shining a torch obliquely across it. *Raymond Lea.*

Directing the light

Lighting direction can produce the all-important impression of depth in the flat print. This comes from the relationship between light and shade. Light by itself reveals shape; shadows combined with light reveal form. When the light source is directly in front of the subject, the shadow falls directly behind the subject, and is invisible. The subject, whatever its shape and form, appears to be flat, virtually a two-dimensional cut-out. With two eyes you may be able to discern depth without the help of light and shade in an actual situation; but on a photograph, where three-dimensional space no longer exists, it is another matter.

Move the light, and the entire picture changes. A cube-shaped object, for instance, looks cubical when one or two of its surfaces are bathed in light, leaving the others sunk in shadow. This is so whether the cube is viewed in real life or in a flat picture. The edge between light and shade tells you its form. The shadow makes the cube look like a

cube; more important, the suggestion of depth is strong. On a cylindrical or spherical object, this lighting direction reveals its form in a more subtle way. The light appears to blend into shadow over a distance. The shape is clear, and the image conveys a strong illusion of depth. All this is possible simply by moving the light away to one side. This is fine, of course, if the light (or the subject) is movable. Where a sunlit subject is immovable, you must exercise patience. The sun moves (all too slowly) across the sky, and you must play a waiting game until everything is right.

Lighting tends to look most natural when it emanates from between 45° and 60° above, and about 45° to one side of, the line of sight. This is the sort of lighting produced when the sun is somewhere overhead during mid-morning, or mid-afternoon. Even when you use complicated lighting set-ups for studio work, you should start with your main light in that position, as your substitute sun. Choose the type of lighting you need to create the desired mood. A spotlight provides sharp directed lighting, with contrasty shadows; a flood, perhaps diffused, softens the appearance. Whichever you choose, it is this 'key' light which provides the form-revealing or 'modelling' illumination.

Set up the other lights to achieve one of two effects: (1) to lighten, or fill in, shadows; (2) to provide special highlight effects on the subject or background. Both, you will notice, are effects supplementary to that produced by the main light. Secondary illumination for lightening shadows should be soft (diffused) and positioned at such an angle and distance that it throws no noticeable shadows. This means that it needs to come from a position close to the camera axis. Highlights, on the other hand, need to be strong and concentrated. Suitable sources are spotlights, lamps which project a narrow beam. Shadows from such lamps should fall outside the picture area; with this proviso the light must be placed where it will deliver the required effect.

Light reveals shape, shadows reveal form. Here, the relationship between shadow and highlight emphasises the three-dimensional quality of the subject. Abrupt changes from light to dark define an object as cubic or angular. Without the shadow, this would not be easy to discern on a flat piece of paper. Likewise, a slow, gentle transition from light to shadow reveals a curved shape.

Left: diffused lighting, with the help of the pale brolly, has softened the shadows and reduced contrast in this portrait. *Manuel Torre.*

Right: the photographer has used the strongly directional light in this scene to evoke a calm evening mood. *Ben Storm.*

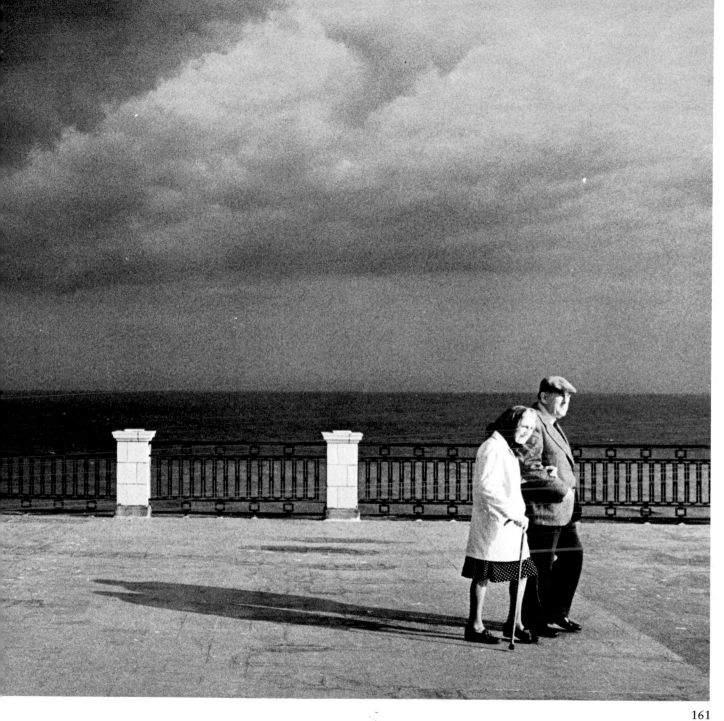

Side-lighting

Real excitement can be generated when we deviate from the norm. For special effects, we can play around with the lighting direction. When the subject is illuminated from the side, the light-and-shadow relationship is exaggerated, and the effect of solidity is dramatic. The subject appears stark and dynamic, and very much three-dimensional. Such extreme side-lighting reveals not only overall form, but also texture. Undulations, pits, projections and surface texture of the object are caught by the light and are emphasised. Surface texture, thrown into relief, adds a new dimension to the illusion of reality. The visual sensation is such that the viewer experiences the 'feel' of that surface and may be almost prompted to reach out and touch it. This makes your illusion act complete: although the image is only two-dimensional, it *looks* real. The features of the human face can also show texture. Sidelighting will reveal the wrinkles and pores of the skin with cruel accuracy. So, unless you particularly want this effect (or want to lose your friends) don't use this technique in portraiture.

Low-angle lighting

A light positioned lower than we normally feel is acceptable produces dramatic effects. Consider the long shadows prevalent around sunrise and sunset; peace vies with menace. Remember the Dracula movies? Evil personified in the 'fanged one' as his victim's blood oozes out of the corner of his mouth, almost dripping into the light source! The hair rises on the backs of our necks, and we shift about in our seats. Perhaps *our* pictures will not elicit such a

Side-lighting reveals the tactile qualities of the subject. This adds a new dimension of reality to the image. Where the surface texture is strong, we could almost reach out to touch it. *Raymond Lea.*

A light held low to illuminate the subject can add a sense of foreboding and even evil to a picture. This gentle cat has been turned into a nightmare figure by the low angled lighting. Such lighting should be used only for special effects.

response; in any event, unless you are sending up a friend, a light shining straight up his or her nose is not likely to elicit co-operation. Nevertheless, you can occasionally use a low light to express a feeling, or to turn an action into something different. Look, for instance, at the picture of the cat accompanying this chapter. It seems to generate evil. Yet he is a very gentle animal, thoroughly good-natured, who just happened to be scratching himself when he was photographed close up, with an electronic flash at a low angle. Who says the camera doesn't lie?

Backlighting

When light falls on the subject from behind, the part of the subject facing the camera is in shadow. Recorded as a silhouette, there is still a remarkable impression of depth. The reason is a little more subtle than with side-lighting. Dark tones are translated by the eye and brain as projecting, or thrusting forward. Light tones, conversely, are seen as receding into the background. Thus the illusion is that the darker subject stands out from the lighter background. With the subject as a silhouette, the separation of distances is heightened by extremes of tonal contrast, emphasised still more by the rim of highlight round the subject. The forcefulness is achieved by starkness of contrast and the clear delineation of the outlined shape.

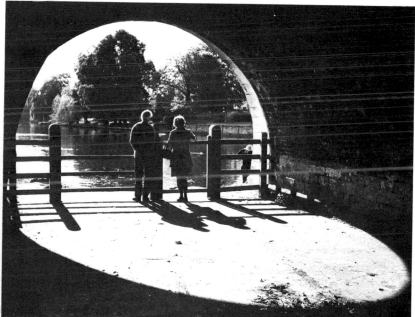

Backlighting must be controlled carefully to achieve the effect you desire. It is tricky, and can cause flare and misleading exposure measurements. If you want detail in the subject, make sure you read only the subject and exclude any other light from the cell. Then adjust your aperture for the value you require. *Raymond Lea.*

When detail is put in the subject, the lighter-toned background is pushed right up the scale into overexposure, and produces a high-key result. Surprisingly, though, the effect you sought to achieve with a silhouette is still present. The burnt-out highlights, appearing in the final print as stark white, achieve separation and depth. The effect overall is light and ethereal. Rim or halo light effects are less harsh and merge with the bright background. Light and shadow, then, are the driving forces for black-and-white pictures. The contrasts make the images; they capture and hold the attention of the viewer.

Handling contrast

Since much photography is practised under bright sunlight, dealing with excessive contrast becomes a problem. It is true that monochrome film needs contrast to create its effect, but too much will spoil this. Empty, solid shadows and bleached-out highlights produce an unsightly soot-and-whitewash effect which is pictorially worthless. A great deal of afterwork is required to produce an image of anywhere near the quality needed to produce a Fine Print. If you can control the contrast at source, the problem is solved. One method has already been mentioned in the previous chapter, namely placing some distance between the light source and the subject. Here are twelve more:

1 Wait until the light is softer. When the sun is hazy or has set, contrast is greatly reduced. Naturally, you can only play a waiting game when the subject is static. However, it is one of the simplest ways of reducing contrast.

2 Find some shade. An easy answer to high contrast is to get a movable subject out of the bright light. Simply move to a shaded area and use the softer light to produce less harsh results.

3 Fill in the shadows. If you can brighten the shadows and thus lessen the difference between shadows and highlights, the contrast is lessened. The difference should be about two stops, three at

the most. Your meter will tell you how much filling in you have to do. The most common method is to use a reflector. A newspaper, white or light-coloured material, even white clothing you may be wearing, are sufficient to throw some of the light into the shadows. If you are in a studio, you can use a second light source or a reflector. Here you have full control; you can see the effect before you shoot. It is a different story with flash, a popular method of brightening shadows. Success depends entirely on how well you know your flash equipment. Test it thoroughly both indoors and out, so that you can produce precise light levels at any time and under any conditions. Take a reading of the subject in the normal way, basing your exposure on a shutter speed which will synchronise with your flash. Use the aperture given to base your calculations for the flash-to-subject distance. However, this gives you a 1:1 lighting ratio, which is too flat. You need 1:4 at least. Two layers of a white handkerchief will do the trick, or a recalculation based on a hypothetical aperture two stops larger than the one you are actually using.

4 Minimise the shadows. Choose a viewpoint where the shadows are largely hidden and become relatively insignificant. Then you can afford to let them remain underexposed and without detail.

5 Use only a part of the contrast range. The step is really an advancement of Step 4. Simply alter your viewpoint so that the subject can be contained within a manageable part of the overall contrast range. For example, instead of taking a portrait with side window light creating extreme light and shade on the face, turn the subject so the window forms the backdrop. Now the subject will be contained entirely within the lower portion of the range, and the highlights can be permitted to burn out.

6 Use a fast film. The inherently wide latitude gives a softer image, and will lower the contrast to something nearer manageable proportions.

Opposite, above: one of the simplest ways of handling the contrast problems caused by a strong, unrelieved sun is to eliminate it altogether. Move the subject into the kinder open shade.

Opposite, below: in the studio, you have absolute control. However, even there you can have problems. The right amount of contrast is required in order to give the subject the punch required in black-and-white pictures. Use the meter constantly to check on the ratio, and control lighting strength and direction accordingly.

Above: outdoors again, soft light reflected on to the face of the shaded subject has dealt with the contrast problem. *Manuel Torre.*

When the brightness range is too long, you have no choice but to make use of only a part of it. You can concentrate on the lower end (as in this case) or you could permit them to underexpose and concentrate on the upper end. The latitude of most films and printing paper cannot cope otherwise. *Frank Peeters.*

7 Use a wide aperture. With some lenses wide apertures produce softer images by introducing more lens flare. So where the contrast is great use the maximum aperture to reduce its effect.

8 Use a telephoto lens. Even though long lenses tend to be softer inherently, you have the additional softness resulting from increased distance. Telephotos drive you back and put extra space between you and the subject. Thus atmospherics such as dust, haze, etc. have a better chance to soften the contrast.

9 Use filters. A blue filter scatters light and reduces contrast. A polarising filter or a yellow contrast filter can darken the sky and bring its tone closer to the tones in the foreground. You can then afford to increase exposure somewhat, to put a little more detail in the shadows. However, filters need careful handling as they can also *increase* image contrast. Soft-focus or diffusion filters deliberately introduce flare, which softens the image by scattering light from highlights into the adjacent shadows. The result is an impression of a shimmering day, and contrast is lowered. Similar effects can be produced by smearing a thin film of grease on a clear filter; making a star-shape with transparent adhesive tape across your lens hood; shooting through a piece of net curtain; or simply using a starburst or other similar filter. An exploration of filters and effects appears on pages 191–198.

10 Overexpose and underdevelop. The first makes sure of shadow detail and puts plenty of density on the film. The second has the effect of reducing overall density and preventing too much build-up of negative contrast. The result is plenty of detail in both shadows and highlights and an overall reduction of image contrast.

11 Use high-dilution development. When your developer is diluted more than normal, the shadows tend to be built up while the highlights are held back, giving lower contrast in the negative.

12 Darkroom treatment. The techniques you can use in the darkroom to reduce contrast in a negative are (a) use a softer paper grade, (b) use a soft-working developer, (c) use water baths during development, (d) use a diffuser in the enlarger, (e) flash the paper to light for about one-fiftieth of the exposure time.

The 300 mm lens necessary to take this shot has brought the contrast within manageable limits. *Brian Gibbs.*

Exposure techniques in black and white

A picture is made in every sense before you press the shutter-release button. This has been said before, but is worth reiterating. The viewpoint must be selected, elements in the scene positioned in a satisfying arrangement, and the correct exposure assessed. Only then should you release the shutter. All these steps are interrelated; a good photograph is the product of them all. However, they can be divided into two separate categories: artistic and technical.

As in many aspects of photography, there is overlap. Training and experience often leads one to establish points of composition along well-tried, almost mechanical lines; witness the application of the rules of thirds and fifths, for example. Also, despite the mechanical process of exposure, there is much room for artistic licence. Nevertheless, the purely technical quality of the picture depends on the initial exposure. Development to the negative stage is linked, but no amount of darkroom sleight-of-hand compensates for badly-exposed negatives. Some limited redress may be possible, but the resultant negatives and subsequent prints will never have quite the sparkle and quality of one made by precise exposure. This, then, is the critical stage of the photographic process. If we have the power of theoretical knowledge, maintained by mechanical know-how, we are free to go in any direction the artist in us chooses.

Ranges and ratios

First, there must always be sufficient light to affect the emulsion. If areas are underexposed, nothing you can do in the developer will help. No method has yet been devised to put detail onto a film after exposure if none has been produced by the exposure itself. If it were possible, you could more or less throw the unexposed film into the developer and *will* a picture to emerge! The truth is that an

Michael Dobson (left), *Ben Storm* (above)

image is only formed by light reflected from subjects in front of the lens. Not all subjects reflect the same amount of light. Much depends on the amount and angle of the light falling on the subject, and on its colour, reflectance and surface qualities. In short, the brighter a subject appears to be, the more light it is reflecting; dark objects reflect less light than bright objects. Thus, between the two extremes of a black object in deepest shadow, and a highly reflecting surface in bright sunlight, there is a range of brightnesses all reflecting differing amounts of light.

The difference between the darkest part of the scene and the lightest is known as the *brightness range*. It is expressed as a ratio. On a sunny beach at midday, for instance, we may find that the highlights are as much as 1000 times as bright as the shadows. The ratio in this instance is easier to understand if you think of brightnesses as *units*. Unit 1 is the deepest shadow in which the presence of something can be sensed (i.e. not quite empty shadow), and the brightest highlight here is 1000 units. The ratio is thus 1000 : 1. Under thick, heavy cloud, however, the picture changes dramatically. Those same areas measured may now show the brightness of the highlights as only 32 times the brightness of the shadows. The units then are 32 and 1 respectively, or a ratio of 32 : 1.

After correct development, the first unit on the negative should show just a trace of density in the shadows, the barest hint of tone. At 2 units it is stronger, with textures just visible; at 4 units full shadow detail can readily be seen and the tone is a definite grey. Over units 8, 16, and 32, the detail is clear as the negative density increases progressively, then at 64 and 128 units most of the available silver halides will have been developed. Total black is reached beyond this point, because almost every particle of silver halide has been reduced to metallic silver, and textures and details are totally obliterated. During printing, the light is held back by the denser portions of the negative, which reproduce as highlights. It is passed more freely by

170

the clearer areas to produce dark tones and shadows.

Latitude
Two factors arise out of this. First, the units we chose moved from lower to higher brightness by doubling, thus linking to the aperture and shutter speed series. Each successive *f*-number passes twice as much light as its smaller neighbour, and each successive exposure time twice as much as the next. The second factor relates to the ability of the film to handle a brightness range. Above a certain point it does not matter how much extra light energy you pour onto a film, as all the silver halides have already been affected. If the saturation point occurs at (say) 256 units, then a negative area receiving 1000 units is no more dense. When printed, it is not possible to tell the difference. Likewise, at the other end, below 1 unit, it does not matter how dark the subject is; the density can go no lower. Thus, zero and ten steps below zero will both produce clear film (give or take a small amount of base fog). They

In this case, exposure was adjusted to suit the mid-tones of the face and hands. The highlight areas produced by the backlighting have been allowed to 'burn-out', enhancing the effect. *Ed Buziak.*

Beach scenes and seascapes such as this can contain a brightness ratio of something like 1000:1, in which case compromise in exposure is the order of the day. *Ed Buziak*.

will all appear as solid black on the print. This is clearly seen in the grey scale, which shows the various density steps and the extreme areas of no detail.

The latitude of a film determines how much of the total brightness range it can cope with. For all practical purposes, a monochrome film is blank below 1 unit and reaches maximum density at 256 units. That is to say, it can show tones and detail within a brightness ratio of 128 : 1, or seven stops. In practice these ratios vary from emulsion to emulsion. The speed of the film decides the actual latitude. Slow films fall a little short of 128 : 1, whilst faster ones extend beyond it. Then there are various after-treatments you can apply, as suggested in the previous chapter, to modify the brightness range present in the negative.

The contrast grade of the paper on which the negative image will ultimately be printed is important. Ideally we should aim at producing a negative to print on Grade 2 (normal) paper each time. However, Grade 2 paper can handle at the very most only a seven-stop spread of brightnesses. Therefore, regardless of what our film might be capable of, we must proceed on the assumption that its latitude is limited to 128 : 1. Now, our original beach scene has a brightness range of 1000 : 1 (ten stops). The paper, and possibly the film, cannot handle it all and still show detail at each end. You are now faced with a decision as to which seven consecutive stops of the ten you are going to fit onto your film.

One way is to put your film's first unit on the brightness unit of 4 in the scene. This would make the highest latitude point of the film coincide with the brightest part of the image, and ensure detailed highlights. The problem is that most shadow areas would then be a uniform solid black. Alternatively, you could try positioning unit 1 of the film on the scene's first unit of brightness. Thus you would get plenty of detail in the shadows, but as your film reaches maximum density at the saturation point of

172

256 units (the eighth stop), the higher brightnesses in the scene (units 512 and 1000+) would record in the print as blank white. You would be, in effect, sacrificing the highlights for detail in the shadows. You could also compromise and select a range in the middle. This time you would lose something in both shadow and highlight extremes. The choice is yours; this indicates the point at which the mechanics of exposure end and personal creativity begins.

On cloudy days you have the reverse situation; the brightness range may extend only over a 32 : 1 ratio, leaving you with two extra stops of latitude. Thus you can fit the scene within that latitude wherever you like. You have the choice of a number of exposures, each of which will still contain the brightness range of the scene.

Meters and tones
Most meters, including all those built into cameras, measure the light reflected from the subject. Although they are able to give you precise information about the brightness value of any part of the scene, they are designed to read in averages. They see every scene as mid-grey. For an average reading of a general scene, this is fine. The meter takes all the lights and darks, and the in-betweens, and as long as these are evenly balanced it will suggest the correct exposure. The indicated exposure embraces all the tonal values. If they extend beyond the established seven stops, the meter will choose an exposure somewhere in the middle of the film's latitude. However, if there is a large dominant tone in the scene the meter can give a misleading indication. Should the tone be mid-grey, all is well. Measure a white one, however, and your meter gives you a higher reading. Shoot at the settings suggested and that white will appear on the negative and finished print as mid-grey. As a result, the darker tones in the picture will be underexposed. For a black area, the meter does the opposite. You get a measurement that is too low, so that all the light areas in the scene are overexposed.

Taking the meter reading from a brightly lit mid-tone renders it a mid-grey standing out starkly against the shadow areas (and against the sky in this shot, because a red filter was used: see later). *Ben Storm.*

As an example, consider a dark building standing next to a light one. The light one gives you an exposure measurement of ½₅₀ second at *f*/16. The dark one reflects only sufficient light into the meter cell to produce ½₅₀ second at *f*/2.8. Both are accurate as far as subject reflectance is concerned, but neither gives the correct reading. If this method were followed through to its logical conclusion and you metered the variety of tones individually within a general scene, you would get a confusingly

different measurement each time. At a shutter speed of ½₂₅ second, for instance, you might get *f*/2 from a doorway leading to an unlit room, *f*/4 from an open shadow, *f*/11 from a brightly lit wall, etc.

In both examples, a constant is required; this can only be a mid-grey tone, an average. In our example, *f*/5.6 falls in between the two extremes and makes a reasonable average so that both the buildings and the surrounding scene receive the

Right: the meter will automatically give you a mid-grey, or Zone V, no matter what the tone of the original subject. This means that you must apply manually the adjustments needed to bring the tone back to where it should be. In this case the natural colour of the stone lion was Zone III. In order to attain this the aperture was closed down two stops after metering.

Left: each tone within a scene tells your meter something different, but the meter averages all the tones to a mid-grey. Therefore a light scene is underexposed and a dark one is overexposed, having been given readings too high and too low respectively. In these pictures, when the darker building (left-hand picture) was metered, the reading was ½₅₀ second at ƒ/4; a measurement of the light building (right-hand picture) gave ½₅₀ second at ƒ/11. In the first case, lighter parts of the image were overexposed; in the second, darker parts were underexposed.

Right: if you adjust the aperture to control one tone, the remainder are affected too. Efforts to produce a strong sky as well as detail in the jets have led to a compromise. The jets, as the darkest part of the subject, were metered first and set on Zone V to ensure detail. Then they were progressively moved down through Zones IV, III and II, while the sky was monitored. Only when the jets read Zone II was the sky the correct value, but that left them without detail. They were then raised to Zone III and the sky, while lighter (Zone VII instead of VI), is acceptable.

Below: A white door or other light object can easily fool the meter. A direct reading causes the meter to average the tone and give you a setting that makes it mid-grey on the negative. Lower values which appear in the scene are pushed down the scale into underexposure. The only way to compensate is to add density after metering: open up by the required number of stops to force the white door up to its proper position on the scale.

correct exposure. It becomes clear, then, that everything in a general scene, regardless of its actual, individual brightness value, should have the same exposure. Only by finding the average to satisfy the meter can you assign the variety of tones into their proper places in the tone scale.

Where there is only a very light tone to meter, we must add density after measurement by opening the aperture to prevent it recording as a mid-grey. One stop makes the value a tone lighter on the print; two stops, two tones lighter, and so on. For a dark tone, we close down the required number of stops. These additional steps are the only way we can return the subject to its proper tonal value and expose the negative correctly.

Since through-the-lens meters measure reflected light, this ability to interpret and re-evaluate what the meter is telling you is important. If you use a spot meter it is absolutely vital. The spot meter sees only a tiny portion of the image. Its angle of acceptance can be as narrow as 1°. Compare this with the 30° or more seen by an integrating meter, including those which read through the lens, and you can appreciate the value of careful measurement and interpretation. Mostly the spot meter sees only a single tone. You have to know what to do with it after you have measured this.

One way of overcoming this problem is to avoid measuring the scene at all. Take a reading instead from a specially designed 18 per cent reflectance grey card. Such a card is used by the makers of meters for calibration purposes, and can be obtained from photographic suppliers. As long as it is held in the same light as the scene, the meter will give a correct exposure reading, and it will not be influenced at all by different tones within the scene. As a bonus, all those values in the scene are automatically placed in their proper tonal positions. It works whether you are faced with a multitude of tones or a single one. If you do not have your card with you, try metering the palm of your hand. The value is about the same as a middle

grey, perhaps a shade lighter or darker, depending on skin colour.

Incident-light metering At first glance, the incident-light meter seems to avoid all this. Using an opal diffuser over the light cell, it measures light incident on (i.e. falling on) the subject (rather than light reflected from the subject); the reading is thus unaffected by the dominant tones in the subject. What is more, if the brightness range is longer or shorter than the film's latitude, it will always place the exposure squarely in the middle. The snag is that, as you have not metered important tones within the picture, it is not easy to know what the relationship of the latitude of your film will be to the scene's brightness range. Nevertheless, despite this shortcoming, the incident-light meter is extremely accurate for general reading when used correctly.

More difficult subjects
Whichever type of meter you have, there are photographic situations which may catch you out, or which require some interpretation. To help you deal with such problems, here are six of the most common:

1 Dominant contrasting background Large, dominant tones within the scene will affect the meter enough to give a false reading. You get too high a reading for a light background, and too low for a dark one. The results are respectively under- and overexposure. Naturally, it is the *subject* which must be exposed correctly; the background does not matter here, so it should not influence the reading in any way. Consider a portrait, to be taken with a dark background. A general reading from the camera position with an integrating meter may give, say, a reading of ⅟₆₀ s at f/2.8. However, a close-up reading of the face alone, (making sure the background does not influence the cell at all) suggests ⅟₆₀ s at f/8. Reading from a grey card we find that the correct setting is ⅟₆₀ s at f/5.6. Now change the background for a white one. Camera position reading this time will probably be ⅟₆₀ s at

A dominating dark tone can lead to an underexposed image. The meter turns it into a mid-grey and pushes other tones well down the scale. Make sure you measure only the important part of the subject.

When aiming for detail in a backlit subject, and the highlights are not important, you can make the shadow side lighter than would otherwise be possible. The eye accepts such tonal values at one or two stops higher.

f/16. The close-up reading will stay as before, as the lighting has not been altered, and the same amount of illumination is falling on the face. For the same reason the grey card reading will not alter. Only the background is different; but this does not affect the subject. If the camera position readings had been used, the face would have been two stops over- and underexposed respectively. Although it may be felt instinctively that the face with the white background is lighter, this is not so; it remains the same. For this problem the best type of meter is the incident-light type.

2 Backlighting In some ways this problem is similar to the one above. With the main light source behind the subject, the effect is an extremely bright background, contrasting strongly with the foreground subject. In this case, the principle of exposure measurement remains the same, i.e. ignore the background and establish the exposure that the subject itself requires. However, at this point it does differ. There are two approaches you can make to backlit shots: either turn the subject into a silhouette, or expose for complete detail. One way of achieving a silhouette is simply to point the meter cell at the light source. That will push the remainder of the tones far enough down the scale to ensure little or no detail can be seen. Another method is to use the technique outlined in the previous chapter. Meter the subject directly and then close down the aperture the required number of stops for the tonal value required. About four stops will give you a silhouette. On the other hand, if you want full detail in the subject, take a close-up reading as before, and then open up two stops. Again, you have total control and can place the values where you want them to be. Above two stops more than the reading, you move into the realm of high key. It is worth noting that where the subject is in total shadow, and the highlights do not matter, you can raise the tonal value of the subject higher than 'natural' without destroying its acceptability. For this problem the best type of meter is the spot meter.

To obtain a complete or
partial silhouette, simply
point the meter cell at the
light source. Greater
control is possible if you
meter the subject directly,
then close the aperture
down by several stops in
order to achieve the effect
you previsualised.
Raymond Lea.

3 Extreme cross-lighting Even though this lighting is useful for emphasising three-dimensional form and texture, as we have already discovered, it does present exposure difficulties, particularly for reflected-light meters. It tends to give inflated readings causing the shadow areas to be underexposed and lose detail. You can, of course, learn through experience to make a manual adjustment after reading. An alternative, and perhaps more reliable, method is to make a two-tone reading. Meter first the highlight side, and then the shadow. Provided the contrast ratio is not too high, the average should be just about right. A simpler method is to use an incident-light meter. No correction will be necessary unless the shadows are very deep, in which case exposure may be increased by one to two stops. Of the three types of meter the incident-light type is best for this problem.

4 Water More potentially good seascapes and pictures including water have been ruined by its high reflectance than by anything else. Water tends to bounce back the brightness of the sky, almost to the same level. It will catch your meter out if you do not give some thought about how to cope with it. Knowing in advance that water inflates reflected-light readings is half the battle. A spot meter scores here; it is able to pick out the subject of interest, even if it is a tiny object surrounded by a great expanse of water. An incident-light meter will not even recognise its existence. If you have only a TTL meter, or a hand-held, averaging type, you would be better advised to use substitute subjects (grey card or hand). Make sure, however, that they are in the same light as the subject. For this type of problem the best type of meter is clearly a spot meter.

5 Night scenes Night-time neon signs, illuminated shop windows, street lamps, and so on, look pretty and urge the attention of your camera. An integrated-light reading from the camera position will get you a great picture of the lights themselves.

Water is notorious for giving inflated meter readings. Subjects that are in it or surrounded by it are pushed down to underexposure. Play safe by taking a substitute reading of a grey card held in the same light, or measure the incident light.

At night, unless the dominant shadows are catered for, the brighter lights cause them to render without detail. Meter the lights and then open up the aperture by three or four stops, or meter the shadows and control the detail as you would with a backlit subject.

The snag is that they will be in an inky black sea. Nothing of the streets or other background details will show. The meter, as usual, is influenced by the brightest part of the image, i.e. the light sources, and gives you exposure estimates which are much too low. You do not want the lights to be averaged into the middle of the scale. You need them right at the top, where they should be, at the extreme upper range of the emulsion. Then the important lower tones, which make up most of the image, will be within the bottom limits. You could, of course, try reading from some of the lower values themselves and closing down the aperture a further two or three stops to position them at more or less their proper values. But, since they tend to be very low, it is possible your meter will not even register. Often there is only one course: guesswork. The more night photography you do, the more adept you will become at recognising various night 'brightnesses'. Thus you will be able to select actual exposure settings which, together with exposure 'bracketing', permit you to expose fairly accurately every time.

180

The best meter for night photography is a spot meter. In this situation an incident-light meter is virtually useless.

6 Extreme close-ups Very tiny subjects may defy reflected-light metering because it is impossible to use the meter without casting a shadow on the subject. If you move back, the background will exert undue influence on the reading. A grey card is one answer, but a better method is to measure the incident light. When taking extreme close-ups with a macro lens or with lens extension tubes or bellows, you will still need to make a further correction. This is because the lens is much farther from the film than usual, and the *effective f*-number (which is the lens extension, *not* the focal length, divided by the aperture diameter) is different from the marked *f*-number. There are two ways to make a correction. The first is to find the effective *f*-number. This is given by the expression:

$$\frac{\text{marked } f\text{-number} \times \text{lens extension}}{\text{focal length of lens}}$$

Small subjects can cause problems unless metered with care. Surrounding tones influence the readings, but since the subject is so small it is difficult to take a reading direct. An incident-light reading will do the trick, or a measurement from a grey card. *Neville Newman.*

accurately. It cannot adjust to abnormal subjects, or to your individual whims, by itself. In nearly all problems of exposure, it turns out that the answer will be found in the identification of an important tone, from which, with the help of the meter reading, an evaluation of the exposure can be made. Provided the brightness ratio is acceptable to the film, the adjusted tone value will position all the other tones correctly. Recognising that the control of tones is vital for making precision exposures – the key to good black-and-white pictures – the next step is to become thoroughly practised in exploiting your meter to this end.

Precision metering

In 'Black-and-white vision', the problem of the translation of colour to tones was touched on. Following pages have made it clear that in order to be successful with monochrome photography you must be acutely aware of the tonal values represented in the scene. They should be assessed and arranged to provide maximum effect.

To find the lens extension you simply add the lens focal length to the amount you have moved it forward from its 'infinity' position. The other method gives the increase in exposure directly. The proportional increase in exposure is given by the expression: (magnification of image + 1)2

For example, if the image scale is 0.7 times that of the object, the proportional increase in exposure is 1.7^2, or approximately three times the metered exposure. If the image is twice the size of the object, the required increase is $(2 + 1)^2 = 9$ times the metered exposure. That may seem a lot, but it is what you would have to give. By the way, if you use TTL metering you do not have to make any compensation, because the meter automatically takes it into account.

Thus we see that correct exposure is the product of meter allied to mind. Do not think that the meter can do all the work. The meter can do only what it has been calibrated to do, i.e. measure light

By now you will have discovered the difficulties of seeing a colourful scene in monochromatic values. The viewing filter does help, of course, but it can only furnish you with limited vision and, by and large, show you when there is sufficient tone separation, or too much. The answer is found in the reflected-light meter methods we have been looking at. For instance, if you have already discovered a mid-grey tone and have made your average exposure, you have a basis for discovering something about the rest of the scene and taken a big step forward in being able to see in monochrome.

Let us say your average gave you $f/8$. Now you meter some nearby foliage and find that, at the same shutter speed, let's say $\frac{1}{125}$ s, the aperture reading now drops to $f/5.6$. That means one stop less light is being reflected, and it will therefore reproduce on the film as one step darker. A reading on a doorway may be $f/2$, or four stops less. This gives you a clear image of what is going to happen

The famous Cologne Dom was 'anchored' on mid-grey, a straight meter reading, giving settings of $\frac{1}{125}$ second at $f/8$. The light wall on the white building proved to be four stops above the metered value, indicating that it would be paper-base white. The darker portion of it was one stop lower. The darkest part of the trees were five and six stops below the metering point: this would be so underexposed as to record no detail. Lighter parts of the same trees were only two stops below. The other tones appeared to fall satisfactorily, so the picture taken.

to that part of the scene, for you know that four stops less than average (or mid-grey) gives you only a hint of tone on the film and will be virtually black on the print. At the other end, some light stonework may read $f/11$, and a yellow sign read $f/22$, i.e. one and three stops respectively above the average reading. In the first tone you will see light grey; in the second you will see little detail because the sign will be almost burnt out.

Visual values
Now you can see how a detailed accounting of tones in the scene will help you to visualise what the finished result will look like. The colours of the objects are more or less incidental. The important issue, and the key to visual translation, is the reflective brightnesses. Meter these, and place them visually, and you gain a clear impression of the final image in monochrome.

This is, in fact, the basis for the Zone System. Originated by Ansel Adams and embraced and promulgated by such notables as Fred Picker and Minor White, it is a highly sophisticated form of negative production. There is a great deal of mystique about the Zone System for those enthusiasts around the edge. When you break in, you find that it is simply a precision method for obtaining preconceived results, from image sighting to Fine Print. Moreover, it helps you decide how you are going to achieve the preconceived image through the various stages before you even make the exposure. Perhaps its greatest value for the black-and-white enthusiast is that it links the various tone readings to a visual key or 'grey scale'. When you can directly relate an exposure check of the type described above to definite shades of grey, then you have a concrete vision of how those tones will appear in the print. Of course, the range of tones is continuous, from white at one end through to black at the other. But that is hardly of help to you; so the stepped grey scale has been devised to simplify the job. Arbitrary steps indicate the full range of the scale in stop values, each one doubling or halving the brightness of its neighbour.

Zoning

The Zone System, not unexpectedly, calls these steps 'zones'. Each zone is given a number; with experience the user begins to cotton on to which subjects fall on which zones. The zone numbers are given in Roman numerals, plus a zero value. Zone 0 is total empty black, and Zone IX is sold, burnt-out white. Middle grey is Zone V. So in our example above we will have found an average tone, say some grey stone, to give us Zone V. The foliage reading is one stop less and falls on Zone IV. The doorway, which was four stops less, is on Zone I. At the other end, the light stone falls on Zone VI (one stop more), and the yellow sign, three stops more, on Zone VIII. By making a direct comparison with the relevant zones on the grey scale, you can actually have a vision of the finished black-and-white print almost forming before your eyes.

After you have played around with the system for a while, it becomes clear that it enables you to be absolutely precise in placing tonal values. For example, suppose you are shooting the backlit scene against the light mentioned on page 00. If you take an average reading, you know that the brighter values will give you an inflated reading and reduce exposure for all the other objects. They will become silhouettes. Do you know just how much detail will record in those silhouettes? Even if that is what you want, can you be sure it will match precisely your conception of the completed image? The answer must be 'no'. All you know is what the average light is, and you may be reduced to bracketing exposures to make sure.

Now try it the Zone System way. Meter the shadow area direct. Let us say it is $f/4$. You know that if you leave it there and shoot, it will record as middle grey on the negative, pushing the higher values right over the top into gross overexposure. Close the aperture down a stop to place it on Zone IV, and you slide the other tones down a stop darker. Make it two stops, to Zone III, and you are into the low values, but still showing plenty of detail. Now move down to Zone II. This is three stops less than measured; at an aperture of $f/11$, you have a silhouette with just a suggestion of detail and texture. This would be a good position to shoot it. Now check the highlight values, and see where they fall. If they are on Zone VIII or IX, that will be fine. You will have the barest traces of tone there too. Any higher, and you are into specular reflections which will register as pure white on the print. By using this method, you have taken the tone accounting a stage further. Instead of finding out just where the other tone values lay, you are now employing the system to exercise full control over what you see and how it will appear on film.

Finding an anchor

Accounting for tones raises an interesting problem. When you start working their positions out, you must first of all establish a basic exposure. Now, in the case of working out a silhouette, the subsequent

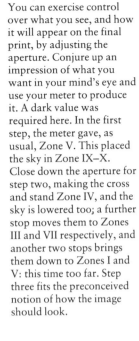

You can exercise control over what you see, and how it will appear on the final print, by adjusting the aperture. Conjure up an impression of what you want in your mind's eye and use your meter to produce it. A dark value was required here. In the first step, the meter gave, as usual, Zone V. This placed the sky in Zone IX–X. Close down the aperture for step two, making the cross and stand Zone IV, and the sky is lowered too; a further stop moves them to Zones III and VII respectively, and another two stops brings them down to Zones I and V: this time too far. Step three fits the preconceived notion of how the image should look.

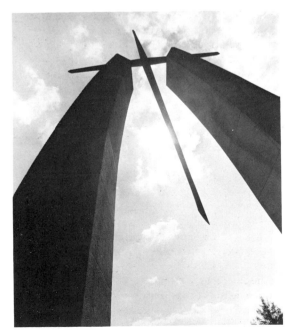

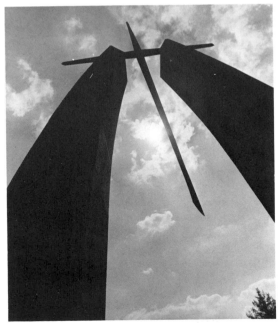

closing down of the aperture sets it for you. But, in a straightforward lighting situation, oddly enough, it is not a simple matter. You need to establish an average setting, which means locating a suitable value to meter. This does *not* necessarily mean a mid-grey. You can meter any value, and as long as you know where it should be on the grey scale, you can open or close the aperture to establish the basic setting. And that is the problem in the beginning: identifying tones.

There are a number of everyday objects which customarily fall in the middle values, Zones IV to VI. If you can identify these, you have a variety of sources for establishing your 'anchor' exposure. Some are listed in the table.

Zone IV	Zone V (mid-grey)	Zone VI
close one stop	straight reading, grey card	open one stop
Skin in shadow	Dark skin	Caucasian skin
Landscape open shadow	Sunburn	Snow in shade
Building open shadow	Weathered wood	White concrete under
Dark stone	Grey stone	overcast sky
Dark foliage	Light foliage	Light stone

The idea is to start with a known value. Look for an easily identifiable one, or a tone over which you want control and know where you want it to be. Let us say it is a human face. The chart suggests Zone VI, and reference to the grey scale satisfies you that it is correct. Zone V is too dark. Therefore, after measurement, you open the aperture by one stop. Now you have your anchor exposure. Other tones can be accounted for, and discovered at what points on the scale they will fall. That gives you the visual image of the scene in terms of shades of grey required for pre-visualisation. Where you cannot find a suitable tone, you can always use your grey card, or the palm of your hand. In every case, you will realise the importance of taking the meter close to the tone to be measured, or of using a spot meter. No other value must be allowed to influence it at all. If your anchor zone is shifted, everything else

will shift with it. While this may not create any special problems in the middle values, at the shadow and highlight ends it could be critical.

The processing link
The point has been laboured that successive steps in the negative-positive process cannot be taken separately. You must not divorce print-making from film development, nor film development from exposure. Indeed, this entire chapter has been devoted to a method of visualising the finished product before you have actually released the shutter, and relating it to exposure. In the middle, development to the negative stage is linked, too. The idea is to develop the film in such a way as to reproduce the negative which precisely represents your exposure manipulations. You have taken the trouble to expose for the right shade of grey; it is important that your development procedure drives you towards that visualised goal.

During development, the highlights begin to form almost immediately. These are the areas of the negative which have received the greatest amount of light and are, therefore, the densest. Since they are full of exposed silver halide, they are quickly reduced by the developer to metallic silver. A little later the less affected areas begin to appear, and so on down the scale until the image in the shadow areas, which has very little exposed halide, starts to form.

Now, the trick is to permit the film to remain in the developer for the exact amount of time to allow each value to reach the correct density. With the regions of lowest exposure, i.e. the shadows, this is not so critical because once all their few exposed halides are developed they become little denser. However, at the highlight end, things are different. Highlights have more halide exposed than is required for a detailed image. If you leave the film in the developer too long, the image continues to gain in density, destroying detail in the process. Conversely, if you do not leave the film in long enough, there is insufficient density overall and the

pictures loses impact and sparkle, not to mention having under-valued greys. The important thing is that development must be carried out in such a way as to ensure correctly valued greys, as well as a correct relationship of these greys to one another. What you do during exposure determines how you must treat the film in the developer.

While expressions of mood are best undertaken during the exposure of the negative, as we have seen already, one can to a limited extent print down or up to enhance emotional expression in the final picture. It is necessary to examine the scene or the image closely to see if there is any way in which it can be improved. Not every possibility for mood enhancement may have occurred to you when you were at the scene; the pressures at that time may have been too much. However, when you have the test print before you, you can examine every aspect of the image at your leisure. Your mind is freer and creativity is able to come to the fore.

Low key

Tones in themselves can be emotional. Dark values, for instance, are sombre; when dark shadows dominate a scene, the subjective experience is of mystery, sadness, even death. There is a power in dark tones which stirs and touches deep down inside. The precise effect, however, depends on the environment it expresses. Let us raise old Dracula again, for a brief moment. There he sits in his castle, embraced in deep shadow. There is fear, the deep foreboding that something evil is about to happen. Compare this with a scene of an old woman in dark, dingy surroundings. This scene, too, is full of dark tones, but here we feel something different: sorrow, horror, perhaps compassion. Try to look at important masses in the scene, and decide at what value they should be to express your emotions. Instead of recording them at their natural value, think again. A Zone V, as an example, may be stronger if lowered to Zone III or even Zone II. Now check to see how this will affect the other tones and masses. Perhaps Zone III is as low as you

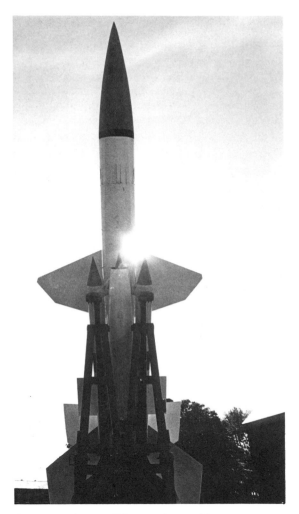

dare go, and you will have to lower this area individually at the print stage by burning-in.

The term for darkened values such as this is 'low key'. In a low-key scene the lower values dominate and allow the higher values to be emphasised only through isolation. There should be plenty of dark tones in the scene to start with. All you do is lower them further. To produce them from nothing is fraught with problems. However, when the values

A darkening of tones often improves the overall appearance of the image. This has been achieved here by printing down; while both pictures would be acceptable, the darker one adds an impression of foreboding.

do not seem to be quite right, you can help things by swinging your viewpoint around so that you are shooting into the sun. Then objects between can be rendered as low as Zone 0 if need be.

High key

Light tones, on the other hand, have a happy feel about them. They can be used to express summer or bright sunlight, and can evoke memories of laughter, enjoyment, youth, and the like. They can

be emphasised in a picture by reversing the exposure procedure outlined above. Place Zone VI on Zone VIII or IX and lighten the whole image (the need for a check on the other zones goes without saying). You are now in the realms of 'high key'.

The difference between shifting the key during exposure and shifting it during printing becomes very clear at this point. In a scene, you will probably find that the deeper shadows range lower than the point where you have placed Zone 0. If you expose the film at that point, because it can show no values lower than Zone 0 the original low zone numbers will all show up as the same black. If you raise the key in printing those low zone numbers will be raised too, along with everything else. They cannot stay black, even though they were originally lower than Zone 0. If you do this at exposure, however, the story is different. If these lower values were, say, Zone 0 minus 4 stops, and you push the key upwards by adding three stops exposure, you still have Zone 0 minus 1 stop. In other words, you still have deep rich blacks.

To suggest that a black is out of place in a high-key picture is wrong. Granted, there should not be large areas of black or the scene will not be truly high-key. However, even a tiny portion of black acts as a focal point and provides a sense of depth for visual effect. It may be as small as the pupils of the eyes in a portrait, or a distant, shadowed cottage doorway in a beach scene.

Of course, key shifting, or rather the mood evoked by it, is a personal thing. It is no good expecting that you will please everyone all of the time. All you can do is please yourself, and hope that there are sufficient who think as you do to make the picture a success. It is all made possible by paying particular attention to the tones present in the subject, and not merely accepting them but making them *work* for you, to emphasise the parts of the image you consider important.

Tone relationships

The variety of tones within a picture can be expressive in either a vivid or a subtle way. For instance, in the low-key picture, if the values are lowered far enough, you could be left with just two: shadows and highlights. The visual power possessed by such two-tone pictures, with their sharply contrasting values, is striking indeed. The reason for this is twofold. First, the contrasting tones act upon and emphasise one another. The

whites seem to be whiter, and the blacks blacker. Second, where the tones overlap, the contrasting values delineate each other's shape clearly.

But now we come to an interesting visual effect. If the lighter tones are grey rather than white, although the separation is still there the image will have lost some of its impact. As the grey becomes darker, so the contrast and impact lessen. Moreover, as one value is altered so the other, too,

188

Predominantly light values (high key) are achieved during exposure. There must be few shadows present; but if the exposure is correct, denser portions of the subject retain their values on the print. If you try to achieve high key by simply printing lighter, the darks are raised too, resulting in the loss of any black and a lack of impact. *Ben Storm.*

is apparently affected. Although there is no actual tone change, the progressive darkening of a lighter background seems to lighten the foreground tone, dragging it along. By the same token, if you lighten the background the apparent tone-separation is further increased. The foreground appears to become darker, seeming to raise the contrast.

Another visual point arises from extreme tonal relationships. Lighter values, of course, reflect more

light than dark ones; this makes light areas appear larger than dark areas, even when in fact they are the same size. This illusion, however, is counterbalanced to some extent by the apparent 'thrusting forward' of the dark values. Both of these effects are useful devices for creating illusions of depth, and strengthening certain parts of the image.

These visual features are important in compositional arrangements, regardless of how

As darks seem to project forward, they are a useful device for introducing the impression of depth to a picture. They contrast sharply with lighter background tones. *Paul Broadbent.*

The idea of visual impact through contrast is even more marked when the scene includes a human being. Even though they may form a tiny portion of the total picture area, people excite interest and catch the eye.

small they might be in the picture. As long as there are no other dramatic contrasts in the scene, even small darks against lights will catch and command the eye. You can use contrast in this way to separate the subject from a messy background. Choose a viewpoint which places the subject against a part of the background with which contrasts tone, and it will be clearly discerned. If the subject is a human figure, it will command even greater attention, no matter how small it is. This is a psychological effect; the viewers will seek out a human figure every time. And when it has attention drawn to it by its contrast against the background, it dominates the image. However, not every picture has to have the impact of vivid contrast to be a success. Indeed, the tones can be quite close together and still give a soothing impression of harmony. In mist and fog particularly, tonal values are subdued and the greys move to the middle of the scale. There are virtually no blacks or white. The tones appear to flow into one another, giving a strong feeling of quiet and peace. Any blacks and

190

white are present only to provide a centre of interest.

This small centre of interest is desirable because it prevents the picture from losing its visual effect. Even in a tranquil scene such a visual point is useful. Because of its immediate attraction it should be an important part of the picture. As a secondary subject, it is too strong and will draw the eye away from the main subject, unless that too is strong. The only way to achieve such a saturated tone in mist or fog is to be close to the subject. It is the fog itself which causes tones to be subdued into greys. Thus, the less fog there is between you and the subject, the less subdued will be the tones of the subject.

Local tone adjustments
So far we have been looking at ways of dealing with tonal values which are already there. These are generally shifted in their entirety by manipulations of exposure and development. Local changes are possible only during printing, where, to a limited

You do not need sharply contrasting tones in every image to achieve interest. Tones predominantly of the middle values, and quite close together, can also produce subjective impressions in images. Here, the feeling is of quiet solitude.

degree, dodging and burning-in provide a means of lightening or darkening certain values. There will be times, however, when we want to make greater adjustments, in a way that the fundamental skills of exposure, development and printing do not allow. In this event we turn to the use of filters. With filters you can change and dramatise values to influence the general mood of the picture. For instance, if in a low-key picture you wish to raise the value of, say, a red door, then you would shoot through a red filter. Not only would it achieve the effect you were after; it would also deepen the contrasts, for a stronger low key.

But perhaps that is going too far ahead. Let us step back a bit, and have a look at how filters work with black-and-white film. Panchromatic emulsions are sensitive to the whole range of hues in the visible spectrum, unlike the earliest emulsions, which were totally blind to red. This sensitivity is, for the most part, fairly uniform across the visible spectrum. However, the response of the eye is not uniform;

for example, it is much more sensitive to yellow than to red or blue. So the film does not respond to colours in the same way as the eye. Therefore, many of the greys we do see in the final picture do not correspond with the brightness we expect. For example, foliage reproduces too dark to be acceptable; tomatoes and other red fruits, too pale; and the sky has a habit of burning itself out. A filter of the right hue corrects this, raising or lowering the various colours on the grey scale so that each becomes more acceptable. This it does by altering the content of the light reaching the film. As we saw in the red filter and red door example above, a filter will pass its own colour unhindered, while altering others. A red filter passes red light and other colours containing red to increase the density of these negative areas. They then print lighter. However, blues and greens, and other colours containing them, are absorbed by the red filter, and record darker in the final print.

Correction and contrast filters

Filters for black-and-white photography can be separated into two groups: correction filters and contrast filters. The first corrects the emulsion's response to the colours seen, and the second exaggerates their differences for special emphasis. The division between the two types is sometimes only in the depth of the filter's colour. A light yellow, for example, corrects, whereas a deep yellow falls into the contrast category. Others, however, such as red, are contrast filters regardless of depth. Filters in each of the categories are:

correction filters	contrast filters
light yellow	deep yellow
medium yellow	dark green
yellow green	orange
light green	red
light blue	deep red

Because the filter stops some of the light from reaching the film, overall exposure is affected. The makers give exposure factors for their filters, but for real control you need to determine your own. You must be quite precise, so that you can understand the meticulous tonal adjustments you are now capable of. Since you are working to such precise limits you cannot afford accidental underexposure. Even a slight mistake can push the delicate value placements down far enough to destroy the first impressions of texture of Zone II and of detail in Zone III. If you follow the suggestions closely, you will make your tests under various lighting conditions. This is important because the type of light source can affect the filter factor. The reason for this is the spectral content of the light. 'Warm' (i.e. reddish) lighting, for instance, will influence 'warm' filters such as yellow, orange and red only slightly, so that these require less adjustment in exposure than the 'cold' filters, the blues and greens. Tungsten filament lamps, and daylight at sunrise and sunset, are examples of 'warm' sources, whereas noon sunlight, overcast daylight and electronic flash are examples of 'cold' or bluish sources. In colder light,

192

Control tones locally with the aid of filters. Different tones can be made lighter or darker to achieve contrast or harmony. Here, three filters have been used to demonstrate the differences that can occur. Top left: no filter. top right: green filter. Bottom left: orange filter. Bottom right: red filter.

the warm filters must have their factors increased, and the cold ones must have them decreased.

Exposure factors are not the only things to be altered by a change in lighting conditions. Tonal values are not quite the same either. Under warm light, for instance, a warm filter increases markedly in effect. In fact, the effect can be so strong that you may need to consider whether the content of the light is 'filter' enough, without the application of further filtering. This problem is most evident in portraiture. In either daylight or tungsten illumination, Caucasian skin tones benefit if they are darkened slightly for that healthy, sun-tanned look. This means that you should avoid using red or orange filters, because they lighten skin tone too much. Thus in daylight you might use a pale green; but under a warm tungsten light you need a cooler blue filter.

Different types of film respond in various ways to filters. Fast films tend to be more sensitive to red,

Always use filters for specific purposes. To keep a single filter in place for all pictures is to lose much of the value of filters. Examine the subject and decide whether a filter will enhance it. In this case a green filter was used to aid the tonal separation of the green leaves and green fern.

giving warm filters a greater effect. Thus, compensation with a medium yellow filter on a fast emulsion may be too much. Cooler yellow-green is much better. The green in it moves the tones back to a more acceptable level. The slower films, being in general less over-sensitive to the red end of the spectrum, respond in a more balanced way to the warmer filters. For instance in the case mentioned above the medium yellow filter is more suited.

Uses of filters
Specific filters tend to be associated with specific uses. Although a particular filter may be suitable for a variety of purposes, there may well be pitfalls. Take green filters, for instance. These are used a great deal to lighten foliage, and increase the separation between the various subtle shades of green which might otherwise be lost. However, green filters also darken the sky, so if the effect is overdone by using too strong a filter a reversal of tones will occur, the foreground foliage becoming lighter than the sky. The sky and other blue areas are also darkened with orange and red filters, dramatically so in the case of the latter. But they darken greens too; if there are large areas of both colours close together, these two completely different colours will merge as the same shade of grey. Orange and red filters are best used to exaggerate and dramatise the contrast between blue and neutral grey or yellow in juxtaposition. A good example of this is a yellow or red building standing out white against an almost black sky.

When considering the need to adjust the value of the sky, you should be aware that the degree of darkening for any given filter depends on the position of the sun. If the sun is close to the field of view, the effect will be minimal. As you move farther away to bring the sun to an angle of 90° and more, so the effect of filters is increased. Sky filters give their best when working away from the sun.

Blue filters are perhaps the most under-used. One excellent use is in portraiture under tungsten illumination, as we have seen. In addition, a blue

filter is valuable for increasing the effect of haze to enhance a mood, or to provide better tone separation between similarly-toned objects as they increase in distance from the camera. Its greatest advantage, though, is to reduce the effects of contrast; it is a useful tool for getting you out of the difficulties associated with an over-long brightness range.

One of the most useful filters is a polarising filter. With it you can create three basic effects. First, you can use it to subdue or eliminate unwanted reflections; this is the use for which it is best known. Secondly, it can reduce the effect of atmospheric haze. Thirdly, it can be used to darken the sky without altering the other tones. The reason for these effects is as follows. Light can be thought of as consisting of waves travelling out from the source. Usually the vibrations, which are at right angles to the direction of propagation, are random in orientation. When light falls on a surface their direction of travel is altered. A matt surface reflects the light in all directions, with lower intensity, having absorbed some of it in the process. However, a polished surface reflects light more or less in a single direction, producing what is called specular reflection. When the surface is non-metallic (e.g. glass or water), the reflected waves vibrate almost entirely in one direction only, and the light is said to be *polarised*.

A polarising filter transmits only light which is polarised in a particular orientation, and if the light incident on it is polarised at right angles to this direction it is completely blocked. Specular reflections can be reduced or eliminated. Thus, shop window displays can be photographed without showing annoying reflections, and highly-polished wood can be made to show its grain. Spectacles lose their unwanted reflections and show the eyes more clearly. Water can be made to vanish and the sand or stones below revealed. It is, of course, important to keep these effects under control. If the impression of the presence of water goes completely, you lose realism. It is preferable to

194

The decision whether a filter should be used must be made carefully. This shot required none at all. A viewing filter showed that, because of the position of the sun in relation to the shooting angle, the sky would be dark enough.

Right: a yellow filter was chosen here, to darken the sky slightly and thus provide a better backdrop for the subject. Note that the sun was behind the photographer, and so maximised the filter's effect. *Raymond Lea.*

set the filter a few degrees away from the precise angle of polarisation, to allow a little of the reflection to remain, for effect.

Specular reflections are most strongly subdued when the light strikes the surface at an angle of 30° to 35°. At steeper or shallower angles the reflected light is only partially polarised, and the effect is less marked. In the same way, the reduction of back-scatter depends on the angle of the sun. The greatest reduction in back-scatter is when the axis of the polarising filter (which is always marked on the filter) is pointing towards the sun. Light reflected from matt surfaces or from polished metal is not polarised, and here the filter has no effect.

Haze is penetrated by a polarising filter on similar principles. Light back-scattered from droplets of water suspended in the air is to some extent polarised, and the filter will partly block this back-scatter, with the result that tonal values in the distance become sharper and clearer. Light from a clear sky is partially polarised, and the use of a polarising filter can darken the sky and increase the contrast between sky and clouds. The effect is at a maximum when the camera axis is at right angles to the direction of the sun, and the axis of polarisation of the filter should be pointed towards the sun. Thus the filter can be used for both haze suppression and sky darkening together.

Do not use a polarising filter when shooting through the windscreen or windows of a vehicle. The toughening process leaves stresses in the glass, and these affect the polarisation of light passing through them in a pattern which is clearly visible through a polarising filter. The result is dark bands or cells all over your picture.

Testing the effect of a filter

Since tonal placement is vital, it is important to know beforehand the precise effect filters will have on certain colours. As they lighten or darken values, they are really shifting them to different positions on the tone scale. You can run some simple tests to ascertain the amount of shift of each of your filters by photographing a colour-patch card, obtainable from photographic dealers. Shoot first with no filter, then with each filter in turn. Do this under a variety of lighting conditions. Then, using the filterless picture as a guide in combination with your tone ruler (see next chapter), compare the values of the various filtered shots. Write the colour of each filter and the lighting conditions on a separate piece of card, and include the appropriate card in each shot. See what happens to the tones and make a note of their new placements. You might consider making a tone ruler for the shift incurred by each filter. At the very least keep a full record so that you can make an accurate decision as to the filter required for a given effect.

Overleaf: a strongly sunlit scene can be transformed into unreality by shooting through a red filter. *Frank Peeters*

Left: an orange filter has dramatised this skyscape to just the right extent. A red filter would have darkened the sky too much in relation to the foreground silhouettes. *Michael Dobson.*

Special effects

The camera, it has been observed, never lies. On the face of it, a perfectly valid statement . . . or is it? The camera takes a three-dimensional subject and turns it into a two-dimensional image. It reduces a multi-coloured landscape to black, white and a range of greys. It destroys all sense of scale, turning the highest building into an image of no more than a few centimetres, or enlarging a microscopic insect to the size of a monster from another world. It destroys perspective. It freezes action so that the fastest racing car might appear to be standing still, and it reverses the procedure to give a blurred impression of speed in a subject moving at no more than walking pace. The camera never lies? The more you think about photography, the more you come to realise that it really does little else.

What is more, all the above examples are found in what might be termed 'ordinary' photography. When we enter the world of special effects, anything and everything is possible. Filters introduce colours and patterns that could never exist in reality, lenses distort and exaggerate, special film produces red foliage and green skies, and unusual lighting turns the mundane into the macabre. Everyday objects become abstract designs; images are multiplied, distorted and blurred; pictures are combined with each other, stretched into panoramic formats and softened at the edges. It isn't until you begin to delve into the secrets of special-effect photography that you realise just how much is possible.

Subjects for special effects
Special effects are all around you. Some rely on no more than understanding the workings of your camera: images grow larger as they blur so that the sun, when photographed out of focus against a sharply-focused foreground object, can appear as a

gigantic ball of fire, even when shot with a standard lens; point sources of light will follow the shape of the lens's aperture as it is stopped down, and so using the smallest stop on a lens will often give a starburst effect on the right subject without the use of any filter. Other times, special effects rely on no more than keeping your eyes open; for instance, seeing and photographing the rainbow that appears in the spray from a sunlit fountain.

Anyone who was brought up on an old-fashioned box camera, or any simple snapshot model that had no double-exposure prevention device, has probably already taken one of the special effects mentioned in these pages purely by accident: taking two pictures on the same frame without winding the film between shots. That mistake, very common in years gone by, but less so in these days of more sophisticated equipment, forms the basis of multiple-exposure photography, a technique which, when used correctly rather than accidentally, can lead to some amazingly unusual pictures.

As we shall see throughout this book, some effects are so simple in their conception that you can't always believe how easy it is to produce them. So when you are thinking out a special-effect picture, don't go about the most difficult way of producing it just for the sake of a technical exercise. When you really think about it, you might find that there is often a simpler way of achieving the same effect.

Special effects should be used with care. This is especially true when using some of the effect filters that are currently available. If the technique you are using is one that adds a certain effect to an existing picture, it should never be used in an attempt to make a bad shot good. Rather, it should be used to add something extra to a picture which is already good in its own right. Conversely, some special-effect pictures show nothing more than the effect itself, and those should be worked on to make them as technically perfect as possible. Remember that *different* doesn't necessarily mean *good*.

200

Learning from mistakes

The photographer about to embark on special-effect work must have patience. He or she must be prepared to waste time, and often a lot of film, on pictures which don't quite come off. Many a time, a picture will need no more than a slight adjustment in some factor to make it work. If you see that in a finished picture, don't try to fool yourself, or anyone else for that matter, into thinking it has worked when it hasn't. Learn by your mistakes, go back and start again. For that very reason, one of the most useful items the special-effect photographer can have is a notebook. As you go through each phase of a complicated process, make brief notes about exactly what you are doing: exposures, lighting etc. If, then, you have to go back and start again, much of your groundwork will already have been covered and it will take far less time to set up your equipment in accordance with your notes and make the necessary adjustment to ensure the right result the second time around. Or the third. Or the fourth. Never be afraid to learn from your mistakes.

Special effects are scorned by many as not being 'real' photography. But, as we saw at the start of this chapter, very little about photography is real. All we are doing when we enter the world of special effects is exaggerating reality, bringing in a little fantasy. The purist might put this branch of photography down as nothing more than a handful of tricks. But it's more than that. Carrying out many of the techniques described here will teach you a lot about straight photography. Special-effect photographers who work at their craft are often a lot more knowledgeable than their 'straight' counterparts. They rarely rely on automation, but really come to know the theory of not only *how* a picture is taken, but also *why* it comes out the way it does. This means they learn all the rules, and then learn how to break them. Very often, the people who take only straightforward pictures have never even learned the rules in the first place. Instead, they have been relying on some complicated modern marvel of electronics to do the work for them.

Page 199: a picture that uses a combination of several effects techniques. The girl was first photographed standing upright against a black background and with the camera on its side. Other images were made by multiple exposure. The sky was first back-projected against a silhouette of a potted plant and 'hills' made from a tablecloth; the moon was added in a dark part of the sky, also by back projection. The colour of the clouds resulted by copying a straight slide of a blue sky on to infra-red film, using tungsten light and a green filter. The moon was originally shot with an 800 mm telephoto lens. The birds were on a separate piece of lith film, which was finally bound with the original image as a sandwich.

All of which perhaps sounds a little too serious. We must not overlook what is perhaps the biggest reason of all for taking this type of picture. Special-effect photography is *fun*! Once you have tried one effect, you won't be content until you have tried them all. And then you still won't be content until you have tried several variations on all the popular themes, going on to invent your own ideas, dreaming up special techniques that might never have been seen or tried before, and producing pictures that are unique to you and your way of working. If you photograph landscapes or portraits or still-life or any of the million-and-one subjects available to the straight photographer, you can exercise creativity and add your own personal touch to the picture but, at the end of the day, you are restricted by your subject. When you are a special-effect photographer, you have no such restrictions. Nothing is impossible.

A thin smear of petroleum jelly on a clear filter or piece of optically flat glass softens the edges of the image. *Frank Peeters.*

Filters

A filter – any type of filter – is a device for removing a specific element from a mixture of any number of other elements. A photographic filter, in its true sense of the word, is no exception. It removes part of the light passing through it, leaving that which remains to give a particular effect. It should be borne in mind, however, that many so-called filters are nothing of the sort. A glance through any manufacturer's catalogue will show a high percentage of 'filters' that should more properly be termed 'optical devices'. Rather than filtering light, they are made specifically to produce special effects such as the splitting of an image into several parts or producing multi-coloured, star-shaped patterns from a point-source of light. Even close-up lenses, by virtue of the fact that they are often manufactured and sold by filter companies, are tending, these days, to be referred to as 'filters'. Hence the reference to a photographic filter *in its true sense of the word*.

Filters, in their many styles, colours and combinations, are probably among the most widely-used special-effect accessories. They must also rank among the oldest. Many photographers who might claim never to have taken a special-effect picture in their lives would be extremely loath to admit to never having used a filter at some time. And from the moment they screwed the most basic piece of coloured glass to the lens of their camera in an attempt to (say) make more of a spectacular cloud formation, they were adding something extra to their photograph, putting an image on to the film that wouldn't ordinarily be there – entering, in fact, the world of special effects.

Types of filter

A filter might be made from any one of a number of different materials, glass, gelatin and plastic being

the most common. The colours are usually produced by dying or coating the base material. Filters can also be made by sandwiching gelatin between glass. However they are produced, their effects are the same. Most good-quality filters are multi-coated in the same way as camera lenses, to reduce flare that might otherwise come from surface reflections. While some lenses have built-in filters and others are designed to be used with filters fitted to the rear element, by far the most traditional place to fit a filter is over the front of the lens. There are four ways of doing this:

1 Screw-in filters are held in their own special ring, designed to screw into the camera's lens mount. Although there are many different makes of cameras and an even greater number of makes of lenses, most manufacturers keep to standard diameters of mount and the filters are made in these sizes. The mount of a screw-in filter has a male thread to screw into the camera lens and a female thread of a similar diameter on its opposite side. Thus several filters can be screwed together if the desired effect demands it. The thread can also be used for fitting other accessories such as lens hoods. Step-up and step-down rings can be used for fitting filters of one size to lenses of another.

2 Some camera manufacturers build their lenses with a bayonet fitting on the front of the lens mount instead of the more traditional screw thread. With these, it is invariably necessary to use the camera maker's own filters which are, of course, designed to bayonet onto the lens.

3 Filters can also be designed to push on to the lens. The outer diameter of most lens barrels is usually around 2 mm more than the inner diameter. If, then, your lens takes 55 mm screw-in filters, it is a fairly safe bet to assume that it will take 57 mm push-on filters.

4 The fourth method is somewhat different. The most noticeable difference is that the filter is square, rather than circular, as is the case with all

204

the above types. Also, it is supplied without a mount of its own. Instead, a separate holder is provided as part of a system. The filter slots into this holder which, in turn, screws into the front of the lens by way of an adaptor, interchangeable for different diameters of lens. This method of attachment is probably the most versatile for the special-effect photographer. The filter holder features several slots, allowing a number of different filters to be used in conjunction and, because those filters are square rather than round, they can be moved up and down in the holder as required, particularly useful when using two-tone or graduated filters. With the circular type, the division between the tones always falls in a fixed place within the picture area, usually straight across the centre; with movable square filters, that division can be shifted to coincide with, for instance, the horizon which, for the sake of better picture composition, might have been placed off-centre.

Filters are made for many different purposes: changing certain tones in black-and-white photography, correcting casts in colour photography, providing special optical effects in either colour or mono, colouring portions of pictures, polarising light, reducing its intensity without colouring it, absorbing ultra-violet radiation, controlling and correcting casts in colour printing, changing the effective paper grade in variable-contrast black-and-white printing, governing the colour of darkroom safelights . . . those are just some of the more common uses. It would take a great deal more space than is available in this short chapter to expound in detail on how and why all these different filters work. What we are concerned with here essentially is the use of filters for creating special effects in the camera. To that end, we will concentrate only on those that are of use to the special-effect photographer.

Filters for mono
White light is composed of a mixture of seven colours: red, orange, yellow, green, blue, indigo

Page 202: a blue filter, used with colour film can turn day into night. Here, to enhance the effect, the moon has been added, using multiple-exposure techniques.

Page 203: filters intended for mono photography can be used to dramatic effect on colour film.

How different filters affect colours. The girl is standing in front of a blue background, wearing a red top and green skirt. In the first picture (top left), the colours register as similar tones of grey. In the following pictures, those tones have been changed by the use of red, green and blue filters in, respectively, top right, bottom left and bottom right pictures.

and violet. The reason the world looks yellow when you look through a piece of yellow glass is because the glass, or filter, transmits mostly light of its own colour while absorbing all the others, especially the complementary colour. Put the same yellow filter in front of a camera lens and, because it is transmitting more light of its own colour than of any other, yellow objects in the picture are better exposed than anything else, while objects of the complementary colour, in this case blue, receive less exposure. If the camera is loaded with black-and-white film, those yellow objects will record darker on the negative and therefore lighter on the print. The blue objects naturally will record lighter on the negative and so darker on the print. From this, we can see that a filter, when used in black-and-white photography, lightens its own colour and darkens its complementary.

Mono photography filters come in several different colours. The most common are yellow, green, orange, red and blue. They also come in different shades of those colours, and the stronger the shade the more pronounced the effect. Because these filters absorb a certain amount of light, their use requires extra exposure. Unfortunately it is not enough merely to screw the filter to the front of your lens and leave it to through-the-lens (TTL) metering to compensate for the difference. That should work in theory of course, but in practice you are up against the fact that meter cells, unlike film and the human eye, read colours differently. Cadmium sulphide cells in particular are more sensitive to the red end of the spectrum than to the blue end. So when using an orange or red filter, the meter will be misled into giving the wrong exposure. For this reason, manufacturers sell their products with a quoted filter factor.

If a filter is designated, for instance, as a 2× Yellow, twice the normal exposure will be needed when it is attached to the lens. That means opening up by one stop or adjusting the shutter speed accordingly. Similarly, a 4× Orange would mean opening up by two stops, since each stop effectively doubles the exposure. So if your normal scene needs an exposure of $\frac{1}{125}$ second at $f/8$ and you are using a filter with a 4× factor, you must adjust your exposure to $\frac{1}{125}$ second at $f/4$ or $\frac{1}{30}$ at $f/8$, whichever is more convenient for that particular picture.

Let's now look at the practical side of using coloured filters for special effects in mono photography. Probably the most frequent use is to help put clouds back into a scene where they have been wiped out by the difference in exposure needed for a typical landscape and the sky above it. A yellow filter used here will darken the blue in the sky (yellow's complementary colour), allowing the white clouds to stand out better by comparison. The yellow filter will also help reduce distant haze to the level of that seen by the human eye, rather than the way it would normally be recorded on film. Substituting an orange filter for the yellow strengthens the effect. Whereas yellow makes skies look natural, orange exaggerates the effect, making them more dramatic. It also helps to reduce distant haze. An orange filter darkens violet, green and blue; at the same time it lightens yellow, orange and red, while increasing the contrast between yellows and reds.

For really special effects, turn to a red filter. With this, blue skies turn almost black, making white cloud formations stand out by stark comparison. Contrast is increased over the whole picture but, if you remember the rule of thumb we began with, you are in for a surprise when it comes to the effect on grass and trees. Because green is near enough the complementary colour to red (cyan is the actual complementary; green's complementary is magenta), you would expect grass and leaves to register darker than normal. In fact, any foliage, photographed in mono through a red filter, registers as nearly white. This is known as the 'wood effect' and here's why it happens.

Green objects in general are seen to be that colour because they absorb the other colours of the

A normal sky becomes far more dramatic with the addition of a red filter in mono photography. Notice how the same filter has lightened the green of the grass rather than darkening it as might, at first, be expected.

spectrum, especially the complementary colour. Most green objects therefore absorb a lot of red. Plants are green because they contain a chemical called chlorophyll. Although this is green, it has the unusual property of failing to absorb all red light, reflecting the longest red rays at the far top end of the visible spectrum, as well as infra-red (see the chapter on unconventional films, page 237). Although the effect can't be seen by the human eye, the film picks up the fact that a lot of red is being reflected from leaves etc. and, with a red filter, leaves naturally record as lighter than usual.

Landscape photography, however, is not the only use to which coloured filters can be put in mono photography. They are useful too for portraiture.

Here, a green filter, darkening its complementary colour, will darken flesh tones and lips. A light-orange filter, lightening its own colour, will help hide freckles or slight skin blemishes, providing you remember that it will also give your subject an apparently pale complexion and lighten lips perhaps a little too much. When using an orange filter for this purpose, therefore, it is often a good idea to ask your model to wear a darker-than-usual shade of lipstick. A blue filter will also give your model an apparent tan, with the added bonus of lightening blue eyes; an effect that works particularly well with male portraiture.

Filters are also useful for copying purposes. Often, the subject to be copied might be old and worn,

perhaps with a bad stain across it. To remove the stain in the copy photograph, simply fit a filter of a similar colour, thus lightening it to the point where it disappears on the negative. Documents that might be on paper which has yellowed over the years can be copied with a yellow filter to lighten the paper and so put back some of the contrast that age had destroyed. If you are copying an old photograph where the image has yellowed and so lacks contrast with the base paper, use a blue filter to darken the yellow. The permutations are endless, just so long as you remember the basic rule about filters lightening their own colour and darkening their complementary.

Filters for colour

All the filters mentioned above can equally be used with colour film, though the effects they give obviously differ tremendously from those obtained with mono film. It takes only the palest of colours to add a cast to a colour picture, and the filters made for black-and-white are far from pale. Nevertheless, they can be used with colour film to give strong, overall casts to pictures. Filter factors and the increased exposures they necessitate hold true for both mono and colour.

Orange and red filters can be used effectively when shooting sunsets, though it must be said that if the sky you are photographing is a particularly spectacular one, the use of these filters is liable to destroy the effect rather than enhance it. It is better to reserve them for use when the sun is setting in a clear, cloudless sky. Try using a green filter here as well. Unlike orange and red, the result will be extremely unlifelike, but realism has never had to be the aim of the special-effect photographer. Blue filters, used with colour film, can turn night into day, or sunlight into moonlight. The effect works best when the shot is also underexposed by around two stops.

There are, of course, a number of filters made specially for use with colour film, not so much for creating special effects, but more as a means of

208

correcting colour casts that might occur under certain conditions which the special-effect photographer might encounter along the way. Here, briefly, are the uses of some of the more popular types. UV filters are practically colourless, but actually filter out the ultra-violet light that causes the slight blue haze in sea and landscapes. A skylight filter is a light-pink colour and helps eliminate the blue cast that might be present when shooting in fine weather under exceptionally clear blue skies.

There are six filters in the straw-coloured 81 series, the most popular being 81A, 81B and 81C. They can be used with daylight-balanced colour film in cloudy or rainy weather, taking out the blue cast that these conditions induce, or for warming shadow areas in fine weather. The 81A can also be used with Type B film, balanced for tungsten light, when shooting with Photofloods. The 81A and 81B are also useful in colour photography for giving a tanned look to a model with pale skin or for warming skin tones that might appear too cold when shooting with electronic flash. The 80B is a strong blue filter for using daylight film in Photoflood lighting. The 80C is a slightly lighter-blue filter which corrects the light from clear flashbulbs when used with daylight flash. The 82A is a light-blue filter for use with daylight film in early morning or evening light, correcting the warm cast evident when shooting at these times. The 85 is an orange filter for shooting Type A film, balanced for Photofloods, in daylight. The 85B is a slightly stronger orange filter for use with Type B film, balanced for tungsten light, when shooting in daylight. All these filters have their own filter factors that apply and are used in the normal way.

Polarising filters

Polarising filters can be used with colour or mono film. Their two most common uses are for darkening blue skies, and for minimising reflections in glass or water. To understand how the filter does that, you must first understand a little of the nature of light itself. Imagine light rays as a series of long,

A simple colour wheel, showing how the three primary colours (red, green and blue), together with the three secondaries (cyan, magenta and yellow) can be arranged in a circle. Each secondary colour is made from a mixture of the primary on each side. Each colour is positioned on the wheel directly opposite its complementary.

Right: the effect of a polarising filter. Normal light vibrates along its line of travel at random (top). A polarising filter acts like a grid, restricting the direction of some vibrations (bottom).

The two most common types of filter are those that are round and screw directly into the front of the camera lens (far right), and the square variety which slot into a special holder which in turn, screws into the lens (right).

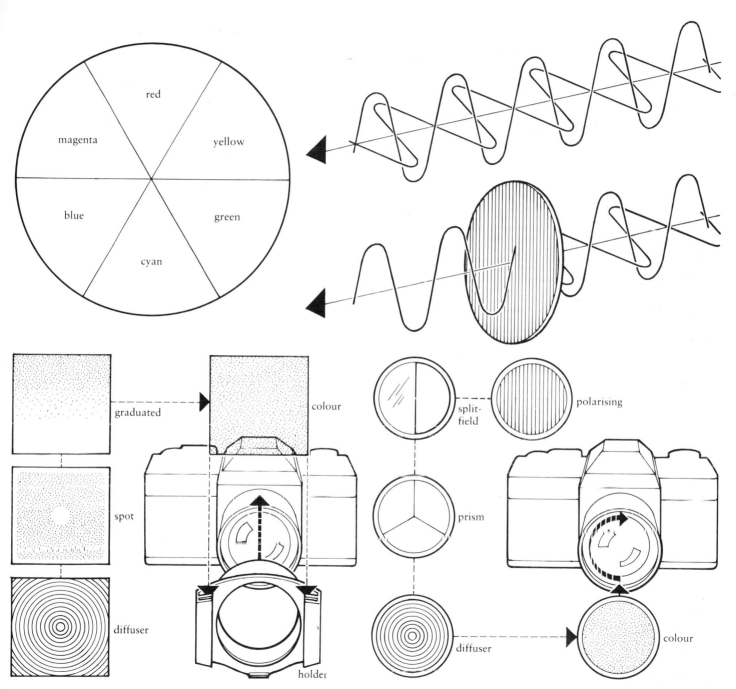

red

yellow

magenta

green

blue

cyan

graduated

colour

spot

diffuser

holder

split-field

polarising

prism

diffuser

colour

A polarising filter can be
used to darken the sky, both
in mono and in colour.

Another use for the
polarising filter is to subdue
reflections. The little girl
was photographed from
outside through a large
picture window. The first
picture is a straight shot;
the second was taken from
the same position, using a
polarising filter.

thin, straight tubes. Within these 'tubes' light vibrates back and forth across the direction of travel in different random planes. When those vibrations are restricted to one plane only, the light is said to be polarised. Polarised light occurs naturally by reflection from non-metallic surfaces like glass or water. A blue sky is a major source of polarised light, since its light is made up from reflections of the sun off particles in the atmosphere. Light can also be polarised by filters. If such a filter is pointed at a source of polarised light and slowly rotated, there must come a point where the filter is blocking light rays in the same and *only* plane as those from the source. At that point the filter absorbs all the polarised light.

Here is a practical example. Supposing you want to photograph the contents of a shop window, but you are being hampered by reflections of buildings opposite in the glass. The contents of the window are being lit by direct light whose rays are vibrating at random. The image of the buildings, however, is brought to you by reflected light which is polarised and whose rays are vibrating in one plane only. A polarising filter can now be fitted to the camera lens and rotated until its effect matches and cancels the one plane in which the reflected light is vibrating. The reflections then disappear. The filter also, of course, cancels the same plane in the direct light which is illuminating the objects beyond the glass, leading to a certain light loss. That can easily be compensated for by an increase in exposure, dictated as always by the filter factor.

The same applies when photographing objects underwater and when surface reflections need to be minimised. Also, when photographing shiny objects such as wet landscapes, a polarising filter can be used to minimise the reflections from objects like leaves or grass. Reflecting the light will have subdued the colours, but the reduction of these reflections gives the picture a cleaner, brighter look. By the same token, a polarising filter pointed at a blue sky can kill many of the reflections that are part of its make-up, rendering the sky much darker.

The degree of polarisation varies with the angle of reflection, and is at its height when you are looking at a surface from an angle of around 30–40 degrees. For that reason, not only the position of the filter on the lens but also the camera angle in relation to the subject must be carefully chosen for the best effect. By the same token, polarised light in the sky is at its lowest near the sun and at its maximum at 90 degrees. Keeping the sun to your side when you are shooting, therefore, gives the best results. If you are using a polarising filter on a single-lens reflex, you can simply fit it and watch the effect through the viewfinder until maximum polarisation occurs. On a non-reflex camera, you will have to turn the filter in front of your eye until the desired effect is found and then carefully, without rotating it any more, transfer the filter to the camera.

Neutral-density filters
The task of a neutral-density filter is simply to absorb and so reduce any light that passes through it, without colouring it in any way. To look at, they are various shades of grey and can be used equally effectively for black-and-white or colour photography. They come in a range of densities, usually designated by a figure that denotes the percentage of light transmitted by the filter. Hence ND50 would signify that 50 per cent of the light is absorbed and 50 per cent transmitted, effectively cutting the light in half and demanding a light increase of one stop – a filter factor of 2. The filters can be combined to give stronger effects. Exposures are then calculated by adding the density factors together or by multiplying the filter factors.

Most filters are chosen for their effect, and the factor by which exposure must be increased is an inconvenience which must be remedied. With neutral-density filters, the reverse is true. They are chosen for their filter factors and are used specifically to cut down unwanted light, allowing the use of wider apertures or slower shutter speeds than would otherwise be feasible. So with the appropriate filter, you can use extra-wide apertures

to reduce depth of field where necessary. You can also use extra-slow shutter speeds when, for instance, you might want to blur motion on a bright day when only a fast shutter speed would normally be feasible. Taking things to their logical extreme, you could use two or more neutral-density filters together to give exposure times of almost hours even in bright sunlight. That way you could photograph a busy street, making all moving objects effectively vanish by virtue of the fact that they would not have stayed in one place long enough to register on the film.

Calculating exposures with neutral-density filters is not always a straightforward task, since reciprocity failure plays its part when exposure times start to get lengthy. Trial and error is therefore recommended before an important picture is attempted, but as a starting point, try opening up one extra stop for exposures of 1 second, 2 stops for exposures between 1 and 10 seconds and three stops for exposures of up to 100 seconds.

Special-effect filters

Now we come to that branch of 'filters' of which some are actually optical devices. Nevertheless, for the sake of simplicity, we will refer to them all here simply as filters. There are many different types, each giving its own individual effect. Here are some of the more popular, together with the effects they create.

Cross-screen Finely-etched lines in the filter glass (or plastic) produce flare patterns in the form of long, straight lines from any point-source of light. The number and pattern of the rays so produced varies with the way the lines are etched. In some, only two lines of flare emanate from each side of the light source; in others four, six or eight lines might be produced, leading to the filters often being referred to as 'star' or 'star-cross' filters. The same filter can also be used as a form of soft-focus device on a subject that contains no point-source of light. The effect works best when the light source is in a position for the flare to be spread across dark areas

of the picture, e.g. the sun coming out from behind stormy clouds. A cross-screen works best at medium to large apertures. Stopping the lens down reduces the intensity of the cross-flare and, with some wide-angle lenses in which the depth of field at small apertures is especially large, the lines on the filter itself might start to appear on the picture.

Diffraction-gratings These are similar to cross-screen filters, but in this case the filter is etched with a series of extremely closely spaced V-shaped lines. Flare is caused across the lines, the light rays interfering with one another and splitting into the colours of the spectrum. The effect is of a series of multi-coloured lines which, as with the cross-screen filter, emanate from any point-source of light. According to the way the lines are etched, these flares can take the form of any number of lines from two upwards. When the patterns show 16 or more lines, the effect becomes that of a circle of rainbow-coloured spears. Again, the effect works best against a dark background.

Rainbow Made by cutting minute grooves in one side of a piece of optical glass, usually leaving a centre spot clear. The effect is to record a central image sharply, with ghost-like, rainbow-coloured images around the edges. The filter is often mounted in a rotating frame that enables the photographer to position the ghost-images in any desired position within the picture area.

Graduated colour The colour on a graduated filter changes in density from a saturated tone at one edge, growing lighter to completely clear on the opposite edge or rim. They are available in a choice of colours and can be used to tone selectively part of a picture: turning a grey sky blue, for instance, or adding a pink tinge to an otherwise clear sky to give the impression of sunrise or sunset. Graduated filters work best in the square type that can be moved up and down in their holder to position the densest part of the colour exactly where it is required in the picture. As well as traditional colours, they are also made with graduated neutral

A cross-screen filter makes stars of point-light sources, such as the highlights in this close-up of black-lit water droplets.

There are several types of diffraction gratings. The more lines that are etched into the filter, the more pronounced the effect. Here and opposite are the effects of three such filters.

1 Just using one etched line repeated across the filter's face practically duplicates the principal image on each side.

2 When the lines are crossed, star-shapes emanate from light sources, as seen by the picture of the sun coming up over the rock formation.

3 Adding even more crossed lines to the etching results in a complete circle.

density areas which can be used to reduce the effective exposure in selected parts of a picture such as a backlit scene which might normally be much brighter than a foreground subject.

Duo-tone These are similar to graduated filters but the separation between two colours or one colour and plain glass is sharply defined, making them much less versatile.

Tri-tone This time three colours are coated on to the filter to colour corresponding sections of a picture. The colours might be arranged in parallel strips, or in equal segments of a circle.

Multi-image A variety of facets make up the filter, splitting the picture into several, identical images. The number of images produced depends on the type of filter and the way the facets are cut. Depending too on which particular filter is used, the images might be arranged in a circular or parallel pattern. In some types, half the filter is clear and the remaining half split into several parallel facets. A subject photographed with its principal point of interest in the clear half will then be seen with repeating images of itself trailing across the picture area from the faceted half, giving the impression of 'speed lines'. A typical subject for such treatment might be a racing-car shot to show the repeated images in a horizontal pattern, or a trampoline-jumper shot to show the repeated images falling away vertically from his feet. Multi-image filters work best when the main subject is fairly small in the picture area and clearly defined against a dark background. Too light a background, as it is repeated by the filter, will tend to overlay and wash out the subject matter.

Colour multi-image A combination of duo- or tri-tone filters with multi-image types. In some, the effect might be of several images and two different colours overall; in others, each image might be independently coloured a different shade. Similar effects can be obtained by combining separate multi-image and multi-coloured filters.

Centre spot Filters of different colours or neutral density with a centre, clear spot. They work well with portraits, still-lifes, flowers etc. when the subject matter can be recorded as normal, but surrounded by a halo of the appropriate colour.

Vario-colour Actually three polarising filters in one. Two are of different colours and are mounted with a grey filter between them. By rotating the mount, the colour of the filter can be varied. If, for instance, the two colours used are red and blue, an infinite number of shades between those two colours can be produced. Other variations might include yellow-blue, yellow-green, yellow-red, or red-green.

Red/green/blue Three filters sometimes sold in a set. They can be used to shoot three exposures on the same frame (see the chapter on multiple exposures), each through a different filter. Since red, green and blue are the main constituents of white light, anything in the picture area which remains stationary between exposures will record normally; anything which has moved between exposures will record in one of the three colours. The effect works particularly well with subjects such as waterfalls, sun sparkling on sea, and clouds. To determine exposure, take an initial reading without any filter in place and divide this by three. An exposure of $1/250$ second at $f/11$, for example, divided by three gives an effective exposure of $1/750$ second at $f/11$. Since that speed is impossible to set on a normal camera, you must compensate with the aperture, making the exposure $1/500$ at between $f/11$ and $f/16$ or $1/1000$ second at between $f/8$ and $f/11$. Taking this as your basic exposure, adjust each individual exposure as normal, according to the appropriate filter factor.

The theory sounds complicated, but as is so often the case, the practice is a lot simpler. In fact, the filter factors tend to compensate for the division of the original exposure and, as a general rule of thumb, follow this method. Simply take an initial reading without a filter in place, open up one stop

Graduated filters are most often used on sky areas. The first picture (top left) was taken with no filter at all. The second picture (top right) has used a graduated blue to deepen the sky's natural colour. The third picture (below left) uses a graduated tobacco to distort tones completely, taking the shot further into the realms of special effects.

Facing page: coupling a multi-image with a multi-colour filter allows you to repeat *and* colour an image.

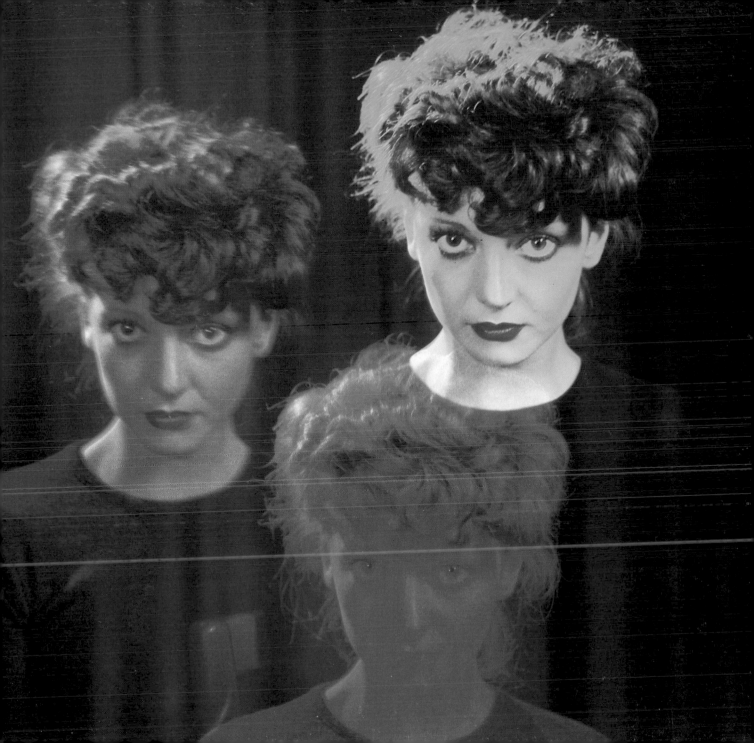

and use *that* exposure for each shot. The first time you try it, bracket by half to one stop to compensate for slight mistakes, but once you have tried the effect a few times, you'll be surprised at how easy and straightforward it is. An alternative method of achieving a similar effect is to have the three filters mounted in a strip that is designed to fall across the front of the lens as the shutter is opened. This is known as a Harris Shutter. Using colour transparency film for such pictures requires very accurate exposure measurement. A slight increase in exposure on any one filter will give a bias of that colour to the final picture. Shooting on colour negative film is easier, since a bias can often be corrected at the printing stage.

Filters and flash
The camera isn't the only place where filters can be used. Certain special effects, not possible with any other method, can be achieved by filtering a flashgun. Obviously, if a coloured filter is placed over the gun, the image will register on the film as that colour. But that's an effect that could easily have been produced by filtering the camera lens. The more interesting effects are achieved by using a filtered flash as a fill-in light source outdoors, so that its light affects only those objects within its limited range. To understand the various techniques, therefore, it is advantageous first to understand the basics of using fill-in flash.

It is a process which is most often used when working in conditions in which the foreground and background are at two different levels of brightness: subjects shot against the sun, models in the shade against brightly-lit backgrounds, etc. Without fill-in flash, it would be impossible to expose correctly for both subject and background; with it, the shadows can be lit to match the exposure for the light behind, thus giving a correctly-exposed picture from foreground through to background. Taking, as an example, a model shot in the shade against a bright background, the first step is to determine the exposure for the background. Let us say that this is $1/125$ second at

$f/11$. If you are using a single-lens reflex with a focal-plane shutter, you must adjust this to an equivalent exposure for no more than $1/60$ second, the maximum speed at which the majority of focal-plane shutters synchronise with flash. We now have a basic exposure of $1/60$ second at $f/16$.

To fill-in the shadow areas (in this example, the model's face), the flashgun must now be placed at a distance from the subject that demands that particular aperture. Work that out by using a manual gun or an auto gun in the manual mode. The quoted guide number for that particular model, divided by the aperture in use, will give you the distance at which the flashgun must be placed from the subject. Use of an extension cable will ensure that you can move the flashgun without having to move the camera at this stage. In theory, this should slightly overexpose the subject, since he or she is now being lit by both natural and flash light. In practice, however, guide numbers tend to be calculated for using the flashgun indoors in an average-sized room, taking into account reflections from walls and ceilings. Outside, there are no such reflections. The effective guide number is therefore less and the exposure tends to be about right. Nevertheless, a little experimentation and bracketing of exposures never comes amiss.

With that little bit of theory under your belt, we can now look at ways to produce special effects with filters on the flashgun. A straight filter (which can be a square of gelatin or coloured glass, or even a piece of coloured Cellophane) fitted over the flashgun will give you a picture in which the subject, lit by the flash, takes on the colour of the filter, while the background, too far away and therefore untouched by the flash, will record as normal. To find the correct exposure, work out what you would be using for a traditional fill-in flash shot, adjust the aperture for the filter factor, then adjust the shutter speed to match the new aperture and so record the background correctly. Keep the exposure to $1/60$ second with focal-plane shutters.

A different effect, but one that is based on similar principles, can be obtained by shooting tungsten-balanced colour film outdoors and filtering the flash with an amber 85B gel. This is a correction filter designed to change the colour temperature of the flashgun (normally balanced for daylight) so that it can be used with artificial light film. The effect is an apparently normally-lit model against a blue-biased background, the result of using tungsten film in daylight.

Taking things another step forward, let us now examine the effect of using two filters, one on the camera and the other on the flashgun. Used the correct way, this can give the effect of a normally-lit subject, posed against a background that has been tinted any one of a number of different colours. Such filters are available commercially and are sold in sets of two, each colour being the complementary of the other: yellow coupled with blue and mauve coupled with green. Here's the theory, using a yellow/blue set. The yellow filter is placed on the camera lens and the blue filter is fixed to the flash. The main subject, lit blue by the flash and corrected by the filter on the lens, now records normally, while the background, unaffected by the flash, records as yellow. If the filters are switched, the background records as blue. With the mauve/green set, the background can obviously be tinted either of these colours, according to which filter is used on the lens.

Exposures are again worked out along the lines associated with fill-in flash, while allowing for filter factors. But since we are now dealing with *two* filters, a little extra thought is needed. Here's an example. Coming back to our original situation, let us assume that we have a background exposure, measured without filtration of $1/60$ second at $f/16$. If the yellow filter is placed on the camera and has, for instance, a factor of $\times 2$, that means opening up one stop. Our exposure is now $1/60$ second at $f/11$. The blue filter would now be placed over the flashgun and might be noted to have a factor of $\times 4$. Its distance from the subject must now be worked

out as before but, allowing for that $\times 4$ factor, the distance must be calculated, based on an effective aperture of $f/5.6$, even though the *actual* aperture in use is still $f/11$.

A final warning

Many of the effects described in this chapter result in colouring all or part of the picture with a seemingly unnatural tone. If you are using colour negative film and having prints commercially produced, that could lead to problems, as automatic colour-analysers try to correct what appears to be an unwanted cast. The result could be a print in which your carefully-contrived special effect has been neutralised or completely wrecked. So if you are trying special effects on colour negative stock, it is advisable to slip a note of explanation in with your film when you send it to the processor. The problem, of course, does not arise if you are making your own colour prints or if you are using colour reversal material.

Three exposures, each through a red, green and blue filter respectively. Where the subject is stationary, the image records as its natural colour. Where the subject moved, each movement is recorded in the colour of the filter in use at the time.

Right: two filters of complementary colours used on the camera and flash render the subject normally, while tinting the background blue, the colour of the filter on the camera.

Far right: a red-filtered flash affects the subject in the foreground, while leaving the background to record normally.

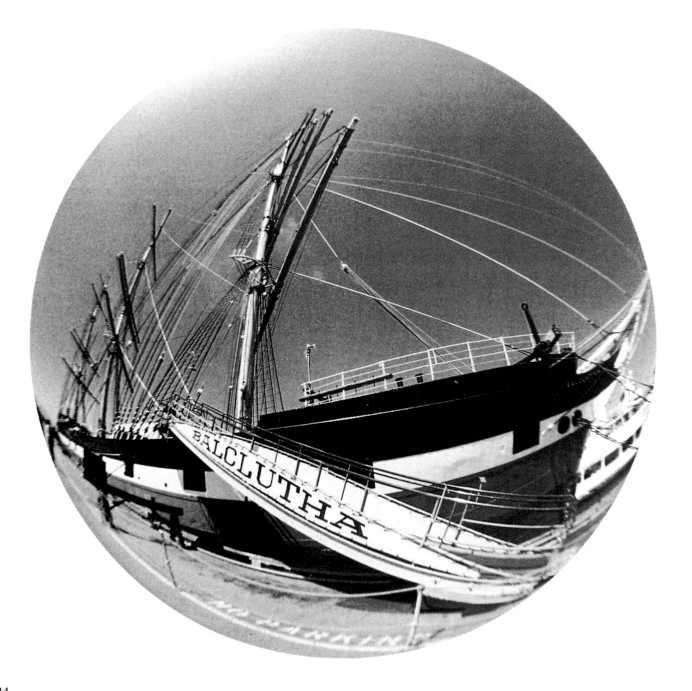

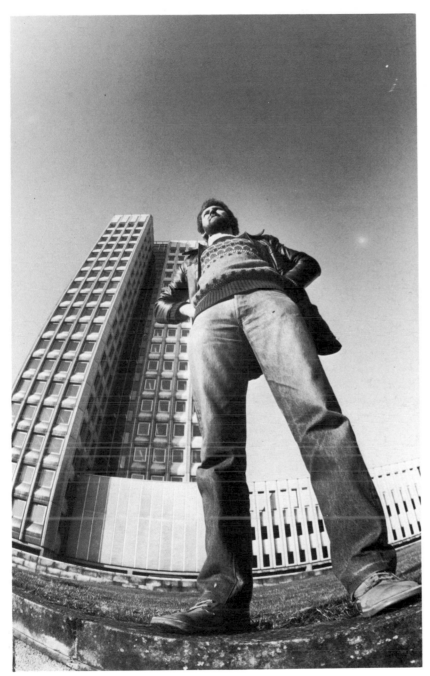

Special lenses

A standard lens, the type that is normally supplied with the camera, has come to be accepted as one whose focal length is approximately equal to the diagonal of the film format. Hence, a full-frame 35 mm camera, taking 36 × 24 mm negatives, will have a standard lens of around 50 mm; a medium-format camera, taking 6 × 6 cm or 6 × 4.5 cm negatives, uses a lens nearer 80 mm; while a 110 camera with a 13 × 17 mm negative size, will have a standard lens of about 25 mm; and so on for other formats larger or even smaller than these. Either side of the standard focal lengths, there are wide-angle and telephoto lenses.

For the purposes of this chapter, we will now refer only to focal lengths as they apply to 35 mm, undoubtedly the most popular format among many professional and most amateur photographers. For that, a normal wide-angle lens would have a focal length of 35 mm or perhaps 28 mm. In the opposite direction, medium telephotos start at 80 mm or 100 mm while perhaps the most popular 'first telephoto' is the 135 mm. After that, there are lenses of all focal lengths, with zooms covering a stepless range between up to 400 mm. This overall range, from 28 mm to 400 mm, is probably the most commonly used. Either side of these focal lengths, we are into the realm of special lenses.

Extra wide
The shortest focal length that could be considered as a 'normal' wide-angle is probably around 15 mm, about the widest that a rectilinear lens can be made. A rectilinear lens is one with corrections that ensure straight lines in the subject appear equally straight in the picture. There is, however, another type of wide-angle lens in which no such corrections are made. This is the fisheye lens, whose longest focal length will be around the 16 mm mark but whose shortest is more likely to be 8 mm or

225

even 6 mm. A fisheye lens is complex in design. It features two large curved elements at the front which 'see' a view that can be as much as 220 degrees across. Light rays from this wide expanse are collected by these elements and brought to a point between other elements, from which they diverge in a more conventional way to meet a normal width of film. There are more elements in a fisheye than in a standard lens and their actual shapes are difficult to compute, grind and assemble in exactly the right way, making the lenses very expensive. Fisheyes work best at small apertures and, for the special-effect photographer, they are most useful for the distortion they produce. More details of how to exploit this feature will be covered later in the chapter on distortion and reflection.

Extra long

At the other end of the scale, there is the extra-long telephoto lens. Early examples, which were termed 'long focus' rather than 'telephoto', were simply lenses of long focal lengths that were mounted in a tube of the appropriate size to separate the lens from film plane. It was necessary, therefore, for the physical length of the lens to be at least the same as its focal length: a 400 mm lens would be at least 400 mm long. A true telephoto lens uses a number of elements to produce the same focal length in a shorter size. Another long-focus lens uses not only conventional lens elements, but also concave mirrors to 'fold' the light. A concave mirror reflects light as would a normal mirror, but also focuses it in much the same way as a convex lens would. With one of these mirror lenses, light enters through a plain glass disc at the front, is reflected off a concave mirror towards the back of the lens barrel, hits another small mirror on the back of the glass disc and passes back through a hole in the centre of the first mirror to be diverged and focused on the film by more conventional lens elements. Such lenses are much shorter than a normal telephoto, though a lot broader.

The advantage of any type of long lens is that it brings far objects closer to fill the frame. Such a lens

is of use to all types of photographer, but of particular advantage to the special-effect photographer are a couple of optical illusions that become apparent at the same time. The first is that perspective appears to diminish so that objects some way apart are seen to be squashed closer together than in reality. The reason for saying the perspective *appears* to diminish is that the lens isn't actually responsible for the effect. Perspective diminishes with distance, not with focal length. If a picture of the same scene were to be taken with a standard lens from the same view point, and the appropriate part enlarged from the centre of the negative to match the field of view taken in by the telephoto, the perspective would be seen to be the same in each picture. All the telephoto lens does is bring that distant scene, *and the perspective associated with it*, closer to fill the frame. The second optical illusion that the special-effect photographer will find useful is the way small objects in the distance can actually be made to look

Page 224: a fisheye lens gives an ultra-wide angle of view, distorting straight lines in the original subject and producing a circular picture.

Page 225: perspective goes totally awry with super wide-angle lenses. This picture was taken with a 15 mm lens close to the man's feet.

Perspective becomes contracted with distance, so long-focus or telephoto lenses, picking out only subjects that are at a distance, give the impression of squashing perspective. This shot was taken with an 800 mm lens on a 35 mm format.

larger than life. Again, it is all a matter of perspective. You expect distant objects to look small, compared with nearer objects. With a long lens, the nearer object can be kept the same size in the frame, while the distant object is brought closer and so enlarged.

A perfect example of this effect can be seen when shooting the moon over a building. With a standard lens, the building can be arranged to fill the foreground, but the moon will record as no more than about 0.5 mm in diameter on a 35 mm negative. Switching to a 500 mm lens, the photographer can move back so that the building occupies the same position in the foreground, but the moon will now record as a massive 5 mm across. When using any type of long lens it is advisable to have a tripod handy, since the lowest speed at which it is feasible to hand-hold a lens gets faster as the lens gets longer. A good rule of thumb

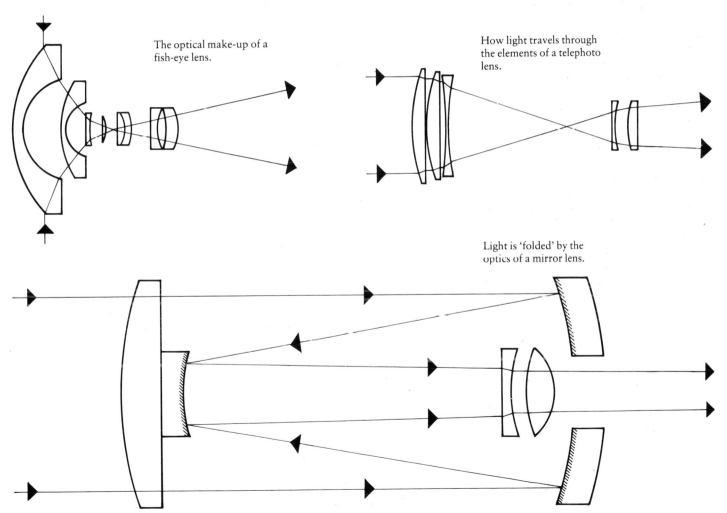

The optical make-up of a fish-eye lens.

How light travels through the elements of a telephoto lens.

Light is 'folded' by the optics of a mirror lens.

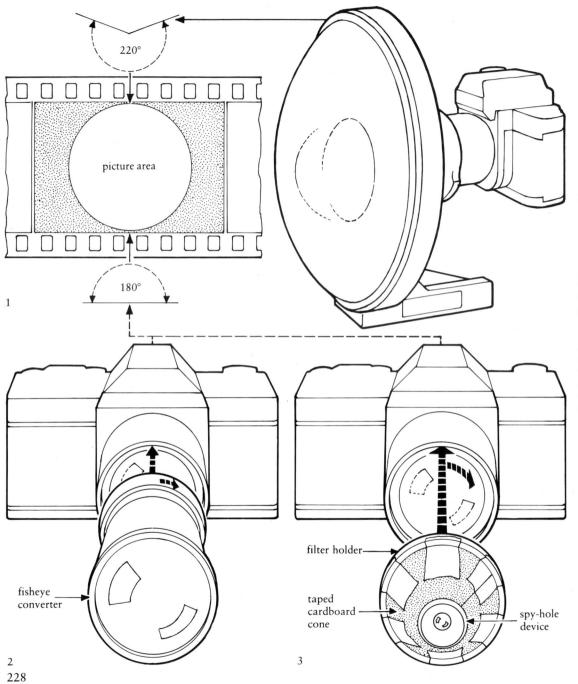

1
A fisheye lens which gives the ultimate in short focal lengths.

2
The inexpensive alternative to a fisheye lens is the fisheye converter which, when fitted to the front of a 28 mm lens, gives a similar effect to a true fisheye. The quality isn't as high, but it is perfectly acceptable.

3
A spy-hole device, normally used for security purposes, can be fixed to the front of a standard lens by means of an old filter holder. The results given are low quality, but similar to that obtained with a fisheye or fisheye converter.

4
A perspective-control lens can correct converging verticals on a rollfilm or 35 mm camera where no technical movements would otherwise be possible.

5
A split-field lens is actually half a close-up lens that covers only part of the frame.

6
A cardboard tube, one end covered in metal foil with a small pin-hole in it, can be fixed to a single-lens reflex in place of the lens to make pin-hole pictures.

7
An anamorphic lens, attached to the front of a standard. It is used to 'Squeeze' the image laterally.

220°

picture area

180°

1

fisheye converter

filter holder

taped cardboard cone

spy-hole device

2

3

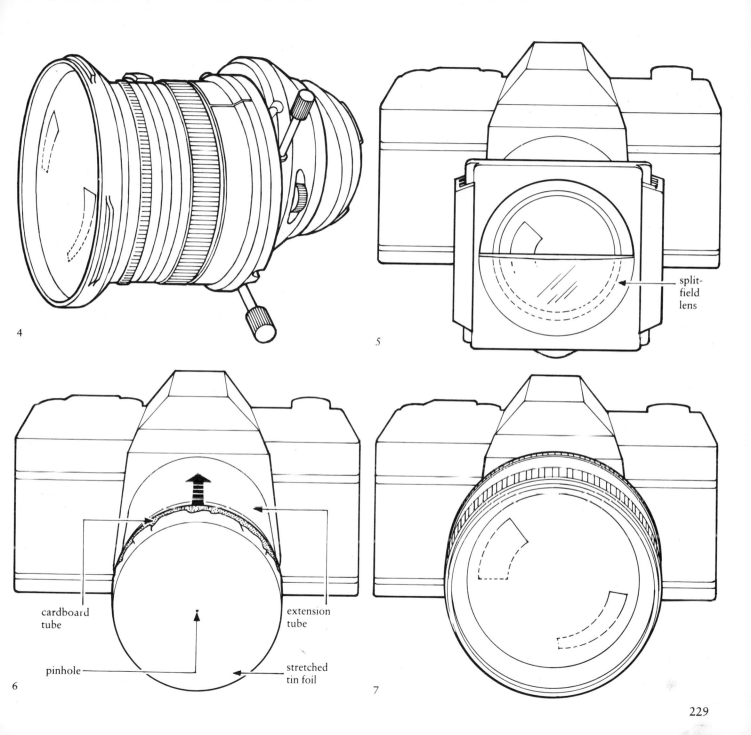

4

5

split-field lens

6

cardboard tube

pinhole

extension tube

stretched tin foil

7

is to think of your slowest hand-holdable speed as the reciprocal of the focal length. Hence, a 500 mm lens should not be hand-held at anything lower than $\frac{1}{500}$ second, a 1000 mm lens at $\frac{1}{1000}$ second and so on.

Zoom lenses

A zoom lens is one in which some of the elements have been made to move in relation to others, changing the lens's focal length, according to their positions. This gives a stepless range of focal lengths, usually in a ratio of around 1:3, such as 28–85 mm or perhaps 75–210 mm, though there are many more choices of focal length than these. For straightforward photography, a zoom lens provides the photographer with a handy range of focal lengths without the necessity of changing lenses. The special-effect photographer is more likely to use these lenses with slow shutter speeds, actually changing the focal length during the exposure for adding a degree of controlled blur to a shot (see chapter on controlled blur), or as one way of producing abstract images (see chapter on abstracts).

Macro lenses

Some method of taking close-ups is often needed by the special-effect photographer. There are many methods, one of which is with a macro lens. This is one that has been made so that the focusing mechanism will extend its distance from the film plane to obtain a 1:1 magnification of the image on the film. More details of these lenses and how they are used will be found in the chapter on abstracts.

Anamorphic lenses

An anamorphic lens contains a system of prisms or, more often, a combination of cylindrical mirrors, both convex and concave, to give the effect of a lens with two different focal lengths. These are at right angles to each other and also to the lens axis. The effect is to give two different magnifications of the image on the same piece of film: one horizontally across the frame, the other vertically from top to bottom. The result is a picture that, while retaining

230

its correct proportions in one direction, is 'squashed' in the other. The lens is usually used on the camera to 'squash' the image in the horizontal plane. Another anamorphic is then used at the enlarging or projection stage to 'squash' the image in the vertical plane, so that the final result is a correctly-proportioned image, but in a panoramic format. More details of the range of anamorphics available and their use can be found in the chapter on panoramic pictures. The lens can also be used without correction to produce different degrees of distortion, as described in the chapter on distortion and reflection.

Perspective control lenses

When a camera is pointed upwards at a tall building, the picture so produced will show the structure appearing to taper towards its top. This effect, which becomes more pronounced the shorter the focal length in use, is known as converging verticals. It can be corrected by camera movements ('Distortion and reflection' chapter), and also by a perspective control lens, sometimes known as a shift lens. The lens fits a standard single-lens reflex. Its unusual property is an ability to shift vertically, while remaining parallel to the film plane. With this, the camera can be aimed straight at the building needing to be photographed, and the lens shifted vertically. The top of the building can then often be brought into the frame without the verticals converging.

Soft-focus lenses

These utilise varying degrees of aberration to diffuse the image, giving a soft effect. More details of how they work and how to use them can be found in the chapter on soft focus.

Lens attachments

Wide-angle and telephoto effects can be simulated with various attachments that fit either to the front or behind of a prime lens. Perhaps the most common of these is the teleconverter. This takes the form of a small extension tube, fitting between the camera body and the lens and containing perhaps

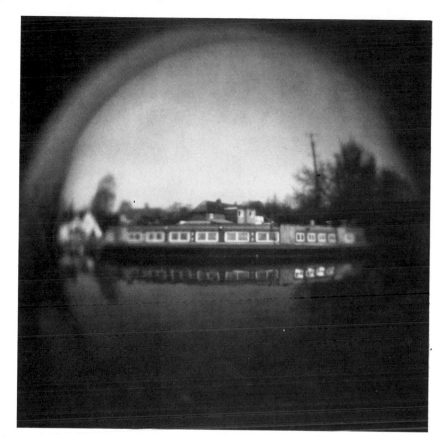

An extremely cheap (though not necessarily high quality) way of producing a fisheye effect. This picture was taken through a spy-hole device, more normally used in doors to see from the inside who is on the outside.

a medium telephoto lens like a 135 mm can be increased to a focal length of as much as 1215 mm. It must be admitted, however, that the quality produced by these front-fitting accessories often leaves a lot to be desired.

Of more interest to the special-effect photographer is the converter that screws into the filter thread of a standard or normal wide-angle lens, giving all the effects of a fisheye lens. Compared with the real thing, these accessories are extremely inexpensive and, while the quality doesn't match that obtained from a true fisheye, the results can be very impressive, especially when small apertures are used. With a standard 50 mm lens, the fisheye attachment gives an angle of view of around 100 degrees, the image being in the shape of a circle with the top and bottom cropped. Attached to a 28 mm lens, the accessory will give an angle or view nearer 150 degrees with a completely circular image.

For an even less expensive fisheye effect, pictures can be taken through a spy-hole device, the type sold for fitting to front doors so that the person inside can see who is outside through a small peep-hole. Such a device can be easily mounted in a piece of matt black cardboard and fitted to the front, and in the centre, of a standard or normal wide-angle lens by way of a conventional filter holder. The effect, though by no means optically perfect, is similar to using a fisheye converter. Use it at the smallest aperture possible for maximum definition. For an effect that goes beyond the fisheye, there is another type of adaptor known sometimes as a bird's eye attachment. This is little more than a small convex mirror in a transparent tube that fits over a standard lens, the mirror pointing back towards the camera. Pictures produced with it are circular, give a massive angle of view and actually show the photographer at the centre.

Another attachment of use to the special-effect photographer is the close-up lens. This usually

six elements. It works in conjunction with the prime lens to double or treble its focal length. A 2× and 3× teleconverter cuts the light down by two and three stops respectively. They can be used with standard lenses to give equivalents of 100 mm or 150 mm lenses, but since for special effects we have been referring to extra-long lenses, they would have to be used with medium telephotos to give the results we need. Hence, a 200 mm lens could be turned into a 600 mm lens with a 3× converter or a 500 mm could be turned into a 1000 mm with a 2× converter – a particularly interesting lens for special effects. There are also teleconverters made to screw into the filter thread on the front of a lens, some extending the focal length by as much as 9× so that

takes the form of a weak, single-element lens with a long focal length which, when fitted to the front of the camera lens, reduces its focal length, thus giving greater magnification. Close-up lenses are measured in dioptres. The higher the number, the greater the magnification. The most commonly-used are +1, +2 and +3 dioptres, all of which can be coupled for greater magnification. Not surprisingly perhaps, a +1 added to a +3 gives the equivalent of a +4. Close-up lenses are also available in a more complex design of several elements that can be moved to vary the magnification, not unlike a kind of auxiliary close-up zoom. The theory behind why these lenses work and how to use them is explained more fully in the chapter on 'Abstracts'.

There is one other type of special lens that is useful for the photographer who cannot afford a true macro. This is the macro converter and, like the teleconverter, it fits between the standard lens and the camera body. It is around the same size as a teleconverter and, once fitted, turns a standard into a macro lens, allowing focusing from about 1:10 down to 1:1.

Split-field lenses

A split-field lens is no more than half a close-up lens. It fits to the front of a standard lens and allows two different subject distances to be accurately focused on the same frame. So, with the camera lens focused at infinity and the split-field lens in place, a picture might show, for instance, a flower sharply focused in the foreground with trees equally sharp in the distance. With a little skill, the appearance of a picture sharp from a few centimetres to infinity can be given. What the picture actually shows is a sharp foreground, a blurred centre portion due to the close-up lens being aimed at a more distant part of the picture on which it cannot focus, and a sharp background from the camera lens without the close-up device. For best results, the camera should be positioned so that the boundary between close-up and normal lens falls along a natural dividing line in the picture.

232

'Unsuitable' lenses

Lens manufacturers go to a lot of trouble to design lenses which are as near perfect as it is possible to get. Compound lenses, consisting of many elements, are put together so that each element works in conjunction with the others to cancel out aberrations and so produce the best possible image. But, for the special-effect photographer, such imperfections can often make interesting pictures. And so there are a number of lenses which would normally be considered totally unsuitable to photography, but with which you can make fuzzy, less-than-perfect images that are nonetheless successful in their own way. Perhaps the easiest way is to use an old-fashioned snapshot camera with a simple meniscus lens. This lens finds it impossible to focus all wavelengths of light at the same point and, using the camera with modern colour film, gives the picture a soft-focus effect.

Lenses not ordinarily meant for photographic purposes can also be used, providing they are mounted on a camera with a focal-plane shutter, without which there would of course be no way of controlling exposures. A simple magnifying glass can be made to work quite well, but you can also use certain objects that were never, ever, intended to be thought of as lenses. The curved side or bottom of a bottle, a marble, the plastic disc out of the centre of your telephone dial, even a glass full of water . . . they are all capable of focusing an image and so all can be used to make pictures.

The first thing you need is a method of mounting your 'lens' on to a camera body. You can do that with cardboard tubes painted matt black inside. The 'lens' naturally must be mounted so that no light reaches the film other than through its surface. To focus the lens, two tubes can be used, one sliding inside the other. For a more sophisticated method of focusing, a bellows unit can be attached to the body of a single-lens reflex and the 'lens' mounted in a black card support on its end, at the point where the camera lens would normally be fitted.

The second problem is to decide how far to mount the 'lens' in front of the camera. To ascertain that, think back to how normal lenses are mounted. Their distance from the film when focused at infinity is the same as the focal length. To focus closer, they are then moved marginally further away from the film plane. Follow the same procedure, mounting your 'lens' at the same distance from the film plane as its focal length, allowing movement in front of this distance, away from the camera, for closer focusing. To find the focal length, hold the 'lens' in front of a piece of white paper inside a room and in front of a convenient window, then focus the image of some infinity-based subject outside the window on the paper. At the point where the image is sharpest, the focal length is equal to the distance between the centre of the 'lens' and the paper. For something like a magnifying glass, that could be quite a long focal length, and so a tube must be constructed to separate it from the body. With something like a marble, the focal length will be so short that it will, in all probability, have to be pushed back into the camera body with a suitable cardboard holder until it is only a matter of millimetres from the film. For that reason, if you are using a single-lens reflex the mirror must be locked up, if possible. Failing that, the alternative is to use an interchangeable-lens, non-reflex camera with a focal-plane shutter.

To focus, the camera should be set on a tripod, the back opened and a piece of ground glass or tracing paper spread across the film plane. The 'lens' is adjusted until the image is as sharp as possible, the tracing paper is removed and the film inserted in the normal way. Exposures present your next difficulty. If your camera is the aperture-priority type, it should be able to handle them automatically, choosing and setting the correct shutter speed accordingly. Otherwise, you must calculate the shutter speed yourself. That means first finding the working aperture of the 'lens' in use. Find that by dividing the diameter of the 'lens' into its focal length. A marble, for instance, might have a diameter of 20 mm and a focal length of

15 mm. Its aperture, then, would be $15 \div 20 = 0.75$. Smaller apertures can be made by masking the 'lens' with pieces of card, in which circular holes have been cut. The diameter of each hole is then used for the calculation in the same way as any normal lens. Exposures are made in the usual way, coupling the found aperture with an appropriate shutter speed.

Pictures without lenses

Pictures can even be taken without any lens at all. In fact, the very first 'cameras' had no lenses, simply small holes through which an image was focused onto some convenient surface. We are speaking here of camera obscuras, the forerunner of today's cameras and devices that date back as far as the 11th century. But long before photographic cameras arrived, camera obscuras were being fitted with lenses and so, when the chemistry for recording and keeping an image was perfected, the physics of producing it were ready and waiting. Nevertheless, it is the theory of those ancient camera obscuras that gives us today's method of producing pictures without lenses.

If a pin-hole is made in one end of a light-tight box, light rays will converge through that hole much the same as they do through a lens, to diverge on the other side and project an image on any surface opposite the hole. If a piece of film is placed there, the image can be captured in the same way as it might be via a lens, providing the exposure is long enough. So a pin-hole camera can easily be made with no more than a box, a minute hole at one end and a method of holding film at the other. The pin-hole itself has a cleaner edge when made in something like aluminium foil or a milk bottle top, rather than in cardboard or any similar material. The foil is then mounted on the 'camera' front with another larger hole behind. The 'focal length' of the pin-hole varies with its distance from the film. Hence, if a long camera is made, the picture will be similar to that made from a telephoto lens. With a small hole-to-film distance, a more wide-angle effect is obtained. There are no depth-of-field

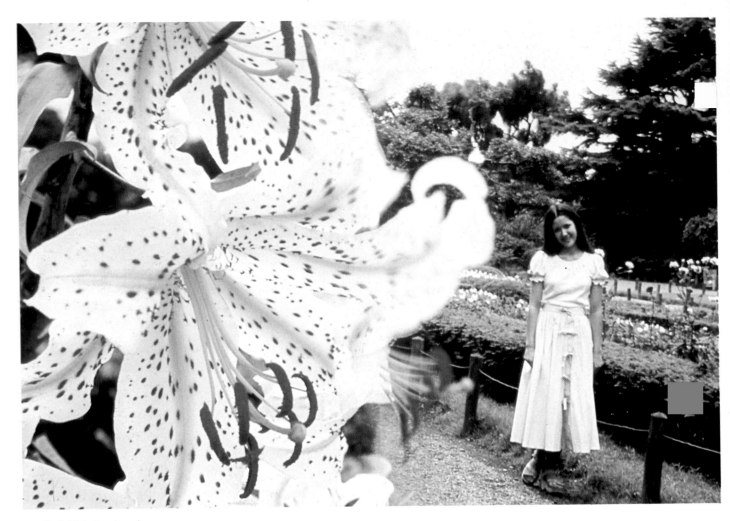

A split-field device gives the
impression of limitless
depth of field. It is actually
half a close-up lens that
affects only part of the
picture area. *Hoya*.

A picture taken with no lens at all. For this shot, a minute pin-hole was made in the front of a tube that was fixed in place of the standard lens on a normal single-lens reflex.

problems; pin-hole images will be sharp from a few centimetres to infinity, irrespective of the 'focal length'. Exposures must be by trial and error, but will often be counted in minutes rather than fractions of a second.

A more sophisticated method of making a pin-hole picture is to make the hole in the end of a tube and mount that in place of the lens on a conventional camera. Again, the longer the tube,

the longer the effective 'focal length'. If, in these circumstances, your camera is an aperture-priority type whose automatic shutter speeds run into the more lengthy times, you can use that to find the correct exposure. In all these instances, it should be borne in mind that the lengthy exposure times will undoubtedly involve reciprocity failure and so exposures should be liberally bracketed, often multiplying what would seem to be the correct exposure by as much as eight times.

Unconventional films

What is a normal film? It can be either black-and-white or colour; if it is colour it is negative or reversal; if it is reversal, it is daylight-balanced or tungsten-balanced. Maybe 99 per cent of pictures taken use a film that falls into one of those basic categories. But for certain specialist uses, there are other films which produce unique effects, either by the use of the film alone, or by coupling it with some other element like filters or lighting.

Infra-red film

What we think of as white light is actually made up of seven different colours: red, orange, yellow, green, blue, indigo and violet. The light rays that convey these colours have different wavelenths, of which the above seven are visible to the human eye. But the rays continue outside the range of what we can see. At the violet end of the spectrum, there are short-wavelength rays that give, at first, ultra-violet which can't be seen, but whose effects can be photographed (see the chapter 'Unusual lighting'), then X-rays and gamma rays.

At the red end of the spectrum, the first 'colour' outside the range of the human vision is infra-red. As these rays get longer, they give way to wavelengths used for broadcasting radio, television, radar etc. Infra-red film is one that has had the sensitivity of its emulsion extended so that it can record the rays beyond the red end of the spectrum and into infra-red. Because of its characteristics, you may have heard it said that infra-red film can be used to take pictures in the dark. This does not mean that it needs no radiation at all. Where *no* energy reaches it, there can be no image recorded on the emulsion. What infra-red film *can* do is take pictures in conditions that *appear* to be dark. If the subject is lit by infra-red rays, the eye cannot see it, but the film can, and it will appear to have recorded a subject in total darkness.

There are two types of infra-red film, one designed for black-and-white photography, the other for colour. Much of the theory behind each is the same, but naturally the results produced are different. Neither film has good keeping properties and it should be stored in a freezer before and after use. The colour film comes from Kodak in standard 35 mm cassettes, the mono version in cassettes and sheet form. It is often recommended to load cassettes in pitch darkness, though experience shows that this is not strictly necessary. Lighting can be from natural daylight, flash or tungsten bulbs. The latter are particularly useful as they are extremely rich in infra-red radiation, thus effectively increasing the film speed. Focusing can present difficulties because infra-red rays do not come to focus at the same point as those from visible light. Most cameras have a red mark on the lens barrel a few degrees to the side of the normal focusing mark, against which the usual distance figures must be aligned when using infra-red. With a single-lens reflex, that means focusing as normal, noting the distance against the normal mark and then shifting the lens so that that distance is against the infra-red mark. If your camera has no such mark, use the $f/4$ point on the lens's depth of field scale. If the lens turns left to right for close focusing, use the $f/4$ mark on the right and vice versa if the lens turns the opposite way. It is wise to work at the smallest possible aperture to extend the depth of field and so cover any small discrepancies in focusing.

Infra-red for mono

The film is not only sensitive to infra-red. It is, in fact, quite sensitive to blues as well. So for results that show predominantly the effect of infra-red film, a dark-red filter should be used to take out the blue. It is not possible to give accurate speed ratings for infra-red film, but suggested exposure times are given with the instructions which, when followed with the usual degree of bracketing, give perfectly acceptable results. In dull weather, it is advisable to open up an extra stop on the recommended exposure because such conditions cause a drop in

the ratio of infra-red to visible light. The way we see objects around us varies with the way those objects reflect visible light. But when they are reflecting invisible light, such as infra-red, the results in the final picture are vastly different to the way we have seen the original subjects. Until you come to know what to expect, the results will seem completely unpredictable, particularly since the amount of infra-red reflection has little or no bearing on the amount of visible light being reflected. Vegetation like grass and leaves tends to reflect a lot more infra-red than visible light, and therefore shows up as white on the final print. Paint and make-up also give results very different to those produced with normal film. Contrast of the picture is increased as the longer wavelength of infra-red records distant objects without the haze that is often associated with normal monochrome landscapes. But don't confuse this haze with fog. Infra-red can't 'see' through fog any more than it can 'see' in the dark.

The film can be processed in standard black-and-white developers, but some plastic developing tanks might give trouble by leaking infra-red and so fogging the film. It is often advisable to develop in a tank and also in the dark, although infra-red can be masked by shielding the tank with aluminium foil, shiny side out to reflect all light rays. Developers recommended by Kodak are D-76, HC-110, D-19 and Microdol-X.

Infra-red for colour

The most widely-available infra-red colour film is Kodak's Infra-red Ektachrome. The film has three emulsion layers, one sensitive to green, one to red and the third to infra-red. Used straight, without filtration of any kind, most objects in the picture will take on a strong, blue cast, although blue skies will record as magenta. To counteract this, Kodak recommends the use of a yellow filter. Pictures taken with that will record most reds as yellow, green foliage takes on a magenta cast, but skies remain blue. A green filter will weaken the strength of the blue in the sky and foliage begins to appear

Page 236: in mono, infra-red film, used with a red filter, gives a strange ghostly effect as buildings and trees turn white and blue skies turn black. *Frank Peeters.*

Page 237: the use of lith film reduces the image to black-and-white, destroying all intermediary shades of grey.

Right: using infra-red colour film with different filters radically changes the look of everyday scenes. This picture was taken on Infra-Red Ektachrome, using an orange filter.

Far right: colour film, balanced for tungsten light, used in daylight gives a blue cast. This shot has been overexposed by one stop to make the blue into a pastel shade and to accentuate the effect on the child's eyes.

purple. Orange and red filters give perhaps the most striking effects, turning foliage orange and making clear blue skies green; any white highlights, and that includes clouds, will turn yellow. One drawback of Kodak Infra-red Ektachrome is that it must be processed in the now-outdated E-4 chemicals, rather than the current E-6 process. Few laboratories will undertake E-4 processing these days, but Kodak still supply E-4 kits for home use and, providing the instructions are followed carefully, the film is almost as easy to develop as black-and-white.

Recording film
This is a Kodak black-and-white emulsion, whose full title is Kodak Recording Film 2475. It is available in 35 mm cassettes and its most obvious difference to other films is its extra-high speed, brought about by an extended sensitivity to red. The film can be rated at ISO 4000/37°, ten times the speed of Kodak Tri-X or Ilford HP5, two films which are normally regarded as being at the top of the speed scale. The film is designed primarily for available-light photography where existing light is especially low and cannot be boosted by artificial means, or for all types of photocopying in which shadow detail and grain are unimportant.

For the special-effect photographer, the very fact that the film gives such grainy results can be used to

a major advantage. It should be used on subjects with strong, compositional lines: cityscapes featuring modern tower blocks seem to suit the image that is produced better than landscapes with soft lines and a more subtle range of tones. And yet, rules *are* made to be broken and the film can equally be used to bring a harsh contrast to what would normally be considered a 'softer' scene. Surprisingly perhaps, it works well with portraits of pretty girls, where the break-up of the image can be printed hard to give a sharp, modern look to a lively model, or softer for a dreamy, almost soft-focus effect. The film's contrast will give a restricted range of tones, bordering on a soot-and-whitewash effect and, with portraiture, skin tones will record particularly pale.

Outdoors, the film's speed can make exposures a difficulty. On a bright summer day, you could find yourself needing something in the region of ¼₀₀₀ second at *f*/16, and there aren't many cameras that can provide that! Because of this, and because of the film's inherently high contrast, it is best to shoot on dull days, when the sun is obscured by cloud. Such conditions give flatter lighting and allow the photographer to use slower shutter speeds and/or wider apertures. Even so, it can still be difficult to find a workable combination and, for that reason, neutral density filters are advisable when working outdoors. In the studio, low-wattage tungsten bulbs can be used, but if flash is being considered, then neutral density filters might again be needed. (See first chapter.) Kodak recommend that 2475 is processed in DK-50, HC-110 or D-19 developers.

Photomicrography film

Here's another specialist film that could be considered the direct opposite of the previous example. Where 2475 is mono and extra-fast, this film is colour and extra-slow. Its full title is Kodak Photomicrography Colour Film 2483 and, as its name suggests, it has been designed to be used primarily through a microscope, though it is also used for copying mono or colour artwork. What it isn't designed for is general photography of landscapes, portraits and the like. Which is the very

This picture was taken one hour after sunset. The sea is illuminated by the faint glow from the sky and the fisherman is lit by low light from the quayside a few hundred metres away. Yet the shot was taken with a hand-held exposure, courtesy of Kodak Recording Film. *Terry Scott.*

reason that it can often be of interest to the special-effect photographer who will use it for just that. Its speed is only ISO 16/13°; thus on a bright, sunny day, it requires an exposure of around $\frac{1}{125}$ second at $f/5.6$. That doesn't give you a great deal of versatility, either outdoors or in the studio. However the film gives extremely high contrasts and very high definition, coupled with a degree of colour saturation seen in few other films. Used for conventional photography, the resulting pictures appear much brighter and more contrasty than the original subjects. Photomicrography Film 2483 is a reversal emulsion, available in 35 mm cassettes. Like infra-red Ektachrome, it must be processed in E-4 chemicals.

Lith films

These films are most often associated with special effects in the darkroom, rather than in the camera. Easily available in sheet form, they can be used for making internegs with a complete absence of grey tones. Prints made from these show only black and white, soot-and-whitewash effects, with no other tones in between. What isn't always appreciated is the fact that similar effects can be made by using the film in the camera. The sheet film can, of course, be used in film holders with large-format cameras, but the film is also available in 35 mm. It is not, however, available in standard cassettes, but must be bought in bulk lengths of 30 metres and loaded into an empty cassette by the photographer. It is also available in 30 metre lengths of 46 mm width. Kodalith Ortho Film 2556 Type 3, with an Estar base and Kodalith Ortho Film 6556 Type 3, with an acetate base, can both be handled in the darkroom in a red safelight and processed in Kodalith Super Liquid or Super RT developers.

Duplicating film

Elsewhere in this book, in the chapter on multiple exposures, we shall be dealing with ways and means of copying slides. One of the problems involved is an increase in contrast, which is why special low-contrast colour films are produced specifically for copying purposes. Kodak Ektachrome Slide Duplicating Films 5071 and 6121 are both balanced for tungsten light and are each suitable for making high-quality duplicates. The first is available in 30-metre lengths of bulk 35 mm and 46 mm widths, the second only in sheet form. Both are processed in E-6 chemicals.

The wrong cast

All the films mentioned until now have used special emulsions. But the emulsion of normal, straightforward slide films can also exhibit special properties in the right circumstances – or rather, when used in the *wrong* circumstances. Although it is not immediately obvious to the naked eye, artificial light is actually a different colour to daylight. Tungsten light is more red, daylight is more blue. These differences are measured on a colour-temperature scale in Kelvins. Daylight is 5500 K, tungsten light is 3200 K. Our eyes adapt from one to the other, seeing both as what we have come to think of as white light. Film isn't nearly so versatile and so must be balanced for one or the other. Hence, colour reversal films are either daylight-balanced or tungsten-balanced. The tungsten-balanced film is known as type B. There is also a type A balanced at 3400 K for Photofloods, but this is something of a rarity in the UK, although it is still very popular in the USA.

There is, of course, much more to colour temperature than described here, but it is sufficient for the purposes of this book to know only that the different types of film exist. Used with their appropriate lighting conditions, or with the right filters (see earlier chapter on filters), they will give a correct rendering of all tones. Used in the wrong lighting conditions, they give interesting special effects. Type A or type B film, used in daylight gives a cold, blue cast to the whole picture, but one in which strong colours such as red still come vividly through. On the other hand, if daylight film is used in artificial light (not electronic flash, which is balanced at 5500 K), the picture takes on a warm, yellow cast. Again this confirms the old axiom: learn the rules first, then learn how to break them.

Unusual lighting

The most important ingredient in any photograph is not the subject; nor is it the camera, the lens, or any other item of equipment. The thing that no photograph can be produced without is light. The strength of the light, its direction, whether it is hard or soft, how it balances between different parts of a picture, whether it is constant or pulses in a series of flashes, if it is inside or outside the range visible to the human eye . . . all these factors and more affect the picture. Many are solely responsible for certain special effects.

Direction of light
Front lighting gives a flat look to the subject, side lighting shows more texture; those are two of the most elementary lighting rules that the beginner to photography encounters. But the special-effect photographer very soon learns that rules are made to be broken; and there are few places where this is more apparent than in the use of light. Portraits, we are told, should never involve a light from below the subject's face. Yet placing one in that very position and making it the *only* light in the picture, can be an extremely simple way of producing a strikingly macabre effect. With the light anywhere below face level, shadows are directed upwards. The features fall into a pattern of dark shadows with patches of light on the mouth, cheeks and eyes, giving a mask-like effect. When shooting in colour, the addition of a gel to the light enhances the ghostly circumstances. The addition of another light directly behind your model gives a glowing rim around the hair which can add to the eerie look of the picture.

Mention of this backlight introduces us to another example of unusual lighting. With a subject placed against a black background and a single light placed directly opposite the camera so that the subject hides the actual source, a rim of light will be

seen, following exactly the subject's profile. The effect works best on rough-textured surfaces, rather than smooth, and so can be seen best around hair and clothing, if the subject is a person. If this type of picture is set up in a studio, the rest of the room is best blacked-out so that no detail registers in the subject itself and the picture shows only the profile of light. This technique can also be used as the basis for an unusual form of portrait lighting, using a reflector to bounce light back into the subject's face and then exposing for the skin tone. The result is an even, shadowless light on the face with a bright halo of light around the hair.

Against a white background, this rear light can be turned away from the subject and shone directly on to the background itself to render the subject as no more than a silhouette. For the best effect, the room should be blacked-out so that no light falls at all on the actual subject, and then the background should be overexposed by two or three stops. If you are using this technique as part of a double exposure (see chapter on multiple exposures), the background needs to be overexposed by at least five stops to wipe out completely any detail in the secondary image. That makes it even more important to ensure that no light falls on the subject.

Painting with light

If the shutter of a camera is opened and a point source of light is moved around within the picture area, it will record on the film as a series of lines or streaks that follow the path of the light. This can be used to particularly artistic effect in the making of physiograms (see chapter on abstracts), but the technique is by no means confined to the making of such regular patterns. A light such as that obtained from a torch beam or even a naked light bulb can be moved in other ways for different effects. It can, for instance, be used to trace around the outline of some object such as a chair in an otherwise darkened room to give a picture showing the chair's shape in a pattern of glowing lines. Another variation is to use the light to trace around the
244

outline of a live model, after first making a flash exposure of the subject. Here, a dark room and a black background are essential.

Both these techniques rely on direct light pointed towards the camera. But reflected light can also be moved during exposure for its own effect. If the camera is on a tripod outdoors at night, the beam of a strong torch can be used to 'paint' a subject with light. The shutter is opened with the aperture set to a medium stop, and light from the torch is moved slowly across the subject. Every part of the subject that the light strikes will be recorded on the film. The light can be used to illuminate the whole of the subject or maybe just a part. A surreal landscape can be built up by illuminating some parts, while leaving others in darkness: a tree here, a house there, perhaps part of a road, the light being moved around while the camera stays on its tripod.

Judging exposures isn't always easy and so a certain amount of bracketing is advisable. One way to ensure that exposure *is* near the mark is to substitute a flashgun for the torch. If it is an auto gun, you do no more than set the appropriate aperture for the speed of film in use and then, with the flashgun off the camera, fire it at your various subjects, allowing the sensor to control the amount of light needed for that aperture in the normal way. If you are using a manual flashgun, work out your aperture as usual by use of the guide number and the flash-to-subject distance, then open up one stop to allow for the fact that guide numbers are calculated taking into account a certain amount of reflection from walls and ceiling in an average room, all absent outdoors. To enhance the effect further, whether you are using a flashgun or a torch, filters can be used on the light source or on the camera to add different colours to the subject.

Polarised light

We have already dealt briefly with the way light is polarised by reflection (chapter on filters) and how the use of suitable filters affects that light to change

Page 242: the simplest of all unusual lighting techniques – shooting a silhouette by exposing for a bright background, and allowing the foreground to fall into shadow. *John Woodhouse.*

Page 243: the worst place for a light in conventional portraiture is below the face. But for the special-effect worker, the position gives an interestingly weird effect to features as all the face's shadows are directed upwards.

An unusual lighting treatment for a portrait. The only light comes from directly behind the model, heavily highlighting her hair. The girl's face was lit by the same light, reflected from a gold reflector close to the camera.

tones and images within the picture. But there is more to polarised light than that. It is used in industry to show how various materials behave under stress, and a similar technique can be used by the special-effect photographer to produce strikingly-beautiful, multi-coloured patterns that could never be seen with the naked eye. The effect works well with plastics which, due to their methods of manufacture, are continually under stress. Examples include transparent plastic drawing instruments such as set-squares and protractors, adhesive sticky tape that has been stretched as it is bound around some object, acetate sheeting, even the wrapping from cigarette packets. It *won't* work with glass, because any stresses applied in the manufacturing process relax as glass cools. The effect relies on the fact that the refractive indices of these materials change with the amount of stress that is applied, either by the photographer or by the manufacturing process. When viewed by transmitted polarised light, these changes break up the light into its spectral components. The effect is known as birefringence. On black-and-white film it shows up as different shades of grey; on colour it is recorded as a pattern made up from the colours of the spectrum.

To make it work, you first need a subject. Try using a small plastic set-square, the sort that is used in schools. Next, you need two polarising filters: one for the camera, the other for the light. You could use a projector as the light source, in which case a normal filter designed for the camera might fit over the lens. But for more versatility, it is better to buy a larger sheet of plastic polarising material from a specialist scientific supplier. Since it will be used to filter light, rather than for photographing through, it need not be optically flat like a camera filter and small examples of the material can be bought relatively cheaply. Place the polarising material over the light source, and back-light the subject, preferably through some diffuser such as a sheet of tracing paper. The second filter is of the normal camera type and that is fitted in its conventional place over the lens. That's all there is to it. Viewing

246

the result through the viewfinder of a single lens reflex, or with the second filter held to your eye if you are using a non-reflex camera, the colours will immediately be apparent. As you turn the filters, the colours of the object will change; as you turn one filter relative to the other, the background will grow dimmer, then brighter. When the two filters are at right-angles to each other, the backlight appears to vanish completely, leaving the object being photographed to stand out vividly against a dark background. This is because the light from the backlight has been polarised by its filter to vibrate in one plane only and that plane has then been cancelled out by the camera's filter. The light on the subject of course has been broken up and is vibrating in random directions. The camera filter cuts out some of these, but leaves enough for light through the object and the colours to record on film.

All kinds of subjects can be photographed this way. Abstract designs or sculptures can be made with various materials and photographed; close-ups can be taken of small areas of stressed plastic. If slides are being taken, the results can be bound as sandwiches with other slides or lith masks (see chapter on montage), projected on to faces or figures (chapter on using projectors) or just used in their own right as colourful abstracts (chapter on abstracts).

Ultra-violet radiation

First a warning: ultra-violet radiation can be dangerous to use. Do not try any of the following effects unless you are absolutely sure of what you are doing. The UV source should be screened so that you do not look at it directly. For complete safety, goggles of the type used with sun-ray lamps can be used. It is, after all, the five per cent of UV in natural sunlight that burns your skin and gives you a tan. Imagine, then, what a concentrated dose over a long period of time can do. Having prepared yourself for the dangers, you need to find a source. Sun-ray lamps are suitable, but by their very nature they will burn the skin if you expose yourself to the

direct beam for too long. Safer is the black light used in theatres and discos. This has a longer wavelength than the light from a sun-ray lamp and is less harmful, though care should still be taken with its use. This latter type of lamp can be hired at a reasonable cost from a theatrical supplier. It gives off less visible light than the sun-ray type, hence the term 'black light'.

A typical UV picture shows objects glowing with what might seem to be impossibly-bright colours against a dark background. Unlike colours seen normally, these colours are not coming from either direct or reflected UV. Ultra-violet radiation itself is invisible to the human eye, but when it strikes certain substances it causes them to glow, as though they are being lit from within and often in a colour that is different from their own. This characteristic is known as fluorescence. Household materials such as detergents, powdered chalk and some toothpastes all fluoresce under UV. Many chemicals such as aluminium hydroxide, magnesium carbonate and zinc sulphide, to name just three, also fluoresce and while they are not as easy to come by, many of them are constituents of dyes and paints that can be bought in any good art shop. Certain papers and felt-tip pens also work well, because of the dyes in their make-up. But not *all* dyes fluoresce, and those that do will not always give off their own colour. The result is as unpredictable as it is fascinating. Bearing in mind the dangers mentioned above, a model can be wrapped in a costume that owes its colour to fluorescent dyes, fluorescent patterns can be added to the costume with appropriate paints or felt-tip pens, even the model's teeth will probably glow! Abstracts can also be made with fluorescent paper or dyes dissolved in water.

The pictures should be taken in a dark room, but although you will see only the light reflected through fluorescence, colour film will pick up a certain amount of the invisible UV, recording it as blue. You can use a yellow filter to absorb that if you want to make the background darker. The UV can also be absorbed by use of a normal UV filter to give a black background. Since the objects being photographed are glowing with normal light, rather than UV, their image will remain unaffected. No special film is needed to make UV-lit pictures, but if you are working in colour, best results are obtained on daylight-balanced film rather than tungsten. Exposure might be unexpectedly long since the fluorescent effect gives the impression of being brighter than it really is. A tripod, then, is almost a necessity for this work. Exposures are measured in the normal way but, as always with any experimental photography, it is wise to bracket.

Lightning

There is nothing difficult about photographing lightning. The difficulty is being in the right place at the right time and, if the storm is raging around you, keeping your equipment dry. Very often, however, lightning can be photographed from afar as the storm approaches, making it unnecessary to actually be out in the rain at the time the photograph is taken. There are two common forms of lightning: fork and sheet. Fork lightning makes the better picture by far. Sheet lightning tends to light up the whole sky and the impression on a picture taken by this light is of a normal landscape on a day when the sun is diffused by cloud.

Lightning is a lot more predictable than it might at first seem. It may never strike in the same place twice, but when viewed from a few miles distant, it certainly plays around one area. That area might be several miles across but, from the camera position, the distance can usually be accommodated within the angle of view of a standard lens. Once you have seen one streak of lightning it is easy to position your camera in anticipation of catching the next.

The pictures must be taken at night. The camera is mounted on a tripod, a medium aperture chosen and the shutter opened. As soon as the lightning flashes, the shutter is closed again, and that really is all there is to it. The picture can be enhanced by

The stresses in three plastic set-squares are shown as coloured patterns when the subject is lit by polarised light and photographed through a second polarising filter. The effect is known as birefringence.

A slightly surreal effect is produced by 'painting with light'. The camera was set on a tripod and the shutter opened on 'B' with the lens set at *f*/4. The tree was illuminated by a normal flashgun fired from one side and the lines of light were made by moving a torch around the area with coloured filters over its beam.

perhaps making multiple exposures, capturing several streaks on one frame. The photograph will also look better if the lightning streak isn't the *only* thing in the picture. A hillside overlooking a town or city would make an impressive location for shooting lightning. That way, the shutter could be opened as normal to record the flash, but left open long enough also to record the lights of the buildings on the same frame. Failing that, a similar picture could be faked once you have some decent lightning shots by double exposing them with other pictures: those city lights taken from a hillside or maybe a straightforward country scene that has been underexposed and taken through a blue filter to give the impression of night. (Techniques for producing double exposures are explained in more detail in the chapter on multiple exposures.)

Moonlight

The only real difference between shooting by sunlight and shooting by moonlight is the length of the exposure. Because the moon is a lot less bright than the sun, exposures are that much longer. Shooting by the light of a full moon on a cloudless night can give a result almost indistinguishable from a daylight shot when using black-and-white film. Even the sky will appear light if the exposure is long enough. On colour, moonlight gives a blue cast that would not be present in sunlight. To take a moonlight picture, first select a suitable subject such as a landscape in which there will be little or no movement during the lengthy exposure. If you want to focus on anything but infinity, use a small torch beside your subject and focus on that. Set the camera on a firm tripod and open the shutter for the required length of time. Exposures will be minutes rather than seconds and, as always, a certain amount of experimentation will produce the best results. As a guideline, make a start with an equivalent of 25 minutes at $f/5.6$ on ISO 100/21° film, shooting at full moon.

Don't try to include the moon itself in the picture because its movement across the sky during the exposure will record only as an oblong blur. If you

250

want it to appear realistically in the final picture, expose to keep the sky dark and then, when you have your first exposure, make a second on the same frame to expose the moon in an appropriate area of sky. Switching to a lens with a longer focal length will give a bigger image to the moon, making it actually look more natural in the final photograph, since a standard 50 mm lens will give an image size on a 35 mm format of no more than 0.5 mm. A lens of 300 mm will give an image size of around 3 mm, making the picture look far more dramatic. An average exposure for recording a full moon with no other detail around it is $1/60$ second at $f/5.6$ on ISO 100/21° film.

Fluorescent lighting

Tungsten-balanced film is balanced for tungsten light, daylight-balanced film is balanced for daylight, but no film is balanced for fluorescent light. Only filters will correct the colour balance of this light for a true rendering. But when did the special-effect photographer look for a true rendering of anything? It's for that very reason that fluorescent light can make another example of an unusual light source. Use it much the same way as you would normal lighting, but shoot subjects that will be enhanced by the cast so produced. Fluorescent light gives a blue cast to film which is balanced for tungsten, not unlike the effect of using that film in daylight; the same light gives an eerie green cast to pictures shot with daylight-balanced film. Exposures are measured in the normal way.

Lightning over a city,
captured during a 4 second
exposure at *f*/16. *Duncan
Bulmer*.

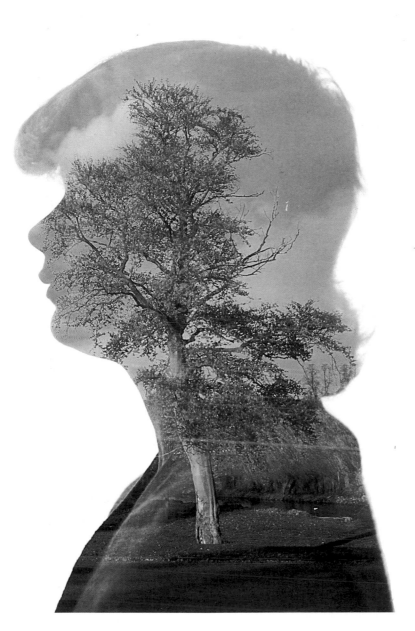

Multiple exposures

A straightforward photograph shows only one image of its subject. The appearance of two or more images on the same print, negative or transparency is, more often than not, due to a mistake on the part of the photographer or the result of a faulty camera. Used with a little thought, however, such 'mistakes' can often form the basis of interesting special-effect pictures. While certain items of specialist equipment, such as studio cameras, professional copiers and masks, are a distinct advantage to the photographer attempting multiple exposures, they are by no means a necessity. The majority of cameras can be used, once you learn a few basic techniques, and most of the accessories needed can easily be made from readily-available materials.

Cameras for multiple exposures

The most suitable camera for the job is one whose shutter can be tripped any number of times without having to wind on the film, and which uses some form of ground-glass screen for viewing, on which the position of various objects in the picture area can be marked. Top of the list for a camera that fulfils those criteria is the studio or monorail model. Such cameras ignore the fripperies more often associated with smaller models: there is no built-in metering or delayed action control for instance. And, more important for this type of photography, there is no double-exposure prevention device. They take cut film in a variety of sizes or rollfilm backs, feature bellows that allow close focusing without the need for any other accessory (useful for certain types of multiple exposure we shall be discussing later) and use a ground-glass screen directly opposite the lens for composing the picture.

Next comes the rollfilm reflex. The vast majority of these have interchangeable viewfinders that, when

removed, allow access to the ground-glass screen (convenient); some feature interchangeable backs (useful); and most include a facility for overriding the double-exposure prevention device (essential). 35 mm single-lens reflexes, on the whole, are less convenient. Some professional models have interchangeable viewfinders offering the same convenience as their rollfilm counterparts; many feature multiple exposure facilities; a good percentage, however, have neither. Which isn't to say that they can't be used for making multiple exposures. All it needs is a little ingenuity.

The problem of an inaccessible focusing screen can be overcome if the camera has an interchangeable screen facility. Even if it hasn't, it is often possible to have a special screen fitted by the manufacturers. Either way, a plain, ground-glass screen divided into squares is the most suitable. With that in place, a similar but larger grid can be drawn on a piece of graph paper, on which the relevant positions of objects seen through the viewfinder can be marked. If it is completely out of the question to change screens, then the position of the objects must be noted on a slightly more trial and error basis. Precise registration is, of course, impossible; but by using the circles of the rangefinder usually found within the viewfinder as a reference point, a fair degree of accuracy can be achieved.

To override the double-exposure prevention device on a 35 mm camera without a multi-exposure switch, the following procedure must be followed. First, use the rewind knob to take up any slack present in the cassette. Without touching the rewind *button*, usually found on the baseplate, turn the rewind *knob* gently in the direction required for rewinding the film until it comes to a stop. Now press in the rewind button. This will free the film transport mechanism in exactly the same way as when the film is being wound back into the cassette. Finally, keeping your thumb on the rewind knob to prevent the slightest movement of your film, turn the lever wind through the full throw of its normal action. This should now have cocked the

254

shutter while allowing the film to remain stationary and thus ready for a second exposure. The technique can be used for any number of exposures on the same frame.

When the multiple-exposure picture has been made, you will, of course, need to wind the film correctly to its next frame, and here you can run into trouble because the rewind knob on the baseplate, at this point, could still be depressed. Although it should pop out as soon as the lever wind is operated in its normal way, it might, in practice, stay in for part of the sweep. If that's the case, the film may not be advanced a full frame and the multiple exposure over which you have taken so much trouble will be ruined by yet another exposure from part of the following frame. The answer is to make one wind as normal, expose that with the lens cap in place so that no light reaches the film, and then make a second wind before taking the next shot. Since this leaves uneven spaces between frames, it is best to mark any slide film that is being sent away for commercial processing with the instruction 'do not cut'.

Multiple exposures can also be made in a 35 mm SLR by running the film through the camera more than once. Load the film in the normal way, advancing it to the first frame. Take off the lens and set the shutter to B. Press the release and hold it down. With the shutter open and the mirror up, the emulsion of the film's first frame can now be seen from the front. Take a pencil and mark the four sides of the frame directly on to the film. Close the shutter, replace the lens and wind to the next frame. You are now ready to make the first of what will be several exposures on one frame. To make the next exposure, the film must be rewound and reloaded in the normal way, and the pencil-marked square on the emulsion should be lined up in its previous place by using a combination of the lever wind and the rewind knob. As before, the film can be viewed by removing the lens and opening the shutter. This method has the advantage of allowing the photographer to make as many first exposures as

Page 253: here, 35 mm film was loaded into a single-lens reflex and the first frame marked as described in the text. A series of landscapes were shot and then the film rewound. In the studio, the first frame was aligned as before and a second series of exposures made, this time of a silhouette against a white background.

Page 252: the first of the two exposures that made this shot was taken outdoors at the bottom of a gentle slope. It was underexposed by one stop in anticipation of the final effect. The moon was added to the same frame a little later, by use of an inexpensive zoom slide-copier, using tungsten as a light source.

Two exposures on the same frame and a pretty girl becomes a ghost. The first shot was made with the girl sitting on the seat. The second shot was made from exactly the same position but with the girl moved out of the picture area.

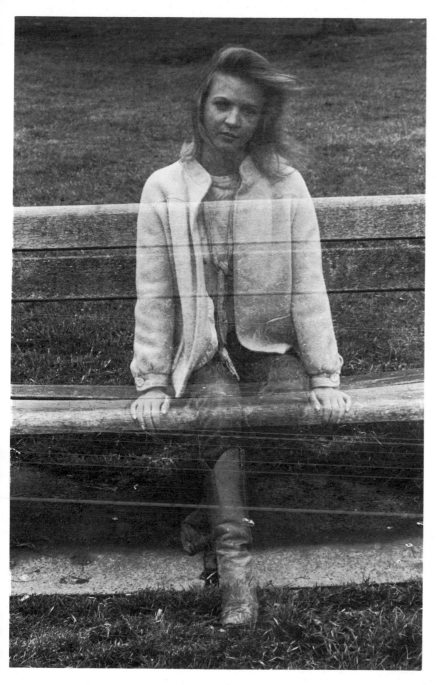

he likes on consecutive frames of film before going on to make a series of second exposures. Different combinations of aperture and shutter speed can then be used on the different frames, allowing bracketing of exposures on the first shot with standard exposures on the second or vice versa. The amount of experimentation and bracketing is limited only by the number of frames available on a single length of film.

Multiple exposures can also be made on 35 mm rangefinder cameras. Without reflex viewing, registration of one image with another is naturally less precise, but double-exposure prevention can be cut out as with a single-lens reflex. It is even possible to make multiple exposures on a Polaroid SX-70 or 600 System camera, in which the developing print is normally ejected from a slot beneath the lens. On the side of the camera, there is a catch which is pressed to open a flap for inserting or withdrawing the film cartridge. If this catch is flipped in the brief moment between the shutter being pressed and the film being ejected, the flap drops, the electronics of the camera go dead and the print doesn't eject. The flap can then be closed again and a second exposure made.

Disc cameras and those taking 126 and 110 film are usually unsuitable for multiple-exposure photography, since such models rarely feature a method of overriding the double-exposure prevention device or rewinding the film for subsequent exposures.

Types of multiple exposure

There are two basic forms of multiple exposure. In the first, two or more images are laid over one another so that, in the final picture, various parts of one picture can be seen, ghost-like, through areas of others. The effect is similar to, though not identical with, that obtained from a slide sandwich. (In a sandwich, the darker parts of one image overlay and block out the light parts of the other; in a multiple exposure, the light parts of one image are exposed *through* the dark parts of the other.) In the

second type of multiple exposure, parts of the picture are masked or lit in such a way as to include areas of unexposed film in the first exposure, and subsequent images are carefully positioned to fall within these areas.

In the former type of picture, exposures must be adjusted according to the number of shots being made on the single frame of film. This is because, as you add each new image, you are effectively adding more light. If each exposure is right for its particular subject, the final picture will naturally be overexposed. The solution is to give less than what would normally be considered the correct exposure for each image that is added to the final composite. If, for instance, two exposures are being made on the frame, each must be half the recommended meter setting; that means closing down one stop on each. If three exposures are being made, the meter reading on each must be divided by three (close down one-and-a-half stops); if four exposures are being made, the reading must be divided by four (close down two stops) and so on, according to the number of exposures involved. In the second type of multiple-exposure picture, each image being recorded in a portion of unexposed film, the overall level of exposure in the complete picture is not affected. Exposures, therefore, are metered and set in the normal way.

The straightforward way of making multiple exposures is to use the camera in its conventional way, shooting each image separately as you position it in the appropriate place in the viewfinder. Another way is to shoot each image separately to make a series of prints or slides and then to copy those on to one master frame in the camera. Equally, the two methods can be mixed, combining straight pictures with subsequent images from slides or prints. If your chosen method involves the use of prints or slides, you will need a method of copying. Depending on the quality of the result you are after, that can be as simple or as sophisticated as you like to make it. Copying stands are available commercially for copying prints. They consist of a vertical support for the camera to

ensure that it stands parallel to the baseboard on which the print is positioned and a couple of lights, either tungsten or flash, placed at 45 degrees on each side to give an even spread of shadowless illumination. Some form of close-up device is needed for the camera which will obviously need to focus closer than its normal closest focusing distance. This can take the form of bellows, extension tubes, close-up lenses or even a macro lens. In the absence of a commercially-made copier, prints may be pinned to a wall and the camera used horizontally on a normal tripod. The trick is to keep the two absolutely parallel and to make sure the lighting is even. Two small hand flashguns placed one each side, again at 45 degrees to the print, work well; or conventional tungsten bulbs in reading lamps can be used. If you have only one lamp or flashgun, try making two exposures, switching the light from one side to the other for each. Remember, though, to halve the meter reading for correct exposure.

The problem with copying is that it inevitably involves an increase in contrast between the original and the copy, something which is only overcome with any success when copying transparencies, and then only by the use of a professional slide copier. This consists of a small light table on which the slide is placed and a support with bellows attachment for the camera. A tungsten light is used beneath the slide to illuminate it for focusing, but the exposure is more often made by flash, a lead from the copier fitting the camera's synch socket. Contrast is controlled by a second flash of variable intensity which is positioned to hit the film at the moment of exposure, resulting in a small degree of fogging and therefore a loss of contrast. If such sophistication is beyond your means, there are smaller, much less expensive, slide copiers that screw or bayonet to the body of a single-lens reflex in place of the lens. With a slide in position, the whole thing is simply pointed at a convenient light source and the shutter pressed. Simpler still, if you have any close-up gear, is to tape the slide to a piece of ground glass, light it

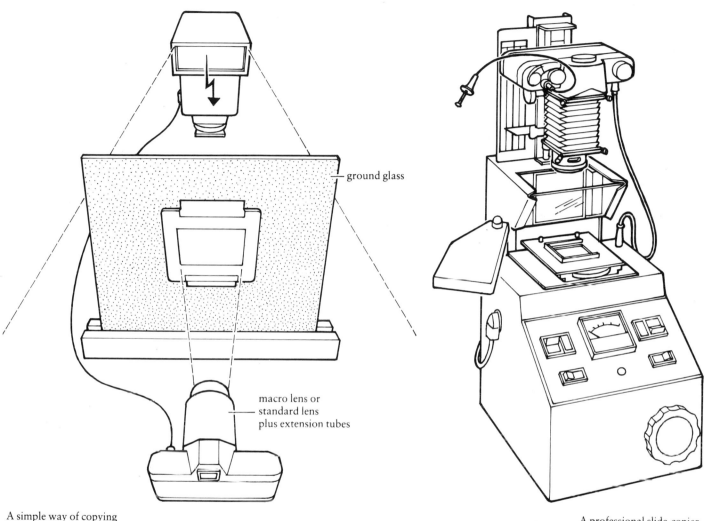

ground glass

macro lens or
standard lens
plus extension tubes

A simple way of copying
slides when making
multiple exposures.

A professional slide-copier
that introduces a degree of
fogging at the moment of
exposure, thus lowering
inherent contrast in the
duplicate.

from behind and line up the camera parallel to the opposite side. Even projectors can be used to project suitable slides on to a screen, from where the various images are photographed with a camera and standard lens.

In each of these latter methods, as well as with the print-copying method mentioned earlier, excessive contrast once again becomes a problem. That can be overcome to some extent at the enlarging stage if you are making your own prints or by use of special low-contrast copying film if you are shooting colour slides (see chapter on unconventional films). Contrast can also be lowered by pre-fogging the film manually to give a similar effect to that obtained from the secondary flash in a professional slide copier. Simply expose the film to an out-of-focus, white surface at a fraction of what would be the correct exposure, then double-expose your actual picture on to this slightly fogged frame. The amount of fogging exposure needed is best found by trial and error, bracketing by half to one stop each side of a set exposure. A good starting point for that is three per cent of the metered exposure on the white surface. That amounts to closing down by five stops. Whatever method you use for making your multiple exposures, the theory of how and why the best results are obtained remains the same. Perhaps the best way of understanding that is to look at some examples.

Subjects for multiple exposures

When shooting for multiple exposures, it is convenient to know the position of various subjects in each picture. If you are using a camera in which the image of the subject is thrown on to a ground-glass screen and the screen is accessible, the glass can be marked with a wax crayon or grease pencil. Afterwards, light polishing with a soft rag will remove the marks. If you have no access to the screen, you must position your various images in relation to reference points in the viewfinder, as mentioned earlier. Here are eight ideas for pictures that can be copied or used as a basis for your own experimentation.

258

1 In a darkened room and against a black background, pose a model in profile with strong side-lighting so that half the face is in shadow. Take the first exposure. Take a second exposure with the model full-face, posed in the dark area of the first exposure. The result will be the two faces on the same frame. Similar effects can be obtained by making the exposures with the model facing in opposite directions in each shot, so that the backs of the heads in the final picture seem to flow into each other. Or take a series of full-length shots with the model standing in the same position, first upright, then leaning to the left and then leaning to the right. The three different upper halves of the body will appear to be coming from the same pair of legs. Filter each exposure with a different colour to enhance the effect even more.

2 Shoot a 'ghost', by first setting your camera up on a tripod and placing your model in front of a suitable background – a brick wall, trees, or anything that presents a strong image. Take the first shot at half the metered exposure, ask your model to move out of the picture area and take a second shot at the same exposure. The result will be a picture that shows your model appearing to be transparent with the background showing through his or her body.

3 Take a picture of a suitable background such as a dramatic sky and, on the same frame, shoot a studio portrait against a black background. The sky will then record normally in the spaces that were black on the second exposure, but the face will appear combined with the clouds. This effect works best if you dress your model in black, and light the portrait so that part of the face is in shadow. The clouds will then come through stronger in the shadow areas.

4 Find a model with an attractive profile and, marking the start of the film as described earlier, shoot an entire role of your subject's silhouette, posing him or her against a white background in an otherwise darkened room and overexposing by at

The result of a double exposure against a black background. The girl was lit, for each exposure, with a light directly in front of her and just above head-height. While her features were illuminated, her back each time fell into shadow, helping the two images to merge more successfully.

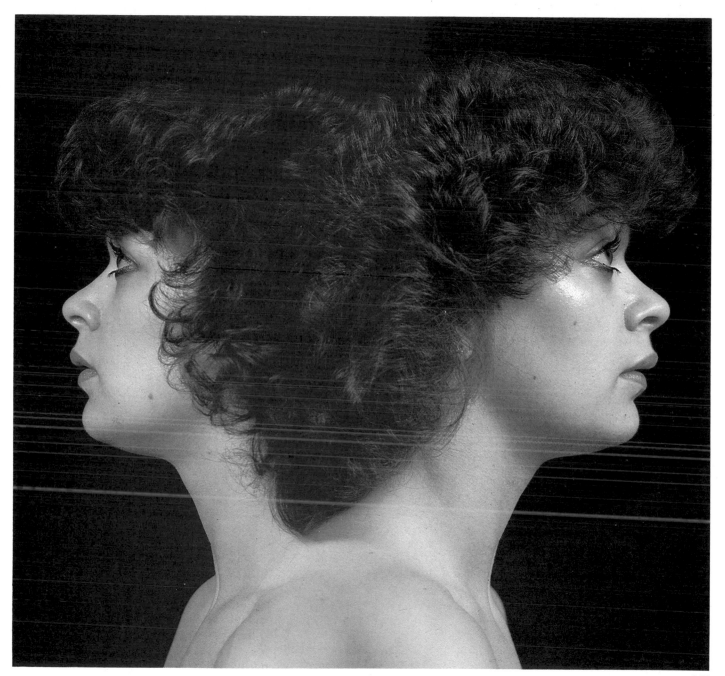

259

least five stops on the metered reading of the white. Rewind the film, line up the marks at the start again and shoot the rest of the film on landscapes. In the finished picture, the landscape will appear in the shape of your subject's silhouette, the white of the background having washed out the rest of the scene.

5 Shoot a sunrise or sunset over some hills, exposing for the sky so that the foreground records as black. Then, in the studio, shoot another object or a person to fall within this black area. The result will show this last subject posed against the dark hills with the sun rising over them.

6 Shoot two pictures of the same scene, with lenses of different focal lengths, using half the metered exposure reading for each. The result will be a picture in which the two images flow into one another to make an intriguing abstract.

7 If you have two similar cameras with interchangeable backs, set one up focused in close-up on a slide of perhaps fire or water. Set up the second camera aimed at a model against a black background. Take the first exposure on the close-up camera, then switch the back to the second camera and make the second exposure. Your model will then appear combined with the slide. If the slide is masked and the position of that mask marked on the viewfinder to coincide with the model's face, this will result in the effect being further enhanced, giving a clear image of the face, but with the background flowing into the rest of the figure.

8 Take a series of texture screens, normally used for sandwiching with negatives in an enlarger and, having marked the start of the film, copy them onto several frames, using one of the slide-copying devices mentioned earlier. Rewind the film, align the marks and shoot again. The final pictures will show the crazed lines of the texture screens over the various scenes captured by the secondary exposures.

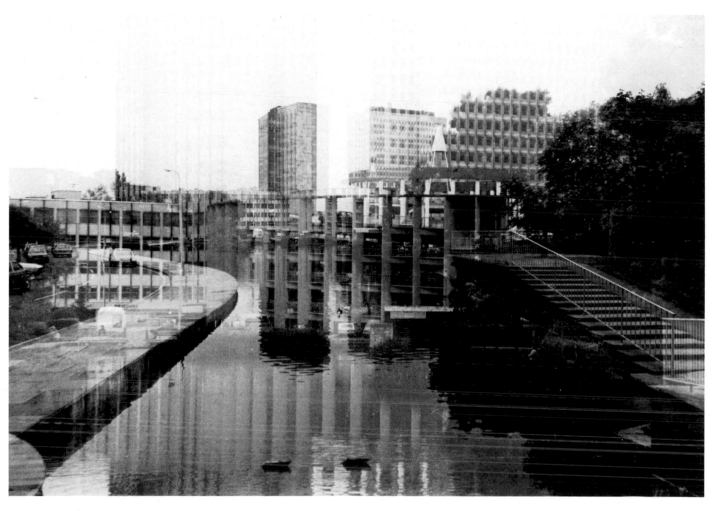

Left: a series of copies was
made of a texture screen,
more normally used for
sandwiching with negatives
in the enlarger. Later, in the
studio, a series of portraits
were double-exposed on to
the same frames of film.

Two exposures on the same
frame and from the same
position, each through a
different focal length of
lens.

Many of these ideas involve combining pictures taken outdoors with others taken in a studio or with pictures lit by artificial light. When shooting in mono, that presents no problem. With colour, the different light sources must be balanced by filtration. (See chapter on filters.)

Using masks

The use of different-shaped masks to block out certain parts of each shot as it is taken can give a completely different look to multiple-exposure pictures. Commercially-made masks are available in set shapes, often as part of a filter system; they can also be tailor-made by the photographer from thin, opaque card to suit exactly the right purpose for a specific picture. One of the most common forms of mask is that which blocks exactly half the frame of film. In the commercial sets, this usually consists of a slat of plastic that slides half-way into a filter holder for the first exposure and then, for the second, can be removed and slid in again from the opposite side to meet exactly the same point. Alternatively, small trapdoors of card can be made and taped over a lens-hood, opening one while keeping the other closed for the first exposure and changing over for the second. Either way, the device can be used for recording the same person twice on a frame, giving the appearance of identical twins. The method is simple. Place the camera on a tripod, close off the right side of the lens and place the person in the left of the frame for the first exposure; open the right side and close the left and take the second exposure with the person on the opposite side of the frame.

Alternatively, the mask can be placed so that it cuts the frame horizontally. Open the top half and make the first exposure, photographing a person filling the frame; close the top, open the bottom and ask your subject to move away before taking the second exposure. The result is a picture showing only the top half of the person you were photographing,

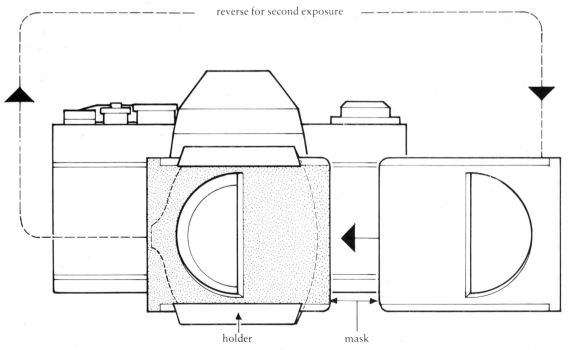

reverse for second exposure

holder

mask

Double exposure masks are available from some filter manufacturers. They enable you to shoot the two halves of one frame separately.

The identical twins in this picture are, in fact, one person. The picture is the result of a double exposure on a single frame, each through an alternate half of a specially-made mask, designed to cover exactly half the lens.

their body fading away to nothing lower down. Repeating the process, but this time asking your subject to take a pace sideways between exposures, will show the person's legs standing without a body to the side of a legless top half. A completely different effect can be obtained by switching the mask back so that it divides the picture area vertically, and lining up the join between the two sides with some thin object such as a lamp post. Make a first exposure with the right side open and with someone looking out from the right of the lamp post. Part of their body will obviously be visible from the left side too, but that will not be recorded with the mask in place. Now swap the mask to the right side and make a second exposure with the person moved out of the picture area. The final picture will show the subject's top half looking out around the lamp post, the bottom half apparently hidden behind the impossibly-narrow width of the post.

Masks are also available, or can be made, in different shapes. One set, for instance, might consist of a black spot in the centre of an area of clear plastic or glass, coupled with a second mask that reverses the pattern to give a clear spot in the middle of a black area. Using those alternately on the camera for two exposures can give the effect of, say, a face superimposed in the centre of a field of flowers. When nothing else is available, various dodges can be employed to mask areas you wish to expose to a different image. The ends of film boxes can be cut or torn and held in place, the result being noted in the viewfinder of a reflex camera. Even a finger can be held close to, but not touching, the camera lens to make a rough mask.

Multiple-exposure photography is like so much else in the special-effects field. There are always expensive gadgets available for specialised work, but often the quick dodge or the hastily-made accessory can work as well, if not better.

Frank Peeters

Why portraiture?

Anyone can take a portrait. The typical snapshot of a friend or relative on the beach is testimony to that. Such a picture may not be a magnificent example of lighting and composition, but it is nevertheless an elementary form of portraiture. That's where it starts for many photographers: on the beach with a friend and a simple camera. But then gradually, almost imperceptibly, the subject begins to get a grip on you, until you suddenly realise that maybe it isn't enough to merely snap a friend standing by the sea. You begin looking for the right *sort* of person with the right kind of face; you start to notice locations, backgrounds; you become aware of lighting, realising that it isn't quite right, not knowing at this stage what's wrong or how to set about improving it, but definitely knowing that you want to try. You're hooked. You're finished with snapshots. You're ready to start taking portraits.

The history

Portraiture is one of the oldest forms of photography, despite the fact that, back in the early days, it was also one of the most difficult. Because of the long exposures involved, models needed a lot of patience, not to mention self-control, and photographers with only one shot per plate were duty-bound to get it right first time. Although the first photograph was taken by Niépce in 1826, the first *practical* method of photography was the daguerreotype, which appeared in 1839, and it was with Daguerre's lengthy, cumbersome and often dangerous form of photography that the first portrait studios opened in the mid-1800s. The model who posed for a photographer in those days would have found himself in a studio, probably on the top floor of a building with a window that ran along the north-facing wall and across the roof, to allow in as much light as possible. Today, as you will see when we come to later chapters,

north-facing windows are still best when it comes to available-light portraiture. Equipment and techniques may have changed, but the quality of certain types of light will remain the same for ever. Many studios in the early days were equipped with a series of reflectors to make the most of the light available, bouncing it about the room and getting as much as possible on to the subject. There were even stories of studios that sported a complicated system of mobile reflectors, out in the street, that followed the sun and reflected light on to other reflectors inside the studio, all controlled by the photographer from beside his camera. That

photographer would have been using a huge plate camera mounted on a solid tripod and pointed at a chair in which the 'victim' sat with his head resting on an iron support. The support was hidden from the camera, but firm enough to prevent him from moving during the lengthy exposure times. Today it all seems laughable. And yet, before you laugh too loud, just take a look at some of those old portraits, the daguerreotypes, the calotypes that followed, and the immensely popular cartes-de-visite that sprang from the days of wet-plate photography. Some of the lighting, and even the expressions on the faces of the subjects, would do credit to any

Portraiture of the past. An original carte-de-visite, popular during the latter years of the nineteenth century.

"VANDYKE & BROWN" NOW
Rich^d Brown

ART PHOTOGRAPHER
LIVERPOOL.

anything else has changed and will continue to change this trait. It is the introduction of studio flash. Exposure times these days are not just short, they're infinitesimal. Flash stops just about any movement, catching a fleeting expression as it crosses a subject's face, arresting all motion and producing more natural results than ever before. The days when the photographer was forced to ask his model to 'hold it' are gone for ever.

The lure of portraiture

Portraiture, then, has fascinated photographers from the beginning. If you have already tried your hand at it, with or without much success, you know something of its lure. But maybe you are a photographer in search of a subject, and you could be asking yourself, quite simply: why portraiture? What is so fascinating about photographing another person? A face is a face. You look at a whole stream of them every waking hour of every day. Why should you want to start looking at them through your viewfinder, or capturing them on film? The answer must be subjective. Different people have different reasons for taking all sorts of different pictures, and so I can only tell you why I personally like taking portraits. The biggest reason is that I like people. No two people are alike, no two faces are the same, and every one presents a new challenge: finding the right pose, the most effective lighting, a relevant location . . . all the elements that add up to a perfect portrait.

photographer of today. The methods were crude, but the results were often superb.

With the advent of faster film, wider lenses and all the other modern gadgets available to you and me, portraiture should by now have broken away from the old confines to become a more lively art form. Yet so many photographers still produce stiff and awkward shots that might have come straight from the Victorian studio. What is more, many subjects actually demand that they be photographed this way, simply because it's the way they've always seen portraits before. One thing maybe more than

To the committed portrait photographer, a session that is working well can be exciting in a way that no other type of photography ever could be. What generates that excitement is the effect of two people, photographer and model, working together towards a common end, each giving his or her particular talent to the production of a great picture. When a session is going right, you and your subject can feel like the only two people alive, cut off from the rest of the world, locked together and intent only on the next shot, the next expression, each one better than the last. When the photographer is a man and the subject is an

For a male photograher, pretty girls make popular subjects. This shot was taken outdoors against the light and a wide aperture used to blur the background. *Brian Gibbs*

Right: male portraiture can be very challenging, especially when the chance occurs to photograph a face such as this. *Kevin MacDonnell.*

attractive girl, it would be useless to deny that there isn't something just a little sexual about the whole thing. There is, but in the most innocent of ways. It's like a mild form of flirtation: the photographer with the model, the model with the camera. She knows that he finds her photogenic, and for 'photogenic' she reads 'attractive'; why else would he want to photograph her? He knows that she thinks enough of him to pose, why else would she be there? Yet photographer and model do not have to be of the opposite sex to create a genuine feeling of excitement in a good session. Women photographers often take the best glamour pictures; the male photographer who is genuinely enthusiastic about portraiture will get as much out of photographing another man as he will a woman. There's nothing weird or unnatural about it. It's simply an almost indefinable feeling that occurs when you know you are getting great pictures.

There comes a point in any portrait session when both photographer and model are relaxed, they are comfortable in each other's company, the photographer is giving suggestions for posing and the model is reacting totally without embarrassment or self-consciousness. Given that point, maybe half-an-hour or so into the session, the photographer begins to know exactly what will work and what will not work with this particular model. From that moment on, as you look through the viewfinder at your subject, you'll find every once in a while that an expression will cross his or her face that you *know* is going to make a great portrait. If you're anything like me, you'll actually feel a quick churn in your stomach at that point, a surge of excitement that transmits itself to your fingers and straight to the shutter release. Click. Its in the bag. And you know without a shadow of doubt that it's right.

The same sense of excitement comes with lighting your subject. You sit him or her down, set up the camera and begin playing with the lights. Then, for the first time in the session, you look through the viewfinder and see things from the camera's angle.

The face fills the viewfinder or ground-glass screen. Suddenly it's no longer just a face, it's a potential photograph, and that old stomach-churning feeling comes again to tell you that you are on the right track. To take a good portrait, well composed, sensitively lit, with a model who contributes the right expression at the right moment, and then to see the finished result the way you originally visualised it, can be one of photography's most satisfying experiences.

That's why photographers take portraits. But why do models pose for them? Ask one hundred models and you could come up with as many different reasons, but basically it comes down to vanity. They like having their pictures taken, they like looking at themselves. That isn't meant as a criticism of models. It's just a fact, and one for which photographers should be thankful. Without that vanity, there would be no one to pose for them. The professional model of course poses for the camera as a way of earning a living. Such models know they are photogenic, they know how to make the very best of their looks and they know they can make money out of being photographed. It may have been vanity that got them into the job in the first place, but it's sheer hard work that keeps them there, and any photographer who hires a professional model will do well to remember that fact. Calling a model vain isn't an insult; vanity may be considered a sin by some, but for a model it's a virtue, and it doesn't hurt the photographer to know that it's there under the otherwise perfect personality of his model. Vanity, remember, likes to be pampered and a little pampering goes a long way in portrait photography. It's all part of the lure for your model.

The art of portraiture

Portraiture is one of the few areas of photography in which it is possible to have everything under your control.Compare it, for instance, with landscape photography, in which the photographer must first find the right scene whose elements have been put together for him in advance, and then must wait until the light is exactly right. How convenient it would be if he could say to a mountain, 'would you mind moving four miles to the left please?', or to the sun, 'could you move lower in the sky to backlight that tree, and try not to change your colour temperature as you move?' The portrait photographer, by comparison, can position his model where he likes, and in the studio he has complete control over lighting. If anything goes wrong, he has only himself to blame.

The purpose of this book is to help prevent things going wrong by telling you how to get them right in the first place. Reading it will help you to take better portraits. In writing the book I am assuming you know little about the fundamentals of portraiture, but equally I am assuming that you do know something about photography in general. You're the sort of person who already owns a fairly decent camera, knows how to use it, but wants to learn how to use it better. For that reason, I have tended not to explain certain common photographic terms in detail. Instead, I have included a short glossary of such terms at the back of the book for easy reference should you need it. A lot of theory has to be included even in a practical book like this, but that theory goes hand in hand throughout with practice. Any advice given is based not on facts culled from some other textbook, but on my own experience. If I suggest a certain lighting set-up or a way of ensuring the right expression from your model, you can rest assured that it works. I know, because I've tried it.

One of the most appealing aspects of portraiture is that it is, in fact, many different types of photography. It's studio, outdoor and available-light photography. It's also candid photography. It can be a form of sports photography and it's definitely a part of glamour photography. Special effects can be introduced to the subject, it works equally well in black-and-white or colour, and it can form the basis of a lucrative freelance business. Your first step, then, is to decide which type of portraiture is

Children make attractive subjects. Even when they are posed, they nearly always look natural. *Ed Buziak*.

for you. Probably the three most popular types are studio, outdoor and available-light portraiture. Each has its own advantages and disadvantages, and each conforms to a recognisable style, although this is a barrier that is worth breaking down.

Studio portraiture's biggest advantage is in its use of lighting. Everything in that direction is under the photographer's control. Pictures can be taken at any time of the day or night, any time of the year. The studio is its own little world where photographer and model can work without hindrance or worry over outside conditions. Sets can be built, backgrounds can be adjusted until they are right for the subject, and work can be carried out in comfort. Unfortunately, much of the time, this can lead to staid, conventional and often totally unimaginative portraiture. If a formal portrait is what is required, then there's nothing to worry about. But once you have learnt the basic rules, don't be afraid to experiment. The studio can be used for informal or way-out pictures too. Special effects can be built and executed with precision; on a more ambitious scale, front- or back-projection can even give the impression of being outside or in places that the photographer and model would never be able to get to in the ordinary way.

The first disadvantage the potential studio photographer faces is expense. Hiring a studio can seem costly when you start looking at rates, yet it is surprising how much can be achieved in only a couple of hours if both photographer and model know what their aim is before they start. And just one sale from one picture taken during such a session can more than pay for the hire of the studio. To fully equip your own studio can also seem extremely expensive at first, and yet amazing effects can be achieved with the simplest and cheapest of lighting equipment set up, in a spare room or garage, for example.

Any form of studio photography will of course always be false. The front- and back-projection

gear just mentioned is too expensive for any but the specialist photographer, so for portraiture in natural surroundings the photographer must move his model outside the studio. Straight away you have the disadvantaage of waiting for the right type of weather. Since it is rare to get exactly the conditions you want, it is advisable to approach an outdoor portrait session with several different types of picture in mind, telling your model to bring a variety of clothes to suit any situation. In fact outdoor portraiture is rarely as simple as it seems at first. You don't have lights to position, but you must still consider lighting, points which I shall be discussing later in the book. But once you have overcome the disadvantages (and with a little knowledge it's easily done) you can produce wonderfully natural pictures outdoors, using backgrounds and props that would never be available in the studio.

Available-light portraiture is something of a compromise between the first two types, and it is undoubtedly the trickiest of the three. Taking pictures indoors by the light of a window is easy enough, but it needs a little guidance, all of which you'll find in later chapters. Once you have the knack, you'll be producing softly lit pictures with a casual and wonderfully emotive effect that makes this type of portraiture, for many, the most exciting of all.

Portraiture can also be candid photography. This can be purely candid (taken without the subject's knowledge) or a mixture of candid and conventional, in which the subject knows he or she is being photographed, but is going about some business, ignoring the photographer, leaving him to choose the moment. This latter way of shooting an 'unposed pose' is particularly effective for bringing out a subject's character or saying something about their way of life. The actual technique of candid photography is allied to a large extent to outdoor and available-light photography. Go for glamour and you can add studio techniques to those other two. True glamour photography is a branch of

portraiture and one that, for obvious reasons, attracts male photographers. And yet good glamour photography, as opposed to pin-ups or the soft-core porn that is so often mistaken for glamour photography, should not be taken for sexual reasons. Many of the world's best glamour pictures are taken by women, who can approach the subject perhaps more objectively than men and who then produce pictures that are truly glamorous, as opposed to merely titillating. One has only to look at beautifully evocative pictures by photographers like Sarah Moon to see that glamour, in the true sense of the word, is an extension rather than a corruption of portraiture. The best glamour pictures will always flatter the model, not insult or exploit her.

As we look briefly at the different branches of portraiture, one thing becomes clear. The basic techniques and styles are rooted firmly in those first three main categories: studio, outdoor and available-light. Those are your basics, and as you progress you may well find yourself increasingly attracted to just one of the three. For the photographer just starting in the subject, not certain which might suit him best, my advice is to try all three. You'll soon realise which is your particular favourite, and you'll learn techniques in all the types that will help when you come to specialise in one particular branch.

Before you begin . . .
Perhaps the best piece of advice that can be given to the photographer about to embark on portraiture for the first time is: *be prepared*. Remember that in this type of photography you have an obligation not just to yourself but to your model as well, and there is nothing worse for a model than to go into a studio or out on location with a photographer who has little or no idea about what effect he wants to achieve. So plan ahead. Have a few good ideas stored in your mind before you start. Then use those ideas as a basis from which to build your session. Here are some more general points worth considering before you get down to the detail.

1 Decide on your equipment. Choose the format you want to shoot with and standardise around that format. Get to know your equipment. Don't shoot an important session using a new camera or lens with which you are unfamiliar.

2 Decide which type of portraiture you are aiming for, but begin at the beginning. Don't try glamour until you have mastered the art of posing and lighting a normal portrait. Don't try special effects until you understand conventional photography. Ideally, start with studio portraiture. What you learn about placing artificial lighting will stand you in good stead for using all other types of light.

3 Find the right model. Use people who like having their pictures taken. Never try to force someone to pose for you if they don't want to. Look for a model who is photogenic, rather than beautiful, pretty or handsome. Personality can mean as much as looks. The best model is one you have come to know fairly well, but not too well. Choose someone who is an acquaintance, rather than a close friend or member of the family.

4 Don't expect a session to go right first time. Be prepared to waste film while you get to know your model. Be prepared even to waste an entire session if it begins to look towards the end that the next one will be more promising. Understand your model's problems as well as your own. Treat him or her like a human being, not just like another prop or piece of equipment.

5 Don't hurry a session, and work in comfort. A model who is being hurried won't give of his or her best, and if you hurry yourself, you're bound to overlook some important point of technique. If you are shooting outdoors, don't work in too cold conditions. If you are inside, keep the room warm. A little music in the background helps too.

6 Don't be hidebound by rules, but don't ignore them either. Learn the rules before you attempt to break them.

274

The art of posing

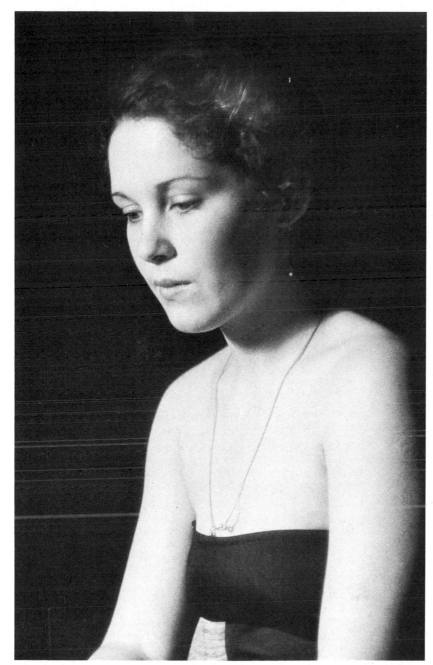

Ron Tenchio

A portrait can be either the subject's picture or the photographer's picture. The former should present a true representation of the model's personality, while the latter becomes much more of a picture in its own right, representing the *photographer's* personality sometimes even at the expense of the model's. What decides more than anything else the course the portrait is going to take is the way in which the subject is posed.

Subject's picture or photographer's picture?
If your intention is to capture someone's personality on film your first duty is to get to know that personality. Watch the way models behave, the way they use their hands when they are talking, facial expressions that they might use more often than others, the way they hold themselves. These are things that your models won't necessarily have noticed for themselves, but when you come to take your picture you can use your observations to direct your subject into a pose that best sums up his or her individual mannerisms. The picture of the girl grinning zanily straight at the camera has created a lot of amusement over the years, and for that very reason it has often been condemned by editors and judges alike. Yet this picture summed up the personality of that particular girl at the time it was taken far more than any serious portrait ever would, and for that reason it can justifiably be called a good picture.

If your subject is a man or an old person with a lined face, don't try to hide the wrinkles. Instead, use your lighting to emphasise them. If you are dealing with a pretty girl, you are more justified in hiding any small imperfections in her features with a soft-focus filter or lens. Also, don't think portraits always have to show people smiling. Some people are naturally more serious than others, indeed some find it all but impossible to smile naturally. If that's

275

their nature, photograph them that way. Such people will look far better adopting a serious expression than being forced to smile or laugh.

Character can also be summed up in a portrait by accessories and surroundings. If your subject, for instance, is a man who is a habitual smoker, don't be afraid to photograph him with a cigarette; if you are picturing a girl who has a particularly way-out dress sense, photograph her in one of her off-beat outfits, rather than in the traditional dress or skirt that would make a more conventional portrait. The picture of the old lady watering flowers in her window box shows how surroundings can tell the viewer something about the subject. In this picture, the old lady is the smallest element in the whole composition, yet she is definitely the most important. The almost claustrophobic conditions in which she lives, coupled with the fact that she still manages to grow a few flowers, tells us a lot about her character.

The second type of portrait, in which the photographer sets out to create an interesting picture in its own right, irrespective of the model's actual character or personality, is far more creative and so can be a lot more satisfying to take. However, if you want to try it, don't forget to tell your model in advance exactly what you are doing. Don't give him or her the impression that you are taking a nice, conventional portrait when, in fact, the lighting or the location is turning it into something far removed from that. Remember that, in agreeing to pose for you, your model has given you a measure of trust and has no real way of knowing what he or she looks like from your side of the camera.

Portraiture of this type is unlike its more conventional counterpart in so far as the model rarely sparks the initial idea. What comes first is the theme of the picture itself. That was very much the case with the picture of the girl standing alone in the empty landscape. It was also the case with two of the pictures shown on page 90: the man in front

276

Surroundings can say a lot about your subject's character. This picture looks like a candid shot, but was in fact carefully posed.

of the power station and the girl on the railway line. All these pictures were taken at the instigation of the phottographer, rather than the subject. In each case, the location came first and was used to inspire the idea for a picture. Having formulated exactly the way the finished picture should be, a suitable model was found to make it work. Professional models are ideal for this type of portraiture because they spend most of their working life posing as different characters, and the end product is their fee rather than the picture. That's their job, so provided you don't make them look silly they won't mind if the picture shows them different from the way they see themselves. Amateur models might be more fussy. The best are those who have had some experience in amateur dramatics and who are willing to 'act out' the idea you have for a picture.

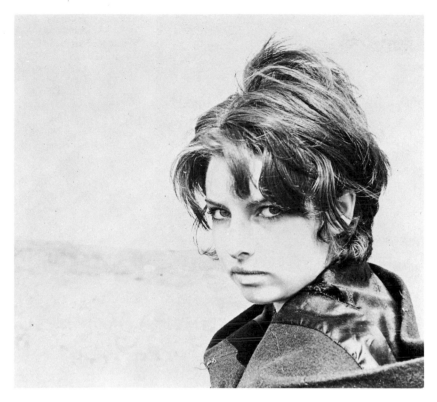

place relative to the surroundings, and then not the smallest bit more than is necessary of those surroundings should be seen in the picture area. More often than not, however, a portrait is a picture of a person, a single person and nothing but that person, the subject should fill the frame.

Learn to look through your viewfinder. Far too many pictures are spoilt simply because the photographer has not obeyed that most basic of rules. It's all too easy to concentrate only on the main subject at the expense of everything else that might be in the picture area, ending up with your subject too small in the frame. It's not so bad with black-and-white or colour-negative film with which you can enlarge just the part you need, but with colour slides it's fatal. Here's a simple test to try. Pick up your camera and look through the viewfinder at an object filling about half the frame. Now *really* look through the viewfinder. Keep the camera still and move your eye around the four corners. There are few people who can take in the whole picture area without moving their eye.

So move in close and use the right lens to fill the frame accurately with exactly what you require. A single-lens reflex of course makes your task simple, but with practice you can equally use a non-reflex camera, even when working close. Learn the relationship between the viewfinder image and the lens view in close-ups; with a bright-frame finder, discover when to use the parallax marks. There is no way I can give you exact instructions on the precise point to position your model, since it will vary with different non-reflex cameras. (With some, the camera's finder provides the required correction automatically as the lens is focused.) But a little trial and error is a wonderful thing. Take a few shots, placing your subject further and further out of the viewfinder frame each time, and make a note of the positions. By the time you have taken and seen the results of half-a-dozen shots, you'll know just the place in the viewfinder of your particular camera that will produce the desired effect on the film at a given shooting distance.

The photographer's picture, as opposed to the model's picture, does not necessarily have to sum up the subject's personality. The idea for this portrait was dreamt up by the photographer, who then found the right model to make the idea work.

Many examples of this type of picture are reliant on locations to provide individuality. But others can be taken in a studio, where it is often the lighting or the application of some special effect that differentiates the subject's picture from the photographer's picture. A later chapter is devoted to special effects, many of which should give you ideas of how to bring your own touch of individuality to your portraiture.

Filling the frame
Posing your subject for an effective portrait begins, not with the subject, but with the camera. A portrait is essentially a picture of a person, and that person should dominate the picture. If the background or surroundings are an integral part of the picture, the subject should be posed in the best

277

You will, however, have another problem: perspective distortion. In talking about non-reflex cameras, we are often talking about cameras without a facility for changing lenses. A fixed-lens camera is usually fitted with a standard lens, and to fill the whole frame with a single face means moving in to around 1½ metres or closer, at which distance your subject's features will begin to look unnatural. The problem is made worse by many of the non-reflex, compact 35 mm cameras currently on the market, most of which are fitted with semi-wide-angle lenses. There is a solution, though not a very good one. You can step back and take the picture from further away. This prevents perspective distortion and parallax problems. But you will have to blow up the final result to fill the print area, and that means a loss of quality. So, to repeat, what I said on page 18, it is possible to use a non-reflex camera for portraiture, but given the choice it's not recommended.

Relaxing your subject
The professional model knows how to relax, or at least how to *appear* relaxed. For an amateur model, looking relaxed in front of the camera is an art still to be learnt. There are a number of ways you can help. Remember that someone who has been asked to pose for the first time is probably quite nervous. It's up to you to relax the model by talking, giving reassurance of the way things are going, and saying things look good even when they look bad.

Tell an inexperienced model to smile and the result can be grotesque. The reason is simple. Naturally smiling people do more than merely turn up the corners of their mouths. A smile is reflected in the eyes as much as in the lips. So those who smile with their mouths without bringing the right light to their eyes will record badly on film. This is something that, as a photographer, you will learn to notice, but many people go through life without knowing it about themselves. So remind your model of the fact. Talk to her, crack a joke or two and make her laugh. Then stop her and remind her of how she was smiling naturally. Once she has
278

Two of the problems of using a non-reflex camera for close-ups. Perspective distortion is seen here in an exaggeratedly large nose, and eyes that appear too close to the sides of a slightly fat face. Parallax is shown by the broken line (the view through the viewfinder) and the solid line (the image likely to appear on the film).

noticed it for herself, she will be able, with practice, to teach herself the right way to smile for you.

Eyes and mouths, then, are your main concern, so learn how to deal with each in turn. Tension can cause your model to tighten the muscles around the mouth, giving an unnatural expression. To relax that part of her face, ask your model to fill her mouth with air a few times, to blow out her cheeks and then to let the air out through her lips. It gives the mouth something to do and the muscles 'forget' their tension for a moment. It is also a pretty silly exercise and will probably make your model laugh, all of which helps her to relax. Licking the lips also helps to relax the mouth. It relieves the dryness caused by nerves, and at the same time adds a highlight to the lips that photographs well.

The trouble with eyes is the way they tend to go dead while the model is waiting for the shutter to click. The actual difference between 'dead' and 'alive' eyes is an infinitesimal change in expression

Right: engage your subject in conversation during the session and you'll get a more natural look to your portraits. *Kevin MacDonnell.*

that you would be hard put to describe in words. But you'll recognise the look when you see it and you'll soon realise that it's enough to ruin a portrait. If you find your model is beginning to take on the glassy, blank look, there is a simple way of bringing the life back to her face. Tell her to look away from the camera, either down at her toes or around to one side; then, when you are ready to take the picture, get her to turn quickly back to face you. The blank look will have gone and you can safely press the shutter. Alternatively, ask her to close her eyes for a moment and then to open them wide as you take the picture.

The way *not* to relax your model is to attempt to direct her into an awkward pose. So start the session with simple, natural poses. Sit her down and make sure she is comfortable. You may only be photographing head and shoulders, but the position of her arms and hands will dictate whether or not she feels relaxed. So allow her to rest her hands in her lap. The more comfortable she feels, the better your pictures will be.

The pose

The most popular type of portrait is the head-and-shoulders shot. To finish with a good picture, you must begin by considering something that might, at first, seem to have little do with either photography or the model: decide what your subject is going to sit on. A backless stool is best, simply because, with a chair, it's all too easy to include the back in your picture without noticing it, thus making an unwanted distraction. The lack of back, however, can present a problem to the sitter, who without that support might tend to slump forward slightly, presenting a round-shouldered look to the camera. Keep a careful watch on that, and always encourage your models to keep their backs straight, even when they are perhaps leaning forward into a pose. 'Straight' does not have to mean 'vertical'.

Faces have two sides to them. An obvious fact, but one that shouldn't be ignored, because very often

one side of your model's face will be more photogenic than the other. Look carefully at your model and you'll soon see which side is best. It might be a hairstyle that is parted to look better from one side than the other. Many people, both men and women, have noses that point slightly more to one side of their face than the other. The side to which the nose points is generally the more photogenic. Whichever is the better is clearly the side to shoot from.

The actual position of the subject's head in a portrait is simple to visualise, once you know a few basic rules. Look at the face and imagine a line drawn vertically down its centre, bisecting the nose. Now imagine another line drawn horizontally through the eyes. The resulting cross should always be placed off-centre. Imagine your picture area overlaid with a noughts-and-crosses grid. The horizontal line of your cross should be along the top line of the grid and the vertical line down the left or right vertical lines. If the subject is looking to the left, the right-hand line should be used, to give more space for the subject to 'look into'. If the subject is looking to the right, the left-hand line should be used for similar reasons. Given the choice, position your subject on the right, looking towards the left. The viewer, who is used to reading from left to right, will also look at a picture that way and his gaze will consequently move across the picture, into the subject's eyes. The effect is obviously far more pleasing than scanning the picture so that your eyes start at the back of the subject's head.

If the cross is exactly upright, the portrait will look fairly formal and a serious expression will suit best. In any form of photography diagonals always suggest movement, and portraiture, although essentially a static subject, is no exception. Tilt the cross forward, so that your subject is leaning into the picture, and the portrait becomes far more relaxed and informal. Tilt it back slightly and a feeling of vitality will be conveyed, but only when coupled with a happy facial expression. Tilt the

280

head back with a more serious expression and the subject will begin to appear aloof. When working with this type of composition, beware especially of tilting the head too far back. The right amount might give the impression of someone throwing back their head to laugh, but go just a fraction further and your picture could look more as though the subject is about to overbalance.

There are three basic positions for a head-and-shoulders portrait: full face to the camera, three-quarters view, and profile, Each gives the picture its own particular mood. A full face, looking straight at the camera, gives immediate contact between the subject and the viewer, building a feeling of intimacy and a certain amount of formality. Keeping the face where it is and flicking the eyes from the camera can change everything. The feeling is that the model has meant to look at you, the viewer, but has been distracted at the last moment by something outside the picture area. The expression becomes one of suspicion or even fear. Tilting the head to look down, then bringing the eyes back to the camera, changes things again. It widens the eyes, giving a woman a vulnerable look. For that reason, it's an expression that doesn't work well with men.

Keeping the eyes on the camera but now changing to a three-quarters view of the face gives an informal, relaxed look. Different moods can be conveyed according to the subject and expression. A woman might look coy, as though the photographer has caught her out; a man in the same pose might look suspicious. The three-quarters view of the face in which the eyes look straight ahead and obliquely away from the camera gives the impression that the subject is aware of the camera, but is preoccupied and has no interest in it. The subject in this pose will look pensive, especially if the whole face is tilted slightly down. When shooting any three-quarters view of your subject, take care not to turn the head too far. Don't let your model's nose meet or intersect the profile of the far cheek. If it does, ask your subject

Leaning forward into the picture gives the pose a more relaxed and informal look.

Page 282: if you have difficulty positioning hands, why not exaggerate them? It may not be considered traditional portraiture, but it can make an effective picture.

Page 283: children can be asked to play roles for interesting portraits. Make sure, though, that you don't overdo the clowning. *Len Stirrup.*

square-on to the camera will appear to have a far broader (not necessarily *fatter*) body than normal. If you are dealing with a lively subject, a young girl with a vivacious personality perhaps, you can even turn your model so that she is facing in a three-quarters pose *away* from the camera, then ask her to look back at you. Be careful with this pose, though. When setting it up, start with the final position for the head, then ask your model to slowly turn her body away and stop while she is still comfortable. Asking her to look too far back can be extremely uncomfortable, and the discomfort will show in the portrait.

It's very easy, when posing your subject, to look only at the face or, worse still, no further than the eyes. Watch the whole frame and pay particular attention to the shoulders, one of which will normally be nearer the camera than the other. Make sure that the angle you are using doesn't make the nearer shoulder unnaturally large. Also, make sure that the nearer shoulder is higher in the frame than the far one.

Hands are perhaps the most difficult element to introduce naturally into a portrait. If in any doubt, it is best either to leave them out, relying on the face alone to give the picture its impact, or to go the other way completely, using the hands in an exaggerated pose such as that in the picture of the girl with her hand spread before her face. If your aim is to include hands in a more natural way, make sure they are in the same plane as the head. A hand has only to be fractionally nearer the camera than the face to look disproportionately large, and the narrow depth of field common to portraiture will quickly render it out of focus. There's nothing worse than an over-large, blurred blob in the foreground to spoil an otherwise perfect portrait.

If you are moving in close, make sure you show enough of the subject's arm to indicate that the hands are actually attached to his or her body. It's all too easy to position your model's face on one side of the picture, with a pair of disjointed hands

to turn his or her head slightly back towards the camera. The profile portrait, in which the subject looks straight ahead at 90 degrees to the camera, makes a dramatic shot. There is no eye contact between the model and the viewer, leaving the impression that the subject doesn't even know that the camera is there. People shot in profile tend to look aloof or more interested in something going on outside the picture area.

However you pose your subject's head, it is inadvisable to pose the body square-on to the camera. Even in a full-face shot, your subject should be seated three-quarters to the camera and then asked to look back. The person who is posed

that might as well belong to someone else coming from the other side of the frame. This is one place where a traditional, hard-backed chair can be an advantage. Turn it so that it faces three-quarters away from the camera, then get your subject to sit sideways, looking back at you and resting his or her arms along the back. It immediately gives a relaxed pose and one that makes a good starting point for positioning hands and arms. Arms along the chair back can look suitably casual, but beware of a distorted elbow pointing at the camera. You might also ask your subject to rest only one forearm on the chair back and then to sit with the opposite hand resting lightly on the first. Relaxation is the watchword when introducing hands into any portrait, so never ask your subject to adopt a pose that is unnatural or uncomfortable. Well positioned, your model's hands will help tremendously to convey his or her character. In the wrong position, they can ruin the whole picture.

Most of what has been said above applies only to posing head-and-shoulders portraits, but much of it can equally be applied to the three-quarter-length or full-length picture. As with head-and-shoulders pictures, unless you are going for a specific effect it is rarely a good idea to pose your model square-on to the camera. It's better to ask them to pose facing at 90 degrees in profile and then to swivel their body from the hips back towards you. A full-length pose is usually best shot in conjunction with some accessory or background that is pertinent to the picture. The reason is simple. The average person is 1½ to 2 metres in height by about half a metre wide, and that makes a very awkward shape to photograph when the person concerned is the only object in the picture. Shoot the subject together with a suitable background and you begin to get a more conventional shape to the composition. A serious-minded man, for instance, can be photographed maybe in a library, where the books in the background form an integral part of the picture and tell you something about his character. Shoot a full-length portrait from between eye and chest level and the subject will look slightly shorter

than he or she really is. Shooting from below knee level makes the model look taller, emphasising legs in a pretty girl. If a full-length portrait is to be shot of the person alone, it's not a bad idea to ask the person to sit down and so immediately take on a more compact shape.

Good portraiture of course means more than following a set of rules blindly. If we were talking about still-life photography, for instance, you might be able to produce great photographs by following the rules. Top-class portraiture, however, relies on learning the rules and then applying them, bending them, even breaking them when the occasion justifies it. Because never forget that your subject is a living person, and it's up to you to find how the rules best apply to each individual you photograph. Rules that work for one face won't necessarily work for another.

Finding just *how* they work best is largely a matter of personal experience, but it doesn't hurt to learn from the experience of others. Portraiture is all around you. Pay attention to the work of recognised photographers whose pictures are published in books or on show in galleries. Look through women's magazines, especially at the cosmetics adverts. Copy poses, and then adapt the ideas of others to formulate ideas of your own. Watch television, particularly soap opera. The programmes that predominantly feature women usually compose each shot to show the stars to their best advantage. The way they stand and move can tell you a lot about posing and give you a wealth of ideas for your own pictures.

Children

You *can* pose children in all the ways mentioned above, but you must allow for a certain lack in their powers of concentration. Children over the age of three will respond to direction, but only for a time. So you can start by posing them the way you would an adult. But the moment their attention begins to wander, it's time to try a new line of approach. Have a few objects available that will interest them,

Find the right child, make sure he or she doesn't become bored and you have the recipe for great pictures. This little girl was given the cap and glasses to play with and her expressions changed as fast as the shutter clicked.

A craftsman often feels more at home in his own environment than in the studio, and so that's the best place to take his portrait, allowing him to work while you shoot. *Roy Pryer.*

Alternatively, if you take him into the studio and ask him to dress in his boxing shorts and look mean for the camera, all you'll get is a picture of someone whose embarrassed expression reflects the strange surroundings in which he has found himself. He's not a professional model, he's a boxer, and nothing is going to make him relax enough to give you the sort of picture you are after.

For the best pictures in these circumstances, then, you should photograph your model on location, in the boxing ring. But remember you are a portrait photographer, not a sports photographer. In this particular example, you wouldn't be shooting pictures of the boxing match itself, but maybe using a long-focus lens to pick out expressions on your subject's face as he goes about his business, shooting him between rounds as he sits in his corner, preparing himself for his next bout. The same goes for most types of sports people: tennis stars, runners, gymnasts. Photograph them in action, but watch too for pictures before and after the action. A picture of a runner, taken as a full-length shot as he speeds along the track with the background blurred behind him, is a good sports picture; a close-up shot of the runner's sweating face, racked with exhaustion at the end of the event, is a better *portrait*.

Another place where the unposed pose works well is in photographing craftsmen: the potter at his wheel, the woodcarver intent on his subject, the craftsman working at his lathe. The biggest problem will be working in conditions suitable to the subject rather than the photographer. Instead of bringing your own lighting to the subject or taking your subject to the best place for your photography, you will have to work wherever that subject is most at home. That could mean vastly different locations ranging from, say, a large sports arena to a small workshop. Wherever you work, you can use techniques described in later chapters to light your subject. For the most part, this will mean applying what you learn from the chapter on available light.

An unposed shot taken with fast film at full aperture. Under these circumstances, the highest quality photography can hardly be expected, but it produces informal shots that would otherwise be unobtainable. *Ron Tenchio.*

not necessarily toys. In the set of pictures on pages 284–285, I merely gave the little girl an old denim cap she likes playing with and my own glasses, then shot the pictures in rapid succession, the child's expression changing with every click of the shutter. The skill comes in applying the rules about posing, together with other rules you have yet to learn about lighting and such, in an almost candid form of photography, watching for exactly the right moment to take the picture.

The unposed pose
Sometimes a pose works better if it isn't actually posed. Take as an example the portrait photographer faced with photographing a sporting personality. Think of a boxer. Without doubt, those words conjure up in your mind a vision of a powerful man, stripped to the waist, gloves on hands, a determined expression on his face and ready to lay into his opponent. Take that man, dress him in a suit and ask him to smile in a studio and you completely destroy his personality.

The character of an athlete who might be embarrassed at posing for the camera in the normal way is captured perfectly by a candid shot taken at the end of a race.
Mervyn Rees

The unposed pose can often tell you more about your model than a formal studio portrait ever could. *Mervyn Rees.*

Page 290: in a professional studio, a softlight, reflectors and effect lights can create just the effect the photographer seeks. *Michael Barrington-Martin.*

Page 291: at home, careful arrangement can produce studio-like portraits. For this wistful shot, direct lighting was the best choice. *Ray Chappell.*

289

The technique for posing your subject isn't unlike working as a candid photographer (see later). Unlike the victim of a true candid picture, however, your subject will nearly always be aware of being photographed. Don't let this work against you. Someone working at a lathe, for instance, having been told that you want to take his picture, might think that he has to put on clean clothes and not get his hands dirty. So explain that you want a natural picture, that you are out to photograph him the way he works. Once he has begun to work, he will rapidly lose himself in the job, forgetting all about the cameraman who is watching him through a viewfinder. That leaves you free to watch for interesting expressions, capturing the picture at the best moment. When it comes to subjects such as sports photography, you can either ask your model to go through his particular routine in private for the camera, again choosing the best moment for the picture, or you can work at actual events, shooting from a distance with medium- to long-focus lenses. The latter way of working is the best, producing splendidly natural portraits of your subjects.

Children too are good subjects for this particular method of shooting. Earlier in this chapter, we dealt with the best way to pose children formally. Going for the unposed pose, on the other hand, gives far more natural results. Children at play have a wonderful concentration on what they are doing at any particular moment that cuts them off from anything else going on around, and that includes you and your camera. Don't go out of your way to be unobtrusive, because that could begin to attract them to you. *You* will become the thing they start to concentrate on. Instead, explain to them that you want to take a few pictures as they play. Once the initial novelty has worn off, they will soon become involved with something else, forgetting all about you and leaving you to follow them around, shooting from only a couple of metres away. The best location for such pictures is out of doors, in a playground or in a field where the children are playing. For lighting, think in terms of the points covered in the chapter on portraiture outdoors.

292

Disguising defects
Even the best models are rarely perfect. Certain poses should be avoided with certain features, while other poses can help hide the defects. If you are photographing someone looking back at the camera over a shoulder, watch out for lines and wrinkles in the neck. These can be flattened out a little by asking your model to look down before he or she looks at the camera; then, looking back, the head is lifted again. Baldness can be hidden by lighting your subject predominantly from the side and shooting from below the chin line. Conversely, a double chin is best hidden by shooting from slightly above head height, so that the subject is forced to look up at the camera. If your model has some unsymmetrical feature such as a slightly twisted nose, don't shoot head-on. If a nose or chin is unnaturally large, never shoot in profile. A large nose, as long as it is straight, can be shot head-on. The longest practical focal length of lens can then be used to compress perspective and so 'shorten' the defect. Lighting should also be arranged so as not to cast a long nose shadow.

If your model has a lined and wrinkled face, you might want to use your lighting, in ways described later, to emphasise the points and so bring out your subject's character. There are times, however, when it might be more prudent to disguise those very characteristics. A middle-aged woman, for instance, might have a few lines on her face that she doesn't want to admit to. She isn't old enough to warrant a character-study type of portrait, but she isn't young enough either to justify a glamour approach; you need something in between. Lighting plays a large part here. The more the main light is taken away from the camera-to-subject axis, the more those lines will show. To help disguise the defect, lighting should be kept more to the front and not too far above head height. The light should also be softened. A hard light in a deep reflector or from a spotlight will emphasise shadows in the lines of the skin, so keep your main lights in shallow reflectors or bounced from umbrellas. (See the next chapter for actual techniques.) Soft focus can also

Children photographed outdoors are often best left to their own devices. The mischief they get into will soon lead naturally to lively pictures.

help 'iron out' lines and stressmarks on a face, and this can be achieved in a number of ways, soft-focus lenses and filters being the two most popular and convenient.

Blotchy skin or freckles can be hidden to some extent in black-and-white photography by the use of filters. Since filters lighten their own colour, a pale straw-coloured one such as an 81A or 81B will reduce the effect, especially when coupled with frontal lighting. But at the same time it will reduce the tone of lips, a fact that should be prepared for in advance by the use of a darker than usual lipstick. The same filters can be used to give a more healthy look to pale skin in colour photography; in mono, a blue filter will have a similar effect, while lightening blue eyes. Both effects are particularly useful in male portraiture.

If a person is naturally short and maybe a little fat, a three-quarters length pose can add a certain amount of apparent height. Don't pose the subject in a way that emphasises a defect; if your model has a large stomach, keep it out of profile, shooting head-on, but with lighting more to the side. Side lighting tends to 'slim down' a face, while frontal lighting makes it appear broader. The right choice of clothes also helps: vertical stripes on a shirt or dress give an apparently slimmer look than horizontal stripes. And remember that the two sides of a face are often quite different. One might be slimmer than the other, so that is the side from which to shoot.

Finally, spectacles and ears. If your subject wears spectacles, watch first for unwanted reflections, then make sure you can see the eyes behind the lenses. If you can't, try a slightly lower viewpoint. If the subject has ears that stick out a little too much, photograph him or her in a three-quarters pose. If the shot must be head-on, reduce the lighting slightly on each side of the face, using barndoors on the lights.

Entertainment events

This chapter covers the things you might photograph when you are out for an evening's entertainment or, perhaps, watching preparations for other people's entertainment. Before we go any further, though, there is one point that is worth mentioning. The majority of theatres, sporting events, cabarets etc. generally prohibit photography. If you are planning to visit a show and take photographs at the same time, make a point of checking first to find out whether photography is permitted. If it is, then you have no problems. If it isn't, try contacting the management of the establishment and asking for permission. If it is granted, be sure to have the fact stated in writing so that any over-zealous doorman or security guard can be forestalled. It's highly unlikely that anybody is going to take your word for it unless somebody can be found to confirm that you are telling the truth — and such useful people can rarely be found when you need them.

Equipment
The ideal camera for photographing night life is the 35 mm single-lens reflex. It is small, unobtrusive, easy to handle and quick to use, but most of all, it is versatile. In an instant you can change lenses, going from the extremely short to the extremely long; you can also change films easily, and quickly, from the fast to the super-fast, and from black-and-white to colour. Better still, you can take pictures in really low lighting conditions, hand-holding the camera. The reason why this is possible is because the 35 mm camera lens can offer you apertures in the order of $f/1.2$, something which just isn't possible with the big, 165 mm lens which is standard for a 5 × 4 camera. Even if such an aperture were possible on large-format camera lenses, it would be almost unusable because of the smallness of depth of field — a matter of a metre or so even at a reasonable distance.

Page 294: it isn't easy to get a shot like this – wide apertures and tele-lenses don't naturally go together – but, at least, you can use a slowish shutter speed. *Robert Ashby.*

Page 295: here, there is rapid movement to contend with. Use the fastest possible shutter speed and wait for the 'dead point' when the upward movement has stopped but the downward movement has not yet begun. *Brian Gibbs.*

A whole television picture is formed by a dot scanning the screen 30 times per second. Use a shutter speed briefer than 1/8 second (or 1/30 second if it is a between-lens shutter) and this is the sort of result you can expect.

Most important events draw massive crowds and, unless you are privileged enough to have a reserved seat, can prove impossible to photograph well. Television, however, can often provide a ringside seat and some quite spectacular pictures. These shots of the wedding of Prince Charles and Lady Diana were taken directly from the television screen. Here's how you can take pictures in this way:

Adjust the TV picture so that it is slightly lower in contrast than normal, set the camera up square to the screen and as close to it as possible, turn off any lights and close any curtains. Now you can take pictures. For cameras with a between-lens shutter, exposure times should be 1/30 second or longer. For cameras with a focal-plane shutter, 1/8 second or longer. With daylight film, ASA 64, exposures of around 1/30 second at f/8 should be about right.

Another important feature of the 'mighty mini' SLR is the ease with which focusing and framing can be carried out, even in the darkest conditions. Whereas using a stand camera in a theatre auditorium would make a dark cloth necessary to exclude reflections of 'exit' and 'no smoking' signs in the ground-glass screen, an SLR camera incorporates its own dark cloth, so to speak. The camera body around the pentaprism, and your eye close to the finder lens, serve to cut out completely any extraneous light, leaving a clear, bright image on the focusing screen.

Finally, the feature which, used correctly, can make a job much easier is the built-in exposure meter. The trouble with built-in exposure meters in some SLR cameras is that in low light conditions it can be extremely difficult to see the needle or readout. This is because the needle is usually located at one side of the image area and, if the picture you are taking consists of one person spotlit in the centre of the screen, the needle will be hidden on the dark edge of the screen. To see the needle and work out whether the exposure you are giving is correct, you have to swing the camera sideways, so that you can see the needle against the bright image area which is now at the edge of the screen. Unfortunately this means that the centre area of the screen, which the meter reads from, is now dark; so the meter is not reading the exposure you need anyway. It's impossible, so what do you do? Well, apart from making numerous tests, the only thing you can do is look up already published exposure information (such as the table on page 000) and work from that. It may not be exactly right for your specific circumstances but, providing you are prepared to hedge your bets a little, by taking some pictures at the exposure settings recommended, some at a half-stop more and some at a half-stop less, you should not go very far wrong.

Cameras with a digital readout in the form of LEDs are useful in this sort of situation, as are cameras with automatic exposure control. However, while the latter will work well where the lighting is evenly

Suggested exposures for available-light pictures

subject	film speed (ISO)			
	64/19°	100/21°	160/23°	200/24°
candle-lit close-up	½ s, f/2	¼ s, f/2	¼ s, f/2–2.8	⅛ s, f/2
brightly-lit shop windows	⅟₃₀ s, f/2	⅟₃₀ s, f/2.8	⅟₃₀ s, f/2.8–4	⅟₃₀ s, f/4
theatre performances, ice shows, circuses (brightly lit)	⅟₆₀ s, f/2.8	⅟₆₀ s, f/4	⅟₆₀ s, f/4–5.6	⅟₆₀ s, f/5.6
boxing, wrestling	⅟₆₀ s, f/2	⅟₆₀ s, f/2.8	⅟₆₀ s, f/2.8–4	⅟₆₀ s, f/4

balanced and contrast is not too great, they can let you down when, for instance, one person is isolated by a spotlight. In a case like this, the massive dark area around the subject may influence the meter to give more exposure than is really necessary and it will be up to you once again to assess the correct exposure and override the meter. If you propose to use a TTL meter in low light situations, it's helpful to know what sort of light-sensitive cell it contains.

Currently, the most popular types are the CdS cell, the silicon blue cell, and the GaAsP type. Most commonly found is the CdS (cadmium sulphide) cell. This is a tiny cell, usually no bigger than a button, with resistance varying inversely to the amount of light striking it. It is extremely sensitive to light and can be used to give exposure readings in very poor lighting conditions. However, such cells do have some minor drawbacks. First, although they are extremely sensitive and give a reading in very low lighting conditions, they can take several minutes to produce a correct reading. Second, they have a memory. If they are exposed to a very bright light they can be put out of action for several minutes. Thus, if you are in a stadium or ice rink and a spotlight hits your meter, it may well start registering shorter exposures than are actually needed. There isn't much you can do about this, except bear the problem in mind. Finally, CdS cells are over-sensitive to red, or light of a reddish colour. This means that in artificial lighting, which has a preponderance of red, the meter will again tend to overestimate the brightness of the lighting.

Unless you allow for this the result will be underexposure. The easiest solution is to adjust the film-speed setting dial to compensate. If you set a film speed about two-thirds that of the actual film speed (say 64 instead of 100 ASA), the results should be just about right. Do make tests with your own equipment, though, before you take any important pictures.

More and more cameras nowadays are being fitted with either silicon blue or GaAsP (gallium arsenide phosphorus) cells. These work in a different way from the cadmium sulphide variety in that when they are struck by light, they generate a weak electric current. However, because this current is so weak they need to be used in conjunction with a tiny IC amplifier. They are then capable of registering a reading on a meter scale.

Silicon blue cells have two advantages over CdS cells, First, they have less of a 'memory' problem, reading much more quickly in poor lighting conditions. Second, because of the blue filter, their spectral sensitivity is much closer to that of a film emulsion. This means that you don't have to compensate in artificial light. Gallium arsenide phosphorous cells are rather less common. Frequently found in digital read-out systems, they are much more sensitive to light and have a better spectral sensitivity – without a blue filter – than silicon blue cells. Each of these cells needs to be used in conjunction with a battery. If your camera uses a battery system, do make sure you keep it up to scratch. Some cameras have a battery check whereby pressing a button causes an LED to flash, or the needle of the meter to move to a specific position. Check regularly to make sure the battery is working at full strength. Most cameras have a switching system, whereby the battery is only brought into use when it is needed. If yours needs to be manually switched off, remember to do so as soon as you have finished using it. This way you won't find you have an almost useless battery when you need it most. Obviously, it is in low light that a battery needs maximum strength. If it is working at

less than its best, it will indicate considerable overexposure. It is a good idea (and one which can save considerable embarrassment) to change the battery every year. Batteries are relatively inexpensive items, and it is considerably more economical to buy a new battery before it is absolutely needed than to find that you have wasted hours of your own (and perhaps other people's) time.

Theatrical-type events

In a situation which is in some way theatrical, for instance, a cabaret performance, an ice show or an exhibition, you usually obtain better, more atmospheric pictures if you use existing lighting rather than try to provide your own. At best, you can rarely do more than use flash on camera during an actual performance, and there are few forms of lighting better calculated to kill atmosphere than straight flash on camera. Of course, using existing lighting does cause lots of headaches. You may have exposure problems, depth-of-field problems, movement problems. However, if you can overcome all these difficulties, you will produce pictures which have more life and more atmosphere than those taken in any other way, even if yours are slightly blurred, a little grainy or even lacking in colour saturation. The important thing is to be prepared. If you have the opportunity, see the show before taking pictures (and make a point of having a notebook with you). Doing this helps you in several ways. First of all, it gives you the opportunity to see and enjoy the performance without having to worry about the camera; and you won't miss a superb shot because you are enthralled by the act. Secondly, it gives you the opportunity to evaluate the strength of the lighting and to decide what speed of film to load the camera with. Thirdly, it enables you to pinpoint the high spots of the show which you really *must* photograph, and also helps you decide where you need to position yourself in order to get the best pictures. All of these points you should record in your notebook. By doing all this, the final product will be greatly improved.

The work of the professional theatre photographer is demanding. Using sets not created by him, models not selected by him and lighting not arranged by him, he has to select viewpoints, incidents and expressions which convey the atmosphere of the production. *John Haynes* (page 300). *Lawrence Burns* (page 301).

Whether you are taking pictures or doing the 'dry run' described above, at an actual performance remember one thing. Although you are there to do a job which may be very important to you and perhaps even to other people, most members of the audience will probably have paid to see the show. It is their right to do so, uninterrupted and without being bothered by you. Some people will suffer stoically and quietly. Others will express their opinions quite forcibly, if they are upset. Don't

spoil other people's enjoyment for the sake of your own, and don't cause folks to think badly of photographers generally. Worse still, if it is an event where photography is normally permitted or you have been given special permission to take pictures, audience complaints may well cause the organisers to think again on future occasions.

If you have been commissioned to take pictures of the show, try to arrange that you do your job at

dress rehearsals. This enables you to move around at will, finding the best position to take your pictures without bothering anybody. Where you have been commissioned to take pictures for publicity purposes, make it clear that you need to do certain things in order to obtain the best shots. Often, the photographer is considered a nuisance who has to be tolerated and who must be kept well clear of the stage and the people on it. If this is the situation, make it clear that, like the performers, you have a job to do, and that, like them, you intend to do it to the best of your ability. You require a certain degree of co-operation and, provided that is forthcoming, you will be able to fulfil your brief quickly, efficiently and with the minimum of disturbance to anybody. Without co-operation, your job will take longer, will be less easy to carry out and will result in poorer pictures. And that won't be to the benefit of either you or the performers.

When you have seen the performance once and noted the lighting and the action, you will be in a position to decide what speed of film you are going to use. Remember, the slower the speed of the film, the better the resulting quality is likely to be in terms of colour and granularity. However, unless you use a reasonably fast film, you are unlikely to be able to produce well-exposed pictures. As that would mean rock-bottom quality anyway, don't hesitate to use a film which is fast enough to do the job. After all, where spot lamps are used, lighting contrast is usually very high, and using a fast film (which is inherently low in contrast) can improve the situation. For choice of material, therefore, use the slowest film that will provide you with some leeway as regards exposure. Remember, you don't want to use the maximum aperture that your lens is capable of, as that won't give you terribly good definition or even reasonable depth of field. Nor do you want to use a shutter speed slower than 1/30 second but, being sensible, 1/60 is about the shortest you can use. So, looking to an exposure of 1/30–1/60 second at about $f/2.8$–$f/4$ in the average city theatre, under spotlamps, you would want a film of about 100 ASA – providing, of course, you are content to take only those subjects which are spotlit. If you intend to photograph subjects which are less brightly lit, or poorly lit, or to take pictures in nightclubs, then you need to think in terms of 200 or even 400 ASA.

A trap for the unwary is provided by coloured lighting. During an exciting theatrical performance it is very easy to be carried away by the drama of a scene and start shooting away for all you are worth. That's fine, provided the lighting is white or at least brightly coloured. However, when red or green spots are used, the power of the light can be cut by half or even more and, if you don't take this into account, you can end up with some very underexposed pictures. Coloured lighting can cause you additional problems with black-and-white films. Although with colour you can see the effects of coloured lighting, with black-and-white material there is no effect. Make an exposure under green

spotlighting with black-and-white film and the result is an overall greyish, dull, unexciting picture, looking just as it would had it been taken using a green filter. The same result occurs, of course, with of any black-and-white shot taken in lighting of only one colour.

Unless you are planning to attend more than one performance of a theatrical work, restrict yourself to two lenses. Which two you choose depends very much on whether or not you have a roving commission. Ideal is fairly wide-angle lens which allows you to include a significant area of the stage, or arena, and a moderately long lens which enables you to close in on one or two individual performers. Having more than two lenses only causes problems and delay when it comes to changing them over. It is difficult enough to find a second lens in the dark and change it without having to decide whether it is a 28 mm or a 50 mm. This, of course, is a situation in which a zoom lens or even a second camera is helpful.

Stage shows call for a very disciplined approach to picture-taking; you can't simply set up a scene to suit yourself. What you can do though, is make fascinating character studies backstage which prove a useful addition to the more conventional shots. *Curzon Studios.*

302

Sporting events

Sporting events, such as gymnastics, swimming galas and basketball, offer one big advantage over theatrical productions as far as photography is concerned. Lighting is usually standard and unchanging. Unfortunately, however, it is not always particularly brilliant and, because many events involve high-speed action, it is worth loading up with the fastest film available. This will enable you to couple a reasonably high shutter speed (to stop action) with a moderate aperture (to obtain maximum depth of field). If necessary, providing you avoid Kodachrome or slowish black-and-white films, you can always uprate the speed of the material you intend to use. Doubling, or even quadrupling, the emulsion speed of many films can be achieved by modifying processing. However, because this involves some loss in image quality it is rarely recommended by film manufacturers, and is best used only in extreme circumstances.

To make a success of sports (or, indeed, any) photography, you need to practise, practise and practise again. Look at the high standard achieved by photographers such as Don Morley and Gerry Cranham and try to emulate it. Look at their pictures and try to work out shooting angles, timing, and how they achieve the standard of pictorialism that they do. Frequently you will find that their pictures were very carefully organised so that, although the picture was taken at a very dynamic angle and at a very significant moment, the actual speed of movement was not at its highest. The result is usually a superb action picture which is well within the reach of the majority of amateur equipment and materials. Why, then, are there so few sporting photographers of this calibre? The main reasons are lack of enthusiasm, lack of self-criticism and, most of all, lack of practice. To be a superb sporting photographer you need to work at it, and the more pictures you take and the more critical you are of those pictures, the better the photographer you will become. If you are enthusiastic and are critical of your own work, the urge to practise will follow.

However, assuming you simply wish to make reasonably good pictures of indoor sporting events, how do you go about it? The first requirement really is to practise, but you don't need to attend the specific events to do that. What you have to do is develop your sense of timing, and you can do that by using your camera where action occurs. In the early stages, make it easy for yourself. Choose a reasonably bright Sunday afternoon, load some fast film into your camera and wander around to the local football or cricket match. You'll find it helps if you have some knowledge of the rules of the game, but even if you haven't, you should be able to produce some interesting shots. Now compare these with the pictures you find in the national newspapers, and ask yourself where you went wrong! Usually it boils down to timing. You shot too early or too late. It may only have been a fraction of a second, but in that time the ball may have travelled half-way down the pitch.

After a couple of months of practice your timing should have improved enormously. You will also have begun to notice something. Lost in the movement and rush of most sporting events, there are moments when all action ceases and perhaps one player is the focus of attention. These moments may last only a split second but they can encapsulate all the drama, tension and expectancy needed for a superb picture and, what's more, they could be taken with an Instamatic camera if need be. The point is, you need to be ready for these moments. You need the anticipation which prepares you for the moment when they occur which enables you to have the shutter open almost before they happen.

When you are able to catch and record these moments out of doors, you will find you can do it indoors too. However, because of the low level of lighting indoors, these are the moments you *have* to catch. So, look for the dead points in the action. The moment when a gymnast, spinning on a bar, reaches the high point and stops, momentarily, before descending; the instant when a high diver

reaches the apex of his leap; the split second before ice-hockey forwards face off. All of these moments of action can be caught using a shutter speed of no more than 1/60 second, and yet they can provide all the urgency and vitality that separates a good action shot from a bad one.

As important as knowing *when* to take the shot, of course, is knowing where to take the picture from. There isn't a lot of point in stopping a super leap – from the rear! Do some research and, before the event begins, work out where most of the interesting shots are going to be. A strong temptation is to position yourself as close to the action as possible, but this can be quite dangerous. Lean over the barrier at an ice-hockey match and you could end up with a fractured lens. For this reason, it is worthwhile using a slightly longer than normal lens and keeping back. Of course, if you have to be part of the audience, you may need to use quite a long lens. This can produce some spectacular (and often beautiful) results, but it does present you with added weight and the problem of holding an unbalanced camera steady. Pistol grips, or even rifle grips, make action shots with a long lens a great deal easier to take, but remember, the really important thing is to practise.

Exhibitions

Exhibitions can be relatively easy or extremely difficult, depending on circumstances. Like indoor sports, they are uncomplicated insofar as the lighting is usually consistent but not very brilliant. Individual stands vary, though, and, depending on the size and scale of the exhibition, some may be mini-showpieces in their own right with multi-coloured spotlamps playing over them.

If you are doing the job professionally, the ideal time is press day. Most exhibitions devote their first morning (or even a preview day) to the press and this is usually quieter than public days with no jostling crowds. Exceptions to this rule are the public motor shows with model girls draped over the cars. Here, you could be very lucky to obtain a

304

clear, sharp picture at any time. By contrast, few business exhibitions suffer from this problem, and even on public days it is usually possible to obtain good pictures.

Good exhibition pictures are the result of dedicated walking. Buy a catalogue and, assuming you know who is who, decide who will have the most interesting stands and visit each one. Normally it is the big manufacturers who can spend the most money and this is reflected in the size of the stands that they build. Don't be too eager to rush to the big boys, though, because sheer size and spending

Some exhibitions offer more exciting possibilities than others, photographically speaking. Take the motor and motor-cycle shows with acres and acres of glittering chrome and brightly-coloured enamels. Add a coloured spotlight or two and the effects can be quite dazzling. These shots were hand-held (1/10 at *f*/8) using ASA 400 film.

probably the least interesting to the average photogapher.

Most of the large exhibition venues use a mixture of daylight and fluorescent lamps to illuminate the halls. However, as the most usual form of stand illumination is the industrial spotlamp, and as the most interesting areas of the stand are likely to be lit by this method, it is sensible to use Type A or Type B slide materials if you are making transparencies. When taking exhibition pictures, try to inject as much of the atmosphere of the exhibition as you can into your shots. This means avoiding the use of flash and looking for the little cameos which tell the stories, such as the sales reps who were bored to tears and intent on drowning their sorrows! It also means looking for unusual angles, looking for 'frames' for your pictures and including some of the crowds.

Look for the stands which have lots of people gathered around them. Sometimes the reason for public interest is an interesting or unusual product. If so, it may be worthy of a picture in its own right. Often the reason for a crowd is a demonstration or a performance, perhaps by a major celebrity. If it is, stay around and watch what happens. Have your camera ready, but be prepared to wait for the next performance when you will be aware of what is going to happen next and can position yourself accordingly. As I remarked earlier, exhibitions are a form of show business in their own right and should be treated as such. Look for the highly-polished performances of the professionals and take just as much interest in the 'first-timers' who are either working like demons or bored out of their minds. Look, too, at the girls. Look at the glossy, well-groomed models, who are used to receiving male attention and who make every customer feel as though he or she is the only one worth speaking to. Look at the girls who find it all a tedious nuisance, and show it, and look at how the customers view them. Finally, look at everybody at the end of a hard day, when they (and you) are footsore and beaten.

power doesn't necessarily produce an eye-catching stand. At a recent exhibition, a major manufacturer of printing machinery rented a whole hall to display his wares. It must have cost a fortune, but none of the money was spent on stand-building. It would have been pointless (and impractical, too) to build a stand because, with a whole hall at his disposal, that manufacturer didn't have to compete with other stands to gain the visitors' attention. Once you entered his hall(and out of sheer curiosity, if nothing else, you felt you had to) you were his. So although that was probably the biggest and most expensive stand at the exhibition, it was also

Close-up pictures

Close-up photography is a fascinating business. It is probably the one form of photography which can offer returns in sheer pleasure in excess of expenditure of either effort or cash. Take an 'Instamatic' camera bought for a couple of pounds, add a close-up lens (worth about the same), and the results can be quite astounding. That's not to say, of course, that better quality equipment will not produce sharper, more detailed pictures, but it does mean that a photographer who can't afford to spend a lot of money on his equipment can produce very satisfactory and informative pictures. What is more, it's a form of photography which is probably more suited to indoor conditions than any other. Just think: you're working in an area maybe 30 cm or so square – a living room table perhaps. Indoors, you can control the lighting, the subject, the temperature and, best of all, the 'weather'.

What is close-up photography though? Where does 'ordinary' photography cease to be 'ordinary' and become close-up? I think probably in most people's minds the barrier (if such a thing exists) is around the one metre mark. Any picture taken at a closer distance than that can be termed close up. For the purpose of this chapter, though, let's go a little closer than that: to within 60 cm, or less, and into the realms of real close-up photography, including the compound microscope.

Using a conventional camera

Before we venture that close, however, let us look at what can be done with a conventional camera. Some modern camera lenses are inscribed with distance scales down to about 30–35 cm. That is going pretty close, and perhaps for the majority of lenses, too close. You see, camera lenses are designed to be optically at their best when the distance between the front of the lens and the subject is much greater than the distance between

the back of the lens and the film plane. As the distance in front of the lens is reduced, so the quality of results delivered by the lens deteriorates. In close-up photography there is a point where image size is equal to half the subject size. When this occurs, subject-to-lens distance equals lens-to-image distance, and the lens is being used in a manner which is well beyond the lens designer's intentions. Of course, this situation can become worse, and when image size becomes larger than subject size (or subject-to-lens distance *less* than lens-to-image distance), the whole thing has turned topsy-turvy and the lens is being used in quite the reverse manner to that intended for it. However, there is a way around this problem and the clue lies in that last sentence. If you physically reverse the lens in the camera, conditions will revert to what they should be and, once again, the distance in front of the *front surface* of the lens will become nearer to what it should be.

If your camera is designed for interchangeable lenses, almost certainly you will be able to buy a lens reversing ring. This is an attachment which fits into the lens socket of the camera allowing the lens to be fitted to it 'wrong way round'. This will probably give you sharper pictures, but it also introduces a problem. Because the lens is 'wrong way round' in the camera, the coupling between the lens diaphragm and the meter is disconnected, and a few types stay at maximum aperture. This is no real disaster. You can get over the problem easily enough by placing a piece of tape over the coupling pin on the lens so that it is pressed in all the time. This means that the diaphragm will operate as you alter the setting rather than as you release the shutter. All you have to remember is that you have to manually stop down to the aperture you need when you are ready to take the picture (and, also, when you are using the camera metering system).

Before you go to the trouble of buying a reversing ring, though, make some tests to find out just how good your lens is at close distance. It may produce pictures which are perfectly satisfactory. If it

doesn't or, if your lens doesn't focus down to very close distances, or if your lens is fixed and non-interchangeable, try using a close-up lens. Close-up lenses provide a good, yet inexpensive way of obtaining reasonably sharp, clear pictures at short distances. Supplementary lenses designed for photographic work are simple convex lenses which can be fitted to the camera lens in exactly the same way as a filter. In effect, they simply shorten the focal length of the camera lens so that rays of light from an object close to the lens are brought to a focus at the film plane instead of behind it.

Supplementary lenses

Supplementary lenses are commonly available in three strengths. The most powerful is usually $+3$ dioptres, the next $+2$ dioptres and the weakest $+1$ dioptre. A $+3$ dioptre lens has a focal length of 0.3 metres. This means that when you fit it to a camera lens of *any* focal length, with the camera lens focused at infinity, a sharp image will be formed at the film plane of an object which is 0.3 metres from the close-up lens. A $+2$ dioptre lens has a focal length of 0.5 metres. With the camera lens focused at infinity, a sharp image will be formed when an object is 0.5 metres from the close-up lens. A $+1$ dioptre lens has a focal length of 1 metre and, in exactly the same way, when the camera lens is focused at infinity, objects 1 metre from the close-up lens will be rendered sharply.

However, you don't need to have the camera lens focused at infinity in order to use a supplementary lens. In fact, focusing the camera lens to distances closer than infinity enables you to photograph objects which are at distances less than the focal length of the close-up lens. For instance, with a $+3$ dioptre close-up lens fitted to a camera lens focused on 1 metre, objects 25 cm from the close-up lens will be rendered sharply. Nor do you need to be content with just one close-up lens – you can use two or more together, if you wish. Using two supplementary lenses together, say, one $+2$ dioptres and one $+3$ dioptres gives you the equivalent of a $+5$ dioptre close-up lens and a focal

Page 306: there is only one way to photograph silverware, and that is using a tent. Direct lighting produces hard, sharp specular reflections which kill the soft, silvery effect. *Kodak.*

Page 307: a superb example of the correct way to photograph glassware. No frontal lighting is used at all. Everything comes from behind to throw the flasks and burette into strong relief. The reflections below add a nice touch, as does the little bit of distortion caused by the conical flask. *Kodak.*

length of 20 cm. Focus the camera lens at infinity, use these two lenses and you can focus on objects 16.7 cm from the front close-up lens.

Using a close-up lens is very easy if you have a single-lens reflex camera or a stand camera. In either case you can clearly see when the object on which you are focusing is sharp. With twin-lens reflex cameras or viewfinder cameras, however, it is not quite so easy. If you have a twin-lens reflex camera you can place the supplementary lens over the finder lens, focus and then transfer the close-up lens to the taking lens. With a viewfinder camera you need a chart such as the one on page 310, and an accurate tape measure or ruler.

However, this still leaves the problem of parallax to be considered and compensated for. We discussed parallax in the chapter on 'The ideal equipment'. If you remember, it is the difference in viewpoint between the camera lens and the viewfinder. Generally, when you look through the viewfinder

you see virtually the same scene that the camera lens sees. However, as you move closer to the subject, the difference in viewpoint between seeing and taking lenses becomes more pronounced and at very close distances (say 1 metre or less) what you see through a viewfinder can be very different from what the lens sees.

The parallax problem can be overcome quite simply by moving the position of the camera so that the lens occupies the space originally occupied by the viewfinder. With a twin-lens reflex camera in which the viewing lens is above the taking lens, this simply means raising the level of the camera by the distance separating the lenses – about 5–6 cm.

With the majority of viewfinder cameras, however, the viewfinder is usually above and to one side of the taking lens, so two movements are involved: one sideways and one upwards. A simple way of overcoming the parallax problem consists of making a wire frame which extends

When taking close-up pictures with a simple camera, you can avoid parallax problems by making a close-up frame similar to that shown here. Attach it to the camera with bracket (1) so that the arms (2) can move backwards or forwards to accommodate the focusing distances (3) of +1, +2 or +3 close-up lenses.

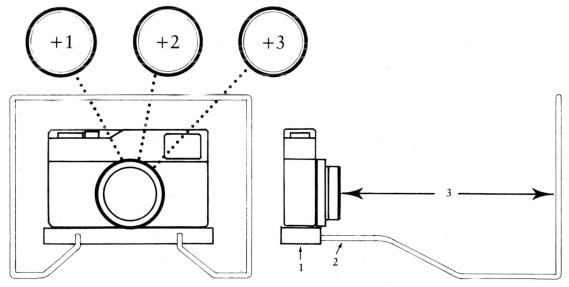

perpendicularly from the camera lens. If this can be constructed as shown in the diagram opposite, it can be used to position the camera so that the subject is centred in the picture area and then, prior to exposure, the frame is dropped out of the field of view. If you are canny, such a frame can be made to extend and retract so that it can be used to position the camera specific distances from the subject. A measuring rule could be incorporated to make this simpler. For any camera relying on a separate viewfinder this can prove an extremely useful accessory.

Close-ups with an SLR

The single-lens reflex camera shows its versatility yet again by proving eminently suitable for close-up work. Admittedly, this isn't always the case. Any pictures in which perspective has to be altered, modified or in any way tailored to suit the needs of the photographer or art director are best left to the stand camera. However, when it comes to record shots, natural history pictures, scientific work or

Close-up lens data

close-up lenses	focus setting	lens-to-subject distance	close-up lenses	focus setting	lens-to-subject distance
+1	infinity	1 m	+3 plus +1	infinity	26 cm
	5 m	82 cm		5 m	24 cm
	2 m	65 cm		2 m	23 cm
	1 m	52 cm		1 m	21 cm
+2	infinity	50 cm	+3 plus +2	infinity	20 cm
	5 m	45 cm		5 m	19 cm
	2 m	39 cm		2 m	18 cm
	1 m	33 cm		1 m	17 cm
+3	infinity	33 cm	+3 plus +3	infinity	17 cm
	5 m	31 cm		5 m	16 cm
	2 m	28 cm		2 m	15 cm
	1 m	25 cm		1 m	14 cm

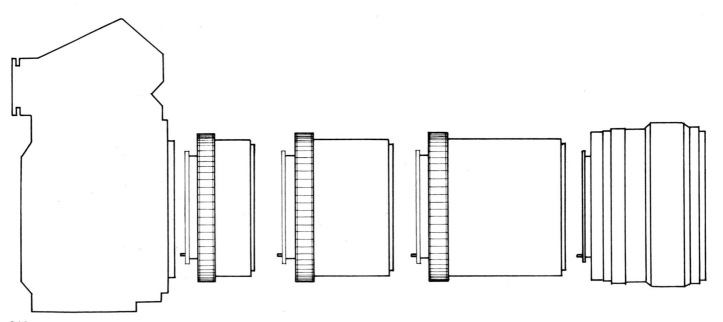

title shots for audio-visual shows, the SLR can show the way. Equip it with close-up lenses, extension tubes or, best of all, a bellows attachment and it becomes capable of producing the most remarkable pictures. Once again, it is the fact that the viewfinder shows you precisely what you will get on the film that makes so much difference. No parallax problems to worry about; no need to bother with tape measures. If it looks right in the viewfinder, then it will look right in the finished picture.

There are several ways in which you can adapt an SLR for close-up work. As we said a little earlier, you can use close-up lenses, extension tubes or bellows attachments; or you can even buy macro lenses which allow you to go to within a few centimetres of the subject and still obtain crisp, sharp results. Each of these accessories has its own particular advantages and it is a good idea to consider carefully what your needs are before making any rash purchases. Undoubtedly, close-up

lenses are extremely convenient. You simply fix one in front of the lens mount and carry on in the normal way. They are inexpensive and, if you propose to do only a small amount of close-up photography, they may well provide an ideal answer. However, if your camera has a high-quality lens, you may not be too keen to lessen its performance by combining it with what is little more than a spectacle lens. Close-ups *are* inexpensive and are certainly not corrected for all the optical faults discussed in the chapter on 'The ideal equipment'. If you feel they are worth trying, then they are cheap enough to buy, try and either use happily or discard. Most of the problems they will cause will occur around the edge of the field, so provided that all the important features of the picture are kept to the centre of the picture area, you should be able to produce quite reasonable pictures.

As their name would suggest, extension tubes are simply metal or plastic tubes which act as spacers

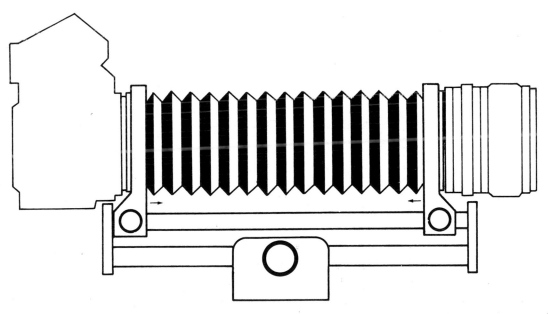

Left: Extension tubes.
Right: Bellows extension unit.

Combination of textures can be used to good effect to produce interesting and attractive still-life pictures. Here, the roughness of the towel contrasts strongly with the satin, an effect enhanced by the use of backlighting.

between the camera body and the lens. All they do is increase the separation between the camera lens and the film plane to enable you to focus on subjects closer to the camera than is normally possible. Extension tubes are a fairly simple accessory. They usually come in three different lengths and can be used singly or coupled together to give a variety of operating distances. They are frequently offered as an accessory by the camera manufacturer himself but are sometimes available more cheaply from independent manufacturers. Depending on the price you pay, they either continue the coupling between the camera body and the diaphragm mechanism, or are non-automatic, requiring you to operate the diaphragm manually.

Because extension tubes come in fixed sizes, they have some limitations. One is that they only offer a fixed series of focusing distances. Even used in combination with each other, the focusing distances of the various combinations do not

always overlap. As a result there will be gaps in the lens-to-subject distance range at which the photographer can work. With the standard lens, though, there is usually little gap between the closest distance at which it is possible to work *without* a tube and the farthest distance at which it is possible to work with the smallest one. Another limitation arises out of this. If you have a series of pictures to take at a variety of distances it becomes tedious having to try, discard and join up different combinations of extension tubes. If close-up pictures are an occasional interest, then the continual experimentation can be part of the fun. However, if you need to take close-up pictures professionally, it becomes simply tedious. Next in the range of close-up accessories is the bellows attachment. This offers an infinitely variable range of close-up distances at which pictures can be taken, governed only by the minimum and maximum distances between lens and film allowed by the bellows themselves. The better the quality of the bellows unit, the more readily it will compress

to enable the lens to be moved closer to the film. Bellows units offer a really convenient and quick method of taking close-up pictures. Again, they are offered as accessories by most of the major camera manufacturers and by independent accessory manufacturers but, either way, they are fairly expensive items.

Finally, a wide variety of macro lenses is available for close-up work. The true macro lens is designed only for short distance work and has a limited focusing travel. It is computed to give really sharp pictures when the subject is magnified on the film – which isn't always terribly convenient for everyday use. Perhaps better for the more casual user is the standard focal length macro lens which allows you to work at any focusing distance from infinity down to a few centimetres. This makes it possible for you to go close enough to take pictures at life size if you wish, or it can be used to take the more conventional pictures of people and places. A minor limitation with these lenses is that they rarely have a very wide maximum aperture. However, in close-up work you usually need as much depth of field as you can muster, and it is more usual to use the mid-range of apertures anyway. Many zoom lenses have a macro facility. This is made possible by their zoom construction, and while it can provide a useful additional feature for occasional use, the quality of the results is sometimes insufficient for serious work.

Choice of focal length

Many photographers think of close-up photography only in terms of standard focal length lenses. Mentioning short or long focal length lenses tends to draw a blank look. The point is, you should exercise the same care over the choice of lens for close-up work as you would for any other form of photography because the lens you choose has a considerable effect on the finished result. For instance, a wide-angle (or short focal length) lens in conjunction with a bellows or extension tubes will give you a much greater magnification than will a standard lens. While a standard 50 mm lens used in conjunction with a bellow unit might give a magnification of ×3, a 24 mm lens, at the same bellows extension, gives a magnification of ×6. However, because such a lens takes in the whole of the subject at a much closer distance than we could view it from, perspective is altered considerably.

Longer focal length lenses give less magnification. However, because their characteristics are the same whether they are used to make close-ups or more conventional longer-distance pictures, they also offer the same sort of benefits. For instance, they allow you to put more distance between the camera lens and the subject. Although this might not seem an obvious advantage at first glance, it does allow you more flexibility with the lighting – units can be located in positions which would be impossible if the camera were close to the subject. It also means that perspective can be flattened. In exactly the same way that you would use a longer than standard focal length lens to take a portrait because parts of the subject project towards the camera, you can use a longer than standard lens to take a close-up to prevent the enlargement of those parts of the subject closest to the camera.

However, if you *do* want large images of small objects you may be physically limited as to the focal length you can choose. The longer the focal length of the lens, the greater the distance that is required, not only between subject and lens, but also between lens and film. This can create difficulties when you consider that, to produce an image the same size as the subject, the lens must be exactly twice its focal length away from the film. Obviously, a bellows unit offering a maximum extension of 180 mm would be useless for same-size work with anything greater than a 75 mm lens, and even a couple of sets of extension tubes might offer less than the extension required. However, there is nothing to stop you coupling these accessories together!

Exposure for close-up work

To all intents and purposes, for work even at quite close distances, the aperture scale on the lens mount

can be considered quite truthful. Nevertheless, it is calibrated to be accurate only when the lens is used at its focal length; in other words, when the lens is focused on infinity. When the lens is used at *very* close distances (say around two or three times its own focal length), underexposure can occur. This is because the inverse-square law is working hard to ruin your pictures. Not only does it apply to light which is travelling from a lamp to the subject, it also applies to light travelling from the lens to the film. While this is a comparatively short distance when a 50 mm lens is focused in infinity, it becomes a much longer distance when that same lens is focused on a spot 250 mm away.

If you are using a camera which has through-the-lens metering, your problems are automatically taken care of. However, with other types of camera, you need to correct the exposure accordingly. The following formula enables you to do this:

$$\text{Exposure factor (in stops)} = \frac{\text{bellows extension}}{\text{focal length}}$$

For instance, if the 'bellows extension' = 150 mm and the focal length of the lens is 50 mm, then the exposure factor = 150/50. In other words, three stops. In case the term 'bellows extension' has you foxed, it dates back to the days of the old stand cameras. It is just as relevant now, though, to the modern stand camera or the bellows attachment for a 35 mm camera. Bellows extension is the distance measured from the rear nodal point of the lens to the focal plane and, if you want to find the rear nodal point, find the point on the lens barrel (with the lens focused on infinity) which is the same distance forward of the focal plane as the focal length. In other words, if you have an 80 mm lens, set it at infinity and measure 80 mm forward from the focal plane. If you mark that point on the lens barrel it gives you the rear nodal point of that lens when it used at the infinity setting.

The above formula gives you the amount by which you have to increase your exposure in stops. In the

314

example described, assume the exposure was 1 second at $f/16$ without taking bellows extension into account. Taking bellows extension into account the new extension would be 1 second at $f/5.6$ (or, alternatively, 8 seconds at $f/16$). In other words, a lens aperture of $f/16$ becomes *effectively* an aperture of $f/45$ and a lens aperture of $f/5.6$ becomes an effective aperture of $f/16$. This plays havoc with our ideas about depth of field. Here's why. At close distances, depth of field at any given aperture becomes more and more shallow. To counteract that, there is a natural tendency for the photographer to close down to a smaller aperture.

The trouble is, if when he closes down to $f/11$ he is really closing down to an effective aperture of $f/32$, the improvement he is gaining in depth of field will be more than counteracted by the overall loss of sharpness due to diffraction. This is because the effects of diffraction increase as the *effective* aperture decreases. It pays, then, to use the largest aperture that you can get away with at really close distances, simply because although the depth of field generally may be shallow, at least the zone of sharp focus will be as sharp as your lens will permit it to be.

One point worth remembering relates to the apparent differences in depth of field between long focal length lenses and short focal length lenses. In fact it doesn't matter which lens you use, since provided the image size is the same and the aperture is the same, the depth of field will be the same. So don't assume that using a wide-angle lens will give you any extra advantage. Unless you use it to produce a smaller image, you are not gaining any benefits as far as depth of field is concerned.

Using a stand camera for close-ups
Apart from the references to extension tubes (which are unnecessary with a stand camera), all that has been said about SLR camera applies equally to stand cameras. Exposure is calculated in the same way, aperture is considered in the same way, and you think about focal length in the same way.

However, you do have other things to think about, too. There are the camera movements which give you greater control over the way you reproduce the subject.

With a stand camera, you can do everything that can be done with an SLR camera, and more besides. This is because, with a stand camera, you can photograph objects from angles and distances which would cause apparent distortion with any other type of camera. Rising and falling front, cross front, swing back are all there to help you produce more realistic-appearing pictures of the subject you are photographing. In the chapter on architectural interiors, we described how the movements of a stand camera can be used to prevent converging verticals. It isn't really necessary to go through that again because the same principles still apply. The only difference is that, taking close-up pictures, you are more likely to look down on an object rather than up to it. For this reason you are more likely to

use *drop* front rather than rising front. Cross front, of course, will be useful when you have to take what has to be a directly frontal picture from a position slightly to one side (to avoid the reflection of the camera appearing in the picture, perhaps). The swings and the tilts will be extremely helpful when you need to make maximum use of the limited amount of depth of field available at close distances.

One tip to bear in mind when taking close-ups with a stand camera is that you should always focus by means of the camera back. Most technical cameras offer this facility, but if yours doesn't, try focusing by moving the whole camera or the subject itself. The reason for this is that by moving the lens alone, you alter both the lens-to-subject distance and the lens-to-image distance and this makes accurate focusing well-nigh impossible. It also makes it difficult to produce an image to a specifically laid-down size.

Two pictures which demonstrate the difference a change of lighting position can make. Left: the lamp was slightly above and to one side of the camera. Right: it was above and behind the subject.

Illumination for close-ups

The same factors that you consider when lighting a conventional subject apply equally when you are working close-up. Always keep the set-up as simple as possible because the more lights you use, the more difficult it is to achieve a balanced lighting scheme. In addition, because the lamps will probably be closer to the subject than normal, you have to avoid either a build-up of heat (if you are using tungsten lamps), or simply too much light. (This is a situation where, with flash, you are looking for equipment with low guide numbers, rather than high ones. While a guide number of 120 is fine when you are photographing interiors, it is overwhelming at distances of a half metre or so.) Another problem is that the camera itself may interfere with the lighting, and it is often difficult to avoid throwing the shadows of the camera across the subject. If you can use a relatively long focal-length lens, this will enable you to get further back from the subject, yet still maintain a reasonably large image.

By far the best way to illuminate close-up subjects is with diffused lighting. Not only does this make it possible to illuminate the whole subject evenly, it also helps to cut down the power of the lighting. Provided you use a good lens hood, an ideal way to illuminate your subject is by means of light reflected from the camera position. Take a large white piece of board or expanded polystyrene of about ½–¾ metre square, cut a hole in the middle of it for the camera lens to look through, and then position this so that it is flat against the camera. If this is then illuminated by a single lighting unit placed to the rear of the subject, above and to one side of it, the board will reflect all the light back to the subject, giving a soft, almost shadowless illumination. Another way of achieving this sort of lighting is by using a ring flash. This is a circular flash tube which sits around the lens to produce a very delicate lighting effect. If you are addicted to close-up work, a ring flash can be a useful addition to your equipment. However, it is something of a luxury for occasional use.

Backlighting can often make the most ordinary of subjects dramatic and exciting. This perlargonium was sitting on a window ledge, with sunlight streaming through behind it.

Top right: a ring flash unit clips to the lens barrel of a camera and provides soft, perfectly shadowless lighting. 1. Flash tube. 2. Reflector. 3. Camera body.

Below right: food shots such as this can be the result of many hours labour: finding just the right fruits, setting up in the most attractive way, and then lighting to produce just the right textures. Skilled food photographers are few and far between. *Curzon Studios.*

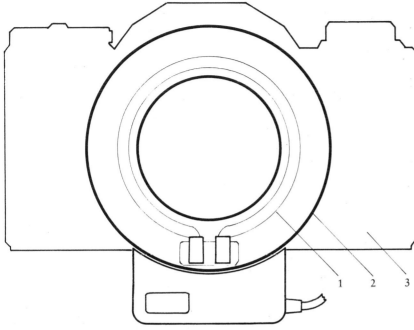

You can use flash to illuminate an object directly if you wish. If you have a computer flash unit incorporating thyristor circuitry, the duration of the flash will be reduced automatically to produce the required exposure. If you do not have one of these guns, you need to cut down the power of the light by placing layers of white tissue over the flash tube window (about three layers of tissue equal one stop, but, for heaven's sake, make tests using your own equipment and your own favourite brand of tissues!) A good method of using direct lighting whilst ensuring that no really impenetrable shadows are thrown is to build a reflective 'box' around the subject leaving it open at the front, back and top. If you then use a single lamp to give approximately 45° lighting, enough light will be reflected from the floor and sides of the box to produce reasonable fill-in illumination. An alternative to this method is use the same box, but with a ceiling added. Then, into the ceiling and two sides, a hole is cut to take the flash heads. Provided these are of sufficiently low power (or reduced by tissues) they will produce very attractive lighting.

Best of all are the results produced when a semi-transparent object (such as a flower) is backlit. Use a main lamp, high, and at 45° to the rear of the object and have one fill-in lamp close to the camera to ensure that solid parts are adequately illuminated. Be sure that no direct light falls on the lens or the whole effect will be lost and all the brilliance deadened by flare. Use a long lens hood or shade to maintain maximum contrast and brightness in the resulting slide or print.

Copying

Although the arrangements outlined previously are fine where solid, three-dimensional subjects are concerned, the requirements are rather different where the subject consists of flat copy, such as artwork, old photographs and the like. Here, instead of an attractively-lit representation of a solid object we are looking for an evenly-lit, accurately-proportioned record shot. If you possess an SLR camera, you will probably be able to

purchase a copying stand as an accessory. This will certainly speed the job up and make it easier to produce a good result. However, unless you do a fair amount of copying, such an investment is unlikely to be warranted. With a certain amount of care, the job can be done quite adequately with the equipment you already possess.

The important things to remember with any copying job are (a) the camera has to be square on to the subject so that the proportions remain the same, and (b) the lighting has to be even. The easiest way to ensure squareness is to place the subject to be copied on a flat, rigid board on the floor or on a table. The camera can then be mounted on its tripod to look down on the subject. If the article to be copied is on the floor, stand the tripod on the floor. If the article is on the table, stand the tripod on the table. Use a piece of cotton or string if the subject is rectangular to ensure that each corner is exactly the same distance from the lens. With flat copy, illumination can be provided by two lamps, one on each side of the camera and at 45° to the copy. Provided the lamps are equally-powered, this will produce even, reflection-free lighting. To check that it is even, stand a piece of card upright on the centre of the copy. The two shadows on each side of the copy should be exactly the same size and shape as each other and should be of equal density (take a reading from each with an exposure meter to be sure).

Coins and medals, although almost falling into the copying category, need to be lit differently. For purely recording purposes where the intention is merely to record what exists in a collection, very diffuse illumination from one side serves the purpose. However, a lot of detail is lost using this form of lighting and, where the intention is to record as much of the existing detail as possible, a more specialised set-up is required.

The best form of illumination would be provided by a lamp situated in exactly the same position as the camera. This is obviously impossible, but a little

318

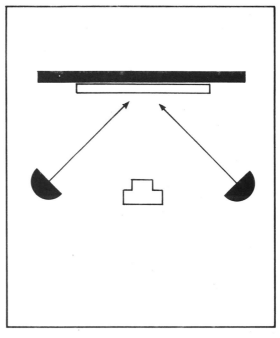

When copying books, pictures, etc., make sure that the subject is perfectly flat and that the camera is perpendicular to it. Illumination should be arranged as shown, with two lamps, of equal power, at 45° to the centre of the object. This will provide even lighting and no reflections.

bit of effort and patience on the part of the photographer can produce results which are almost as good. What you need to do is build a small box about 15 cm high and open at the top for the camera to look down into. Paint the interior black and cut a window into one side. Fit a rectangular sheet of glass (as flat and as blemish-free as possible) into the box so that it is at 45° both to the camera and to the window (the accompanying diagram shows how this can be done). If you now place the coin to be photographed at the bottom of this box and shine a lamp through the window, some of the light will be reflected from the underside of the glass down onto the coin. The effect will be as if the lamp were actually in the same position as the camera. Naturally, the glass should be as clean as possible so that the camera has a perfect view through it.

Some not-so-close-up situations
With glassware and silverware, it will probably be necessary to move the camera back a little. In most

cases, the objects concerned will be large enough to allow you to photograph them without any special accessories such as close-up lens or bellows attachments.

The interesting thing about objects made of glass is that they are usually transparent. Trying to photograph transparent things can sometimes be rather tricky; however, making beautiful pictures of glassware is very easy indeed, provided you follow the rules. And the most important rule of all is never light the glassware directly! Take a trip to a shop which specialises in glassware and take a look around. Invariably, the glass will be set off to its best advantage either by being displayed in front of a strongly-lit (or transilluminated) background or by being placed on a perspex floor which is lit from below. Look at the way the curves and facets of the tumblers and decanters are picked out with delicate high-lights and soft shadows. It's impossible to reproduce that effect with direct lighting.

For best results, then, purchase two sheets of perspex and a sheet of hammered or ribbed glass of a texture that pleases you. Then, after cleaning it so that it sparkles, set up your glassware on one of the sheets of perspex and place either the hammered glass or the other sheet of perspex behind the subject to act as a background. Now use one, or at most two, lamps to illuminate the base and background either directly or indirectly. You can photograph either clear or coloured glassware in this way but, if you are using colour film and the glassware is clear, try placing coloured gelatin filters between the lamps and the backgrounds. The results can be quite startling.

Like glassware, silverware, stainless steel and other shiny metal objects need indirect lighting. All these materials reflect light in a specular fashion. This means that they will show the reflection of the lamps, the camera and cameraman, the background and everything around them in a very unphotogenic way if they are lit directly. Nor will they look the way we imagine silver ought to look: bright, shiny

and metallic. Nor do dulling sprays work very well. While they take the bright shine away, they also take away the silvery look that the object ought to have. Although it may sound a little unusual, there is only one way to photograph silver, and that is the professional way: using a tent.

For best results polish the silver thoroughly and place it on a sheet of white background paper, or a perfectly white plain linen tablecloth. Then, using white net curtain material, build a tent around the silverware, leaving the tiniest of holes for the lens to look through. Try to ensure that all the supports for the netting are outside, rather than inside, otherwise they will be reflected in the silver objects themselves. Now, if the whole of the outside of the netting is lit, this will produce a bright, matt-white background which will be reflected by every part of the silver to produce just the right effect, a beautiful one. And, when you look at the results, look for the reflection of the lens. If you polished the silver well enough, it should be there!

Taking pictures through the microscope

No chapter on close-up work would be complete without a mention of photomicrography, which is the correct term for pictures taken using a microscope. However, photomicrography is a very specialised subject in its own right and in the space we have available here, we can do no more than touch briefly upon it. If that sounds somewhat daunting, don't be too put off, for the good news is that *anybody* can take photomicrographs *without* specialized equipment. Simple cameras and simple microscopes will produce surprisingly good results but, obviously, the better the equipment (particularly the microscope optics) the better the pictures you can make.

Ideally, you should be able to remove the camera lens and use only the microscope to form the image. The camera lens is not strictly necessary. Nevertheless, if you have a camera with a fixed lens, leave the screwdriver where it is, for the moment, and tackle the job as follows.

Set the camera lens to infinity. Now, using a tripod, support the camera above the microscope so that the lens is at the position which would normally be occupied by the eye. You can find this position reasonably accurately by darkening the room, switching on the illuminator and then holding a piece of white paper above the eyepiece of the microscope. A small circle of light will be formed on the paper and if you move the paper up and down until the circle of light is at its smallest, that will be the position that the camera lens should occupy. The 'eyepoint' varies according to the eyepiece of the microscope so don't be surprised if, when you change the eyepiece, the camera position needs to be altered. Set the lens diaphragm of the camera to maximum aperture. It plays no part in the formation of the image and, if you stop down, you will succeed only in vignetting the image and producing a smaller picture with a restricted field of view.

If you can remove the camera lens, do so. You will then need to support the camera above the eyepiece of the microscope. You can do this using a tripod or, alternatively, you may be able to purchase (or make) a microscope attachment to fit your camera. Because you are not using the camera lens, the microscope will not focus a sharp image at the film plane when it is set up for normal viewing. To produce a sharp image, you have to increase the distance between the object and the objective (the

lower lens of the microscope). Using an SLR or a stand camera, it is easy to check image sharpness on the focusing screen in the normal way. With other cameras, you will have to place a piece of ground glass or flashed opal at the film plane and focus before loading the film.

Illuminating the subject

If you have ever tried to take pictures through a microscope, you may have been upset and surprised to find that the pictures you took did not appear to match the quality of the image you saw when you looked through the eyepiece. If so, the reason could well be that the illumination you used was deficient in some way. Although in any aspect of photography good illumination is important, in photomicrography it is vital. To obtain maximum resolution and image contrast you need to set the lighting up very carefully, following recognized guidelines.

The most commonly-used lighting scheme, Kohler illumination, consists of using the field condenser to focus an image of the light source at the substage condenser which, in turn, focuses an image of the lamp condenser in the plane of specimen. This system may sound a little complex when stated as baldly as that. In practice, though, it is not difficult to set up and, when you've done it once, it will be easy thereafter. Follow these steps and you should have no problems.

1. Use a small, focusable spotlamp, preferably fitted with a tungsten-halogen lamp, and place it at a distance of about 25–40 cm from the back lens of the substage condenser. Position the lamp in the lamphouse so that its filament is centered in respect of the optical axis of the field condenser.

2. Using the field condenser, focus a sharp image of the filament on the back surface of the stopped-down substage diaphragm. This image should be slightly larger than the maximum usable aperture of the diaphragm.

Facing page: in each picture, only two lamps were used. In the left-hand shot, they were positioned on either side of the glass, pointing at the background so that all the illumination was reflected. A yellow gel covered one lamp and a violet gel the other. In the shot on the right, they were still at either side, but behind the glass and

directed at it. This time, the background was shielded from the lamps by pieces of card so that it darkened, throwing the glass into sharp contrast.

Above: a picture taken using cross-polarization to show stress patterns on a glass bulb as it is blown. Cross-polarization is achieved by using one polarizing screen in front of the light source and another – which is rotated until maximum effect is produced – in front of the camera lens. *Curzon Studios.*

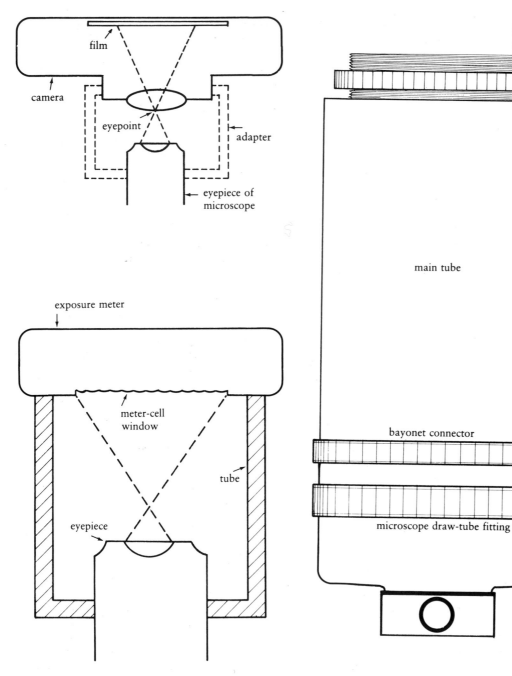

film

camera

eyepoint

adapter

eyepiece of microscope

exposure meter

meter-cell window

tube

eyepiece

lens mount adapter

main tube

bayonet connector

microscope draw-tube fitting

Top left: for photomicrography, a camera with an integral lens should be positioned so that light emerging from the eyepiece is focused on the front surface of the camera lens. Bottom left: the ideal position to take a reading from is at the film plane. When using a separate exposure meter, a tube to prevent extraneous light reaching the meter window will be needed. Near left: for interchangeable-lens cameras you can use a specially-constructed microscope adapter.

3. While looking into the microscope or viewing the image on the camera screen, stop down the field diaphragm on the lamp and move the substage condenser until you obtain a sharp image of the field diaphragm in the specimen plane. Before doing this, you will need to focus the microscope on a specimen and then remove the specimen.

4. While still viewing the image of the diaphragm, open the field diaphragm until its diameter is equal to, or slightly greater than, the entire microscope field as seen. The substage condenser should then be focused so that the colour fringe around the image of the lamp diaphragm is predominantly blue-green.

5. Adjust the substage diaphragm so that the back lens of the objective is filled with light. The edge of the diaphragm should be *just* visible within the periphery of the back lens. If the diaphragm aperture is too large, flare will occur within the microscope and image contrast will be reduced. If the aperture is too small, poor resolution will result and interference fringes may affect image quality.

Obviously, this sort of illumination is produced most readily with a microscope illuminator that has been designed for the job. However, any small spotlamp with a condenser which can be focused could be adapted to do the job, and even a projector might be pressed into service.

Two further lighting requirements are that (a) the illumination should be powerful enough to keep exposures to a minimum, and (b) it should be of a colour quality which will suit the film you intend to use. Tungsten-halogen lamps are ideal from both points of view. First, because they give out a very powerful light and, second, they are suitable for films balanced for tungsten lighting. It is worth mentioning that even though the illumination matches the film for colour balance, to achieve real accuracy, some filtration may be necessary. This is because the microscope optics may impart a slight colour cast and if the pictures are required for scientific purposes, this may not be permissible.

Assessing exposure
Exposure assessment is easy for cameras with TTL metering. You simply take the reading in the normal way. If you haven't got this facility, make a rough estimate of the exposure needed by darkening the room, switching on the illuminator, opening the camera back (before loading the film, of course) and using an exposure meter with the window placed in the film plane. This is unlikely to give you anything more than a *very* rough idea of what the exposure is, simply because you don't know the lens aperture. However, it will, perhaps, form the basis for reasonable test exposures.

Photomicrography for fun
Although photomicrography is mainly carried out for scientific purposes, it is an interesting branch of photography in its own right. Certainly, if you do become enthusiastic about it, it is likely to take up more and more of your photographic time. Photomicrographs can be amazingly decorative. Provided you can find the right subjects, you can produce some remarkably beautiful pictures. What's more, if you are producing them for decoration, they don't need to be so technically accurate. Try taking photomicrographs by polarized light, if you want really pretty effects. Place one polarizing filter on the light source and the other somewhere between the objective and the eyepiece. Rotate one of these (while watching the image) until the most colourful result is achieved. Not all subjects work with polarized light, and some of the best effects can be found using crystals (photographic hypo is ideal) in a low-power microscope. These can be formed by dissolving a small amount of the chemical in distilled water, placing a drop on the microscope slide and then allowing the water to evaporate (obviously, you need only very tiny crystals!). Other subjects which give the right result with polarized light are some rock sections, hairs, and plant and animal tissues.

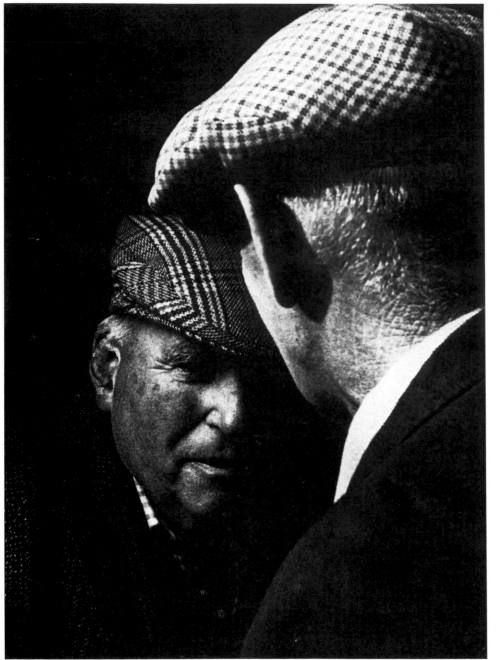

Gerry Chudley

Neville Newman

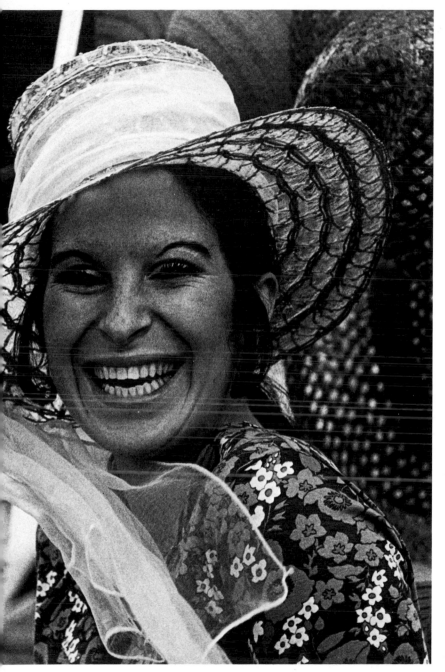

Presentation

Photography doesn't end the moment you press the shutter. After picture *taking*, you must start to think about picture *making*. The end product of any branch of photography is obviously the photograph, the effect of which can be considerably strengthened or practically destroyed by the way it is presented. Nowhere is this more true than in the presentation of portraiture.

Presentation in processing
It is not the purpose of this book to talk about developing and printing. At the end of the usual darkroom work, however, there are some options open to you that are worth considering: surfaces of printing paper, a few simple effects that can be introduced at the printing stage, the actual tone of the image . . . little extras that give your print just that added difference that lifts it above the norm.

The first option open to you is the choice of a matt or glossy printing paper. Such a choice is often a matter of personal preference, but it is worth considering that it can also be used to enhance the subject matter. A soft-focus, romantic type of picture, with muted pastel shades if it's a colour print, works best with a matt surface. On the other hand, if your subject is harder, using strong contrasts or strident colours, the effect will be enhanced by printing on a glossy surface. By the same reasoning, portraits of women often work best on matt paper, while male portraiture looks better on glossy. But don't be afraid to break those rules if, for instance, you are picturing a very modern girl with extra colourful clothes and way-out makeup. Without a doubt, she would be a subject for the glossy treatment. The exception to all this is when you are submitting pictures for publication. Despite the effect you are trying to achieve, the printing process involved demands glossy originals. Printers *can* reproduce from

matt-surface papers, but the reproduction loses contrast and therefore quality.

Toning is another process worth considering for more effective presentation. Sepia toning (the old-fashioned brown-print look) is the one that immediately comes to mind, but don't forget that black-and-white prints (or mono slides for that matter) can be toned with many other colours as well, including blue, red and green. The basic process means little more than making the right type of print and soaking it in the toning solution either as soon as the print has been made, or at a later date. The black in the original image is then converted to the required colour. Don't confuse *toning* with *dyeing*. A colour dye affects the paper base, leaving the blacks as they are. The two can be combined to give a two-toned picture for even more weird and wonderful effects.

All these effects of course have to be matched with the type of model originally photographed. The multi-coloured effect just described would work perfectly with a young person, dressed and acting out of the ordinary, but that same subject would be destroyed by the use of a sepia toner, which gives the feeling of an age and days gone by. Similarly, for a particularly striking effect, you might like to dress your model in vintage clothing, pose him or her in a suitable setting and try to recreate some of the old-time pictures. Sepia toning would give just that little extra needed to lift the presentation into something special, especially if, in that particular example, the toning were combined with the next technique.

Vignetting at the printing stage is an effect that works better with portraiture than with any other subject. A vignetted picture is one that shows the principal subject in the centre, with all other detail towards the edge gradually fading away to clear, white paper. The effect can be achieved by cutting a hole in a piece of card and holding it midway between the enlarger and the baseboard during printing. Different effects can be created by

differently shaped holes, but the most effective for our subject is an oval shape. Soft focus or diffusion can also be introduced at the printing stage for a different form of presentation. Obviously, as before, it must be used with the right subject: a dreamy, glamorous picture of a woman, rather than a hard, straight picture of a man. The effect is made by any of the methods previously described in the section on taking soft-focus portraits in the previous chapter. From soft-focus lenses to petroleum jelly on a filter, all methods work as well on the enlarger as they do on the camera. But note that on the camera soft focus works by diffusing light into the darker areas, whereas in the enlarger diffusion spreads the shadows into highlight areas.

Texture screens make another interesting variation in presentation. These are small pieces of film with a texture printed on them. They are sandwiched with a negative (mono or colour) and the two are placed in the enlarger together. Processing is then carried out as normal, the final picture showing the portrait combined with the texture. The screens can also be used bound with transparencies. One of the most effective uses is for making pictures that appear like oil paintings, a form of presentation that could lead to extra sales if you are out to make money from your portraits. Texture screens commercially available from, among others, the Paterson company include: old master, reticulated grain, tweed, rough linen, tapestry, dot screen, drawn cotton, gravel, centric, denim, rough etch, stucco, grid line, steel etch, scramble and craze. The names speak for themselves.

Mounting prints

The most common mistake that many photographers make when they first begin mounting prints is to make things too complicated. A good picture will stand or fall by its subject matter. The mount is there to complement it, not to try to make a bad picture good, or to outdo it. So here's what *not* to do. Don't mount your print in the middle of a white mount and then begin to draw black lines around it. Don't mount it at a

A texture screen bound with the negative at the printing stage gives your portraits a different presentation, making photographs look like paintings.

peculiar angle just for the sake of it. Don't use brightly coloured mounts. Don't use strangely shaped mounts. And finally, don't take any of the above too seriously. Right back at the beginning of this book, I said that you should never be hidebound by rules, but that you should always learn the rules before you attempt to break them. Print mounting is a perfect example of just that. Everything I've just said *not* to do *can* be done when you know what you are doing and when you have the right print to play with. But start by keeping things simple.

Mounts need not be seen at all. They can be used purely and simply as a method of keeping your prints stiff. For exhibition work, in which the picture is the most important aspect, it's often best to use a mount that is exactly the same size as your print and then to stick it down flush with the edges. (In practice, it is best to use a mount that is very slightly larger, mount the print and then take a very slight trim off all the sides to keep it clean.) If you do decide to use a mount that is larger than the print, the most conventional mounting, with equal space all the way round, can still be very effective. If you want to add ornamentation to the mount, keep it simple, nothing more than a *thin* black line, maybe a centimetre from the sides of the picture and drawn neatly with a proper artist's pen. Don't try to use black ball-point, you'll only end up smudging it. And if you are in any doubt at all about your proficiency with a pen, ask a qualified artist to do the job for you, or don't attempt it at all. Drawing four lines equidistant from a print, all of the same thickness and all meeting at an exact right angle, seems the simplest thing in the world . . . until you try it. If in doubt, leave it out.

White mounts are probably the most popular, with black coming a close second. Choose your mount to match the mood of the picture. Grey is fairly popular, but it needs exactly the right picture to make it work. More often than not, the colour gives the overall composition a drab, muddy appearance and destroys the effectiveness of the picture on account of it. Coloured mounts can be used with colour prints, providing the colours are chosen with care. The colour of the mount should always complement the picture, and it is best to stick to dark shades. A black mount suits a pale picture, but can work equally well with a dark-toned portrait, especially if a thin white line is drawn around it. Coloured mounts should rarely be used with black-and-white prints.

Another rule that can be broken, providing you do it for the right reason, is mounting the print off centre. If your picture is of an unconventional subject and you really think it warrants off-centre mounting, then try it. Think of the mount the way you thought of the picture area when you were first

composing the photograph. Even here, the rule of thirds still works. So move your picture to the appropriate area of the mount, leaving maybe equal distances top and bottom, but with one-third space on one side to two-thirds space on the other. Or move it down as well so that there is a one-third/two-thirds ratio above and below the print as well as on each side. If you are going to do this and your picture indicates movement, mount it so that the larger of the spaces on either side is on the side of the print *into* which your subject appears to be moving. For example, if your subject is looking to the right, there should be more space on the right of the mount for him or her to 'look into'; mount the picture the other way round and the effect is immediately jarring. Again, if the subject warrants it, don't be afraid to stray from the traditional shape of mount. If your picture is long and narrow, use a similarly shaped mount. If the subject is off-beat, you can go for even stranger shapes like triangles.

Most of what has been said above applies basically to conventional cardboard mounts. But prints can be mounted on other materials too. Wood is the most popular alternative, but one that should be reserved for flush-mounted pictures. Wood makes a good mount, but not a very suitable surround to a picture. You can mount on most wood-based boards in the conventional way, using dry mounting tissue or specialised adhesives. Also, you can buy commercial woodblocks made specially for the job. These are available in all standard printing-paper sizes, and comprise a block of wood with an adhesive coated on one side protected by a sheet of paper. The paper is pulled away and the print placed on the adhesive, pressing it down as the paper is carefully and completely removed. When the whole print is mounted, it can be trimmed with a sharp knife to cut off protruding edges. The back of the block can then be fitted with a stand or hanger for displaying the picture.

Framing and hanging
Framing is a lot like mounting, in so far as the same

328

basic rule applies: make the frame complement the picture, not compete with it. Remember that the real subject, the reason for hanging it on the wall in the first place, is the photograph, or possibly the combination of photograph and mount. The frame is there only to hold it all together. So keep it simple. The days of the elaborate frame are dead.

Picture-frame mouldings plus glass can be bought in standard sizes and fitted together quickly and easily. When you buy a frame, however, buy one slightly larger than the print and then mount the picture within the frame. A print can look good flush-mounted on its own, but once a frame is added, it tends to need a little space around it, separating the margins of the print from the edges of the frame. In this instance, it is better not to fix the print directly on to the mount, but to mount it *behind* a sheet of card in which an aperture has been cut for the print to be seen through. The effect, when hung in a frame, is far more appealing than a print standing slightly proud of its mount.

Presentation is also about hanging frames in the right place, and the position isn't always dictated by aesthetics alone. Chemistry comes into it too. Colour prints tend to fade when left in the sun for long periods, so if you are hanging such a picture, avoid a wall on which the sun shines continuously. It's worth considering in advance that a picture to be hung in a shady part of a room might be worth making a little lighter than normal in the first place. Another tip is not to hang frames directly opposite windows, otherwise reflections in the glass will make it difficult to admire the picture. And don't be afraid to hang several prints together in a group. Four pictures arranged in a square of small frames can often have more effect than a single picture in one large frame.

Albums
Picture presentation has come a long way since the days of the family album with its row after row of snapshots, held in place by their corners, slipped into slots in the page. These days, presentation of

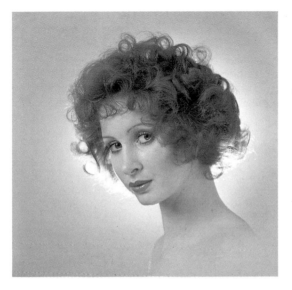

card mounts with appropriate apertures cut out, through which the slides can be viewed.

The other type of album is even more versatile. Each page is coated with a permanently sticky adhesive and then covered with a sheet of clear plastic. The plastic is peeled back, the prints placed in position on the page, and the sheet replaced over the top. The prints are held firmly in whatever position you choose to place them, and can be easily viewed as the pages are turned. The prints are well protected and can be re-arranged when necessary, simply by peeling back the plastic, removing the print and replacing it with another.

prints can be arranged far more informally and given more effect on account of it. The two most popular form of photo album now are the clear envelope type and the self-adhesive-page type.

The first of these consists of pages that are, in effect, clear acetate envelopes. In some, the envelopes are page size; in others, each page contains a number of separate envelopes into which several prints can be slipped. The latter type obviously caters only for a stock size of print, usually a standard enprint size, and because of its layout very little imagination can be used in design of the pages. The album that features page-size plastic envelopes is far better. These can be used to hold large prints the size of the page itself, or a sheet of thin card on to which several smaller prints have been mounted. This allows greater freedom of presentation. You can arrange prints in the way you want them in relation to each other, choose a suitable background colour for the mount, or change pages round as required. The pages are often bound on a loose-leaf principle, allowing them to be detached and rearranged at will. You can even mix prints with slides, slipping in black

Presenting slides

There are eight different ways that a slide can be viewed (upside down, back to front, etc.) and only one of them is correct. When presenting your transparencies, then, your first objective is to make sure your viewer sees them correctly, starting with the mounting. There are three types: card, plastic and glass. Card mounts are now dying out, though when you can get them they are still the cheapest and, in my opinion, the most convenient. The transparency is simply placed in position, the mount folded over it and the two sides pressed together for instant adhesion. They are simple to use and ideal for writing exposure details etc. directly on to the margin. Plastic mounts come next, in which the transparency is held in a more secure framework that keeps it from slipping. The mount is in two parts; one is pressed into the other and secured with a firm 'click'. Glass mounts are a variation on this, with the added protection of a sheet of ultra-thin glass built in to protect the transparency; more complicated aluminium and plastic versions have to be sealed in a mounting press. Out of the three, glass mounts protect your slides the best. But both slide and mount must be completely free from dust before mounting. They must also be dry, as the slightest drop of moisture will produce Newton's rings.

Once the slide is mounted, it must be spotted. It is the spot that tells the viewer which way round to look at the picture, so it is most important to get it right. The spot, which can take the form of a special self-adhesive disc of paper or can equally easily be drawn in with a pen or pencil, should be in the bottom left-hand corner when the slide is viewed correctly. That way, when it comes to be projected, the spot will fall in the top right-hand corner and naturally between the fingers of the projectionist as he slips it into place. If slides are to be projected, they can be kept either in slide boxes, ready for projection on a manual projector, or loaded into magazines ready for showing on an automatic type.

For the photographer who wants to keep his slides on file for possible publication or to show his work to potential customers, there are a number of neat methods that combine tidy storage with an ease of effective presentation. These take the form of plastic storage wallets of around 40 × 25 cm in size. Each has a set number of pockets to accept mounted slides, some have diffused plastic backs to make viewing easier, and a few have a second plastic oversheet that covers the whole thing, adding extra protection. The number of slides held in the sheet varies with the size of the transparency. An average-size sheet might take twenty 35 mm slides, twelve 6 × 6 cm, nine 6 × 9 cm, four 5 × 4 inch or two 7 × 5 inch. Some sheets are made to fit into their own ring binders and so present the slides in album form, others are made with metal bars to fit a standard filing cabinet.

A variation on the same idea, but one that gives a rather better form of presentation, comes in the shape of a selection of professional slide-display products. These are made from stiff black card with suitably sized apertures cut away, the shapes and sizes varying to suit all the standard formats. Card-mounted slides can be slipped into the back of the sheet and the whole thing encased in a clear acetate envelope. When viewed, only the pictures themselves can be seen against a black surround. A similar idea is also produced for single slides from

330

35 mm up, which slot into small sheets of 5 × 4 inch card, each of which in turn fits into its own plastic envelope. Using only one for each transparency is something of a luxury, but it makes the very best of your work. If you are out to sell your pictures, presentation is a major part of the battle.

Projecting slides

It is very difficult to devote an entire slide show to portraiture. There is a vast difference between a single portrait viewed on its own and a whole sequence of them projected one after another at a captive audience. It is better, then, to make portraiture a section within a larger and more varied show. The trick is to keep the slides as varied as possible. If you have a set of six similar pictures, all of which you consider to be good, be strict with yourself and pick out the one slide that is the best of the bunch. It will have far more impact that way. The best show is one that is made up from a varied selection of pictures, all shot with different models, at different times, under different conditions. That will keep things far more interesting for the audience.

When putting the show together, keep similarly toned slides next to each other. Don't jump from a high-key subject to a low-key picture and back again, because the sudden appearance of a light screen after a relatively dark one hurts the eyes, and you are there to entertain your audience, not to irritate them. During the course of the show, vary the angles of the portraits continuously, interspersing close-ups with full-length and three-quarter-length shots. Keep the show varied and keep it short. The best slide show is the one that leaves the audience wanting more, not wishing it had all ended ten minutes before.

Presentation to clients

There are whole books written on seeking markets, but there is more to a sale than merely taking a picture and finding a market. Even when you have done both those things, there is still

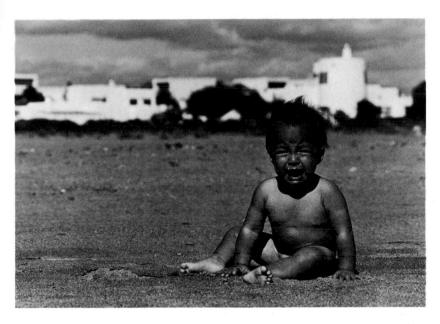

It's not the sort of picture that a proud parent would want in a frame on the wall, but the sort that most parents like to keep in an album. *Graham McEune.*

and bottom with two sheets of *stiff* card. Better still, use a wood-based board, although it must be admitted that this does tend to make the parcel rather heavy and therefore expensive to post. You'll have to weigh the cost of that against the value you put on the prints and how much they might be making you if someone wanted to buy them. Once the package is securely sealed, buy some *Photographs Do Not Bend* labels. Stick one in the top left-hand corner of the envelope and another on the back. Again, don't stint. Warn everyone what's in the package.

Transparencies are best presented to a prospective client in the black professional display sleeves mentioned earlier. Second only to those are the transparent storage wallets also mentioned. Remember that if you are showing your work to someone whom you hope to interest in a sale, it's to your advantage to give the customer the easiest way of looking at, and comparing, a selection of slides. An editor, for instance, who might be looking at your work with a view to using some of it in his magazine, won't want to stop to look at each slide individually. He will want to see a good selection at a glance, to get a general idea of the quality and subject matter before looking at things in more detail. When sending slides through the post, steer clear of glass mounts; they crack too easily. If you are sending your work to a market for possible publication, use only card or plastic mounts. The process involved in printing a colour transparency necessitates the printer removing it from its mount, and he will want the easiest way of doing so. Glass mounts only make his life more difficult.

something that will help give your pictures a greater chance of success: the way you present your work. If you are selling prints, or even giving them away, cardboard folders will do a lot for the presentation. They can be bought relatively cheaply from photographic suppliers and overprinted with your name to help publicise your work. The folder opens like a book, and the print is secured either by the corners or by slipping it into an inner sleeve with an aperture for the print to be seen. This latter type might be slightly more expensive but is better for the job, especially since you can buy them with a variety of differently shaped apertures. An oval, for instance, would be ideal for one of those old-time sepia portraits discussed earlier.

If you are sending prints through the mail, don't skimp on the packing. It might cost just that little extra, but it will be worthwhile in the end. There is nothing worse than a tatty, dog-eared print: if you send yours by mail with no form of stiffening in the envelope, that's just how they will arrive. Pick an envelope that is slightly larger than the print or prints that you wish to send, and pack them top

Presentation of the final product is every bit as important as the technique that went into taking the pictures in the first place. First impressions count, and your presentation is the first thing that anyone sees of your work even before they look at the actual pictures. It says a lot about you and, by definition, says much about your photography too. So take the time to do the job properly. Never ruin a good picture by poor presentation.

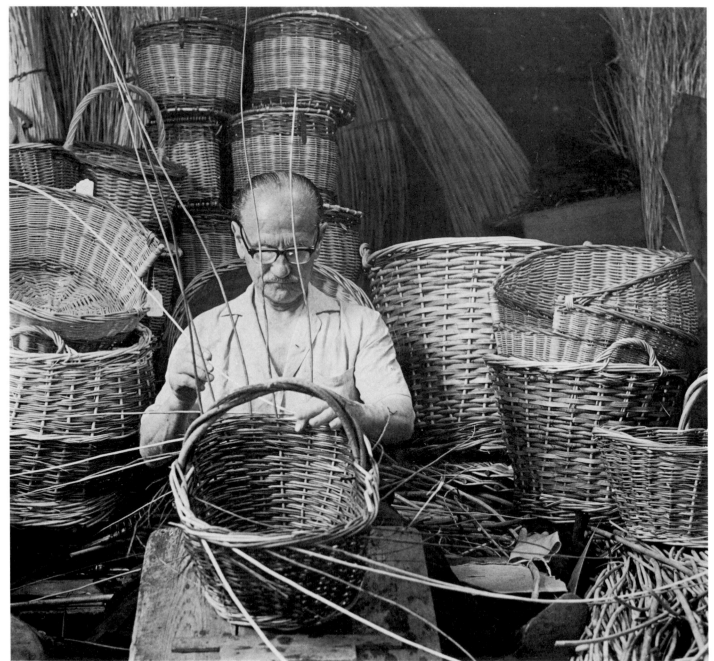

John Le Bas

Index